PAINTING A HIDDEN LIFE

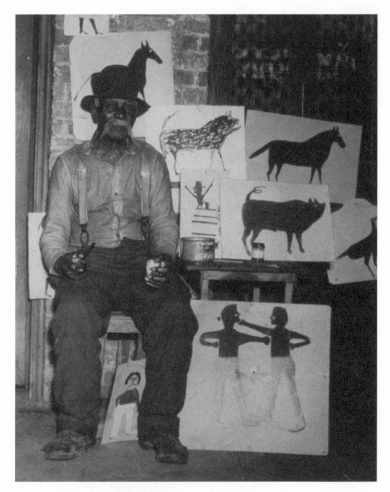

Bill Traylor, June 1940. Photographer unknown. Acme Newspaper, Inc.
Photo courtesy of Judy A. Saslow Gallery.

PAINTING A HIDDEN LIFE

THE ART OF BILL TRAYLOR

MECHAL SOBEL

)(

LOUISIANA STATE UNIVERSITY PRESS
BATON ROUGE

Published by Louisiana State University Press
Copyright © 2009 by Louisiana State University Press
All rights reserved
Manufactured in the United States of America
First printing

Designer: Barbara Neely Bourgoyne
Typefaces: Whitman, text; Avenir, display
Printer and binder: Thomson-Shore, Inc.

Stanzas from "All the Wrong White Folks" and "Ku Kluck Klan" are reproduced from Bruce Conforth's M.A. thesis, "Laughing Just to Keep from Crying," copyright 1984, by permission of Bruce Conforth. Excerpt from "Bill Traylor's 'Female Drinker,'" by Jeanne Curran, *Dear Habermas*, 23:15, May 1, 2005 (online), is reproduced by permission of Jeanne Curran.

Library of Congress Cataloging-in-Publication Data
Sobel, Mechal.
 Painting a hidden life : the art of Bill Traylor / Mechal Sobel.
 p. cm.
 Includes bibliographical references and index.
 ISBN 978-0-8071-3401-6 (cloth : alk. paper) 1. Traylor, Bill, 1854–1949—Criticism and interpretation. I. Title.
 ND237.T617S63 2009
 759.13—dc22

 2008031232

The paper in this book meets the guidelines for permanence and durability of the Committee on Production Guidelines for Book Longevity of the Council on Library Resources. ∞

For Zvi, Mindy, Daniel and Noam

Many people seem to think that the slaves left us a legacy of misery. I don't agree. They also endowed us with an attitude toward life that the blues idiom embodies. . . . [t]he fact that not only is one's personal plight sometimes pretty awful and unpromising, but also that life itself often looks like a low-down dirty shame that shouldn't happen to any creature imaginable. The blues require you to confront chaos as a fact of life and improvise on the exigencies of the situation, however dire, on the opportunities or the options that are also always there.

—ALBERT MURRAY, 2001

CONTENTS

ILLUSTRATIONS

BLACK-AND-WHITE ILLUSTRATIONS

COLOR PLATES *following page 70*

ACKNOWLEDGMENTS

My debts to those who have helped me in writing this book go back to Milton Brown's courses on the social history of American art, given at Brooklyn College many years ago, which were important to me in ways I did not fully realize until I undertook this project. The same is true of Edith Halpert's Downtown Gallery in Manhattan, one of the first galleries to display the works of African American artists. I visited this gallery almost every Saturday for several years. Four people I knew in Brooklyn in this early period of my life—Lita Maramarco, Catherine Small, Dorin Klibinow Kay, and Betty Meyrowitz Adelson (who occasionally joined me on gallery visits)—influenced me deeply, affecting the work I have chosen to do. I have lost touch with some of them, but I would like to thank them all, especially Betty, whose friendship over all these years has been very important.

I have become indebted to many other people in doing this study of Bill Traylor. Antoinette Beeks, Traylor's great-granddaughter, provided critical information about the artist and his family; K. K. Bunseki Fu-Kiau shared his rich insights into Traylor's symbolism; and Marcia Weber and Miriam Fowler were both generous in sharing their findings on the life of Bill Traylor.

On several visits to Judy A. Saslow in Chicago, she took me into her home and, saying she had found a sister, shared her long history of involvement with and love of Traylor's art. The great majority of reproductions in this book are here by the generosity of Judy A. Saslow, to whom I express my deep appreciation and affection.

I am very thankful for the special insights and friendship of Williadean Crear, my research assistant in Alabama. Together we interviewed a number

of folk artists, among them Buddy Snipes, Yvonne Crumpler, and Joe Mintner. We visited Benton together several times, and attended a Sunday service at the Benton Black Baptist Church of Rev. Taylor, whose rituals harked back to the past, and where his mother and other congregants spoke of their experiences. I thank them all.

At the New Bethel Baptist Church of Pastor J. D. Ruffin in Tyler in 1993, Mattie Dixon, one of his congregants, and her friend Sefal Foster, then eighty-two, volunteered to talk with me about black life in the Benton area in their childhood. Their suggestion of the significance of Freemasonry in this area of rural Alabama, confirmed in a talk with the family of Brother [Mason] Thomas Wimbly in Benton, pushed me to explore black Freemasonry in Traylor's time. John Jackson, also a Mason and the mayor of White Hall, an all-black town near Benton, argued that I should be concerned with the civil rights struggle. I finally came to share his view. I want to thank him, as well as Ruffin, Dixon, Foster, and the Wimblys for their help.

Loretta Valtz Mannucci and the Milan Group for Early American History hosted me and responded to my early thoughts on Traylor. Yvonne Crumpler, department head at the Tutwiler Collection of Southern History and Literature in the Birmingham Public Library, together with her staff, Jim Pate, Mary Beth Newbill, Don Veasey, and Elizabeth Willauer, helped me find my way in the archives and sent on important material after I left, as did Mary L. Jones. Robert Cargo, Georgine Clark, and Frank Turner gave me insights into Alabama folk art, particularly that of Buddy Snipes, whose symbolic imagery resembles Traylor's. Ralph Luker searched out rare and important Alabama newsclips and local contacts. David Evans set me straight about leopards in the blues. Delores Greenberg, a close friend for most of my life, gave me strong support while I worked on this project, and provided critical data as well. I thank them all.

Both at the beginning of my research and near its end, the New York City gallery owner Luise Ross talked with me about Traylor and proffered very important advice as well as slides from her collection. William Louis-Dreyfus, Janet Petry and Angie Mills, Anthony Petullo, Gerald Fineburg, and Harriet Kelley generously provided images, while others were made available with the help of Shelley Farmer, Jina Valentine, Laura Pasch, Kathleen P. O'Malley, Deanna Cross, and Peter Brams.

Lynne Porat, the chief librarian of the Interlibrary Loan Service of the University of Haifa, provided a lifeline to books and articles from around the world. Elliott Stonehill and Noam Sobel (who also visited with Judy A. Saslow) sent me copies of rare materials and photographs of Traylor's art.

A number of colleagues and friends gave my manuscript readings that were extremely important. I thank Shane White, Alan Taylor, Helen Paloge, Keren Omry, Judith McWillie, Ilana Hairston, Grey Gundaker, and Bill Freedman for their critical help. I thank Fredrika Teute for crucially illuminating the convoluted paths to publication, and for her warm friendship and support.

At Louisiana State University Press, Rand Dotson, senior acquisitions editor, played a crucial role in bringing this project to fruition, and Lee C. Sioles, Catherine Kadair, and Barbara Bourgoyne facilitated its smooth production. Manuscript editor Susan Brady edited it with sensitivity and skill. I sincerely appreciate their warm support.

I also thank my family—Zvi, Noam and Shlomit, Daniel and Tami, Mindy and Danny, Nahum, Hadas, Hillel and Tal, Ira and Tal, Asa, Shany, and Shalem, Luna, Avigael, and Elia—for their place in my life. Zvi Sobel, with whom I have shared my life for over a half century, read a manuscript of mine for the first time and gave it a crucial critical analysis. I give him very special thanks for this and much more.

And last I would like to thank Bill Traylor, although there is something more I would say to him, if I could. There is a tradition followed at many Jewish funerals that one of the people who prepared the body for burial addresses the dead person directly, and asks his or her forgiveness for any pain, discomfort, or dishonor caused by the procedures undertaken. Certainly, I hope that what I have written about Bill Traylor will enhance the memory of him; nevertheless, I feel a need to turn to him and ask his forgiveness for revealing things that I believe he wanted to have kept secret, and to tell him that I honor him greatly.

PAINTING A HIDDEN LIFE

INTRODUCTION

Bill Traylor is now widely recognized as a major artist, both in America and in Europe. His paintings are in the collections of the foremost American art museums, and in many minor ones; they are frequently on display in galleries; and their sale prices at auctions are on a sharp upward trajectory, with the higher-priced ones in the six-figure category. Traylor's paintings are striking. Their spare, powerful "radical modernity" is an aspect that seems particularly shocking when it is known that the artist could not read or write and spent much of his life (although much less than is generally thought) on a fairly isolated Alabama cotton plantation. Nevertheless, he produced art that reminds viewers of ancient cave drawings, Africa, and the works of Picasso.[1]

Bill Traylor began his life enslaved on a cotton plantation in Benton, Alabama, in 1853, and died in 1949 in a dreadful, rat-infested Montgomery nursing home for poor, old, and sick black people. Between 1936 and 1946, aside from two bus trips north to visit some of his children and a brief stay at one of their homes to recuperate from an operation, Traylor was a homeless man painting outside on a Montgomery street. Between 1939 and 1942, Charles Shannon, a young white artist, befriended Traylor, collected and stored some 1,200 of Traylor's paintings, and tried to promote their exhibition and sale, investing time, energy, and enthusiasm. He arranged two local gallery shows of Traylor's works, the first one at the New South Gallery in Montgomery in February 1940, six months after he first saw Traylor drawing, and the second at the Fieldstone School of the Ethical Culture Society in Riverdale, New York, in 1942. The paintings did not arouse serious interest in the larger art world, and Shannon stored them away until the late 1970s, when, thirty years

after Traylor's death, he renewed his attempts to promote them. He found that the response of the art world had changed radically as a number of folk art collectors, gallery owners, and museum curators began expressing serious interest in Traylor's works. A key event was the inclusion of thirty-five of his paintings in the exhibition "Black Folk Art in America, 1930–1980," at the Corcoran Gallery in Washington, D.C., in 1982. This prestigious traveling exhibition, and the singling out of Traylor's works for very positive notice by the press, put him on a fast track to recognition.[2]

When I first saw Traylor's paintings in the early 1990s, I, too, was immediately taken by them. I believed they contained cryptic symbolic messages I could not interpret, and for a long time I thought the key to understanding them was to be found in the cultures brought by enslaved Africans to the American South. Indeed, the path to Traylor's world of wonders does begin there, but it continues into the culture of every phase of his life, from his childhood until well into his old age. Between 1853 and 1949, Traylor lived in many changing lifeworlds: that of the enslaved, of so-called freedmen and freedwomen, of the blues, of Jim Crow, and, in his very old age, that of the Catholic Church. His experiences in each of these periods contributed to his inner life and to his encoded art. Seeking to understand Bill Traylor's hidden messages has been an extraordinary experience in which I have come to see this long period he lived through, as well as Bill Traylor, his art, and my own perceptions, in a new light.[3]

I now believe that Bill Traylor developed a complex worldview incorporating layers of different values and understandings into a unique individual matrix that is reflected in his autobiographical paintings. These values, developed over a lifetime, helped him through major crises, but he knew that his paintings could not openly reflect the views he had come to hold. The Jim Crow–controlled society punished the expression of independent thought or any criticism by black people. Often death was the price paid by those who violated these limitations. Traylor utilized symbols widely shared in the black communities he lived in that were not recognized by most white people, a fact that allowed him to paint his subversive messages and post them for all to see. Nevertheless, he took a life-threatening risk in doing this.

I view Traylor's paintings as both autobiographical, reflecting his joys and his sorrows, and as clear but coded statements of his rage and his call for retribution. In this, they were also acts of social protest, as they were posted for

all to see. Recent scholarship has begun to uncover other previously unrecognized acts of social protest by lower-class blacks in the South prior to the civil rights movement, and to recognize the importance of this early underground dissent primarily for the reevaluation of its own period, but also as critical to the success of the later movement. An important stream in this early dissent was expressed in the "bitter blues" lyrics of the 1930s and 1940s, which were widely heard by the poorest blacks and are known to have influenced early black leaders in the South. Many of Bill Traylor's paintings can be seen as bitter blues and as part of this early wave of protest. They expressed anger and pain over Jim Crow and advocated the use of conjure power and violence to overcome this oppression. That white people who saw his works either did not understand Traylor's symbolism or chose to block out its meaning enabled him to display his drawings in his sidewalk "gallery" on a very busy downtown Montgomery street in the heart of the black shopping district. There they were seen by a good number of the African Americans who were to take part in the Montgomery bus boycott six years after his death; I believe that many understood his messages, and that they had a hidden impact.[4]

Since the 1982 Corcoran exhibit, a host of critics have addressed Traylor's works in catalogues of museum and gallery exhibitions, in collections of essays on what is termed folk, or outsider, art, and in journals and newspaper articles. Many critics have viewed Traylor as drawing wonderful visual narratives of black folk life, while others, knowing there is something darker and far more complex in them, have suggested that it is best to portray his concerns as enigmatic. There is general amazement at the extraordinary level of artistic achievement: His sense of balance, movement, emotion, and use of color and space—"something close to visual haiku"—all appear remarkable in the works of an untrained and illiterate old man. With the exception of *African Voices in the African American Heritage* (2003), Betty Kuyk's brilliant study of the African iconography of Traylor's paintings and her fine discussion of the artist's need to make peace with his personal past, virtually everything critical written about Traylor's art focuses on this remarkable form and has little to say about content.[5]

Shannon's views were a foundation for this approach. He believed that Traylor "wasn't an analytical person," and stressed that he was "spontaneously intuitive." In his first public comments on Traylor, composed for the catalogue of the February 1940 exhibition, he wrote: "He has recorded the

life he has known with a boundless imagination that is steeped in a real joy in living." Shannon provided museums, galleries, and the press with this limited view of the meaning of Traylor's artwork as well as a brief, placid outline of his life. He not only owned virtually all of Traylor's pictures and claimed to know their significance, but he presumed to construct Traylor's life narrative as well. Almost everything in Shannon's outline of Traylor's life, as well as his interpretation of Traylor's art, needs to be reconsidered.[6]

In this book, I assess Traylor's art as reflecting his personal values and as tied, positively and often negatively, to the values of the communities he lived within: the plantation conjure culture he was born into, the blues culture he matured in, and the Jim Crow culture he learned to secretly violate. An analysis of the impact of his natal family on his values and his work opens the study, and his responses to the traditions of conjure, the Baptist Church, the black Masons, the blues, and both white and black Catholics follows. While recognizing Traylor's rich cultural heritage, I view the effect of his son's lynching on his life and his art as the linchpin of his development after 1929, affecting his beliefs and social concerns as well as his late call for violent retribution.

Traylor's paintings suggest that from childhood on his visual universe was extraordinarily diverse. He communicated through images and symbols similar to those used in Africa and the African Diaspora. In assessing these symbols, I follow the interpretations of symbolic anthropologists working in the tradition of Victor W. Turner, who regarded symbols as "determinable influences inclining persons and groups to action." Traylor mixed conjure signs, black Baptist symbols, as well as those of the Freemasons, along with symbols that had special meaning in Black Belt culture. The cross, which carried both conjure and Christian symbolism, and the lynching tree, were central. Using these symbols, he created a visual language that had great power and also, in his hands, great beauty; given that he lived for so long behind a "wall of silence for his spirit," it held mystery as well. There was "a man in the man" named Bill Traylor, and under pressure from an inner spirit that he believed existed, he made a violent break with his past, expressing his pent-up rage and the determination to change his life and the lives of those around him. This is the story of one man, but it reflects the internalized pain of several generations, and focuses on the paths black people blazed long before there was the march down the Selma-Montgomery highway.[7]

1

PAINTING A HIDDEN LIFE

(1853–1904)

Any song that we sing have reference to the life that we live.
—VERA HALL, 1948

All art is a sort of hidden autobiography. The problem of the painter is to tell what he
knows and feels in such a form that he still, as it were, keeps his secret.
—LEWIS MUMFORD, 1936

Between 1939 and 1942, Bill Traylor painted an autobiography in which he
succeeded at the task that Lewis Mumford saw as critical: He both revealed
much of what he knew and felt, and yet kept his secret well hidden. His
myriad paintings are his "papers"—a vast archive that cannot be consulted
in any one place and cannot be quoted. Near the end of his life, Traylor was
looking back to his beginnings and his "coming up" and to both the positive
and tragic events he had experienced; he reframed their meaning as part of
a new whole, and his pictures can be said to speak for him. However, while
I believe I understand an important part of what Traylor was both revealing
and concealing, others might well see different parts of the man and his work.
He was a man of many secrets, and his best paintings seem to vibrate with
all the electric energy they contain, holding it in and letting it out at one and
the same time.

Bill Traylor could not write; his children and grandchildren, who could,
kept his secrets as well. Traylor was not interviewed for the WPA project
collecting the narratives of the enslaved, but several reporters attempted to

speak with him in the 1940s. He did not respond freely; in fact, he barely responded, though he did talk to others, sometimes at great length. Nance Varon, the young son of a family that owned a local restaurant catering to the black community, reported that, while painting on the Montgomery sidewalk, Traylor spoke with him almost every day, and that he was quite talkative. Margaret Traylor Staffney, his granddaughter, remembered that when he lived in his daughter's house he recounted his dreams to her every morning, although he would not talk about his paintings. Charles Shannon, the white artist who collected Traylor's works and maintained contact with him between 1939 and 1942, once noted that he talked constantly while he painted, but Shannon recorded only a small number of brief comments made by Traylor. These are important, but they provide limited access to what he thought and felt. Kitty Baldwin, a close friend of Shannon's who accompanied him on visits to Traylor, commented: "Conversations with Traylor virtually did not take place. Bill Traylor wasn't interested in them." In 1987, Shannon ruefully noted that he had not asked Bill Traylor any questions: "Now, I sometimes wish that I had. I only knew what he volunteered to tell me." As there was little that Traylor volunteered to tell Shannon, and much of what he did say was a screen for the truth, it is his pictures we must query.[1]

Although the pictures are critical, there is, in addition, a wealth of recorded data that relates to Bill Traylor and his family: census reports, wills, "slave schedules," and a slave owner's diary. From these documents it is possible to reconstruct the outline both of his natal family's development and of his own life, an outline that is crucial to the evaluation of Traylor's work.

Like so many of the enslaved, Traylor was not sure of his own birth date and gave differing reports to the census takers over the decades: seventeen in 1870, twenty-six in 1880, forty-four in 1900, fifty-five in 1910, eighty in 1920, and seventy-five in 1930. In 1940, a friend wrote on one of his paintings that his birth date was April 15, 1855, and that was the date he had recorded at St. Jude Catholic Church at his baptism in 1944. However, when he said he was seventeen in 1870, the very first time he was asked his age by a census taker, his response would suggest the year of his birth as 1853. This date is supported by analysis of the "slave schedule" made of the human property on the Traylor plantation, where Bill was enslaved in 1860. Slave schedules noted the age and sex of each enslaved person, but recorded no name other than that of the owner. Had Bill been born in 1855, he would have been five

in 1860, and his brother Emet, born a year later, four. There were no boys of that age on the schedule of Thomas Traylor, the man who owned Bill Traylor in 1860 (see table), but there were two boys aged seven and six, no doubt Bill and Emet. Both the 1860 slave schedule and Bill Traylor's self-report in 1870 support an 1853 birth date for Bill Traylor.[2]

At his birth, Bill Traylor's family included his mother, Sally; his father, Bill; his sister, Liza; three older brothers, Henry, Frank, and Jim; and within a year, his younger brother, Emet. Together with some seven other black people who had been the property of John Traylor, Bill and his family were enslaved

HUMAN PROPERTY ON THE TRAYLOR PLANTATION IN 1860

1. Name of Slave Owner: Thomas G. Traylor[a]

2. Number of Slaves	Description			[Suggested Names and Relationships][b]
	Age	Sex	Color	
1	55	M	B	[George (Calloway)]
2	54	M	B	[Bill (Calloway)]
3	45	F	B	[Sally]
4	23	F	B	[Liza (Sally's daughter)]
5	17	M	B	[Harrison (Drusilla's son)]
6	16	M	B	[George (Drusilla's son)]
7	15	M	B	[Henry (Bill and Sally's son)]
8	14	M	B	[Richmond (Drusilla's son)]
9	14	M	B	[Frank (Bill and Sally's son)]
10	13	M	B	[Jim (Bill and Sally's son)]
11	9	F	B	
12	9	F	B	
13	7	M	B	[Bill (Bill and Sally's son)]
14	6	M	B	[Emet (Bill and Sally's son)]
15	2	M	B	

3. Number of Slave houses: Three

Source: Adapted from "Slave Inhabitants in Old Town in the County of Dallas, State of Alabama, 21st day of June, 1860 . . . ," 1860 Slave Schedule, State of Alabama, Schedule 2, p. 321.

[a]Thomas G. Traylor, the son of John Traylor, was born on January 12, 1842, and came of age to claim his inheritance, including these enslaved people, on January 12, 1860.

[b]The slave schedules give no names. These names are suggested on the basis of data in both Calloway and Traylor census records, and John Traylor's will and diary.

on a small cotton plantation near the village of Benton, in Lowndes County, Alabama. Most of the adults had known each other for many years, and their deceased former owners, John and Mary Calloway Traylor, had each known one of Bill's parents long before they were married.[3]

John Traylor's relatively isolated cotton plantation was located on a narrow dirt road leading west, through wooded terrain and over wooden bridges, some twelve miles to Selma. In the other direction, more open, the road led over Church Hill to the small village of Benton, and forty miles down the pike to Montgomery. Bill Traylor was born here into a community that was almost entirely black and almost entirely related to him, either fictively or by blood. Perhaps even the most powerful man, the white "master," was, in a peculiar fashion, a fictive kin. Many of the enslaved, including Bill Traylor, referred to their owners as their "white folks," and in many cases, including that of the Traylors, their lives had been intertwined over several generations. Bill Traylor later memorialized George Traylor, the white man in authority while he was growing up, by having a literate friend write on one of his self-portraits that he was "Raised Under Mr. George Traylor," while the explanation he gave Shannon for leaving the Traylor plantation was that "My white folks had died and my children scattered," as if these factors were of equal significance.[4]

John Traylor, the founder of the plantation Bill Traylor was born on, was George Traylor's brother. Born in Edgefield, North Carolina, in 1809 to parents from Virginia and South Carolina, John moved to the Alabama frontier in 1834, hoping to make enough money as an overseer to buy land and slaves. He oversaw several large plantations, one of which had a reputation for particularly brutal treatment of the enslaved, and then, in 1842, moved to his own small cotton plantation, where the land and enslaved black people had indeed been purchased with the money he had earned. Diaries kept by overseers and small plantation owners are rare, but, remarkably, the family preserved a diary kept by John Traylor between January 1834 and April 1847. This document provides significant data relating to the small black community of kin and fictive kin who had been together long before the birth of Bill Traylor in 1853.[5]

Bill Traylor's father, for whom he was named, was born in Georgia in 1805 or 1806. Together with four other African Americans owned by Benjamin Calloway, he worked on the Calloway farm in Jones, Georgia, south of Savannah, until Calloway moved his family and his enslaved workforce to a new farm in Alabama in 1828. In 1836, John Traylor, then a twenty-seven-year-old

overseer, traveled to this farm to court and marry Benjamin and Nancy Calloway's fifteen-year-old daughter, Mary, and took her off to live with him at the plantation he was overseeing. After the death of Mary's father some four years later, John Traylor attended the "sail" of her father's estate, where he purchased Bill [Calloway], George [Calloway], and Drusilla, as well as two children, most likely Drusilla's offspring. He brought them to his new plantation near the village of Benton, in Lowndes County, where they began to break ground for cotton and build a cotton gin, a house for the white family, and cabins for themselves. Bill [Calloway], George [Calloway], and Drusilla became the nucleus of both the Traylor workforce and the life of the new black community. They found a few enslaved workers already on the farm, among them Sally, born in Virginia about 1815, who had been John Traylor's property for some time. Sally, who already had a daughter, and Bill [Calloway] soon became a couple, and by the time Bill Traylor was born in 1853, he was their fourth son. Although Bill Traylor was a third-generation American, there is evidence that his parents, and the other adults around him, lived in an African-influenced lifeworld and were able to maintain basic aspects of their African parents' understandings and culture and pass them on to their offspring.[6]

When John Traylor died in 1850, the plantation population included eight black children—four of Sally's offspring and four of Drusilla's, who remained single—and three of Mary's white children. Bill [Calloway], George [Calloway], and Drusilla lived in close proximity to Mary Calloway Traylor most of her life, and their children lived in close proximity to her children. John Traylor's diary provides a terse but tantalizing description of the daily life on this plantation. He recorded his own very active social life in detail: He went to singing and preaching events at a large number of churches, to weddings, "infars" (parties to welcome a bride to her new home), "barbycues," a quilting, an election; and he once arranged a race between the enslaved cotton pickers he was overseeing and those on a nearby farm. Both before and after his marriage he traveled to visit friends and family whenever he could, and volunteered to make a census count of the Creek nation, which kept him away from his plantation for two months. Notwithstanding all these activities, his drive to succeed financially appears to have been paramount. He often urged himself on, repeatedly writing, "Go a head steam boat," and seemingly assessed his own abilities highly, noting, "Who can beat this? Me."[7]

Sally (1815–1880+) *m.* Bill [Calloway] (1805–1860+)

Liza	Henry	Frank	Jim	**Bill**	Emet
1837	1845	1846	1847	1853	1854

Bill Traylor *m.* Larisa Dunklin (1872–)

Pauline	George	Sally	Rueben	Easter	Alice	Lillian	Child
1884	1885	1887	1892	1893	1895	1896	1898
		[Sarah]		m: Graham	[Aline]	m: Hart	
		m: Howard					

Nettie ("outside child")

1887

m: Pitts

Bill Traylor *m.* Laura Williams (1870–)

Clement	Will	Mack	John Henry	Walter
1896	1901	1903	1908	1915
[Son]				[Bubba]
[Uncle Son]				

Jimmie ("outside child")

1902

Note: There were a number of other children in Bill Traylor's homes over the years, including Arthur (b. 1910), Hank (or Plunk, b. 1910), and Kisu (b. 1915). They may have been "outside children" of Bill Traylor, who reported that he had fathered twenty children.

When John Traylor wrote of the enslaved, he generally restricted himself to their work, although when they shared limited social time it was noted. They occasionally did go to Baptist church services and revivals together, and he accompanied them on a few "holodays" given for fishing, but, aside from their work, the lives of Traylor's laborers were, for the most part, out of his conscious purview. He recorded the output of the enslaved forces he oversaw, the largest group numbering seventy-five men, women, and children, and his pride in the significant increases in their productivity while he oversaw them. The methods he used to gain these ends were never discussed, although we know that other overseers often beat workers who did not meet their quotas. The cotton crop he was responsible for at the largest plantation he oversaw went from 66 bales in 1834 to 230 bales in 1839, with no increase recorded in the enslaved workforce, facts that raise questions.[8]

Traylor did record that while he was an overseer he whipped enslaved workers who tried to run away, "berayed" or befouled a "negr gal" for an offense he did not record, and once whipped two enslaved workers for the crime of "harlern," or hollering out field calls. He may well have suspected that these sounds, unintelligible to him, announced plans of the shouters to take their freedom, and indeed one of the two he whipped for hollering fulfilled this expectation and escaped the next day. Traylor also recorded that he went out with patrollers looking for others who had escaped: He "Caut Jo with dogs" and gave "gall," a bitter punishment, to another recaptured man.[9]

John Traylor did not record any punishments given to his own, relatively small, enslaved force—a total of some twelve adults and children, augmented at times by rented enslaved workers. He kept a record of the free time he allowed his workers; ironically, he generally gave them a free day on July Fourth, Independence Day. The only word in his diary that suggests his reflections on the condition of the enslaved is found in his note on June 2, 1838: "gave the po hans holoday."[10]

Bill [Calloway] became a central worker on John Traylor's farm, and either worked together with John Traylor at the most important jobs or was relied on to do the same work alone. There are many notes of "mee and Bill" building the key structures or of Bill's laboring by himself. Sally was taken note of too, beginning with the early record that John went to church with her at his first posting as an overseer. The diary includes a note about the birth of one of her children and perhaps the death of another when he recorded

that on February 23, 1844, "I made a coffin an barid [buried] a negro childe Martha." Unlike Bill, Sally worked together with others in a "gang," clearing ground, picking cotton, or plowing the land, as black women generally did in Alabama.[11]

What is unusual in John Traylor's diary, however, are his detailed records of having left his plantation and his enslaved workers without any supervision for various periods of time ranging from a few days to several months. He had begun this pattern when he was an overseer, and clearly stated it was a "tast [test] of my hans left in the field for the first time." Each time he returned, he commented that the work he expected the enslaved to have done was indeed done well. In a society where white slave owners and overseers claimed that slaves had to be brutally overseen in order to ensure production and keep them from taking their own freedom, he provided no explanation for his own unusual behavior or that of his enslaved work force. This record indicates that in some ways this Traylor plantation was out of the ordinary, but it raises a question that cannot be answered: Did Traylor reward the enslaved or threaten to punish them?[12]

The "marriage" of Bill [Calloway] and Sally, and the names of their children, Liza (Sally's daughter) and their three sons, Henry, Frank, and Jim, are attested to in the will of John Traylor, who died in February 1850, three years after his wife's death. Given that John Traylor, a practicing Baptist, went to church regularly and encouraged his enslaved workers to attend as well, his use of the term *marriage* suggests that Bill and Sally, who was also a churchgoer, had a church-sanctioned union. Traylor's will, like his pattern of absenting himself and depending on his slaves to do the work assigned to them, had an unusual aspect as well. John Traylor left both his land and his enslaved workforce to his young children, which was to be expected, but he directed George Traylor, his brother, to keep the enslaved people together on this land until his children would come of age, beginning in 1860. In doing this, he sought to protect the inheritance of his own children, but he also protected the black community he had lived with since 1842. The enslaved were to remain as a single working unit, and not be separated one from the other, or sold away. His brother, George Traylor, honored his instructions, and as a result Bill Traylor, born three years after John Traylor died, and his younger brother, Emet, born a year later, as well as Sally and Bill [Calloway] and all their children, Drusilla and her children, and George [Calloway] were able

to stay together long after John Traylor's death. The only change in the group was brought about by natural causes: Drusilla died before the war began, and Bill [Calloway] was dead before the war was over. Billy, as Bill Traylor was then called, lived on the John Traylor plantation with his family and the rest of this group of enslaved people from his birth in 1853 until the end of the war in 1865.[13]

These records provide far more information than was previously known of Bill Traylor's family, but they are no more than a matrix on which to build. As noted, beyond his pictures, Bill Traylor left few records of his own thoughts and none of his parents'. There is only one autobiography of an Alabama black man who shared many of Bill Traylor's life experiences that does explore ideas held and actions taken: that of Ned Cobb, who dictated his life story, *All God's Dangers*, to Theodore Rosengarten in 1968–69. While Cobb was much younger than Traylor, his report of the comments made by his Grandma Cealy, who was about the same age as Traylor, and born enslaved on an Alabama plantation, suggest what may well have been Traylor's experience. Cealy told her grandson that after the war black people "would open up every once in a while and talk about slavery time—they didn't know nothin' about no freedom then, didn't know what it was but they wanted it. And when they got it they knew that what they got wasn't what they wanted, it wasn't freedom, really."[14]

Bill, too, experienced nothing of freedom when he was enslaved and little of it afterward. As Alabama plantation managers put enslaved children to work at a younger age than was customary in Virginia or other East Coast areas, Bill was probably working by 1859, when he was six. He began work under the direction of George Traylor, although John Traylor's son Thomas took legal possession of the enslaved when he came of age in January 1860. The following year, however, Thomas joined the Confederate army and George Traylor returned to managing the plantation. Bill Traylor worked under George Traylor during the war and long after, and was still there when George Traylor died in 1881. Although he paid his respects to "Mr. George Traylor" by having his name and role in his life recorded on a picture, other paintings by Bill Traylor suggest his criticism of and anger at white masters, overseers, and bosses. He painted these white men carrying rifles and exhibiting upright postures of superiority when they rode their steeds in the fields where blacks were working. At the same time, he surreptitiously threatened

them with violence by painting their bodies over large white poles, figuratively shafting them. (See the white man on a horse in the collage of Traylor's paintings shown in plate 34, lower left, and the shafted white man in *Hunter on Horseback*.)[15]

Bill Traylor remained enslaved until the end of the war. The first northern soldiers to come through Benton were Wilson's Raiders, who, after taking Selma, were on their way to Montgomery when they camped outside Benton on April 11, 1865. A story was later told that Bill Traylor had memories of these soldiers wrecking havoc on the Traylor plantation while he hid from them in a tree; however, there is a report from one of the Raiders that local black people lined the road and welcomed them. There is no way of knowing exactly what Bill Traylor did in this period other than that he stayed on the property after the war was over. Walter Calloway, enslaved just south of Montgomery, told a WPA interviewer of the havoc Wilson's Raiders created on the Calloway plantation, where they appropriated all the food they wanted and burned the rest. Calloway, nevertheless, remembered their raid as a marker of the great change that was supposed to have come about: "Twarn't long atter dat dey tell us we'se free. But lawdy, Cap'n, we ain't neber been what I call free." Bill Traylor, like Cealy and virtually all black people in the South, was certain to have agreed.[16]

Bill's father, a central figure on the plantation, is likely to have played a similar role in Bill Traylor's life. His death between 1860 and 1866 was a loss that compounded the problems that his son had to face in this time of traumatic change. By 1866, Bill's four older siblings were married and had established separate households, so that at the age of thirteen "Billy" became the "head" of the remaining family. This was recorded in the state census of the ostensibly free "colored" people in Alabama taken in that year. Almost all the heads of black families—the only ones listed by name in this census—were recorded by first name only. The next census, the 1870 U.S. Census, recorded both the first and last names of all the household members, and confirmed that William Traylor, age seventeen, as he responded when asked his name and age, was the head of a household that included his younger brother, Emet, age sixteen; their mother, Sally; and two younger girls, Susan, age seven, and Mary, age nine. These girls may have been Sally's children or grandchildren or fictive kin for whom she took responsibility, as so many were doing after the war. William and Emet Traylor were working as farmhands to support them all.[17]

William, or Bill, Traylor and most of his siblings and their families, as well as the families of Drusilla's children, stayed in or near Benton long after the end of the war, and a number were still working for George Traylor in 1880. They were kin and fictive kin, and knew each other well, having weathered together the last decades of slavery, the war, and the early postwar days of dreadful antiblack violence. A significant number of the women chose not to work outside their homes after the war; Sally Traylor was among them, and she may have enjoyed her new status for over a decade. By 1880, however, she was recorded in the census as "maimed, crippled, bedridden, or otherwise disabled," and was being cared for by Susan Walker, a seventeen-year-old woman, probably the seven-year-old Susan Traylor who had been in the household a decade earlier.[18]

After the war, the fact that Alabama blacks did not experience true freedom was made evident by the behavior of their white bosses: Many continued to whip their black workers and denied them freedom of movement. While it is known that the last legal owner of Bill Traylor, the white Thomas Traylor, was called "master" long after the end of slavery, there is no documentation of any of the Traylors beating their workers; however, in a period when a great many blacks set out on the roads to test their freedom, almost all the black Traylors stayed put. Bill Traylor continued working for George Traylor, and lived in close proximity to the white family as well: His home was a shack three houses away from the substantial home of the white Traylor family. When George Traylor died in 1881, his young son Marion, who had spent time with Bill as he grew up, took over. There was little immediate change in Bill Traylor's working life, except for a brief period when Alpha Champion, the county surveyor, hired him to serve as flagman as he surveyed Traylor lands in 1888.[19]

Bill Traylor did make a significant personal move in 1884: He started his own family with Larisa Dunklin, their relationship beginning when she was not yet thirteen and Bill was thirty. By 1887, they had three children, Pauline, George, and Sally, but they had not married or set up a household. The children were apparently living with their mother in her family's home, while Bill was alone in his shack on Traylor land. Young women often had children but continued to live and work with their parents. Charles S. Johnson, in his 1934 study of Alabama black life, *Shadow of the Plantation,* maintains this was a common pattern in the rural black communities of the cotton South: Some-

times a man "owned" or acknowledged that he was the father of the children living with their mother's family, and sometimes the father and mother later married. Many married men had "outside children" while they remained heads of households together with another woman. Couples sometimes simply lived together while others formally married, some at the outset, others later. If a married couple agreed to part, this was regarded as a divorce; a person went to court to get a formal divorce only if the second party would not agree to end the union. These various patterns were widely followed by Black Belt African Americans throughout Bill Traylor's lifetime, and their effect was clearly apparent in Traylor's attitudes and behavior toward women and children. These attitudes were reflected in his paintings: Men and women are depicted as attracted to one another, but they almost always also keep their distance from one another, sometimes marked by an arm outstretched between them. Other women are symbolically depicted as massive burdens for men, as in *Man with Construction on Back* (plate 15), or are in obvious conflict with violence threatened, while children are rarely on the scene. The sex act is shown between truncated bodies, bodies without torsos, arms, or head, as in *Five Figures with Dog and Leg Construction* (plate 12).[20]

Ralph Ellison and Albert Murray may be (figuratively) looking over my shoulder and shaking their heads when I take into consideration Johnson's data and conclusions. They felt that both black and white social scientists, including Charles S. Johnson and Gunnar Myrdal, could not to be trusted to understand lower-class southern black life; that statistics and "objective" observation were inadequate. Murray wrote to Ellison: "What I see when I look at social science surveys and profiles of 'my people' (which is to say, my idiomatic American relatives) is a bunch of science fiction tar babies!" Ellison found Myrdal wanting primarily because he viewed "Negro culture and personality simply as the product of a 'social pathology,'" which might be altered by fuller "assimilation" of white values. In their own writings, both Ellison and Murray wrote of complex black individuals, often in or from Alabama, whom they seemed to know up close, and whose culture they valued. Murray indeed was born and grew up in Alabama, and both he and Ellison went to college there, graduating from Tuskegee in the 1930s.[21]

Johnson maintained that people in the Black Belt were not usually upset by infidelity, but by the "transfer of affection." If this was the case, Bill Traylor had probably transferred his attachment to another person in 1887. In that

year, Larisa Dunklin had their third child, but Bill Traylor also had a daughter by another woman, and Bill and Larisa parted for some years. They got back together again in August 1891, and to mark their reunion they formally married and had their marriage recorded in the "Colored Marriage Record Book" of Lowndes County. Their new household included their three children as well as Bill's outside daughter. By 1900, there were five more children in their family; however, Bill Traylor had already begun another relationship with Laura Williams and fathered her son, reflecting again both infidelity and a transfer of his affections, as Laura Williams continued to bear his children and later became his second wife.[22]

Bill Traylor remained in Benton through the hopeful years of Radical Reconstruction, when, in the face of growing white violence, black men widely joined the militant Union League and voted in state and national elections. Founded by blacks and whites, the Union League supported blacks' participation in the Republican Party and encouraged their "quest for land and autonomy," organizing militant responses to white violence. In April 1867, the League estimated it had thirty thousand members in Alabama, and the numbers were going up every month. With the help of the League, over 96 percent of the Alabama black men legally allowed to vote were registered by October 1867. There are no extant records of League membership from Benton, and no hint that Traylor had been a member, but given the high figures for voter registration, Traylor may have registered and voted when he came of age in 1874 in the critical election that returned the Democrats to control in the House of Representatives. It is more certain that he was a member of an organized social group, as it would appear that almost every black man was in a "secret" benevolent society, both for the rich (and time-consuming) social life, as well as the sick benefits and funeral costs provided. His art indicates his knowledge of Freemasonry, but it is possible he was a member of more than one of the secret societies, as were so many of the people around him.[23]

Traylor remained in Benton and continued working for the white Traylors long after the formal end of Reconstruction in 1877. Over the last decades of the nineteenth century, he experienced the loss of rights and the damage to the dreams of freedom that most blacks had shared after the war. In the 1880s and 1890s, segregation increased, as did physical violence and lynching, while economic conditions deteriorated. Lowndes County, where the population was over 88 percent African American, was widely known for

its extreme poverty and for its harsh repression of black people. This was one of the reasons W. E. B. Du Bois selected Lowndes as the location for a research project on black life that he carried out in the fall of 1906. Organizing the project together with the sociologists Monroe Work and Richard Robert Wright, twelve local interviewers were hired to interview more than five thousand black people. The Department of Labor had commissioned the study and was scheduled to tabulate the answers to Du Bois's questionnaires; however, Charles Patrick Neill, the commissioner of the department, was appalled by the data they received. Considering the answers unclear and unusable, he repeatedly delayed the printing of Du Bois's analysis. Neill did not appreciate the significance of this data on the economic and social affairs of a large cohort of black peons living under the most severe Jim Crow conditions, which Du Bois described as the "best statistical study of the real meaning of emancipation ever attempted." His questionnaire, which dealt with folklore, amusements, reading, social organizations, as well as economic conditions, suggests that the replies may well have been a treasure trove of self-reports on the lives of southern black people at the beginning of the twentieth century. Both the data and Du Bois's essay on this material were mislaid or destroyed by the Department of Labor.[24]

While Du Bois was unequivocal in his judgment that in Lowndes County the "white element was lawless, [and] the Negroes thoroughly cowed," something more than the poverty, peonage, and illiteracy of most of the blacks living in Lowndes County attracted Du Bois to study this region. An experiment of revolutionary proportions had been undertaken in Lowndes and seemed to be succeeding, an experiment that captured his imagination and hopes, as he indicated in an essay on the economic outlook for black people that was published early in 1906. Du Bois wrote that over the last ten years something radically new had occurred in Lowndes County: "a scheme of cooperative land buying under the Calhoun School. It was asked for by a few Negroes who could not get land; it was engineered by a Negro graduate of Hampton; it was made possible by the willingness of a white landlord to sell his plantation and actively further the enterprise by advice and good will. It was capitalized by northerners and inspired by a New England woman." Some one hundred black people, twenty-nine of whom had been born enslaved, were selected to participate in this experiment, and by 1906, seventy-seven held deeds to more than three thousand acres of land. Local black people called the community

the "Free Land," and Du Bois noted, without giving any details, that they ran their community by "a peculiar system of self-government." More than sixty-five of these owners had replaced their one-room slave shacks with two- or three-room homes, and in place of a poor three-month school, a much-advanced school began operating for an eight-month school year. The teacher at the old school chose to become a student at the new one, attesting to the great improvement that had occurred.[25]

On September 22, 1906, Du Bois was in Lowndes County involved in research for this study when word reached him that a massacre of blacks was under way in Atlanta, where his wife and child were awaiting his return home. In panic, he took the train back to Atlanta that day, and while traveling wrote "A Litany at Atlanta," which describes his encounter with an inner devil that urged him to seek violent retribution: "There is that clamoring and clawing within, to whose voice we would not listen, yet shudder lest we must,—and it is red. Ah! God! It is a red and awful shape." His dread of the bloody reality, and his fear that his own family might have been attacked, turned his spirit to darker images of what might be expected in the Jim Crow South, and of his own urges to respond in kind. Indeed, the Calhoun experiment did not begin a positive trend. It raised much white anger for the very reason that it provided proof that black people could succeed as free landowners, and it led to increased pressure on whites not to sell their land to blacks. As black people in the county knew, and as Tom Dent, a black resident, later affirmed: "Independently or defiantly inclined blacks in Lowndes had to get out if they expected to live." Du Bois, too, turned to other venues to express his defiance.[26]

There is no evidence that Traylor was defiant at this stage, but there is evidence that he was aware and angry that people and forces he could not control had tied him down and controlled him. His painting *Man with Top Hat and Green Trousers* (plate 1) shows the subject, presumably Traylor, as a hobbled giant, forced to move about on his knees, while a number of Lilliputians attack his genitals and his anus, and one figure is about to hit him over the head. This picture can be seen to document the external manipulation Traylor felt he was subject to, as well as his feelings of entrapment, but, given his upright torso and high hat, he records that he internalized his anger and kept an upright image of himself; nevertheless, it took a long time and several traumatic events before he could break out of a long moratorium, and leave Lowndes.

Before Traylor made his move from the Traylor plantation in the first decade of the twentieth century, relocating to an area close to Montgomery, Jim Crow laws had been extended in ways that particularly affected the growing black communities in urban areas. In these cities, southern blacks were "shocked" and "shamed" that black people on trolleys were forced to sit in back and relinquish seats to whites when the vehicles were crowded, demeaning "conditions imposed after forty years of unrestricted travel" on public transportation. In response to these new humiliating constraints, black people living in Montgomery waged an all-out trolley boycott in 1900, a tactic that was less successfully followed in some twenty-five other cities across the South. In Montgomery, most of the black population walked or used black-owned drays, and "after two years the company was so hard hit that it simply suspended enforcement of the law." Bill Traylor was no doubt aware and proud of this success, but sadly it was short-lived as after the black population resumed using the trolleys, "Jim Crow arrangements were quietly reinstated," and the strike was not resumed.[27]

Other gains of the Reconstruction period were also cut back, most significantly, the right to vote. Alabama black men had voted in larger numbers than the white population of the state in the late 1860s, so it is no surprise that, with restitution of white power, their right to vote was immediately curtailed as whites set out to reinstate their total domination of the political process. By 1901, voting rights had been effectively denied to most black men in Alabama: In that year, not a single black man in Lowndes County was registered to vote, and only 3,000 black men in all of Alabama—out of the 240,000 who were over twenty-one—were registered. Ned Cobb, who was fifteen in 1901, explained that he gradually came to understand the deep impact of "takin' the vote away": "As I growed to more knowledge I thought that was as bad a thing as ever happened—to disfranchise the nigger. Tellin him he didn't have a right to his thoughts. He just weren't counted to be no more than a dog." In thinking about the future, Cobb was again impressed by the thoughts and actions of the older generation, particularly that of his grandmother Cealy: "My grandmother and other people that I knowed grew up in slavery time, they wasn't satisfied with their freedom. They felt like motherless children—they wasn't satisfied but they had to live under the impression that they were. Had to act in a way just as though everything was all right. . . . Had to do whatever the white man directed em to do, couldn't voice their heart's desire."[28]

It is unlikely that Traylor, whose experiences were close to that of Cobb's grandmother, voiced his heart's desire then. To suggest what might have been his innermost wishes while he still lived in Lowndes County, we have to look at his culture and his art. Though the extant paintings were done much later and present a retrospective view of what his life had been like or what he would have liked it to be, they reveal a great deal about Traylor. As long as Traylor lived in Benton, we know that he had to follow Cealy's pattern: He "had to act . . . as though everything was all right." Leaving Benton was his first break with the most repressive aspects of the Jim Crow system, but it apparently took his committing a violent act to get him to leave. Because Traylor's culture significantly influenced his reactions to this act, it is important to consider his values and understandings of life in his enslaved childhood and in the years he spent working for the white Traylors before dealing with this major break in his life.

Guion Griffis Johnson, a white social historian, noted in 1937: "It was often said that a slave was two persons, the one who worked in his master's field by day and the other who 'pleasured' himself by night." She was certain that an enslaved person thought about himself this way, and that the "life, which he led with his own people, apart from the ever-watchful eye of his master, was the life that made slavery endurable." Given that there were periods when there was no white supervision on the Traylor plantation, and the diary record that suggests that John Traylor did not invade their life after work, it is likely that Bill Traylor was born into an extended family whose members had been able to lead a fairly full second life with their own people.[29]

Since Johnson made that comment, a great deal has been written about the changing culture in the last generation of slavery as well as the first generation of emancipation that Traylor grew up in, rich in music, dance, and oral lore. However, several aspects, critical to an understanding of Bill Traylor's visual universe, have not been appreciated: Black life in this period also provided a daily opportunity for observing pictures, as well as a conjuration practice that called for pictures to be drawn by practitioners and clients.[30]

Pictures literally surrounded every black person, as the houses of the enslaved and later the freed people were almost universally papered with pages from newspapers and magazines, both to keep the cabins insulated and as decoration. As photography became more prevalent in the press, and advertisements more modern, the houses of black people became virtual galleries

of drawing and photography. This use of newspaper also reflected and influenced an aesthetic that was expressed in homes and art crowded with images and objects, which Zora Neale Hurston identified as "the will to adorn." Hurston viewed this as a leading "characteristic of Negro expression," and found it exemplified in a home she visited in Mobile, Alabama, in the late 1920s. "The walls were gaily papered with Sunday supplements of the *Mobile Register*. There were seven calendars and three wall pockets. One of them was decorated with a lace doily. The mantel-shelf was covered with a scarf of deep home-made lace, looped up with a huge bow of pink crepe paper."[31]

Bill Traylor reacted strongly against this aesthetic in his art: His work was characterized by the modern view that less is more, and this rejection of a leading "characteristic" of his community's culture is a significant signpost of his personal independence and values. But Traylor certainly did not reject everything, and in fact the central values of his parents' culture were his values, although later he often altered their valence and their expression.

The ubiquitous use of newspaper as wallpaper, apparent in a number of photographs taken of the interiors of black housing during the Depression, provided children with pictures to emulate, and adults with visually rich surroundings. Figures 1.1 and 1.2 suggest how the small spaces in which black people lived were filled with pattern and design arranged with much care; and that children were provided comics as well as modern designs to look at. The impact of this wallpaper is still remembered in at least one Alabama community today: A woman from Gee's Bend—a fairly isolated black town thirty miles southwest of Selma that long retained much of post–Civil War culture—was asked about the roots of her quilting art exhibited at the Whitney Museum. She commented that when she was growing up, she had looked at newspaper pictures on the walls of her cabin and said to herself she could make pictures like these.[32]

There was also a conjure justification for the practice of covering walls with newsprint: It was believed that witches were compelled to read every letter, and therefore were deflected from evil behavior. This is not a curiosity or an insignificant aside: Conjure impacted every facet of life in the Black Belt. The worldview of Bill [Calloway], Sally, Drusilla, and George [Calloway] was built on the tradition of conjuration, and conjure became a critical aspect of Bill Traylor's worldview as well. This tradition was rooted in a number of Afri-

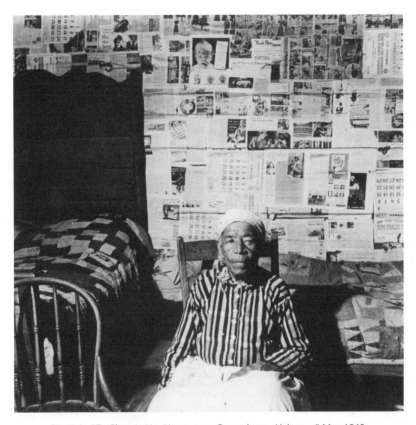

Fig. 1.1. "Ex-Slave in Her House near Greensboro, Alabama," May 1940.
Photograph by Jack Delano. Library of Congress, LC-USF34-044461-E.

can cultures, including that of the Igbo, many of whom had come to Virginia (as Sally's parents had), as well as that of the Kongo peoples who came to Georgia (as the parents of Bill [Calloway] had), a subject critically explored in the groundbreaking work of Betty Kuyk, *African Voices in the African American Heritage* (2003). Her analysis of the impact of Kongo and Igbo values and beliefs on the art of Bill Traylor provides the foundation for understanding that part of Traylor's iconography that grew out of these evolving immigrant traditions.[33]

Bill [Calloway], George [Calloway], and Drusilla were all born and raised in coastal Georgia, where the black community is known to have widely shared conjure beliefs related to those brought from Africa. Long before it

Fig. 1.2. "Interior of Negro Tenant Farmer's Home," October 1935.
Photograph by Ben Shahn. Library of Congress, LC-USF33-006018-M2.
Art © Estate of Ben Shahn/Licensed by VAGA, New York, N.Y.

was generally accepted that African culture had come into Georgia in a robust fashion, the Georgia Writers' Project of the WPA collected and published a compendium of conjure knowledge from people who had previously been enslaved in coastal Georgia. The editors and writers, including Mary Granger, Melville J. Herskovits, Charles S. Johnson, Lorenzo Dow Turner, and Sterling Brown, recorded the presence of innumerable conjure doctors and root workers and the widespread use of conjure bags, little bottles, cross marks, foot tracks, and a host of recipes for conjure and root medicines, in virtually all cases citing "African parallels." Those interviewed who said they didn't believe in conjure generally went on to tell of conjure beliefs they did regard as significant.[34]

Traylor absorbed conjure understandings of causality and purpose in his childhood: They were embedded in the injunctions he received from his parents and fictive kin, in the folk tales and adages he heard from those around him, in the medicine and advice he was given when ill, and in the games he played. These understandings were part and parcel of a conjure worldview based on the assumption that all events are caused by spirits that exist both

within human beings and in a spirit world, and that one can learn how to appeal to the outside spirit world for aid, particularly if one wants to catch and control the spirit of another person. People were enjoined to turn to an initiated expert—a conjurer, witch, or root worker—for instruction on what spirits, or enemies in contact with spirits, were planning to bring about and how this might be altered.[35]

What was learned was "by its nature secret," and, as Grey Gundaker emphasizes: "To speak loosely could diminish its power and turn loose uncontrolled energies." Instructions often involved the use of constructed objects— figures of men and women, or animals, and bags or containers filled with power-infused materials. Conjurers taught their clients how to create and use these objects, many for therapeutic purposes, and others for turning back harm onto those who sought to injure the person appealing for help. Healers, root workers, and conjurers with knowledge of these materials, objects, and rituals were certainly among those brought to America in the slave trade, and while they were generally regarded as powerful and dangerous, their advice was widely sought and followed by many in the population of the enslaved, as well as free blacks and whites, and passed on to the following generation. There were many teachers in the wider community, as a conjure worker near Waycross, Georgia, explained: "Well, yo' learn lots of it from master craftsmen—people, older time people who have been following it fo' years, done made experiment on dose things an' know de ones which will work."[36]

While most every person in the black community knew signs, symbols, and recipes from the conjuration repertoire, it was generally assumed, even by those who claimed they "did not believe," that conjure doctors had special powers. A number of conjure doctors active during Traylor's lifetime claimed to have been trained by one of the best-known workers in the field, the first Dr. Buzzard, apparently a white man who practiced in South Carolina from some time before the Civil War until about 1887, who was followed by many black men who took his name; or Aunt Caroline Dye of Arkansas, an African American woman who lived from about 1855 to 1918, and was followed by self-appointed namesakes as well. Some spoke of well-known root workers or witches who began to initiate them as children, while others found mentors who invited them to apprentice themselves later in life, or who took payment in exchange for their knowledge. While this conjure tradition had its roots in African cultures, and was brought by Africans to the new world, many white

people sought treatment from conjure doctors, often after white doctoring failed to help them, and/or because as southerners they had grown up sharing values and ideas with both black children and adults, and had come to believe in conjure as well. A small number of these white people became practitioners who treated both blacks and whites.[37]

While I was among those analysts who viewed the African American conjure tradition as having lost its consistency over time, Bill Traylor's art taught me its strength as well as its congruence with twentieth-century Black Belt values. In addition, the massive data and analyses of Harry Middleton Hyatt, reanalyzed by Michael Edward Bell, and the brief but cogent essay by David H. Brown have convinced me that hoodoo was based on a far more coherent belief system than I had thought. Remarkably, Hyatt's collection allows us to explore the nature of this tradition during Traylor's lifetime and how Traylor might have come to know it. Between 1936 and 1940, Hyatt, a white Episcopal minister, interviewed 1,605 African American conjure workers and their clients, and published the transcribed interviews in five massive volumes, which he introduced with his sense of their meaning. Hyatt had experimented with faith healing himself, and communicated his respect for their learning to his informants, many of whom assumed he wanted to become a conjure doctor. He also paid them for the time and trouble they took to tell him of their experiences. The end product is a massive compendium of conjure lore and practice that can be mined for many aspects of black culture.[38]

Traveling from Delaware to Louisiana, Hyatt stayed in black hotels and hired black taxi drivers to canvass the neighborhoods for informants. Hyatt's lengthy interviews provide a revealing view of the training, understanding, and experience of a wide variety of both professional conjure doctors and their clients, many of them quite old. These older informants talked of the "old," or traditional, way of doing "conjures" in which capturing spirits was seen as the central task of the conjure doctor, who always carried a "small black bottle" for this purpose as well as a "purse," "grip," "briefcase," or "kit" to carry this bottle as well as herbs and medicines.[39]

A number of Traylor's paintings show a man carrying a small black case and/or a small black bottle. In January 1987, when Betty Kuyk interviewed David Ross Sr., owner of the Ross-Clayton Funeral Home, where Traylor was given a place to sleep during the Depression, she asked if he remembered Traylor. Ross, shocked at first to hear this name that he had last heard some

forty years earlier, responded, "He always carried a bag with him." He singled this out as the most distinguishing item associated with Traylor, and was certain others in the black community would remember him when told he was the man with the black bag. Ross also said that when he wanted to know something about Traylor he didn't ask him, but asked Traylor's friend, suggesting that Ross kept his distance from a man carrying such a kit and/or that Traylor kept his distance from others. Given what conjure clients said about conjure practitioners always carrying a "purse" and what Ross said about Traylor being identified by his bag, Traylor's paintings of a man with a small black bag appear to be self-portraits that announced to the black crowds that passed his pictures on the street in Montgomery that he was a man with conjure power. (See *Blue Man with Umbrella and Suitcase*, plate 2.) The umbrella, which appears in many of Traylor's paintings, may well have been a stand-in for the African seer's carved and power-laden walking stick.[40]

Many of the conjure doctors or healers who spoke with Hyatt believed, "You have to be born with this power," and held that there would be physical signs to signal this ability at birth, such as a caul over the head, red-rimmed eyes, blindness, or what was termed two heads. "Two-header," "double sighter," or "two-facer" were old terms that refer "to the worker's contact with spirits who reside in the conjure doctor's head and may guide him or her." Close analysis of the head of the figure in *Man Wearing Maroon and Blue with Bottle* (plate 3) reveals two hat brims, two hats, and two necks. Given this doubling on one body, this is literally the portrait of a two-headed man holding a small bottle of "spirits," or a bottle for catching a spirit, and wearing a shirt that also has a symbolic bottle for holding spirits as its front panel. Note also the numbers at the waist, and the suggestion of an erect penis, the first perhaps indicating complexity while the second was associated with a particular spirit's authority. This playful picture also appears to be an announcement that passed by white people but informed many blacks that Bill Traylor was laying claim to special powers.[41]

In the late 1930s, Traylor seemed to be announcing that he was a man with conjure knowledge, but this does not answer the question of what it entailed for him. Did others consult him as a conjure doctor, or was he portraying himself in a role he did not actually play? In his childhood he had been surrounded by adults who might well have taught him the old ways of doing conjuration, with their African provenance, which would have prepared him to

take on such a role, and the bag he actually carried suggests this was a role he really played. While no evidence has been found of clients who came to him for help, perhaps those who bought his pictures were paying for visual aids for conjuration, or possibly received something else from his black bag as well.

The old ways followed in his youth were "based on the image of the body as a container for a soul as content," a soul that could be "removed" by a conjurer intending harm. The conjurer, however, could choose to attack the body directly "by blocking . . . the body's orifices." These ideas appear to have formed the basis of Traylor's beliefs exemplified in his pictures of ubiquitous little bottles to put spirits in, and myriad bodies apparently being attacked.[42]

While helping clients to attack their enemies was an important part of what conjure doctors did, spirit protection was at the heart of their work. Hyatt explained that it was believed that "Every disturbance of the . . . human body—bad luck, headache, broken arm or disease—is caused by an evil spirit someone sends into it by calling on the help of God or the devil. Only a master of spirits can rid the body of an evil spirit." While some conjurers turned to Jesus or to God to help them get rid of evil spirits, most seemed to look to other spirits to do this work, spirits that Hyatt heard about but did not analyze. One informant told him clearly: "Ah conjure thee by de spirits of de watah dat choo [you] do mah will." Their names probably were new, but water spirits were part of the old tradition: In the Kongo culture, "Nearly all of the 'healing' minkisi are derived from water spirits and the majority of them cause possession."[43]

People who knew and taught this tradition also populated the Black Belt in Alabama. A conjure worker or doctor that Hyatt regarded as "a first-class craftsman"—one of the best he met—talked at length of what he had learned from the man who introduced him to the craft about 1905: "This old man . . . his name was Uncle Charlie Jackson. . . . He was down in Alabama," where he did conjuration with live snakes. Jackson's key teaching involved the use of the "one-inch or one-ounce" black bottle he always carried in his practitioner's "purse." He put roots appropriate to the case and iron nails to represent the people involved inside the bottle, but before he closed it, he said the Lord's Prayer "into it," and then at 3:00 a.m. he would "bury it with the mouth toward the sunrise." In 1905, there was a seventy-year-old Charles Jackson living about thirty-five miles from Benton, in Marion, Alabama. Jackson reported to the census taker that he didn't work but that he owned his own home. Doing

conjure work would not have been reported, but it could well have provided the funds for him to have become a homeowner, which was not common among blacks in rural Alabama. This Charlie Jackson may well have been the mentor of whom Hyatt was told.[44]

The thousands of rituals and recipes collected by Hyatt deal primarily with the use of excretions from the body: urine, feces, sweat, blood, hair, fingernails, and skin scrapings, in mixtures with dust from gravesites, metals, bluestone, salt, potash, snuff, needles, nails, lye, cayenne pepper, and myriad other products, all to be used in detailed ritual ways that are most often concerned with blocking or unblocking a path into or out of the body in order to protect or harm a human being. In their talks with Hyatt, most professionals went into great detail in regard to rituals and recipes for creating packets of such goods, widely called hands, mojos, or conjure bags, that could harm or protect people, cross or uncross them, and cure their ailments. As Wyatt Mac-Gaffey explains, similar packets were made in traditional Kongo culture: "A gourd, a bag, a bark box, a pot or a snail shell" was filled with "grave dirt, kaolin (white clay) or stones, taken from the place where the spirit in question abides, [which] metonymically incorporates the spirit in the *nkisi*," which has been variously described as sacred medicine, or a seal. A second class of items metaphorically informed the spirit of the help requested, and a third class, items from a person's body, informed the spirit of the person to be affected. Such items were used in making Alabama mojos, or hands, which were often carried for protection by those for whom they were created or buried on the grounds or in the houses of intended victims. Many of Traylor's paintings seem to allude to the blockage of the genitals or the bowels as a major concern, as fingers point to the bowels and spirit figures are attached to this area. In the picture *Big Man, Small Man* (plate 4), this part of the body is specifically targeted: The large figure is credibly pointing to a conjure object buried nearby that has caused his problem, while the spirit figure is targeting his backside.[45]

An X or a cross within a circle was one of the key symbols in African American conjure. (See *Animated Scene*, fig. 4.6.) An expert conjure doctor from Waycross, Georgia, explained his work with spirits to Hyatt by saying: "Well, yo' take a clean sheet an' yo' draw yo' a circle on dat clean sheet of paper an' put a cross in dere jes' lak dat, yo' understand, dat's de fo' corners of de earth." In one of Zora Neale Hurston's initiations into conjure in this period, she was taken to a lakeside in the middle of a swamp where, as she

explains, "A candle was burning at each of the four corners of the clearing, representing the four corners of the world and the four winds." Hyatt came to the conclusion that the "crossmark in hoodoo frequently represents the *four corners of the earth*," although this marking popularly signified an act to cross or uncross an individual with a conjure threat. As Ben Washington, who lived in the pinewoods outside Eulonia, Georgia, noted: "Ef yuh ebuh see a cross mahk in duh road, yuh nebuh walk obuh it. Das real magic. Yuh hab tuh go roun it. It's put deah by a enemy an if yuh walks cross it, duh ebil spell will cause yuh hahm. Duh cross is a magic sign tuh do wid duh spirits."[46]

Robert Farris Thompson and Wyatt MacGaffey have long considered a symbol known as the Kongo cosmogram, a cross imposed on a circle, as central to Kongo beliefs, and Thompson has found ample examples of parallel symbolism in Cuba, Brazil, and the United States. Their analyses of the cosmogram are based, in part, on the experience and ideas of K. K. Bunseki Fu-Kiau, an initiate of secret Kongo societies who has become an important interpreter of Kongo beliefs for blacks and whites in America. Fu-Kiau explains that in Kongo culture, life is plotted along a circular trajectory, beginning with conception at the southern, or yellow, pole; birth in the east at the white point; the height of development and accomplishment in a V-shaped quadrant around the northernmost pole, which is red; and death at the black point in the west. The center point was seen as green, the color of success. Bill Traylor's palette reflected these and other "symbolic colors of conjure in order to identify roles and communicate attitudes toward people and events." The bottom half of the circle, below the "water line" that marked the division between the top and bottom, was believed to be the domain of spirits, and this was marked in Traylor's pictures as well. Circles or half circles are in a number of Traylor's paintings, as is a *T*, which Thompson posits signifies the bottom spirit half of the circle, with the vertical line indicating that spirits could travel up into the world of the living from the domain of death. This emphasis on the bottom half of the circle may have been of particular significance to Traylor, as he apparently came to believe he had a special relationship to the Spirit of Death. In several of his pictures, the line that is the top of the *T* is the top of a coffin as well. (See *WPA Poster,* plate 5.)[47]

African Americans widely believed that an individual's spirit, central to life and afterlife, was always at risk. Hyatt felt that virtually all his collected data dealt with the way "To catch a spirit or to protect your spirit against the

catching or to release your caught spirit," which he termed "the complete theory and practice of hoodoo." In the old tradition, drawing pictures and, later, taking photographs were an important part of the process of capturing, harming, or protecting spirits, techniques that have barely been taken note of by modern analysts. One of Hyatt's informants explained that if: "somebody dey hate an' got evil in 'em fo' 'em—ah've heard of 'em makin', drawin' a pitchure of 'em. Jes' set down an' draw a pitchure of dat person an' take it an' ca'y it an bury it in de cemetery. Take it an' bury it in de cemetery jes' lak yo' buryin' dat person body, an' talk to it. . . . In six mont's time dey'll be a dead person." Clients were told to be actively involved in the conjure process and not to rely totally on the work of the conjurer. They were instructed that to harm a person they should "draw somepin', yo' know, like a pitchure of 'em," and put graveyard dirt on a hand or some other body part, and the person will get sick in that body part, and soon die. One client recounted that: "In case dat yo' wus hurted by anyone an' yo' would go tuh a root doctor. Well, dis doctor, he would draw dis pitchure of de individual who did dat tuh yo' an den, aftah dat, he would build a fire an' in front of de smoke, yo' see, he'll hold de pitchure up. . . . Put it, yo' know, on a stick or somepin, an' den yo' shoot [it]."[48]

I believe that Traylor's painting *Snake and Two Men* (plate 6) was made to harm an enemy's sex organ according to conjure directions. This powerful drawing introduces us to Traylor's rage at a white man, and to the power he believed he could tap into even though he was an unfree black man in the Jim Crow South. Traylor's family refers to all the time he spent on the Traylor plantation as a continuation of his initial enslavement, and this painting may refer to the conditions that Traylor lived under both prior to the Civil War and as a field hand and a sharecropper afterwards.[49]

In *Snake and Two Men*, Traylor painted a man behind eleven bars precisely paralleling a figure found in the lexicon of pictograms and ideograms, termed *nsibidi*, used in a secret Leopard Society organization for men in southeastern Nigeria and southwestern Cameroon. Similar groups, formed by the enslaved brought to Cuba and Haiti, adopted these symbols; the symbols were also brought both directly from Africa and from these islands to sections of the American South. In this lexicon, a figure of a man with bars across his body signifies a man is being beaten or is a captive, as Traylor certainly was. There is another Traylor picture titled *Man/Bars* with just three bars across the body of a figure whose right arm is pointing up and left arm is akimbo. In this sec-

ond picture, the figure's head is rhombus-shaped, with one corner-point at the top, which parallels the *nsibidi* sign for "a bad man." It is probable that Traylor had knowledge of this lexicon as he used several more complex symbols from it in *Figures and Trees* (plate 24). Further analysis of the African, Haitian, or Cuban influences on Traylor's use of symbols substantiates the complexity of his referential world.[50]

The bars in Traylor's picture *Snake and Two Men* numbered eleven and in *Man/Bars* three, numbers that would have meaning to those in the black community familiar with playing dice and policy playing. Policy, a lottery game with roots in the colonial and early national periods, was geared to attract the participation of the poor as very small amounts could be wagered and large prizes were promised, and it was widely popular in black communities. Eleven and three are generally regarded as lucky numbers, but *Aunt Sally's Policy Players Dream Book* suggests that they carry a mixed and heavy burden as well. First published in the 1890s and reprinted many times in the Jim Crow period, this was a pamphlet that correlated dream images with numbers to bet on, and it sold well among black policy players. The booklet was published with a black woman's face on the cover, ostensibly that of Aunt Sally, the purported author. In *Aunt Sally's . . . Dream Book,* the number three is generally associated with good fortune and described as "a happy sign" of "friendship and wealth," but it is noted that the number can also signal "misery" as well as "treachery" to come. Surprisingly, most of the numerous prognostications associated with the number eleven in *Aunt Sally's* lexicon are dreadful, such as "prepare for persecution," "imprisonment," "sickness," and "mourning," but several suggest that "sorrow" will be followed by "joy" and that "liberty" will follow "imprisonment." Can the eleven bars on the lower figure in Traylor's powerful painting indicate future luck for the man being beaten and/or enslaved? "I'm confident all of my race will someday move out from under earthly bondage," were the words of Ned Cobb, born in the Black Belt not too far from Traylor. His grandmother Cealy had said, "Colored people once knowed what it was to live under freedom before they got over in this country, and they would know it again," and Cobb become convinced that: "the bottom rail will come to the top someday. . . . But won't nobody do it for them but themselves." I think Bill Traylor came to believe that too.[51]

The snake was an important image in both the African and the Western tradition. In *Aunt Sally's . . . Dream Book,* a snake signifies "injury by the mal-

ice of a man." The snake image was used in an important statement by John
Henry Gosse, a young man from England, who in 1838 was a teacher on the
plantation of Judge Reuben Saffold, the very plantation where John Traylor
became the overseer in 1840. Gosse, appalled at the violent methods used to
punish and control the enslaved on Saffold's plantation, fled Alabama after
his contracted time was up. Back in England, he warned: "Slavery is like a
huge deadly serpent, which is kept down by incessant vigilance, and by the
strain of every nerve and muscle; while the dreadful feeling is ever present,
that, some day or other, it will burst the weight that binds it, and take a fear-
ful retribution."[52]

Bill Traylor would not have used these words, but his image can be seen
to suggest much the same reality: The snake in this picture is ferocious, with
a huge head and exposed teeth, and it is threatening the upper figure, whose
wide-open eyes suggest his great fear while his splayed legs indicate his in-
ability to move in order to save himself. The half circle marking his genitals
suggests that this area has led to his troubles, and is marked out for conjure
harm. In West Africa, the lower half of a circle symbolized fertility as well as
the abode of the spirits. Had lust gotten this figure into trouble? The bottom
figure in this drawing, while in captivity behind eleven bars, seems to be
preaching wisdom to, or threatening, the figure above: the akimbo position
of his hand on his waist traditionally meant the person was putting down evil,
while the hand raised at a 45-degree angle and pointing up signified that retri-
bution would be the Great Spirit's. In this picture, the enslaved figure is wise
and in contact with spirit power while the free figure above is threatened
and half dead, although he, too, has raised one arm, perhaps seeking protec-
tion from the threat. The picture appears to be an encoded message about
responsibility and morality as well as a threat, and its green color may signify
the eventual success of the man at the bottom. The snake is carrying out this
threat, and in Gosse's words, "the dreadful feeling is ever present, that . . . it
will burst the weight that binds it, and take a fearful retribution."[53]

The threat encoded in this picture made by the enslaved black man at the
bottom appears to be against a white man at the top. Bill Traylor once demon-
strated to Charles Shannon how anyone could tell which figures were white
people in his drawings: "He placed his little stick [a homemade ruler] down
on the profile of one of his figures and said, 'Now you see there, when the
stick touches the nose and the chin but it doesn't touch the lips, it's a white

man.' He said, 'If it touches all three, it's a black man.'" Applying this rule, the upper figure, threatened by the snake, is a white man, and the charge against him in this painting is likely to have been sexually exploiting enslaved black women. More than a charge, this image seems to record a conjure threat against the perpetrator.[54]

While most narratives written north of slavery either openly or covertly referred to the reality of whites' sexual abuse of enslaved women, after the war and in the Jim Crow era, those who had been enslaved and were still living in the South did not speak easily of white sexual exploitation. A rare description given by a black in the Jim Crow South of his white owner's sexual violation of black women was reported by a witness identified only as the son of Harry Green, born enslaved in South Carolina not too far from Charleston. Andrew Polk Watson, an African American anthropologist working for the Fisk University Social Science Institute, interviewed Green's son several times between 1928 and 1931. Green's son told Watson about a number of relatively acceptable events while enslaved: He spoke of his uncle's ecstatic preaching, his mother's travels in the spirit, his father's love for the family, his own conversion, his white mistress's support for their religious activities, and his white master's generally decent behavior, violated only when he was drinking. In his last interview, he spoke for the first time of the sexual demands on enslaved women made by this white man, and although he labeled it "not" an accusation, he said:

> He was a good man, but he was pretty bad among the women. Married or not married made no difference to him. Whoever he wanted among the slaves, he went and got her or had her meet him somewhere out in the bushes. I have known him to go to the shack and make the woman's husband sit outside while he went in to his wife. . . . I used to ride behind him on horseback, and whenever he went to see a woman he would leave me with the horse along beside the road, and he would go a little distance into the bushes and thickets— far enough from the big road to be out of sight. . . . I am not accusing him of nothing, but these are just things I saw. He wasn't no worse than none of the rest. They all used their women like they wanted to, and there wasn't nobody to say anything about it.

This interview was put on deposit in the Fisk archives for many years, and perhaps the interviewee thought that was where it would remain. It was,

however, published in 1945, but neither the name of the man interviewed nor that of his owner was revealed.[55]

In 1937, when Susie R. C. Byrd, an African American, interviewed Rev. Ishrael Massie, born in Virginia in 1849, he gave witness to very similar white behavior, at the same time as he made it clear that he would never have spoken of such things to a white person. He stated it was "common" for masters to tell black husbands to leave their beds to do some task and that they would then get in bed with the wives, much as his master had done. He believed that white people were being collectively punished for these actions: "Don't ya kno' God gwine keep er punishin' white folks—keep er sendin' dem floods, win' storms an' lettin 'asters [disasters] come to deir chillun an' deir chillun's chillun in dis day an' time."[56]

White sexual predation continued in the Jim Crow period, and may well have affected Bill Traylor's son Will and the whole Traylor family. In 1926, Will Traylor's wife, Mimia, gave away a daughter one day after she was born; family members explain that the baby appeared too light skinned to have been Will's child. Will and Mimia remained together to have another child that Will acknowledged, which suggests that the child given away was not fathered by a white lover but by a white man who forced himself on Mimia. This event may have rekindled Bill Traylor's rage at white sexual abuse he knew of in the past as well. At this point in his life, Traylor did not share Rev. Ishrael Massie's conviction that the Christian God was punishing white folks for these crimes, but he apparently did believe that he had access to powers that would respond to the message embodied in this image. Traylor drew a condemning illustration that he believed would call down the wrath of a powerful conjure spirit, embodied in the snake, on the perpetrator.[57]

A circle of people, with a leading figure in the center, is painted in at least three of Traylor's works. Fu-Kiau, on seeing one of these pictures, commented: "Traylor is in the circle. He is willing to be initiated. He dreams he sees the shadows of ancestors below. He is left inside the circle with the nature of the white man, symbolized by the white man's hat. He is calling to the sky with his left hand, and his right hand is in the traditional position that indicates power, confidence and his readiness to fight. But those around him can't help him. And there is only one black behind him."[58]

Traylor can be said to be picturing himself as a leader who could call down the spirit and put down enemies, but who nevertheless did not have a signifi-

cant following. Traylor would have known circle symbols from many sources. Ring shouts—ecstatic counterclockwise movements in a circle—were central to black Baptist practice during Traylor's coming-up period. Bill Traylor would have had experience with them while on the plantation and probably at the local Baptist church where Sally, Bill's mother, was a member. (See *Preacher and Congregation*, plate 7.)[59]

The circle rituals that Bill Traylor painted were much like the one Thomas Higginson witnessed in his black regiment in 1862. Higginson notes that, as in Traylor's picture, there was "someone in the centre": "Men begin to quiver and dance, others join, a circle forms, winding monotonously round some one in the centre; some 'heel and toe' tumultuously, others merely tremble and stagger on, others stoop and rise, others whirl, others caper sideways, all keep steadily circling like dervishes." Traylor's circles no doubt referred to powerful black Baptist rituals, but they also suggest a connection going back to African practices, as Fu-Kiau notes, and were central to hoodoo and Masonic rituals as well.[60]

In 1846, John Dove, grand secretary of the all-white Grand Lodge of Virginia, published an analysis and an illustration of the Masons' "Point within a Circle" in his *Virginia Text-book:* "There is represented in every regular and well governed Lodge, a certain Point within a Circle—the point representing an individual brother; the circles, the boundary line of his duty to God and man, beyond which . . . he is never to suffer his passions, prejudices of interest to betray him, on any occasion." After the close of the Civil War, Dove gave a copy of this illustrated text on Masonic practices to a leading black Freemason, who saw to it that Dove's textbook was widely adopted as the rule for rites, rituals, and symbols in Prince Hall lodges. The black Freemason's fraternal order, which was first organized by Prince Hall in Massachusetts in 1775, and later named after him, had always emphasized rituals and symbols, but apparently did not have a common basic rulebook prior to this time.[61]

Black Freemasons were enjoined to see themselves as always standing at that point within the circle that marked their moral duties. As with the white Masons, oral learning was enhanced by visual cues: Symbols, drawn on their banners and aprons, and on the floor, including the circle and its central point, played a significant part in their rituals. All Masons were taught to work with these and other symbols in their quest "to reach further" and to "make order out of chaos." The initiation ritual for an Entered Apprentice, the

first degree, states, "Here, all is symbol," and the textbook notes, "Here, we learn to look at the symbolic nature of everything that exists." Each member of the black Freemasons was expected to enter the tent of Solomon and journey up the ladder to personal completion.[62]

While black Masons shared the white Masons' emphasis on learning the secret symbolic Wisdom of Solomon, black Masons "claimed that the deeper truths presented by Solomon originated in the African civilization that preceded him." Joanna Brooks credits Prince Hall with "transforming the signs, symbols, and secretive practices of the Masonic temple into a template for race consciousness." Brooks notes: "Master Masons were entitled to guide initiates through . . . rites of transformation and were considered possessors of a second sight." By referring to Master Masons' "second sight," Brooks signifies that black Masonry had ties to the conjure tradition: the leaders were seen as two-headed seers who had contact with spirits.[63]

Bill Traylor provides evidence of his exposure to these ways of thinking about symbols and symbolic expression through visual representations of the Masons' square often drawn as a T square, and compasses often drawn as triangles, as well as the plumb line and plumb rule, the gavel and the chisel, all of which he reproduced in his drawings. Sometimes Traylor incorporated Masonic imagery in a simple fashion: In his painting of a man with a black bottle in hand (*Flat-Backed Drinker; Drunken Chicken Walk,* plate 8), the arm bent above and the arm and leg below the body make two triangles. How can this fit with what the Freemasons taught? Prince Hall, the founder, suggested an answer to this question in 1797, stating that those who lived according to the values they professed as Freemasons "may cheerfully go the rounds of the compass of this life, having lived according to the plumb line of uprightness, the square of justice, the level of truth and sincerity."[64]

In *Flat-Backed Drinker; Drunken Chicken Walk,* "the rounds of the compass of this life" are suggested by the two triangles or compasses used to draw circles. The upright neck of the man, taken together with his unusual flat body drawn on the horizontal, becomes another Masonic tool, the builder's square. The Masons taught that the "square and compasses . . . are the tools of a freeman" and the basis for a rational evaluation of reality. The square represents matter, and the triangles, spirit; and these two together are used as the symbols of all three levels of Masonic development. For the Apprentice, matter symbolized by the square is placed above spirit symbolized by

the triangle; for the Fellow, they are balanced; and for the highest degree, Master, the triangles or "the compasses [representing spirit] are laid over the square." In Masonic symbolism, a right-angle triangle stands for a "complete man"—one whose body, mind, and spirit are developed, while the equilateral triangle stands for the perfected man. Traylor used these symbols to draw this subject, telling us in a most visual fashion his evaluation of his character. He drew a bent-over man, drinking, but the symbols he used to draw his body, the Mason's square and the right triangle, tell us he met the tests of upright-ness, truth, and sincerity, and was a complete man. Similarly, in the painting labeled *Man Walking Dog* (plate 9) the man's arms form a triangle, but one arm is also part of a Mason's square, while his moving legs are another sturdy Mason's square carrying him forward. This figure is proclaiming that he is a free man, whose spirit dominates over matter, but one who is unable to hold his head up high as he is burdened by a varmint climbing up his body.[65]

Although no membership lists are extant from the early postwar period, lodges of African American Freemasons were particularly popular in postwar Alabama. In the North, the popularity of the Freemasons among middle-class black people has been documented, and it has been assumed that Masonry was for the upwardly mobile; however, in Alabama and the rest of the South, Masonry was popular among the poorest illiterate black workers tied to the land. Perhaps renters and sharecroppers were more likely than day laborers to join this secret society; nevertheless, of the ten Prince Hall Lodges in Ala-bama in 1867, half were in small towns and rural areas. Lowndes was and is one of the poorest counties in the country, yet there was a black Freemasons lodge near Benton from the second decade of the twentieth century, when St. Anthony Lodge no. 223, Prince Hall Grand Lodge F&AM of Alabama was established. By that time, there were 340 Prince Hall Lodges in Alabama, with some four thousand members.[66]

The black Prince Hall Freemasons was the most important fraternal order in the long list of orders that proliferated after the Civil War, among them the Odd Fellows, the Colored Knights of Pythias, the Improved Benevolent and Protective Order of Elks, as well as the Galilean Fisherman, the Nazarites, the Knights and Daughters of Tabor, the Knights of Honor, the Independent Order of Good Samaritans, the United Brothers of Friendship, the Benevolent Order of Buffaloes, the Ancient Order of Forresters, the Sons and Daughters of Jacob, the Seven Wise Men, and the Grand United Order of True Reform-

ers. W. E. B. Du Bois collected this list and any data he could find about the secret societies in 1909, and in 1910, Howard W. Odum maintained that the number of black men in these secret societies equaled that of black men in the churches, but no serious follow-up analysis was made. In 1977, Lawrence Levine recognized the potent power of these secret societies, and suggested that, "When their role is finally studied with the care it demands, I suspect it will become evident that they played a subversive part."[67]

The critical analysis of these fraternal orders and their role in communal life is just beginning, but it is already clear that the black fraternal orders have roots that go back to the period of slavery. These fraternal lodges became a crucial supportive network after the Civil War and in the Jim Crow period, providing some security for their members through sickness and burial funds, with the larger organizations sponsoring orphanages, old age homes, and hospitals. Beyond that, they were *Landsmannschaften* for black people whose place of origin was "the slave plantation." Previous condition and race were the unvoiced guidelines for membership; although the rituals looked back to a past of free African people, they secretly worked for a free American future. Nan Elizabeth Woodruff has recently studied their role in Mississippi and Arkansas and confirms Levine's belief that the lodges in the American Congo, as she terms this area, played a militant role in the hidden opposition to Jim Crow. They played a similar, if more muted, subversive role in Alabama.[68]

The Prince Hall lodges met twice a month on weekday nights, and in addition to the elaborate oral learning procedures, they put their membership through difficult initiations. Traylor no doubt felt that the circle rituals he witnessed among Masons and Baptists were related to each other: He would have often seen the same men participating in both rituals. Traylor's circle can thus be understood as reflecting African, Masonic, Baptist, and American conjure traditions. While all his experiences contributed to his imagery, the central figure in the circle calling to the sky is more likely to have been appealing to a spirit than to Jesus, and he might well be calling for retribution against his enemies in the Jim Crow society rather than for personal redemption.[69]

Other symbols were open to this layering of associations that had a political significance as well as a spiritual one. While triangles had a powerful meaning in Freemasonry, standing for spirit, in Africa a dark triangle was a *nsibidi* symbol for a leopard skin, and among Christians it was widely the symbol of the trinity. Ladders were another meaning-laden symbol. The

small wooden homes of African American slaves and freed people had lad-
ders placed outside so that in case of a fire in the chimney, the roof could be
reached rapidly, either to put out the fire or to push the burning chimney
away from the structure. (See fig. 1.3.) A great many of Traylor's paintings
include such a ladder leaning against the outside wall of a small house. Kuyk
emphasizes the African use of symbolic ladders "to reach the spirit world,"
but the ladder is also central in Masonic imagery: each man was to see him-
self climbing up toward personal completion aided by the pillars of faith,
hope, and charity. Black Masons made use of the ladder to cement Masonic,
African, and Christian views. As with the white Christian Masons, black Free-
masons were taught to envision themselves moving up a ladder toward God,
but African Americans were reminded that Jacob envisioned angels descend-
ing as well as ascending: "How few of us appreciate this part of its teachings,
and realize the probability of the return of those who have gone before, and of
their labors in our behalf. In the still watches of the night they are around us."
Traylor shared this African belief in the return of the spirits of those who have
gone before, and his ladders may well have referred to this. The forefathers
came down; they could, if they chose, help the living to get to something bet-
ter in life. One of Traylor's pictures shows a ladder with fourteen rungs. When
Joe Minter, a Birmingham folk artist, saw this picture, he immediately said:
"Double seven, that's the completion number."[70]

In many paintings, Traylor painted small figures tied by cords or sticks to
larger figures. These small figures appear to be visual representations of the
"little me"—an African perception of a separable soul. Geoffrey Parrinder
has noted: "The African might say that 'in each thing is another thing,' and
that 'in every man there is a little man.'" Many African Americans of Tray-
lor's generation, describing their trance experiences, noted that a "little me"
had come out of their body. One said, "There is a man in a man," another
that "little Mary came out of Old Mary." This little figure appears in African
American language and literature across a wide space and time spectrum:
It can be found in the oral narratives of conversion dating from the period
of slavery, and in twentieth-century works as well, including the statements
of hoodoo practitioners and their clients who spoke of their souls or spirits
leaving their bodies.[71]

While Traylor's art illustrates his extensive knowledge of conjure lore,
Traylor's little figures, unlike those depicted in the wider literature, often

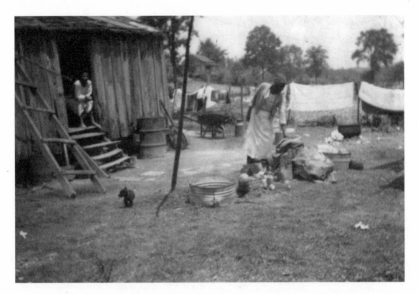

Fig. 1.3. "Abraham Jones's Backyard, Village Springs, Alabama," May 1937. Photographer unknown. WPA Slave Narrative Project, Manuscript Division, Library of Congress, Mesnp 0102336.

seem to be goading and prodding the big figure to change its behavior. They seem to be moral arbiters but at the same time dangerous spirits, often poking a person's genitals or anus, or threatening a person with a cudgel or hatchet. They illustrate the possibility that Traylor was changing the tradition from within as well as the likelihood that he turned to dreams as a proper source for his art. (See "little me" spirit figures in *Big Man, Small Man*, plate 4; *Untitled: House with Figures and Animals*, plate 17; and *Animated Scene*, fig. 4.6.)

While many of Traylor's pictures seem to re-create his nightmares, they suggest that his nightmares reframed what happened to him in the outside world, and were the basis for picture images. The black sculptor and blues musician James "Son" Thomas said, "If you ain't got it in your head, you can't do it in your hand." As William Ferris notes, Thomas and other black artists, including Harmon Young and the blues musician Sam Chapman, painted images of what they had seen in their dreams. This practice was widely followed by black artists. An Alabama informant told Newbell Niles Puckett in the early 1920s that, "A dream is regarded as a real experience in which the soul of the sleeper goes to another world." Dreams were widely respected

and much talked about in the African American communities of the Black Belt, as they had been in most African cultures, where they were regarded as "the wishes of the spirits." They were believed to foretell the future and bestow power, but needed the interpretation of diviners. African Americans continued to respect dreams, but as with many aspects of culture that had been institutionalized in Africa, dream interpretation became a more private affair, although dreams were often recounted in churches during the process of conversion. In the Sea Islands, dream interpreters played a formal role, but parents and other elders became the adepts to whom most African Americans brought their dreams. As noted, when he was living in his daughter's house, it was Traylor's daily practice to speak of his dreams to his granddaughter Margaret. It is likely that his surrealistic images reflect the dreams that kept him in touch with what pained him most, and provided him with an imagery to hide what he most desired.[72]

Betty Kuyk holds that her detailed analysis of "dress, bodily movement, ceremonies of secret initiation ritual, association with spirits, and use of the spirits' symbols reveal that vestiges of the [Igbo/Kongo] tradition abounded in the New Orleans region," as well as in the art of Bill Traylor. I share her conviction that Traylor's art demonstrates that African beliefs, values, and symbols were the important ground on which he built his values; however, over time his life in the Black Belt brought Traylor into contact with new traditions and new problems, and led him and many others to create a culture quite different from that of his parents. At the turn of the century, Bill Traylor still honored many of the old ways: In 1901, when his and Laura's second son was born, he gave the child his father's, and his own, first name; the fate of this child called William was to critically change the life and art of Bill Traylor. Bill Traylor had named the daughter born in 1887 Sally, after his mother; however, she changed her name to Sarah, which can be glossed as reflecting both her personal need to break away from her father, and the need of her generation to break with the past. Bill, already fifty when he fled the confines of Benton in the first decade of the twentieth century, was breaking with the past as well, and, in many significant ways, eventually became far more modern than his children.[73]

2

"SEEM LIKE MURDER HERE"

(1904–1928)

Every day seem like murder here.

—CHARLIE PATTON, 1929

Bill Traylor was "knocked in the head" many times in his life—a punishment threatened in myriad of his pictures, and apparently a common way to talk of calamity in the Black Belt. As Ned Cobb said, "I always knowed to give the white man his time of day or else he's ready to knock me in the head." One hard hit on Traylor's head apparently came just before he left Benton, perhaps in early 1904. Traylor explained his leaving by noting, "My white folks had died and my children scattered," but that was only a small part of the story, the brackets around the heart of a tragedy and Traylor's new beginnings. (See the threatened "hit over the head" in *Blue Construction with Dog,* plate 10.)[1]

When Betty Kuyk queried David Ross Sr. about Bill Traylor in January 1987, he told her much more than that he "always carried a bag with him." Ross remembered a number of things, noting: "I saw him with papers and things. . . . He was a good sitter. He could sit quiet and say nothing. So I didn't quiz him. I figured he didn't want to hear that noise." Ross got the information he wanted by turning to Jesse Jackson, another man from Lowndes County (in fact, from the town of Benton) who "stayed together" with Bill Traylor "a lot." Ross mentioned Jackson in his introduction to the most important part of his account, when he recalled that Traylor "used to yell in his sleep. I heard him hollering in his sleep, so I asked Uncle Jesse Jackson if he knew what was

happening," and indeed Jackson had an explanation. Disclosing a secret that Traylor did not want revealed, Jackson said, "Traylor had murdered a guy long ago, and it came down heavier on him every year."[2]

Kuyk found this report a key to her understanding of Bill Traylor's behavior as well as many of his drawings. Viewing Traylor's art from an "African perspective," she sees it as a record of his "journey of preparation for death" in which he sought to regain his inner balance, which she believes he had lost as a result of the murder he is reported to have committed. She makes a strong case for interpreting a number of pictures as recounting his intention to commit a violent act against a man sexually involved with his wife. Singling out *Kitchen Scene, Yellow House* (plate 11) as the most explicit picture, Kuyk maintains it "juxtaposes the turmoil caused in the home by another man 'messing around' with Traylor's woman and Traylor's desire for retribution." The top half of this painting shows a seemingly pacific household scene, but I would suggest that Traylor's imagery in this scene suggests that he believed his wife was using conjure against him. Lighting a lamp, as his wife is doing in this picture, was commonly a part of conjuration rituals. If the victim's name written on paper, or something from the victim's body, such as hair or fingernail cuttings, was placed within the lamp, combined with the appropriate ritual, it was believed harm would be caused to the intended victim. Several other pictures show a man and a woman, presumably Traylor and his wife, on either side of a huge lamp, with the woman controlling the switch. In *Kitchen Scene, Yellow House,* Traylor appears ready to drink from his wife's water pitcher, perhaps to show that he trusts her, but he indicates she is not trustworthy in the scene below. In the bottom half of the picture, their house—painted yellow to signify the strong emotions it once contained—is empty. A crucial violent act is being carried out close by: A cudgel is being raised by one male figure, apparently Traylor, over the head of a second man who is holding on to the foot of a large bird, evidently representing Traylor's wife. On the right side, there is an outline of a turned-over house that is in great part erased. Shannon viewed this as a rare example of Traylor having erased something he did not want in this picture, but I would suggest Traylor wanted this house just as it was: a wiped-out, turned-over, spirit house, representing the loss of his first family in the wake of the violent murder signified.[3]

While Kuyk posits that Traylor's murder of this man might have happened at the time when Bill and Larisa broke apart for several years in the 1880s, or

at the end of their marriage in the first decade of the twentieth century, this painting seems to confirm that the murder occurred in the second period, well after Bill and Larisa had established their home together. Other evidence suggests that this event was likely to have occurred in the last few months of 1904, after the death of Marion Traylor.[4]

Many of Bill Traylor's drawings picture a man preparing to violently attack another man by knocking him over the head with a cudgel, and these pictures often make it clear that both men were sexually involved with one woman and that this triangle is at the basis of the first man's rage. Once Kuyk made this interpretation, it is virtually impossible to miss this story of another man having sexual relations with his first wife. Given Jackson's account, it would appear that Traylor is the attacker in this tale to which he felt compelled to return again and again. The painting *Five Figures with Dog and Leg Construction* (plate 12) repeats this narrative of sex and rage as well as the symbols that Traylor often used for males and females: Powerful booted male legs without an upper body are drawn with a central penile projection into the smaller female buttocks splayed above. Figures stand all around this strange copulation scene: A male figure below is wielding a large hatchet at the same time that he is fingering the central male's buttocks, while a second male is just above him, fingering a bird. Traylor's description of another one of his pictures (*Untitled:* House with Figures and Animals, plate 17) indicates that his drawings were sometimes synoptic, presenting an ongoing story in one frame. He himself is conceivably several of the figures in *Five Figures with Dog and Leg Construction,* including the small man being poked in the backside at the right and the man poking another bird to the left. It may be the story of his relationship with his wife over time or with several women, but clearly it reflects the rage he had for the other male having sex with, or jazzing, his bird.[5]

In light of Ross's report that Traylor had murdered a man, an interview taped at the second Traylor family reunion, held in 1992, has particular import. Miriam Fowler and Marcia Webber, both of whom have an abiding interest in Bill Traylor's work and have uncovered much information about his life, interviewed Myrtha Delks and Margaret Staffney, two of Bill Traylor's grandchildren. The interview was recorded against the background of family talk and loud music, making part of it difficult to understand; however, when asked about Bill Traylor's wives, the responses can be clearly heard. One granddaughter said, "He didn't talk about no wife," while the second

responded, "I remember him saying, 'When my wife was with child, I would go away and stay till the child was born and then I would come back.'" One reports, "He had two wives," and the other responds, "1900 to 1904. I believe the secret lies there."[6]

This last ambiguous comment now makes sense. One "secret" from 1900 to 1904 may well have been that Bill Traylor had children with his second wife, Laura Williams, at the same time that he lived and had children with Larisa; census records confirm this story. The more deeply hidden narrative relates to his first wife's affair and the murder of her lover that led to the breakup of that family and the disappearance of Larisa. Larisa Dunklin Traylor's name does not appear in any public records after the census of 1900, nor is she written of in the Traylor family memoirs assembled for the reunions. In explaining a picture showing a woman and a child, Traylor once recounted: "The girl is telling her mother, 'Please don't leave,'" which may well be a record of what Larisa Traylor did after this event. Traylor apparently portrayed his first wife as a spirit bird in many of his paintings, suggesting that while she left the family around 1904, she died before many of the events he painted took place. In Traylor's painting *Yellow and Blue House with Figures and Dog* (plate 13), the Spirit of Death stands above what is presumably Traylor's house, with one hand holding a dead bird and the other around the neck of a live bird. The dead bird may well represent Larisa, and the second bird, at risk, may be his second wife. Since Traylor seemed to conflate his own image with that of the Spirit of Death, this picture suggests he may have felt he had played a role, through conjure, in bringing about Larisa's death.[7]

Bill Traylor's violent life experiences and those of his family, friends, and kin are the likely background of many of Traylor's depictions of violence. Autobiographies of the formerly enslaved often tell of the beatings men and women gave each other and the violent punishments parents gave children in the generation after slavery ended. Such violent behavior is confirmed by Charles S. Johnson's study of the lives of rural black people in Alabama, where the chief cause of death in 1929 was violence. People told Johnson, "Dere's so much cutting and killing going on." This was echoed in blues songs ("Every day seem like murder here"), as well as in Bill Traylor's drawings. Violence of white against black and black against black played a role in almost every black person's life. Community members recognized that the white police, courts, and the laws were unjust; they chose to settle disputes between them-

selves if at all possible. However, questions have to be raised about Johnson's conclusion that death by violence was accepted with "casualness or fatalism": Given their life experiences, black people in Alabama were widely armed with knives and guns, and prepared to defend themselves.[8]

The violence attributed to Bill Traylor would suggest a reason and a time both for his leaving Benton and for a growing concern with conjure. When questioned about Bill Traylor's past in the 1980s, the white Traylors made no mention of a murder connected with his name, suggesting that his role in a murder was not reported to any white person, including the police, who as enemies of black people were avoided if at all possible. The police cared little about black-on-black crime; as the Mississippi bluesman Honeyboy Edwards noted, "If you killed a black, generally wouldn't nothing much happen to you," but it was best not to involve them in any black violence if at all possible. Traylor was probably far more worried about retribution from the dead man's family or from his spirit. Zora Neale Hurston, who collected conjure lore across the South in the late 1920s and 1930s, noted: "It is a common belief that murderers are always harassed by the spirits of their victims and often forced to confess." Conjuration was often used to "turn back" a harmful act, so that it would hurt the individual who was responsible for the act, and as the years passed Traylor apparently believed this was what was happening to him. Traylor might well have turned to a conjurer to help him, as the tradition was known to have solutions for such problems. Harry Middleton Hyatt's extensive collection of hoodoo data includes a number of recipes for avoiding punishment for a murder, as well as for finding an unknown murderer. If he murdered a man, Traylor would have needed the first and feared the second.[9]

Traylor told Shannon that he had decided to leave Benton after the death of the last of "my white folks," but he didn't say to which white person he was referring, and he allowed Shannon to assume he left Benton in 1938. It was, however, Marion Traylor's death in 1904 that marked the end of Bill Traylor's personal ties to the white Traylor family, and the end of his life in Benton. Marion Traylor, born in 1862, had apparently spent time as a child with Bill Traylor, and they knew each other well. In 1881, when George Traylor died, Marion, then nineteen, became the "boss" of Bill Traylor, who was twenty-eight. Bill Traylor worked for Marion Traylor until Marion's death in 1904, serving briefly as a flagman with the team that surveyed his land, but working

as a farm laborer and sharecropper for virtually all this time. When Marion died, Bill Traylor did not regard the next generation as his "white folks": He had no ties to Marion's young children, and apparently felt he had lived on Traylor property and as Traylor property far too long.[10]

Traylor's move away from Benton in the first decade of the twentieth century not only took him away from a large circle of black friends and family, but also marked the end of the period in which he had a white "boss man" who knew him, and whose parents had known his parents. The black and white Traylors of the early twentieth century were descendants of people whose lives had been intertwined from early in the nineteenth century. If a black person had trouble with the law, it was expected that he or she would turn to a local white man with some influence for protection. In a period when such protection was increasingly important, Bill Traylor was without protection after Marion Traylor died on September 26, 1904. It may well be that the murder occurred in the months following that event, and that Bill Traylor, troubled by the possibility of violent retribution for the act he had committed as well as by the breakup of his family and the fact that he had no white folks left, left Benton himself.

Bill and Larisa's older children, Pauline, George, Sally [Sarah], and Bill's "outside" daughter, Nettie, all born between 1884 and 1887, "scattered" around 1904, setting off for Alabama cities and then, for the most part, heading north. Larisa, too, apparently left, but there is no evidence of what happened to her or to her youngest child, born in 1898. Bill Traylor and Laura Williams, who had three sons born between 1896 and 1908, later reported they had married in 1909, the year Traylor set up a new home for Laura (or Larcey) on a rented farm on Will Seller's plantation in Montgomery County. In 1910, this new household was also home to nine children; this time one was hers, four were his, and four were theirs, with a fifth son born in 1915. As the older children in their combined family married, or as they reached maturity, they too left home. Most eventually moved north as well, with a large part of the family settling in Detroit, others in Washington, D.C., Philadelphia, and upstate New York. Over the years other children, possibly Bill's outside children, or grandchildren, among them Plunk, Arthur, and Kisu, were in the Montgomery County household as well. Bill Traylor had fathered and raised two large families. While half of the first family left their first home

because of the family crisis, most members of both these families became participants in the exodus north, joining in the search for freedom made by more than 1.5 million African Americans in this period.[11]

In many ways, Traylor's second family seemed to mirror the first. Bill Traylor's two wives were born about the same time; their names were similar and have been confused by family members: Laurine or Larisa, and Laura or Larcey. In both cases, the households had consisted of about nine children for a period of time, with the older children leaving when they came of age and newborns replacing them. Over time, the grandchildren and great-grandchildren seemed to conflate the two families into one, with one mother named Laura, perhaps to avoid discussing the violence that had broken up the first family, but also because four of Larisa's children had become part of Laura and Bill's family. Larisa became a phantom figure in the family history.

While murdering a man may have led Bill Traylor to flee from Benton and to move near Montgomery, by 1909 he was, perhaps for the first time, actively seeking a way to get more of what he really wanted. The move changed Traylor's life in many important ways. First, he became "a farmer"—a renter of land rather than a sharecropper—which was definitely a step toward more independence, if not more income. Second, he had some freedom to adopt a new persona away from the place where he had "come up," where both older blacks and whites played a role in controlling black children and adults. In Benton, there had been whites that were protective, but they were also paternalistic, and many were violently repressive. Now, although he was on the old Seller plantation, he was, relatively, on his own.

It was the custom for black farmers from the surrounding area to travel to Montgomery on Saturdays. With its rapidly growing black population, Montgomery was visited by black minstrel groups and entertainers, among them Silas Green from New Orleans, Mahara's Minstrels, and the Rabbit Foot Minstrels, known as "the Foots," with Pa and Ma Rainey, the "Assassinators of the Blues." In the city there were also more opportunities to come in contact with a wider world of conjure practitioners and clients, and, freed from the strictures of a small community dominated by the mores and folkways of the older black people, Traylor had more opportunities to drink and dance at local juke joints and to hear more blues music. As John W. Work, Lewis Wade Jones, and Samuel C. Adams found in their rediscovered study of the Delta

and its musicians, mobility widely brought about a change in activities, values, and music for African Americans in the Black Belt. For Traylor, too, this move led to a stimulating change in his life.[12]

Jukes were of central importance in the creation of a new black culture of the first decades of the twentieth century. Zora Neale Hurston explains: "Jook is the word for a Negro pleasure house. It may mean a bawdy house" or a place "where men and women dance, drink and gamble. Often it is a combination of all these." Hurston knew jukes were rough, but she believed something special was happening in them: "Musically speaking, the Jook is the most important place in America. For in its smelly shoddy confines has been born the secular music known as the blues, and on blues has been founded jazz. The singing and playing in the true Negro style is called 'jooking.' The songs grow by incremental repetition as they travel from mouth to mouth and from Jook to Jook for years before they reach outside ears." The hollering in a juke has been compared to that in ecstatic church services, and the experience had a similar effect on some of the participants. The blues and the jukes helped bring coherence to a new black worldview, which paralleled the role of the spirituals and the African Baptist and Methodist churches in the period of slavery.[13]

Charles Peabody heard early blues while on an archaeological dig of Indian mounds in Coahoma County in northern Mississippi in the first decade of the twentieth century and was taken by them, as were W. C. Handy, Jelly Roll Morton, and Gertrude "Ma" Rainey: Each reported a first blues experience in that decade. Peabody observed blacks' daily life, filled with music, and provided a firsthand report of what Christopher Small has termed "musicking"— the taking part in a musical performance by those who create the words or music, perform, listen, dance, or react to the happening in any fashion. Peabody heard exciting and moving singing from sunup to after sundown, some sounding strange and African to him, and some much like popular music of the day. The improvised couplets that Peabody took special note of dealt with "'hard luck' tales (very often), love themes, [and] suggestions anticipative and reminiscent of favorite occupations and amusements," such as "They had me arrested for murder/And I never harmed a man." Rhymed couplets with their first line repeated became the most common structure of blues lyrics, which soon came to have several other distinctive characteristics: a pause between each half line, a musical response to the lyrics, and blue notes that are "sung or played at a lower pitch than those of the major scale for expressive pur-

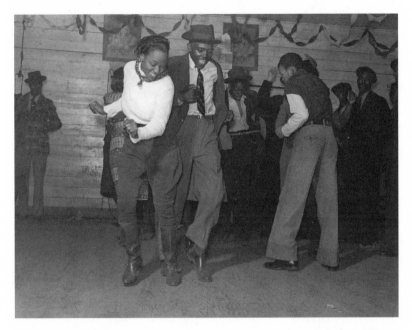

Fig. 2.1. "Jitterbugging in Negro Juke Joint, Mississippi Delta," November 1939. Photograph by Marion Post Wolcott. Library of Congress, LC-USF34-TOI-052594-D.

poses." These early blues, which Bill Traylor no doubt both heard and sang in this decade as well, were often perceived by outsiders as "of a mournful and haunting character," but as Albert Murray emphasizes, "even as the lyrics recount a tale of woe, the instrumentation may mock, shout defiance, or voice resolution and determination."[14]

The folklorist Howard Odum began collecting African American songs in the South in the same decade, taking note of many blues and a number of bitter songs, and in 1911 he published the lyrics in several articles in academic journals. "Ain't it hard, ain't it hard, ain't it hard to be a nigger" was a refrain he heard in lyrics describing how black people were cheated regularly of all they had earned, and enslaved in chain gangs. The white invasion of blacks' lives was reflected in numerous songs, including several that described white policemen "creeping around the bedside" of blacks. Odum chose not to reprint many of these bitter songs in the book of lyrics he later published; it is not clear if this was due to an unwillingness to credit the singers with social consciousness, or a recognition that these might support fears of black violence.[15]

Odum was particularly interested in the process of song creation, and the language created in the black community. He noted: "Of special importance as makers and mediums for negro folk-songs are the 'music physicians,' 'musicianers,' and 'songsters.'" He thought the term "musicianers" referred to those who primarily played instruments, while "songsters" were those who generally sang, but he found the term music "physicianer" more elusive. He suggested that it might "denote more nearly a person who is accustomed to travel from place to place, and who possesses a combination of these qualities"—musician and singer. It is likely, however, that this phrase came into use when black musicians were hired by traveling medicine men to attract an audience, but it may connote that those who made and played this music had the power to cure the sick.[16]

Many of the early songsters described themselves as people who "told the truth," among them Henry Townsend and Furry Lewis. In 1972, James H. Cone still shared this view: "The blues are true because they combine art and life, poetry and experience, the symbolic and the real. They are an artistic response to the chaos of life." He believed that the key "thing that goes into the blues is the experience of being black in a white racist society." Albert Murray, writing in 1979, took this evaluation further, holding that from the beginning the blues were a ritualized expression of a worldview, "confronting the complexities inherent in the human situation" and "making a statement . . . about perseverance and about resilience and thus also about the maintenance of equilibrium despite precarious circumstances and about achieving elegance in the very process of coping with the rudiments of subsistence." In what seems a contradiction, but actually goes to the heart of the matter, Murray emphasized that the blues accomplished these goals by means of their good-time, stomping character.[17]

The early "music physicians" singing the blues took a modicum of freedom in a period when few in the Black Belt could. They broke out of virtual slavery as they would not work on the cotton plantations or underground in the mines; they were not tied to the land or to a white boss. They could sleep in the day, and their work in the nighttime provided pleasure for their audiences in the jukes. While they were generally poor and homeless, they were considered free spirits for whom music, dance, sex, and drinking were central, and they were becoming heroes to many of the young who followed them.

Their music used bits and pieces of the old field-hollers and work songs in a new way, and spoke of the yearnings, the pain, and the pleasures shared by so many. While they often seemingly accepted violence and murder, their songs were at the same time bitter commentaries on the realities of black life.[18]

The jukes were indeed places to have a good time, and notwithstanding the bitter lyrics sometimes sung there, they were, as Murray emphasized, filled with stomping, dancing, drinking, and explicit sexual behavior. A great deal of public pleasure, as well as violence, was taken in all of these areas. Eighty-six-year-old Ellen King of Mauvilla, Alabama, evaluated the situation in 1937: "Young generation done gone, Satan got 'em, too much 'juking' these days. . . . All they do is juke, juke, juke!" Many black people shared her disapproval of jukes and the music that was played in them, especially members of Baptist or Methodist churches who generally judged the songs as sinful tunes sung by sinning people.[19]

Many churched people were, nevertheless, attracted to jukes and the blues, and a number became attached to them. Vera Hall has left a revealing description of how blues and blues singers became part of the lives of her churchgoing family. Born around 1902 near Livingston, Alabama, Hall grew up in a Baptist family where both the church and music were quite important, and her talent as a singer was recognized when she was quite young. Her family did not sing sinful songs, and the blues were definitely regarded by most churchgoers as sinful; nevertheless, Vera Hall "learnt all my best songs" from Rafe Addison, a blues singer who did not attend any church but was a welcome guest at her parents' farm. Rafe Addison never cut his hair, wore pinned-together rags for clothes, did not work at a regular job, and lived underground in a dugout cave. "When I came to realize I was seein' Rafe around our home I thought he was some of our people—kin to us—he stayed there so much, but Mama said, 'No, he's not any of our people. He just love to stay around here and we enjoys him. Rafe always be singin.'" Rafe Addison sang old favorites as well as songs that he made up by himself; and then he'd sing the blues.[20]

Rafe certainly got Vera Hall singing the blues. She mimicked his singing as a child, and the blues played a complex but significant role in her adult life. She visited juke joints to listen to the music, and she sang blues for white folklore collectors. She justified her singing blues for folklore collectors as a paying job, and visiting jukes as a way of getting pleasure that she felt was

legitimate: "My mother always told me that 'ligion never was desire to make your pleasure less, and so that's is my pleasure to hear [the blues] and I likes it now to go where it is if I kin."[21]

Vera Hall understood that the hard to bear pain of Jim Crow in each black person's life led to a need for the blues, and she told a simple story to explain this painful reality. She recounted that while Lilly Porter, a black woman she knew, was shopping in a nearby town, some white children came running by and Lilly had to move quickly to avoid them. Moving aside, she accidentally brushed up against a white woman's body. Infuriated, the white woman called the local sheriff, who jailed Lilly. The same sheriff accused a second black woman, Sarah, of being drunk, and attacked her on the street: "Hit her the side of the head with that old thing they call a 'blackjack.' Now don't you think that's enough to give a person the blues." Hall then sang: "I'm goin' to the river, sit down on the ground, / If the blues overtake me, jump in the river and drown," and explained, "I have known of women just cryin' like somebody was dead when they heard a song like that."[22]

A number of the older songs Rafe taught Hall had a different character; they were "jump up" songs about black men who fought the systematic dehumanization of the Jim Crow system. Using racist terms, such as "bad coons" and "niggers," these songs sounded acceptable to whites, but they held a different message for blacks. One of Rafe's favorites included the lyrics: "Railroad Bill was mighty bad coon, / Shot the sheriff by the light of the moon. / They try to catch him but they never will."[23]

The Bill of this song was Morris Slater, an Alabama turpentine worker, who in October 1892 became an outlaw and a black hero after a violent incident developed when a deputy sheriff tried to take his unregistered rifle and he resisted. The sheriff took a shot at him but missed; Slater shot back, wounded the white man, and ran for his life. Over the next few years, Slater's exploits became legend in the black community: He was viewed as both a black Robin Hood, robbing food to give to the poor, and a man with great conjure power able to change himself into an animal and elude all capture by escaping on the railroad. This myth grew when several black detectives, hired to trick him into their confidence, disappeared. Slater was shot and killed in March 1896, but long after that date many believed he was still alive and talked of his continuing exploits. The song telling his story was clearly a praise song, and while the version Vera Hall sang was mild, more radical

verses were widely sung, among them: "I'll buy me a pistol just as long as my arm / Kill everybody ever done me harm." This and variants such as "Gonna buy me a shotgun long as I am tall" were popular traveling refrains that were incorporated into many blues lyrics.[24]

A number of the publicly sung blues did call for acts of violence; however, those analyzing the lyrics overlooked this aspect. Adam Gussow emphasizes that the very first race record, "Crazy Blues," written by Perry Bradford and recorded by Mamie Smith, which was a wild best seller in 1920, blatantly called for violence against whites. This fact was totally overlooked by every music critic and historian until 2002, when Gussow centered his blues book on the issue of violence, and in particular on the last couplet in the "Crazy Blues" lyrics: "I'm gonna do like a Chinaman, go get me some hop / Get Myself a gun, and shoot myself a cop." Ignoring this refrain, and the others that called for killing those who did you harm, white critics writing about the blues held the opinion that they were generally devoid of social criticism of the Jim Crow system and virtually never called for violence against whites. In the lyrics recorded by blacks that do call for vengeance against whites, these views were camouflaged by verses and music that were about totally different matters—most often sex, drinking, and lost love. It was universally accepted among black people in the South that singing openly about Jim Crow and lynching was taboo. Leadbelly (Huddie Ledbetter) seemed to suggest that blacks in the North might have forgotten this, when he noted in 1937, in a song he wrote about the Scottsboro boys, that he was going to tell the colored people in Harlem: "Don't you never go to Alabama, to try to sing," or to live. The people in Alabama and the rest of the Black Belt knew the risks, yet many of the unpublished songs, intended to be sung when whites were not present, openly called down wrath on white people. Lawrence Gellert was a rare collector who was allowed to hear a great many of these songs calling for violent opposition to Jim Crow, lyrics sung by and for black people, now on file in the music archives of the University of Indiana.[25]

Lawrence Gellert, born in Budapest in 1898, grew up in New York City, where he was deeply influenced by the social concerns of his older brother, the artist Max Gellert, who was active in the Communist Party. In 1920, after a breakdown, Lawrence Gellert traveled south to recuperate without any plan as to what he would do. "One of his first sights . . . [in Asheville, N.C.] was a corpse of a Negro two days dead dangling from a barn rafter in full view

of passersby." This first sight of a lynching affected his immediate course of action, and the rest of his life. Settling in Tyron, North Carolina, where he found a number of northern liberals, Gellert soon moved into the black section of town to live with Wesseye Jackson, an African American, and it was there that he heard black people singing protest songs that were rarely heard by whites. He came to believe that these lyrics could be used to arouse blacks in the South to more actively oppose Jim Crow, and whites in the North to support civil rights protests. He planned to collect and publish protest songs, and from the outset did not reveal his sources, a policy that later led some scholars to question their authenticity.[26]

When Gellert began traveling through the South to collect more songs, his approach was unlike that of any other folk-song collector in the region. Gellert slept on "dirty floor pallets in miserable ghetto hovels," and shared the food and drink of the black poor. He noted, "I've been chased by sheriffs in the country and brass buttons and blue coats in towns, jeered at and cussed by respectable white folks everywhere for consorting with 'niggers.'" There were times when he feared for his life; he felt he had come close to being lynched when he was asked to accompany an accused black man being moved from a jail in which he had been collecting songs. Nevertheless, he chose to remain as close to the black community as he could, and noted: "I've passed for Black myself on more than one occasion." Gellert sought out men who had been in prisons and chain gangs and attended their jukes and their churches, establishing a rapport that led black people to sing powerful protest songs for him to record.[27]

Refrains from Gellert's collection voice pain and fury:

> Slavery an' freedom
> Dey's mos' de same
> No difference hahdly
> Cep' in de name

> ❧

> Nigger he jes' patch black dirt
> Raisin' part de white man's Eart'
> Lawd cain' you hear him groan an' weep
> White man' aplowin' his'n soul down deep[28]

> ❧

I feels mah hell a risin'
Six feet a day.
Lawd, if it keeps a risin',
Gonna wash dis damn lan' away!

❊

I grow yo' cawn, get nothin to eat,
Buil' big houses,
Sleep in de street,
'Cause I'm a nigger, dat's why.

❊

Well, worm get turnin',
Cat hug a lion,
Mah hell get risin',
Care nothin' bout dyin'
'Cause I'm a nigger, dat's why.

❊

I feel it comin', Cap'n,
Goin' see you in God-damn,
Take mah pick an' shovel,
Bury you in Debbil's lan'
'Cause I'm a nigger, dat's why.[29]

Both the lyrics above and the lyrics of the powerful song "Death Is in This Land," below, are rawer and more militant than the songs sung for recording companies, the so-called "race records" of the 1920s and 1930s. The "captain" in this song and others was the white prison guard in charge of the chain gang. In common usage, "Jack" was a term for a locomotive, and "ballin'" referred to the driver's hand motion for faster speed, but "ballin' the jack" also referred to a sensual dance, and came to mean a sexual encounter as well.

Old Sarpint crawl on his belly, Lord.
Cat, he walk on his back, Oh my Lordy;
But the meanest varmint in this world
Is the captain I has got;
Death is in this land, my Lord,
Death is in this Land.

Bull whip a singing 'round my head, Lord.
Black man swinging ball and jack, Oh my Lordy;
From way down Rome to old Cairo
Ballin the jack, doubling all the way back;
Death is in this land, my Lord,
Death is in this Land.[30]

In the South, some black people sang for Gellert because they shared his hope that his song collection would influence white people in the North, and it did initially find an audience there. Beginning in 1930, a number of articles Gellert wrote on the songs appeared in the left-wing periodicals *New Masses,* the *Worker, Music Vanguard,* and *Mainstream;* Nancy Cunard included an article with a number of songs in her important compilation *Negro: An Anthology* (1934); and the Hours Press and the American Music League, both left-wing publishers, brought out two collections of lyrics and music, *Negro Songs of Protest* (1936) and *"Me and My Captain" (Chain Gangs)* (1939). Sterling Brown, who wrote much of his own poetry in blues form, highly praised Gellert's collection in several of his essays, noting it was authentic and "invaluable to anyone seeking to know the American Negro." The imagery in the antilynching song "Sistren an' Brethren" Gellert published in 1935—"Yo' head tain' no apple Fo' danglin' f'om a tree, / Yo' body no cahcass Fo' bahbecuein' on a spree"—may have influenced Adam Meerpol in his writing of "Strange Fruit" in 1936. In 1937, at the height of Gellert's success, several dramatic stage presentations in New York City were based on his collection: Two black choreographers and six black dancers presented a powerful "call for social justice for African-Americans" based on Gellert's collection, while the white choreographer Helen Tamiris dramatized a number of the songs in a modern dance presentation for a Federal Theatre production, *How Long Brethren,* staged with white female dancers and a black chorus. Together, the protest songs certainly did have some impact in the North; however, by the early 1940s the leftist coalition that had supported Gellert's work was in disarray, and in the same period white folklorists raised questions about the authenticity of his collection and the honesty of the collector. Within a short time, both Lawrence Gellert and the songs he had collected dropped out of public sight.[31]

Researchers have now begun to reassess the significance of Gellert's collection, much of it still unpublished and on disks and tapes made in the field,

testifying to its authenticity. The work of Steven Garabedian is of particular importance, as he has made a critical study of all the Gellert materials available, and compared the lyrics Gellert collected with the lyrics in the collections of John and Ruby Lomax, Newman Ivey White, Howard Odum, and Guy Johnson. Garabedian maintains that all the collections contain some black protest songs, but that the other collectors didn't label them as such and didn't emphasize their importance. Given this research, and new evidence considered below on the significance of the "bitter blues" to those who later became black activists, Gellert's black songs of protest deserve to play a far more important role in the analyses of southern blacks' reactions to lynching and Jim Crow than they have thus far.[32]

There is evidence that these protest songs were important for a number of people in the South. E. D. Nixon, born in 1899, a major actor in early Alabama protest actions who was centrally responsible for starting the Montgomery bus boycott, made a clear statement of their effect on his own life. A self-educated man, Nixon became a Pullman porter, a union "grievance handler," and the leading black union organizer in Alabama. In 1940, he brought together more than seven hundred men to march on the Montgomery County Courthouse (several blocks from where Traylor sat painting) to demand voting rights. President of the Montgomery NAACP in 1945 and of the Alabama NAACP in 1947, it was Nixon who posted bond for Rosa Parks, as he had for hundreds of other black people over the years, and pressed to use her arrest as a test case for a bus boycott. Nixon believed he was in line to become the leader of the bus boycott and was upset when he did not get this position, but he recognized that an "educated person" would get a better reception in the press and among the populace. In the icon-building process engulfing Martin Luther King Jr. that followed the success of the boycott, Nixon's role in the long process that brought about the strike was almost totally overlooked, but it had been crucial. In light of this, his evaluation of the role of protest blues in his life is of some significance. In 1979, Nixon told Steven M. Millner, a black sociologist, that back in the 1930s and 1940s, he had been deeply affected by satirical blues lyrics that he heard in his travels as well as in Montgomery. Calling them the "bitter blues," he credited their angry commentaries with playing a crucial role in forming his own social consciousness. Millner's interviews with many from this generation convinced him that long before the civil rights movement, the bitter blues had deeply influenced black

people. The increasing evidence of the number and local variation of protest songs lends credence to this view.[33]

Gellert held that the following song states that black people are increasingly following Nat Turner's example and are ready to slay whites. His reading rests on his interpretation of the line "not turn her" as an "ingenious concealing pun," as he reveals at the close.

> You mought be rich as cream
> And drive coach and four team
> But you can't keep the World from moverin' around
> And <u>not turn her</u> back from the gaining ground
>
> You mought be Carroll from Carrollton
> Arrive here night afo' Lawd make creation
> But you can't keep the World from moverin' around
> And <u>not turn her</u> back from the gaining ground.
>
> You can't never tell what yo' work ox gonna do
> Cause you never know who you mought be talkin' to
> You can't keep the world from moverin' around
> And <u>NAT TURNER</u> back from the gaining ground.

A claim that Nat Turner's example of violence was gaining followers certainly required concealment in the Jim Cow era.[34]

The suggestion in the last stanza of this Nat Turner song that the whites' "work ox" was an unknown entity getting ready to react violently appears in a number of the underground songs, such as one called simply "Work Ox," which opens with the refrain "I ain't gonna be your old work ox no more, . . . I done my due, ain't gonna do no more," and closes with: "Well. I tell you people and I tell you true, You can never tell what your old work ox gwine do." One significant difference between these hidden bitter blues and those that were sung in public and on race records is that the bitter blues are often blunt, revealing, and simple. As they weren't intended for records or public performances, the songsters didn't have to conceal their meaning, nor were they shaped by popular audience reactions. Their quality may have suffered as a result of their being underground songs, but their existence and their content are important. And considering the large number of bitter blues that Lawrence Gellert alone collected, there were bound to have been a large number of unrecorded songs that reflected a militant response to Jim Crow.[35]

While the songs that made it onto race records seem to accept life as it was, especially in regard to violence, drinking, and sexual pleasures, this acceptance, as has been noted, violated the ostensible values of white society. Blues musicians of the 1920s and the 1930s also often referred to conjure, another violation of acceptable beliefs, perhaps in part because it made clear they too had a source of power. While blues songs seemed to respect conjure lore, at the same time they opened it up to public view in a new and irreverent way. Blues songs refer to virtually all the major conjure rituals and rites, including the use of John the Conqueror root, foot tracks, and goofer, or graveyard dust, as has been documented by catherine yronwode.[36]

There is little doubt that Bill Traylor was conversant with the conjure rites and remedies suggested in blues songs, as both older traditions in black singing—the hollers and the work songs—as well as older traditions in conjure had a longer life in Bill Traylor's part of Alabama than in many areas of the South. Traylor, however, also knew a tradition that, so far as is known, did not have a wide following in Alabama. His pictures suggest that he had come to see himself as a two-headed seer in touch with the Spirit of Death, who appears in many of Traylor's paintings. The clothing, colors, and symbols that Traylor incorporated in painting this spirit speak clearly of the Haitian provenance of this tradition. In Haiti, the Spirit of Death was known as Baron Samedi, and while Traylor is not known to have used this title, in a number of pictures Traylor demonstrated that he was familiar with details of the Haitian tradition in regard to the dress—the top hat, the purple and black undertaker's suit he wore, and the buttons on his white shirt-front as well as the greenery or the cane often in his hand; and he apparently knew of the powers this spirit was believed to wield in regard to social criticism, sexuality, and death. Perhaps the clearest notice that he gave of his recognition of this spirit's role is the picture discussed above (*Yellow and Blue House with Figures and Dog*, plate 13), which shows the Death Spirit on the roof of a double cabin holding a dead bird/woman.[37]

Maude Wahlman was among the first to note that "Traylor often drew a . . . figure very similar to Baron Samedi." Betty Kuyk, citing Wahlman's work, went much further in her analysis, and concluded that Traylor's figures are Samedi images, which she placed in the context of his African-influenced worldview. Kuyk also identified a wooden bust found in a New Orleans barbershop around 1930 as a Baron Samedi statue used in conjure rituals. Zora

Neale Hurston's reports support the view that voodoo practitioners in New Orleans in this period claimed to be servitors of a spirit controlling death, but there is little evidence of what powers beyond this he was believed to have. That the sculpture was found covered with blood and chicken feathers clearly indicates it was used in a conjuration ritual, but little more. Traylor's paintings do go further. While *Yellow and Blue House with Figures and Dog* indicates that he believed this spirit had the authority to bring about death, other Traylor paintings add to and complicate his role. Together they suggest a complex body of belief clearly related to the Haitian tradition.[38]

It is not difficult to explain how Traylor may have come in contact with a follower of this spirit and learned aspects of the Haitian tradition. Although African vodun was known in eighteenth-century Louisiana, virtually all commentators agree that voodoo practices were given new life in New Orleans when some ten thousand Haitians, after some years in Cuba, arrived in New Orleans in 1809, doubling the population. It has been widely assumed that this tradition had little significant influence outside Louisiana; however, given the research of Hyatt, this assumption should be modified. Hyatt found that conjuring in Mobile, Alabama, was deeply affected by beliefs prevalent in New Orleans and was significantly different from that in Virginia, the Carolinas, or Georgia. Many people and goods traveled by water from New Orleans to Mobile, and from Mobile up the Alabama River to Selma, Benton, and Montgomery. A person who believed in the Spirit of Death and was conversant with secret society pictograms could well have come this way; ideas traveled well. Traylor could have encountered a person who shared these Haitian or Cuban traditions with him while in Benton or Montgomery, or Traylor, too, may have traveled to New Orleans after he left Benton.[39]

While Traylor's portrayal of the Death Spirit in his paintings has much of the classical Haitian form of Baron Samedi, the Haitian dark glasses are missing, and Traylor's Samedi smokes a pipe (as did Traylor) rather than a cigar. He does, however, sometimes wear formal undertaker's clothing in the traditional Samedi colors of purple and black, and he often wears a top hat, carries a cane, and is drawn with fronds coming out of his hand. Other pictures illustrate gravediggers' tools. Clearly these signs and symbols associated with Samedi in Haiti were known to Traylor, even though they were not widely known in Alabama.[40]

Writing in the early 1930s, having completed her project as a participant-observer of conjuration in the Deep South, particularly in the New Orleans area, Zora Neale Hurston reported that "Hoodoo . . . is burning with a flame in America, with all the intensity of a suppressed religion." She emphasized that even within the black community, "believers conceal their faith. Brother from sister, husband from wife. Nobody can say where it begins or ends." Hurston had set off lightheartedly on an adventure that turned quite serious after she undertook a series of initiations with two-headed doctors in New Orleans in 1928 and 1929. Robert E. Hemenway, her biographer, goes as far as to suggest that her initiation into the service of the Spirit of Death in 1929 "marked her for the rest of her life."[41]

As hoodoo activities were illegal in New Orleans, Hurston used pseudonyms for the hoodoo practitioners she contacted. The first person she approached was "a Catholic Hoodoo doctor" she called Luke Turner, who worked with the skin of a snake that he noted had been Marie Laveau's source of power. She wrote that he initially suspected her sincerity, but in a trance experience was assured that she was a genuine seeker and accepted her as an acolyte. Hurston lay naked on a snakeskin for three days and nights, during which time she had "five psychic experiences." Her success led her mentor to paint a red and yellow lightning bolt on her back, signifying "that the Great One shall speak to me in storms." She was also marked by "a pair of eyes . . . painted on my cheeks . . . a sign that I could see in more ways than one." She drank her own blood mixed with that of the other initiates, and completed the ceremony at midnight with the ritual sacrifice of a sheep in a nearby swamp, followed by the burial of her written petition to the spirit.[42]

Notwithstanding these experiences, Hurston sought a deeper initiation into conjuration. Another Catholic practitioner who claimed to be related to Marie Laveau, whom she called Anatol Pierre, agreed to teach her to contact spirits through meditation. He revealed the secret names he used to call on some twenty spirits, many of them abiding in snakes: "Great Moccasin for all kinds of power"; "Kangaroo to stop worrying; . . . Jenipee spirit for marriages," and the "Death Spirit" for any "killing."[43]

Hurston didn't relate any successes in calling on these spirits by name, but she did recount her continuing odyssey. She next became the acolyte of a woman she called Kitty Brown, the only female conjure doctor she came in

close contact with in New Orleans. Brown invited Hurston and five initiated practitioners to participate in a death ceremony intended to kill a man who had abandoned one of her clients. A "rudely carved [bust length] wooden statue," which may have looked something like the one found in the New Orleans barbershop in the 1930s, or perhaps like one of the bust-length figures painted by Traylor in a rich blue, was crowned in red and set on a black satin-covered box. After petitions from each of those present at the ritual calling for the death of the lover were placed in the statue's mouth, each participant, including Hurston, danced for some forty minutes in the personal style they chose, with each dancer successfully entering an ecstatic state. The efficacy of the ceremony, however, was never tested, as the man who was targeted to die soon felt unwell and, fearing that the woman he abandoned had "hoodooed" him, returned to live with her. She, in turn, hurried back to Brown to ask that the spell be removed.[44]

Hurston remained a seeker, still hoping to encounter a more powerful spirit force. Knowing that the expression of spirit worship was both freely engaged in and more openly ecstatic in Haiti, she traveled there to witness and participate in what she imagined would be a far more overwhelming experience. Indeed, in Haiti she found what she was looking for, and was particularly taken by the practices of those who openly served and were "mounted" or possessed by the Death Spirit, known as Baron Samedi. They were generally from the poorest sector of the population, and while they drank cheap whiskey, ate poor food, and wore old clothes, they nevertheless felt free to criticize their rich and powerful oppressors. Those "ridden" by this spirit believed he entered their body, and spoke with his voice; they often carried a large wooden penis, his symbol, and brandished it as a weapon against tyranny.[45]

Several of Traylor's pictures provide evidence that he also associated this spirit's powers with criticism of pretension and power, and that he too portrayed a penal rod as an instrument of choice to harm white enemies who were murdering blacks. *Hunter on Horseback* shows a white man sitting upright on his steed with a faintly visible huge penile rod "shafting" his body. A similar horizontal shaft passes through the white rider chasing a lynch victim in the collage of Traylor's paintings (plate 34). In both cases, the shaft seems to have been on the paper that Traylor chose for these paintings. He made use of a given weapon, as it were, and apparently did not draw the shafting rod himself. There are also many depictions of coded sexual relations in which

the penis appears as a powerful shafting rod, such as in *Figure/Construction: Yawping Woman* (plate 14).[46]

Traylor dealt with sex symbolically in many paintings, where powerful legs are male, and rounded buttocks or the fronds of a palm tree stand for the female. In Haiti and Africa, the fronds of the palm tree often represent a female spirit connected with herbal healing and protection from evil as well as punishment of those who take advantage of the weak. Called Aizan in Haiti and Aizan Aulekete in Dahomey, she symbolizes "freedom and interaction" between the living and the dead. Whenever or wherever Traylor learned of this symbolism, he used it in his art.[47]

A picture of a man burdened by a massive symbol carried on his back, *Man with Construction on Back* (plate 15), can be seen to be a man burdened by a woman, reflecting the feelings Traylor apparently had by the late 1920s. The fronds of the palm tree are her head and arms; the exterior shape is one of feminine buttocks, and the red form inside seems to be one Traylor used for the labia and vagina, the red marking power and danger. The shape appears also in another important picture, *Untitled*: Figures and Construction (plate 16), where a male is inside the vagina, and two male figures are holding a discussion above. One gloss might be that the man, perhaps Traylor, is both the figure within the woman and the figure to the left above, and is being admonished by the spirit figure to the right for his sexual life. In this picture, both the man and the spirit to the right are being prodded in the rear from below. Many conjure recipes were intended to close up the body and stop urination, ejaculation, defecation, or the menses; or, if the body had been stopped by conjure work, to open it, as a "locked" condition was regarded as a serious, life-threatening condition.[48]

Another picture, *Untitled:* House with Figures and Animals (plate 17), dated July 1939, may well be a summary tale of Traylor's sex life. Traylor described part of this picture to Shannon, who wrote the following on the back of the cardboard: "7/39 goose grabs little boy's penis through fence / boy ties himself to the calf who dashes through a hole in fence—little boy caught." This description, suggesting that Traylor portrayed several figures in one painting representing the same person at different stages or that space and time were conflated, is a pattern of synoptic vision that Thompson identified as common in African art, and is clearly important for the interpretation of other Traylor pictures as well. In this picture, Traylor was the "little boy

caught," while the many-colored double house at the center of the picture is perhaps symbolic of the two households Traylor established over time, their emptiness signifying his current lack of attachment to both of them. Both sides are empty, his two wives and all his children gone. Below the house is a huge writhing snake, and below the snake is a male figure with one leg amputated, lying prone and being poked in the groin by a small spirit. Was Traylor imagining or had he dreamed of what awaited him in the near future? His painful legs and swollen feet had been troubling him for years, and he would indeed have a gangrenous leg amputated a few years later. All three male figures in this painting are in pain, and two are obviously suffering attacks on their genitals. Only the bird on the roof facing right is calm, while the giant menacing snake is making his way without opposition.[49]

Sex is the text and the subtext of this picture, from the snake to the proud bird looking off to the right. Sexual experimentation was the subject of a great many blues songs, both openly and covertly, and sex was the subject of many of Traylor's pictures. Traylor, however, would have had to conceal his sexual concerns from whites. He wasn't presenting his art in a juke, where both blacks and whites expected sexual innuendo in the performances. A black man was forbidden to express sexual feelings or comments on sexuality and hang them on display on a busy downtown corner where white women and children would pass them by. Black males' sexuality was seen as a threat to white women, and any expression of it in public was dangerous.[50]

By the beginning of the twentieth century, conjure had passed through much development and change in America. While Traylor's conjure beliefs were rooted in Igbo and Kongo belief systems, other African and African Diaspora traditions were mixed in, especially aspects of Haitian vodou via New Orleans, and no doubt some European and Indian beliefs as well, as maintained by catherine yronwode. The changes accelerated over the course of Bill Traylor's life, affected by the sale of books and other commercial products often marketed by white entrepreneurs. By the 1930s, conjure was increasingly called "hoodoo," and this term was and is used to refer to what is believed by yronwode to be a "folk magic tradition" rather than a religion. African American conjure or hoodoo in the 1930s was, however, still centered on a belief in spirits—both in living human beings and independent of them in the spirit world of the dead—and these African-based beliefs were at the basis of a coherent spiritual worldview.[51]

The devil in this conjure tradition was a figure deeply influenced by Christian ideas, yet he nevertheless reflected African-based understandings of Legba and Eshu. In her study of the ritual of blues singers "selling their souls at a crossroads" in return for musical ability, yronwode emphasizes that the blues singers who recounted such crossroads experiences were all seeking a skill, and that the figure who taught it to them, although "sometimes called 'the Devil,'" was "also known by the names 'the rider,' the 'li'l ole funny boy' or 'the big black man.'" yronwode maintains that this figure "was a teacher of manual dexterity and mental wisdom"; however, most black people who reported on such an experience did not meet with a benign teacher. Hurston describes her venture to get a black cat's bone as the "most terrifying" of all her conjure ventures, one in which "Strange and terrible monsters seemed to thunder up to that ring," which was a magic protective circle within which she stood. Hurston as well as a number of Hyatt's informants explained that the person who wanted a spirit's skill or wisdom "had to sit at the crossroads at midnight in complete darkness and meet the Devil, and make a compact." The conjure doctor William Jones, of Mobile, Alabama, was among those who taught that to get a powerful black cat's bone, "you must sell yourself to the devil." Some did speak of the possibility of meeting either Jesus, who would teach you "the right," or the devil, who would teach you "how tuh put evil things ovah." The Christian devil had influenced the understanding of this figure, but African figures, although not necessarily called by African names, were recognized as appearing at many crossroads, too. Conceivably, the figures that were labeled "African People" at the New South Gallery in Montgomery in 1940 were figures Traylor had met at a crossroads circle. (See Traylor exhibit, fig. 4.3.)[52]

The American hoodoo tradition, unlike vodou in Haiti or vodun in Africa, had not developed a priestly class or ruling hierarchy that decided on acceptable or unacceptable practices. While Dr. Buzzard and Caroline Dye had reputations as great conjure workers, other individuals simply chose to adopt their names. Only in the New Orleans voodoo tradition was a Haitian model ostensibly followed: Marie Laveau, a Louisiana Creole who was apparently initiated in a Haitian vodou tradition, named her daughter Marie and trained her in this tradition centered on ecstatic service to the snake god, Damballa. The Laveaus were a powerful voodoo family in a period stretching from before the Civil War through much of the nineteenth century. Virtually all the

conjure practitioners Hurston contacted in the New Orleans area in the late 1920s still claimed some relationship with the last Marie Laveau. This was a unique phenomenon in North America.[53]

In the wider American conjure tradition, an individual could seek out a mentor or many mentors, as Hurston did, and mix and match beliefs within a large range. Although hoodoo acts "are formulated *and* interpreted according to a stable deep structure," every hoodoo "performance" was unique. Moreover, a conjure doctor was given legitimation and supported by his clients; thus it was the black public that in great part determined the limits and directions of change in conjure. Clients would have abandoned a practitioner who blatantly violated the accepted system, but this was a system that appeared open to change and individual variation. In the period of Jim Crow when new initiatives were needed, this flexibility served many black people, including Bill Traylor, very well.[54]

An analysis of Traylor's painting labeled *Figures and Construction* [with gun] (plate 18) makes manifest the relatedness of hoodoo practices and blues culture to the strains in Traylor's life that can be tied directly to the murder he reportedly committed. Beginning with the man at the left holding a gun aimed at the penis of the man above, it would appear that Traylor is again telling us that he killed a man who caused him much harm by having sexual relations with his wife. This event evidently remained central to his inner life. The man he is set to attack is at the top, fingering a bird, presumably Larisa Traylor. What Paul Garon identifies as the "revolutionary nature of the blues" applies to this and many of Traylor's pictures: "Through its fidelity to fantasy and desire, the blues generates an irreducible and, so to speak, *habit-forming* demand for freedom." The black "blues singer rejects and even ridicules the repressive norms" of the white people who are in control. Bill Traylor had come to share this revolutionary core of a blues worldview. He rejected the repressive norms of the whites in control, as well as those of the moralistic black churches. This Bill Traylor drawing sings of violence, sexual pleasure, heavy drinking, conjure, and a demand for personal freedom.[55]

Christopher Small holds that: "The blues . . . represents the continuation of that resistance of black people to spiritual annihilation which was at the centre of all their artistic activity from the first days of slavery." Traylor's picture *Figures and Construction* [with gun] takes us into Bill Traylor's lifeworld and exemplifies his personal resistance to spiritual annihilation. The two fig-

ures in the outer circle at the right are probably Traylor as well, running all the rest of his life from what he had done to the man he was shooting above, but at each phase he holds one arm up at an angle. This body language sends a message, signaling once again that the Great Spirit will demand retribution, while his lower arm held akimbo signals that he will put down evil through the use of conjure power. The female figure enclosed in a small place by what appears to be the body of a snake, with the snake's head to the right, may be a representation of his second wife, suffering after the death of her son but protected by a snake spirit. She seems to be holding out the sides of the circle, the oppressive reality of life, to keep them from coming in on her. The woman below the coffin—or below the midline of the "Four Corners of the Earth"— holds up Traylor's world. She is feasibly his first wife, now a spirit in the realm of the dead. As in African traditions, the dog to her left is being used by Traylor to see into the spirit world.[56]

It is important to reemphasize that conjurers and their clients believed that drawings could alter reality and that Traylor was likely to have drawn conjuration figures long before he began painting on a Montgomery street. It was believed that a portrait would bring the subject's soul to the portrait painter; a damaged portrait could bring injury; a buried portrait could bring death. The drawing of a circle on the ground could protect those within it. The drawing of symbols—in particular the quincunx, the triangle, the circle, and the cross—could affect the present and future, bring healing or cause pain. In the 1890s, a black woman in Georgia was observed drawing slowly in the sand, while intoning an incantation. She drew a cross, surrounded by lines that made it look like a four-leaf clover, or perhaps the four corners of the earth. When she was done, she reported that a pain in her side, which had been caused by a witch, was gone. The figure she drew closely resembles an Ife Yoruba "anti-witch guard."[57]

When Bill Traylor drew something, he, too, believed he was affecting the real world. Hatchets and guns in blacks' hands were "drawn"—a play on words—but these visions were believed capable of altering "real life." In his old age, Traylor painted scenes in which he was attacking his enemies and preparing to bury them with picks and shovels in the expectation that his paintings would have powerful results. He was threatening murder and mayhem. As in the following lyrics from Gellert's collection, Traylor's images often seem to parallel those bitter blues lyrics that advocated attacks on white enemies:

All the wrong white folks you do to me,
Bound to come back somehow, just you wait and see.

You gotta know sure, I ain't treated right,
Seem like you awful careless with ton dynamite.

Some of these days soon I'm gonna show you I'm a man,
Not no tail monkey just a rattlin' his chain.

I feel it comin' white folks, gonna see you in Goddam,
Get me a pick and shovel and bury you in the Devil's land.[58]

Traylor still had a long way to go before he could devote himself to finding a voice for his anger and desires. A significant rise in the price of cotton between 1914 and 1919 did help Bill Traylor move toward greater independence; nevertheless, in the 1920s he had to "fall back," as Cobb termed it. Many reasons for his troubles can be suggested: the boll weevil, eroded soil, poor weather, and above all, the precipitously falling cotton prices. Illness afflicted him and his wife Laura, as did the departure of the older children from the farm. Bill and Laura Traylor were no longer able to do farm work and could not support their family; at the same time, some of the older children were moving to their own farms and beginning to take responsibility for several younger children whom they referred to as their brothers and who were, perhaps, Bill Traylor's outside sons. Their actions helped Bill Traylor but at the same time undermined the control he had exercised over his large family since his marriage to his first wife. The troubles and changes didn't help Bill and Laura Traylor's relationship: By 1928, they were both ready to leave the farm and their life together. Memories of the murder that had set Bill Traylor on his life's path were coming back to harm him. Traylor's painting of an enlarged red-stomached man suggests he shared the Slave Coast view that anger was a "fire in the stomach." He desperately needed to find a way to voice this pain and take a stance against his enemies. He set off alone to find a new life.[59]

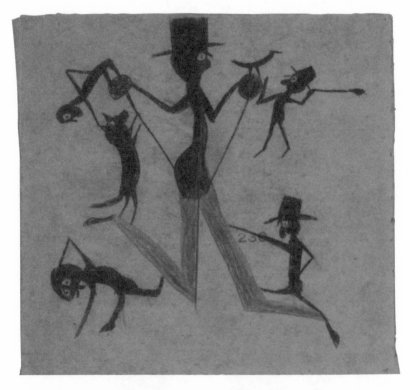

Plate 1. Bill Traylor, *Man with Top Hat and Green Trousers*, 1939–42.
Courtesy of Judy A. Saslow Gallery.

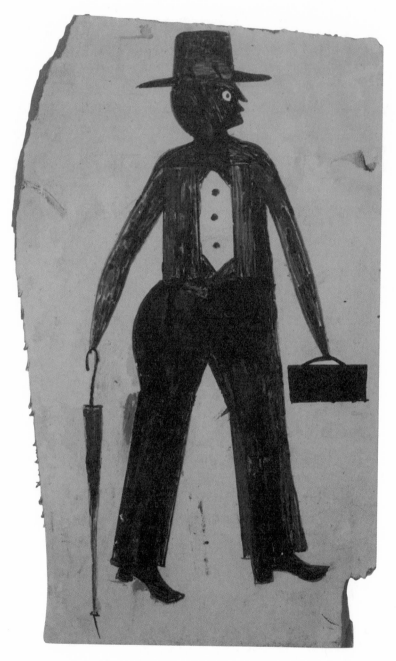

Plate 2. Bill Traylor, *Blue Man with Umbrella and Suitcase*, ca. 1939.
Courtesy of The Anthony Petullo Collection of Self-Taught and
Outsider Art, Milwaukee, Wisconsin.

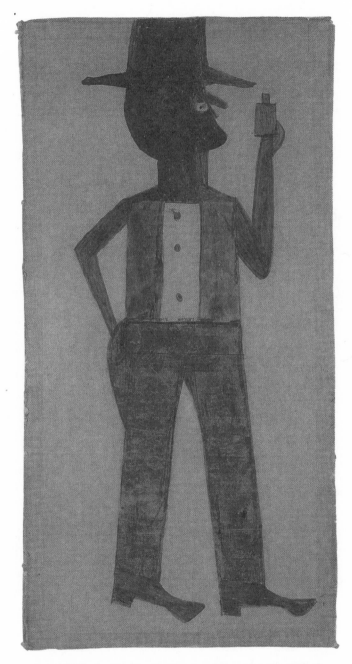

Plate 3. Bill Traylor, *Man Wearing Maroon and Blue with Bottle*, 1940–42.
Courtesy of William Louis-Dreyfus.

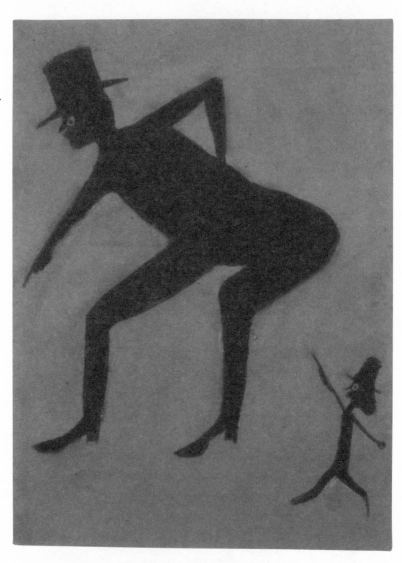

Plate 4. Bill Traylor, *Big Man, Small Man*, 1939–42.
Courtesy of Judy A. Saslow Gallery.

Plate 5. Bill Traylor, *WPA Poster*, 1939–42.
Courtesy of The Harmon and Harriet Kelley Foundation for the Arts, San Antonio, Texas.

Plate 6. Bill Traylor, *Snake and Two Men*, 1939–42.
Courtesy of Judy A. Saslow Gallery.

Plate 7. Bill Traylor, *Preacher and Congregation*, 1939–42.
Courtesy of Judy A. Saslow Gallery.

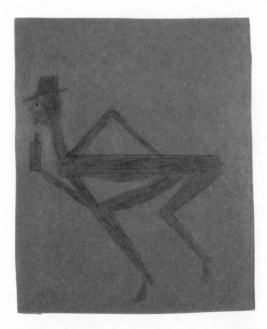

Plate 8. Bill Traylor, *Flat-Backed Drinker; Drunken Chicken Walk*, 1939–42.
Courtesy of Judy A. Saslow Gallery.

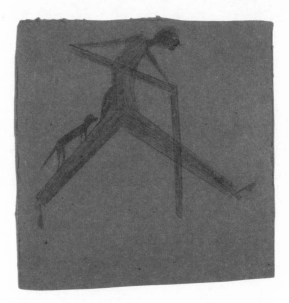

Plate 9. Bill Traylor, *Man Walking Dog*, 1939–42.
Courtesy of Judy A. Saslow Gallery.

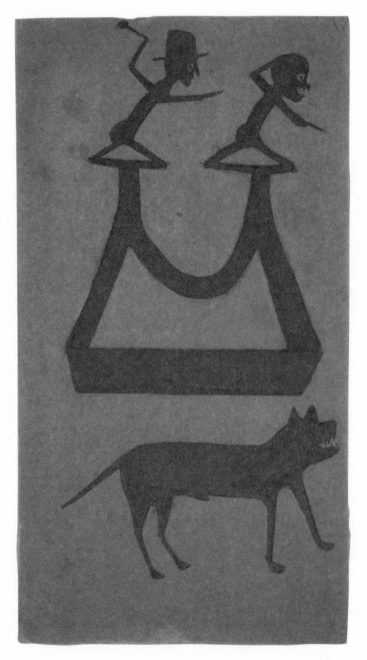

Plate 10. Bill Traylor, *Blue Construction with Dog*, 1939–42.
Courtesy of Judy A. Saslow Gallery.

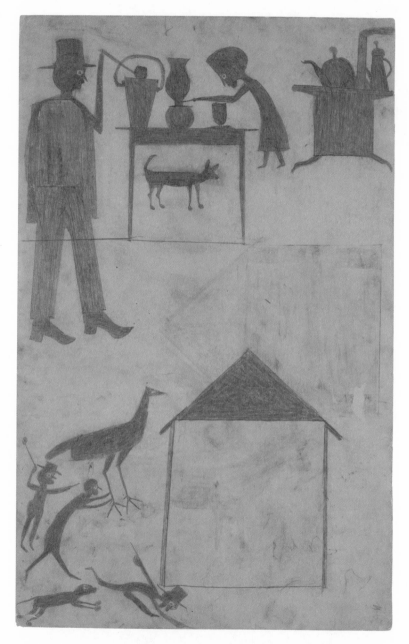

Plate 11. Bill Traylor, *Kitchen Scene, Yellow House*, 1939–42.
Pencil and colored pencil on cardboard. 22 x 14 in. (55.9 x 35.6 cm.).
The Metropolitan Museum of Art, Purchase, Anonymous Gift, 1992 (1992.48).
Image © The Metropolitan Museum of Art.

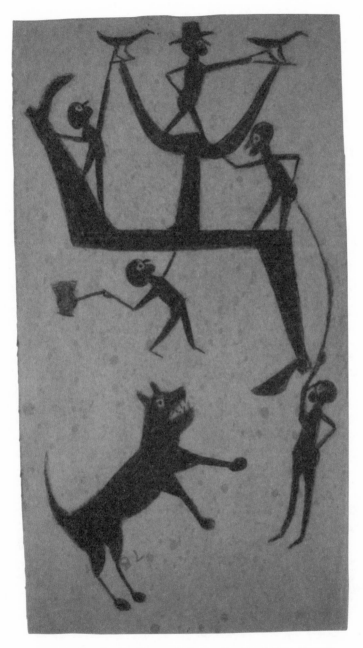

Plate 12. Bill Traylor, *Five Figures with Dog and Leg Construction*, 1941–42.
Courtesy of Judy A. Saslow Gallery.

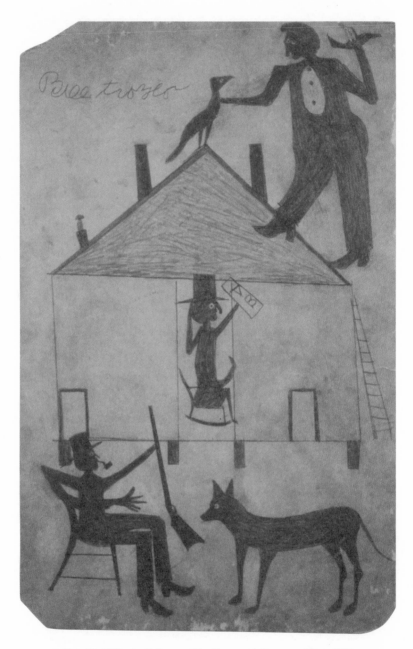

Plate 13. Bill Traylor, *Yellow and Blue House with Figures and Dog*, 1939.
Courtesy of Judy A. Saslow Gallery.

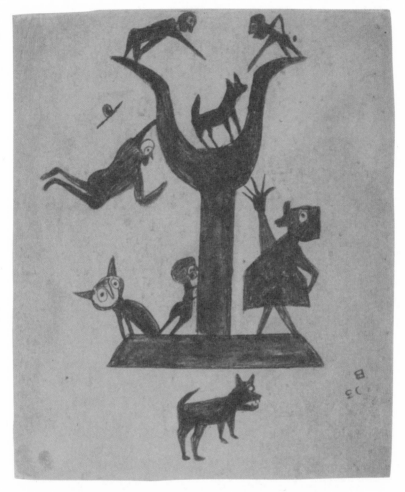

Plate 14. Bill Traylor, *Figure/Construction: Yawping Woman*, 1939–42.
Courtesy of Judy A. Saslow Gallery.

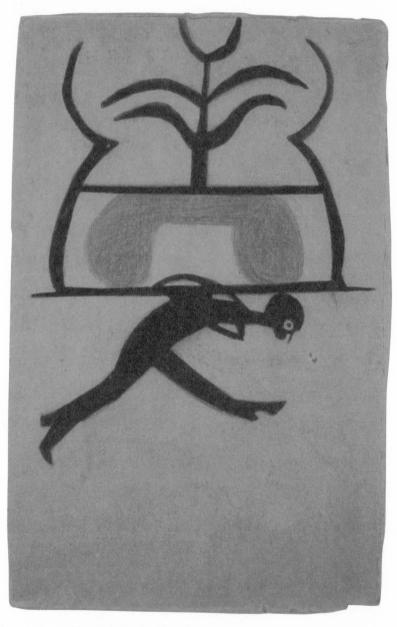

Plate 15. Bill Traylor, *Man with Construction on Back*, 1941–42.
Courtesy of Judy A. Saslow Gallery.

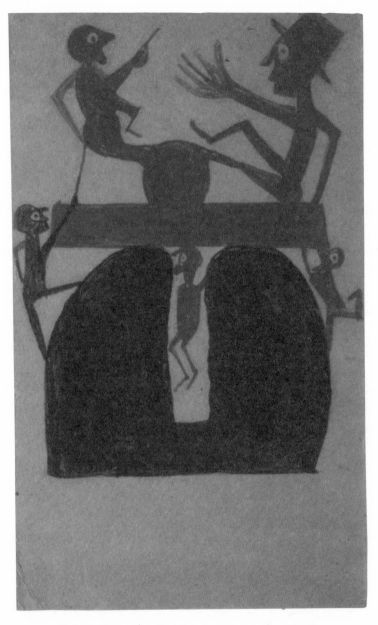

Plate 16. Bill Traylor, *Untitled:* Figures and Construction, 1939–42.
Courtesy of Luise Ross Gallery.

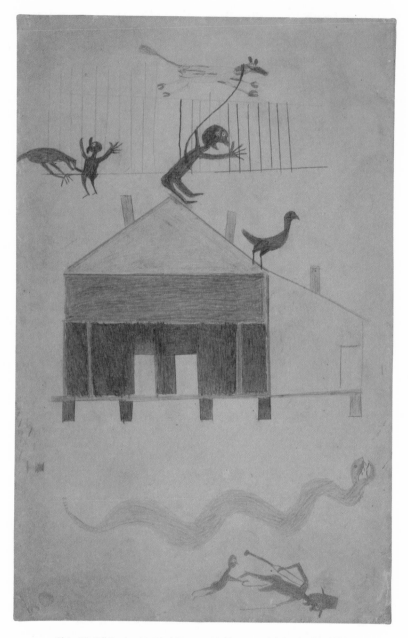

Plate 17. Bill Traylor, *Untitled:* House with Figures and Animals, July 1939.
Courtesy of Hood Museum of Art, Dartmouth College, Hanover, New Hampshire;
purchased through the Florence and Lansing Porter Moore 1937 Fund.

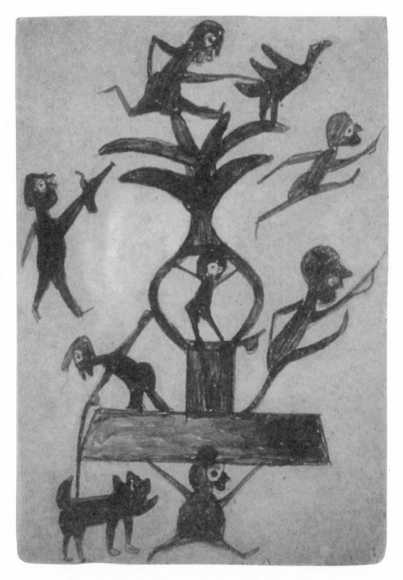

Plate 18. Bill Traylor, *Figures and Construction* [with gun], 1941–42.
Courtesy of Morris Museum of Art, Augusta, Georgia.

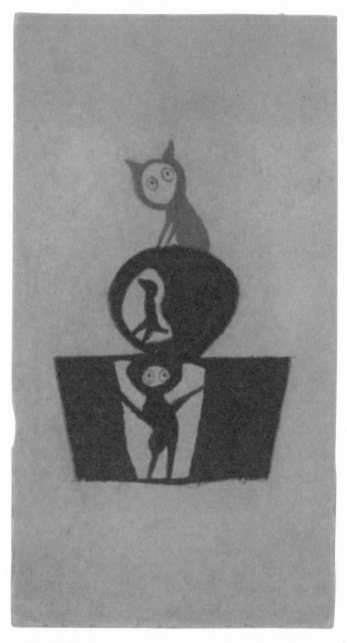

Plate 19. Bill Traylor, *Construction: Blue/with Orange Cat on Top*, 1939–42.
Courtesy of Judy A. Saslow Gallery.

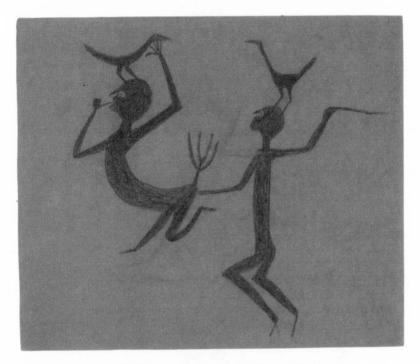

Plate 20. Bill Traylor, *Two Figures with Pitchfork*, 1939–42.
Courtesy of William Louis-Dreyfus.

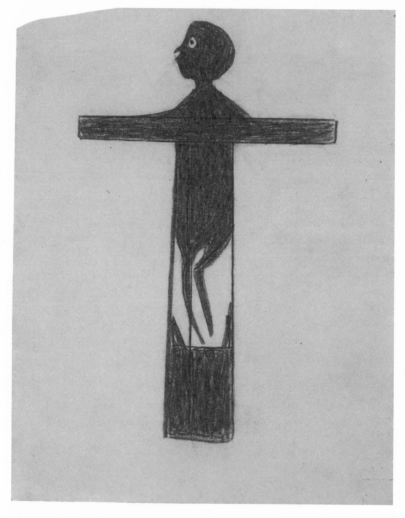

Plate 21. Bill Traylor, *Crucifixion*, 1939.
Courtesy of William Louis-Dreyfus.

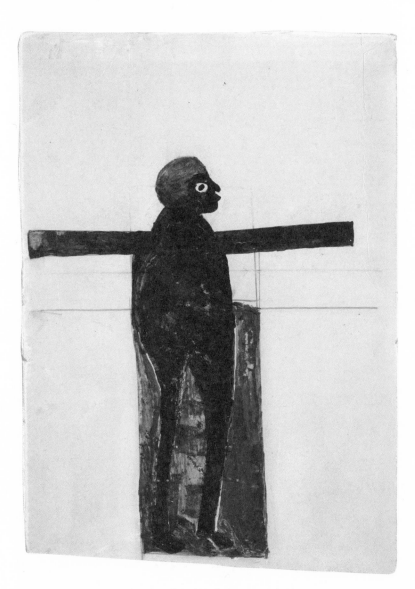

Plate 22. Bill Traylor, *Black Jesus*, 1940–42.
Gouache and pencil on cardboard. 13 1/3 x 10 in. (34.9 x 25.4 cm.).
The Metropolitan Museum of Art, Promised Gift of Charles E. and Eugenia C. Shannon
(L.1995.38.10). Photograph © 1997 The Metropolitan Museum of Art.

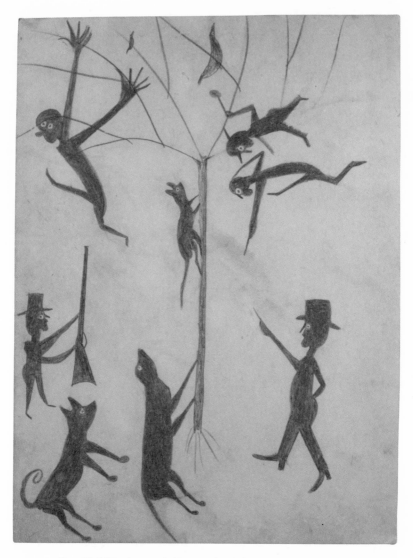

Plate 23. Bill Traylor, *Untitled* [previously titled *Possum Chase*], 1939–42.
Courtesy of Janet Petry and Angie Mills. Promised gift to Intuit:
The Center for Intuitive and Outsider Art.

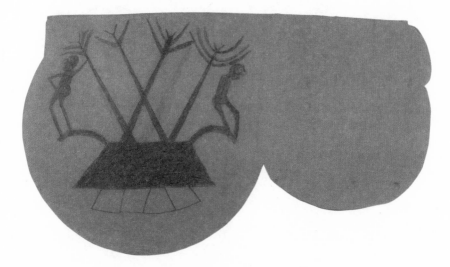

Plate 24. Bill Traylor, *Figures and Trees*, 1939–42.
Private collection.

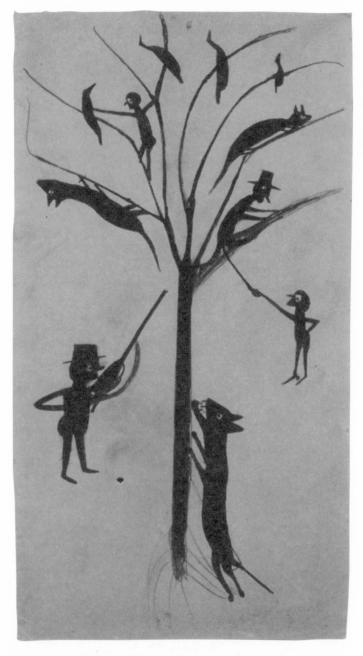

Plate 25. Bill Traylor, *Possum Hunt*, 1939–42.
Courtesy of Judy A. Saslow Gallery.

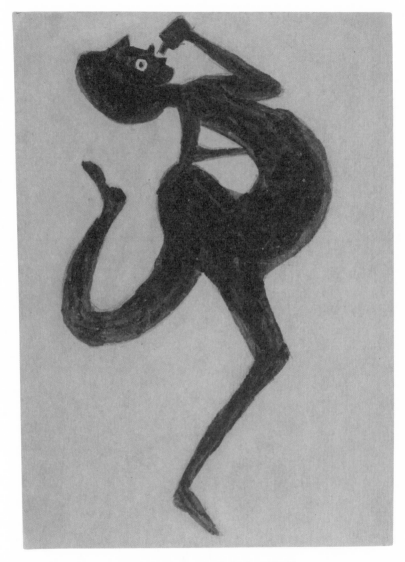

Plate 26. Bill Traylor, *Female Drinker*, 1940–42.
Gouache and pencil on cardboard. 11½ x 8½ in. (29.2 x 21.6 cm.).
The Metropolitan Museum of Art, Promised Gift of Charles E. and Eugenia C. Shannon
(L.1995.38.4). Photograph © 1998 The Metropolitan Museum of Art.

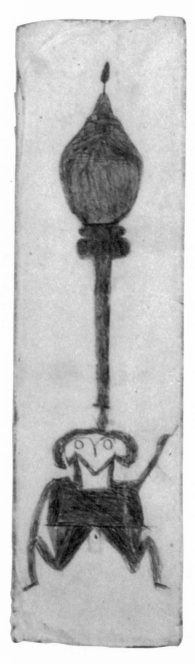

Plate 27. Bill Traylor, *Figure in Front of Street Light*, June 1939.
Courtesy of Luise Ross Gallery.

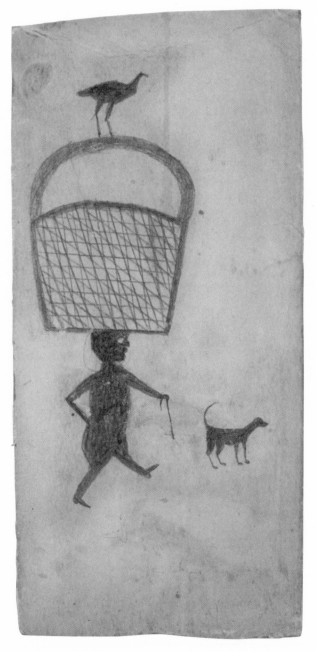

Plate 28. Bill Traylor, *Man with Basket on Head*, Summer 1939.
Courtesy of Judy A. Saslow Gallery.

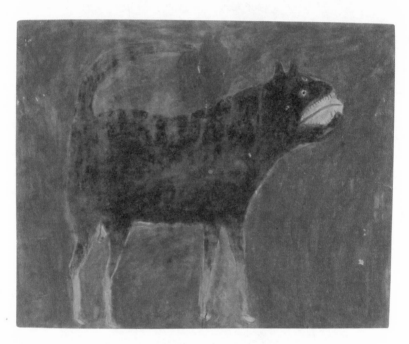

Plate 29. Bill Traylor, *Mean Dog*, 1939–42.
Courtesy of Judy A. Saslow Gallery.

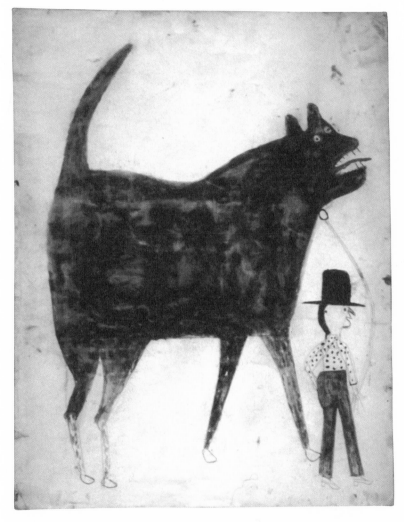

Plate 30. Bill Traylor, *Untitled:* Man and Large Dog, 1939–42.
Courtesy of Luise Ross Gallery.

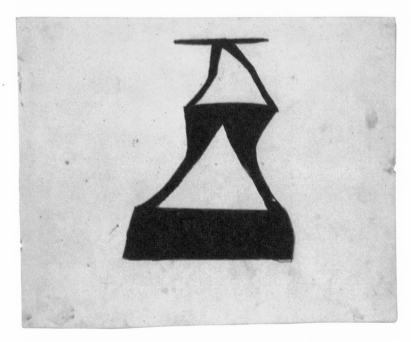

Plate 31. Bill Traylor, *Untitled:* Abstract Form, 1939–42.
Courtesy of Luise Ross Gallery.

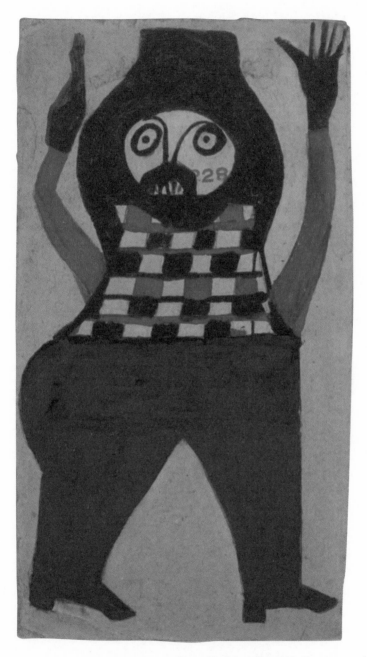

Plate 32. Bill Traylor, *Mexican Man in Checkered Shirt*, 1940–41.
Courtesy of Judy A. Saslow Gallery.

Plate 33. Bill Traylor in Bragg Street Backyard, Montgomery, Alabama, March 2, 1946.
Photograph by Horace Perry. Courtesy of Georgine Clarke, The Alabama State Council on the Arts.

Plate 34. Collage of Bill Traylor Paintings, Bragg Street, Montgomery, Alabama, March 2, 1946.
Photograph by Horace Perry. Courtesy of Georgine Clarke, The Alabama State Council on the Arts.

3

"MY HEART STRUCK SORROW"
(1928–1930)

My heart struck sorrow, and the tears come rollin' down.
—ABRAHAM POWELL, 1939

Another hidden violent event lies at the heart of Bill Traylor's life narrative: the violent death of his son Will. By 1928, all of the family had left the farm on the Seller plantation, and Will, who had married Mimia Calloway and fathered several children, went with his brother Mack to Birmingham. Although unemployment there was reported at about 18 percent, they hoped to find jobs in the local mines or industries. The others chose to go north to Philadelphia, Washington, D.C., upstate New York, or Detroit, where Easter Traylor Graham's home became a haven for many of the Traylors, including some of those who had first gone to Birmingham. Bill Traylor went to live in downtown Montgomery, which, as he knew, had a growing black community. Laura Williams Traylor may well have gone there, too: In the 1930 census, a black woman named Laura Williams, listed as a "mother in law," was living in Montgomery with Julius Jackson and his wife, Eliza Williams Jackson. This Laura Williams may have been Bill's wife, and Eliza one of her children born before her marriage to Traylor. In any event, the marriage of Laura and Bill was over, and Bill Traylor was living downtown by himself.[1]

When he first came to Montgomery, Bill Traylor found employment as a laborer and then as a shoemaker, and was able to rent places to live in, the first on Coosa Street, not far from Monroe Street and the downtown area that he came to call home. He probably had spent time in this area together

with many other farmers from the surrounding countryside who came into Montgomery every Saturday. Later he moved a few blocks to a small shack on Bell Street, by the railroad tracks. In 1929, Traylor was living there alone, aged and ailing, when he was given a hard "knock in the head" by news of the violent killing of his son Will.[2]

The police account of Will Traylor's death was reported in the *Birmingham Post* on August 26, 1929, the day he was killed. Police officers C. L. Justin and B. F. Walker reported that at 1:00 a.m. they "discovered . . . an unidentified negro . . . attempting to break into a West End home." They said "he was reaching for a gun," so they shot him "three times in the chest." They reported that when they searched his body they found "a pistol and a flashlight." That morning a "verdict of justifiable homicide was returned after an investigation by Coroner Russum." Within a day or two, the police knew both the identity of the man who had been killed and where his father, Bill Traylor, was living. Informed of his death, Bill Traylor traveled from Montgomery to Birmingham to identify the body of his dead son.[3]

Bill Traylor never told Shannon anything about Will Traylor's death. By allowing Shannon and others to believe he and his family were in Benton until the late 1930s, Traylor avoided talking about both the traumatic breakup of his first family and his son's violent death in Birmingham. The family still does not talk about any of these events in public. At the family reunion in August 1992, Margaret Traylor Staffney, daughter of Will and Mimia Callaway, said that in his last years, when he was in his daughter Sarah's backyard, Bill Traylor cried whenever he saw her and her siblings, and kept saying, "Billy's little children." She knew he cried because "he was remembering something," but both Margaret Staffney and her sister Myrtha Delks agreed that they didn't know what led to Will Traylor's death or what Bill was remembering. "No one told us," one of them said. No doubt there were things not to be spoken of in those times, lest speaking bring about even more terrible events. The family called them "hush-hush" happenings, and everyone, even little children, knew what that meant. However, the grandchildren were still not talking of how Will died in 1992. The two booklets drawn up for family reunions in the early 1990s outline the lives of family members, but make no mention of how and where Will Traylor died. In 1993, when Bill Traylor's family issued a statement as part of the settlement of the case they brought against Charles Shannon requesting a portion of what they believed should have been their

inheritance, a very brief reference to the lives of his children did mention that Will Traylor had been shot and had died. Who killed him and under what circumstances was not in the statement released to the press. Sixty-three years after the event, the family still could not talk openly of Will Traylor's death.[4]

Assuming that the newspaper story was correct, one might understand the reluctance to admit that a man in the family was a thief, but the family does not accept the published story as true, and preserves a very different account of his death. In 2004, I met with Antoinette Beeks, a great-grandchild, who spoke with me at length about the family. During this interview, she came to the decision that it was time to break the taboo on talking about this subject, and revealed her great-grandfather's account of the events. She was, however, not ready to reveal any of the details of when and where Will Traylor died; I had to uncover this without family help. Beeks did say that Bill Traylor had reported to his family that the police had "lynched" Will Traylor, and that they told him they killed his son because "he was peeping in the window at a white woman." In 1929, a black man who accused the white Birmingham police of lynching his son and lying to the press would have expected to suffer violent retribution. Traylor and his family decided not to speak of Will's death, and it became a "hush-hush" event.[5]

Will Traylor's name does not appear in the lists of lynched people kept by the Tuskegee Institute, the *Chicago Tribune*, the NAACP, or Project Hal, an open data bank on lynching to which names can still be added. The Tuskegee Institute early decided that there must be at least three people in the "mob" that killed a lynch victim, and that it must be an "illegal event." The death of Will Traylor does not meet these criteria; however, the Tuskegee Institute itself violated this definition and included some killings carried out by two people and by law officers. Two policemen shot Will Traylor and reported to the press that he was a thief, and that they suspected he was guilty of breaking and entering into many homes in the neighborhood. Bill Traylor, however, was told by policemen that Will had been "peeping" in a white woman's window, and he believed this signified it was a lynching, I think correctly so. "Peeping" at a white woman through a window was viewed as violating her body and soul, and was a charge leveled at a number of lynching victims. Add to this that it was 1:00 a.m., and the woman was likely to have been in bed, and the "crime" was compounded. Will Traylor was certainly killed without trial or legal process, and although two men with legal authority to use guns

killed him, they were following "lynch law," a popular belief—documented in the writings of Ida Wells-Barnett—that there were crimes that had to be dealt with by killing the perpetrators without recourse to the courts. In this period, whites widely defended the use of lynch law in cases in which black men were accused of violating white women in any way. These people claimed lynching saved white women from the trauma of having to recount any crime committed against them in court and served as a necessary warning to all black men. In their shooting of Will Traylor, the two policemen were supported by the police commissioner, the coroner, and virtually all their fellow policemen. In the late 1920s, some fourteen thousand men in Jefferson County, most of them in greater Birmingham, were members of Robert E. Lee Klan No. 1, and this Klan included "most of the city's policemen, if not all of them." They were the invisible lynch mob standing behind the two policemen as Will Traylor was lynched.[6]

We have further reports of Birmingham policemen lynching blacks that summer from Robert W. Bagnall, who was employed as a field worker for the NAACP in 1929, and was traveling around the South to report on racial violence. Bagnall was in Birmingham in August, during the very time when Will Traylor was murdered. What he learned there led him to claim that of all places in the South "Birmingham . . . holds the prize for terrorism" as the "police and courts are run by . . . the Ku Klux Klan. Without provocation police shoot Negroes so frequently there that it is no longer news." Bagnall's report, published in the NAACP journal, the *Crisis*, provides details of some of these recent killings of blacks by the Birmingham police: the killing of a schoolteacher who didn't move quickly enough when told not to loiter on a street corner; and the shooting of an undertaker sleeping in his car trying to protect it from thieves, who had a pistol on the seat between his legs. Bagnall offered the help of an NAACP investigator to look into these and similar cases, but "prominent Negro citizens of Birmingham insisted that he should not be sent."[7]

Bagnall's report confirms that Traylor's decision to maintain silence about his son's murder was not unusual or irrational: Black people in Alabama, on the basis of police behavior, were too frightened to testify to what was going on. In 1952, twenty-three years after the killing of Will Traylor, Charles Denby, born on a plantation in Lowndes County, wrote an autobiography in which he discussed the personal impact of lynching incidents in his birthplace. Denby, who had escaped to Detroit to work in a factory, had become

a "Marxist Humanist" and a journal writer and editor while working there, but he remained constrained by fear that his family would be harmed if he revealed his real name or the true location in his autobiography. It was not until 1978, after all family members had either died or left Alabama, that he could reveal the truth: His early life was not as he had written, spent in Tennessee, but in Lowndes County, Alabama, where "Black oppression was probably as complete and total . . . as almost anywhere else in the South," and it was there, he wanted the world to know, that the lynching incidents he had written of had taken place.[8]

We are so far from this time now that it is important to emphasize how dangerous it was for blacks in the South to voice any disapproval of the system. Any open criticism of white repression was talking back in a way that was not allowed within the hearing of most whites. Alan Lomax recounts a telling story from this period that brings home the reality of fear in the everyday life of African Americans. It begins with a 1947 recording session that Lomax held in New York City. Big Bill Broonzy, Sonny Boy Williamson, and Memphis Slim, southern musicians who were then living in Chicago, were sitting with Lomax in a Decca recording studio on a Sunday, drinking, singing, and talking, while a tape machine was running. Lomax writes: "I think they really forgot I was there as they talked, played, and sang to each other." Lomax had never before been allowed to hear the shocking things they said about their lives and the bitter songs that they sang, which seem understated now, but in the 1940s, with the Klan again on the march in Alabama and in the rest of the Deep South, their words would have been dangerous if heard there. Memphis Slim said: "Yeah, blues is a kind of a revenge. You know you wanta say something, you wanta signifyin like—that's the blues. We all have had a hard time in life, and things we couldn't say or do, so we sing it." Memphis Slim explained that you had to be very unusual to "talk back": "You know, . . . we had a few Negroes down there that wasn't afraid of white peoples and talk back to them. They called those people crazy." Big Bill Broonzy reacted to this turn in the conversation, commenting: "Crazy people, yeah. I wonder why did they call them crazy, because they speak up for their rights?" He then explained what could happen to such crazy people: "I had an uncle like that and they hung him. They hung him down there because they say he was crazy and might *ruin* the other Negroes. See, that is why they hung him, because he was a man that if he worked, he wanted pay; and he could figure as good as

the white man." Memphis Slim and Broonzy, as well as Traylor and virtually all the people living in the Black Belt, knew how dangerous any opposition to Jim Crow was not only for the individual acting "crazy": "You try to fight back, then it's not just you they're gonna get. It's anybody in your family."[9]

When Broonzy, Williamson, and Slim later heard the tape played back, they had frightened and angry reactions, but Lomax would not agree to destroy the tape. One of them explained to Lomax: "When those Deep Delta Pecker-woods heard the records, they'd come looking for them. If they couldn't find them, they'd go after their *families*, burn down their houses, maybe kill them all out." They demanded that at the least he must never release their names. Notwithstanding his southern background, Lomax was not prepared for this response. He thought that these established blues musicians working in the North would have put such fears behind them. He valued the tape too much to destroy it, but promised never to reveal their names, and did not do so until 1990, after all three had died. Lomax, however, did publish the conversation and the music in 1948 and 1959, but gave the participants fictitious names.[10]

African Americans often hid their thoughts and much of what they knew from whites. In her autobiography, Zora Neale Hurston did not reveal her correct birth date, birthplace, several of her marriages, or much about her feelings. She warned readers that, "the Negro, in spite of his open-faced laughter, his seeming acquiescence, is particularly evasive. You see we ar' a polite people and we do not say to our questioner, 'Get out of here!' We smile and tell him or her something that satisfies the white person because, knowing so little about us, he doesn't know what he is missing." As if talking of others, Hurston wrote: "He can read my writing but he sho' can't read my mind."[11]

Traylor did share parts of his life story with Charlie Rhodes, a black man who spent time with him on the Montgomery streets, and taught Bill Traylor to sign his name on his pictures. Bill Traylor had Rhodes record George Traylor's name and his role in his early life on one of his paintings, but Traylor clearly did not ask him to write of his son Will's violent death at the hands of the Birmingham police. If Traylor shared any of his secrets with Rhodes, Rhodes did not reveal them. Traylor's appreciation of Rhodes was expressed on November 9, 1941, Rhodes's fifty-fifth birthday, when Traylor painted a wonderful portrait of Rhodes all in blue, including his face, hands, and feet, walking on all fours with his hair standing on end, perhaps signifying they shared experience with the spirits.[12]

Most people with life experiences similar to those of Bill Traylor revealed little about their thoughts, with the exception of Ned Cobb (1885–1973), whose comments have been cited several times. His autobiography reveals a wise, articulate, and courageous man. Born in the Black Belt, Cobb was the age of Traylor's first child, Pauline, but like Traylor, he was illiterate, and they shared many experiences in the long Jim Crow period. Cobb described the crux of white racist inhumanity: "I've gotten along in this world by studyin the races and knowin that I was one of the underdogs. I was under many rulins, just like the other Negro, that I knowed was injurious to man and displeasin to God and still I had to fall back." Cobb was not broken by the situation, but didn't have any support for resisting. "I didn't believe in this way of bowin to my knees and doin what *any* white man said do. Still, I always knowed to give the white man his time of day or else he's ready to knock me in the head."[13]

Ned Cobb did have an opportunity to join with others for support that came too late for Bill Traylor. When the Communist-sponsored black Share-croppers Union was founded in 1931, Cobb was ready to join, and in the union he experienced collective support and action. After joining, Ned Cobb got a serious "knock in the head," but it was in response to an act he chose to risk and that he knew would cause him grief. In December 1932, Cobb armed himself and joined in the defense of a neighbor fighting foreclosure. In the ensuing shootout, Cobb was wounded, and soon after he was sentenced to twelve years at hard labor. Cobb talked at great length of this experience and of what it had meant in his life: He and his family suffered severely for his actions, but he felt he had done the right thing and was proud of it. In con-trast, Traylor knew that the knock he received in 1929 was not in response to any action that he had chosen to take; he was initially not proud of anything that happened in relation to the killing of his son, and he was not prepared to discuss it openly. His paintings, however, tell us a great deal about how he later felt about this event, as protest painting became the antilynching action he eventually took.[14]

In 1928, Grover C. Hall, a white southern liberal who was the editor of the *Montgomery Advertiser,* also took courageous action, waging a strong cam-paign against lynching and other KKK violence, which won Hall a Pulitzer Prize for his writing but alienated many whites in the South. The State of Alabama, however, responded both to his criticism and the mounting bad

press from outside the South and proudly reported a remarkable decline in lynching in 1929: Not one lynching was formally recorded in Alabama in that year. Although the many Alabama black people known to have been killed by whites without trial in 1929—including Will Traylor and the people described in Bagnall's report, as well as Handy Fuller, whose death is noted below—all should have been listed as lynching victims, not one was listed.[15]

On March 26, 1931, the National Guard did prevent an Alabama mob from lynching the nine black Scottsboro "boys" charged with raping two white "girls." Poorly defended at the outset, eight of the young men were sentenced to death, and the Alabama Supreme Court upheld the sentencing of seven of them in what black people and their Communist supporters widely saw as a "legal lynching." While eventually reprieved from death, the men essentially lost their lives—the last one freed in 1950—emerging damaged from years of brutal imprisonment for a crime they did not commit. Their experience was memorialized in the bitter blues song "Scottsboro," recorded by Lawrence Gellert:

> Paper come out, Done strewed de news,
> Dat Seven po' chillun Moan deat' house blues.
> Seven po' chillun moanin' deat' house blues.
>
> Seven nappy heads wit' big shiny eye,
> All boun' in jail an' framed to die,
> All boun' in jail An' framed to die.
>
> Messin' white woman Snake lyin' tale,
> Dat hang and burn And jail wit' no bail.
> Dat hang an' burn and jail wit' no bail.
>
> Worse ol' crime in white folks lan'
> Black skin coverin' po' workin' man,
> Black skin coverin' po' workin' man.
>
> Judge and jury All in de stan',
> Lawd, biggety name Fo' same lynchin' ban'.
> Lawd biggety name fo' same lynchin' band.
>
> White folks an' nigger in great Co't house
> like cat down cellar wit' no hole mouse,
> like cat down cellar wit' no hole mouse.

Paper com out, Done strewed de news,
Seven po' chillun Moan deat' house blues.
Seven po' chillun moanin' deat' house blues.[16]

The Communist Party and its local auxiliaries defended the young men charged in the Scottsboro case, and took on as well ten recorded cases of lynching in Alabama in the 1930s, raising money and pursuing the issues actively in the courts and in the press. They charged the local black elite, including those in the NAACP, with "ambivalence, timidity, and organizational weakness," noting that fear and a desire to protect what they had achieved kept them from defending poor black people. The Communist-led International Labor Defense organization provided the key legal defense in all these cases, and the prestige they gained from this in the black community helped them to recruit poor blacks into the Communist Party and the Communist-supported Sharecroppers Union. This black "political voice" in the fight against lynching and Jim Crow aroused the fear, anger, and opposition of whites in general and the black elite.[17]

When Gellert traveled in Alabama to collect responses to the Scottsboro case, he observed this growing activism of blacks, much of which was carried out in secret. In the early 1930s, many were joining the largely underground black Sharecroppers Union (whose meetings were often disguised as Bible study groups or sewing clubs) in Lowndes, Montgomery, and some five other Alabama counties, and participated in the cotton choppers' strikes in 1934 and 1935. While some members of the black community later sang about these strikes and the extreme white violence that broke them, Gellert found that after Scottsboro the "new militancy" among the rural Alabama black people elicited a stronger white reaction, making it much harder for a white man to collect any lyrics: "It was like an occupied country."[18]

Violence against blacks, particularly high in the period just after the Civil War, had continued into the period of radical Reconstruction, when armed white paramilitary groups engaged in a "wave of counterrevolutionary terror" climaxing in the 1873 massacre of 280 black people in Colfax, Louisiana. Ida B. Wells was the first to collect data on whites killing blacks without legal warrant in this period. Basing her study on the published reports of white men, she concluded that, between 1865 and 1890, violent black deaths at the hands of whites totaled over 10,000. The *Chicago Tribune* began a count of lynch re-

ports in 1882, and by 1950, the paper had records of 4,730 lynching deaths, 90 percent in the South, with over 87 percent of the victims African Americans. Adding the many thousands of African Americans killed between 1865 and 1882, the unrecorded lynch victims over the whole period, as well as those who died in urban "riots" yields a total of African Americans killed that is substantially higher than what is reflected in the widely cited lynching records.[19]

Southern black people were well aware of this history. The massacres that occurred in some thirteen urban centers in the fifty years following 1892 hit home in the South as well: In this period many of the sons and daughters of Black Belt workers, including Bill Traylor's children, moved to these cities in hopes of a better life, and it was, in part, resentment of their having entered the work force in these communities that led to the riots. The first race riot in this period was in Wilmington, North Carolina, in 1898, and the last was the bloody massacre in Detroit, Michigan, in 1943. Traylor visited his children and grandchildren living in Detroit a year before the massacre there, and no doubt was aware of the violence the following year. Between 617 and 767 black people were killed in these urban attacks, which Gunnar Myrdal, writing in the 1940s, was ready to call acts of mass lynching. Lynching closer to Bill Traylor in the counties of Lowndes, Dallas, and Montgomery was reported throughout the period, and the news of a lynching in the rest of Alabama, as well as in Georgia and Louisiana, would have reached Traylor quickly as well.[20]

Adam Gussow maintains that it was the blues that enabled black southerners to maintain their "psychic health" in the face of the ever-present reality of lynching. In his study of the impact of lynching on the men and women who made and sang the blues, based on their autobiographies generally published fifty years and more after the events, Gussow maintains that these blues musicians were "wounded and formed" by this violence. Big Bill Broonzy, Mance Lipscomb, Esther Mae Scott, Josh White, Willie Dixon, Yank Rachell, B. B. King, and many other black musicians witnessed lynching and/or feared for their own lives in near-lynching experiences. Images of mutilated bodies—fingers, toes and "privates" cut off—were kept in mind and sometimes entered their poetry, but were not spoken of openly in those days.[21]

In recounting the formative events in his life in 1990, the blues musician Big Joe Duskin (b. 1921) told the story of how he'd witnessed the lynching of his cousin Handy Fuller in Birmingham the same summer that Will Traylor

was murdered there. Fuller had stolen "a sack of potatoes, and a loaf of bread and a chicken," and he had left a signed note in the store stating he took these things because his "kids were hungry" and that he'd pay for what he took when he got a job. This promise led to his death. That night Joe Duskin and Handy Fuller were sleeping in the family home in Birmingham when "the Klu Klux Klan come and got [Handy] out of the house." Sixty years later, Duskin still vividly remembered the scene: "I thought they was ghosts . . . and I seen em when they put this rope around his neck. . . . And I seen em when they put him on this mule, they had his hands tied behind him. They put this big rope on his neck and said 'Hit the horse on his ass as hard as you can so he can drop right from him and break that black bastard's neck. . . .' When he fell I heard his neck snap like that, see." The family "buried him and that was that."[22]

Duskin remembered another lynching that he tied directly to his need for the blues. When he was quite young he often ran off to hear blues at a juke, going through a swamp to get there. On one of these treks, "I saw a man with a rope round his neck, . . . snakes comin out of his eyes and ears and mouth, and I stood cryin like mad cause . . . the man wouldn't answer." His uncle found Joe Duskin crying at this site, comforted him, and buried the body of Dawson, who "didn't do nothin to nobody!" Soon after this, Duskin "got very enthusiastic over the blues," which gave him a way of dealing with the damage done to him by lynching.[23]

Blues songs often reflect thoughts of lynching while they ostensibly maintain the taboo about not referring to them in public. Howard W. Odum collected and published the following lyrics without commenting on the KKK association:

> They're gonna hold a meetin' there
> Of some society.
> There's 'leven sheets upon the line,
> That's ten too much for me.

Concern with lynching in the recorded blues was more veiled, but Gussow believes it was pervasive. He maintains it can be found in "anxieties about encirclement, torture, and dismemberment; as a blues nightmare about Hell's 'dragons'; as direct address to an oppressive phantasmic presence . . . that . . . does him many sorts of harm."[24]

Traylor's art reflects these very fears, suggesting his overwhelming concern with lynching. In picture after picture, Traylor exhibited his "anxieties

about encirclement" through figures enclosed in small circles, boxes, or caskets. (See *Construction: Blue/with Orange Cat on Top*, plate 19.) Dismembered figures are prominent in his works: there are heads without bodies, bodies without heads, arms without hands, and numerous one-legged figures. Traylor's paintings suggest that "an oppressive phantasmic presence" has done him harm, and he seeks to address it. Traylor's paintings provided him with the same outlet for his pain and rage that singers found in the blues, and gave him the space to reframe what he should be and do in the face of lynching and Jim Crow.

The song "Blue Spirit Blues," recorded by Bessie Smith in 1929, refers to these anxieties and fears. While this song seems to be about a dream of the devil and hell, its reference to dragons suggests the Ku Klux Klan. Blue spirits attack the subject, signaling the location is a conjure landscape where everything is blue, much as it often is in Traylor's paintings, where there are blue spirits, dogs, clothes, and skin. In the lyrics, bloodshed makes those happy who stick forks in the subjects, suggesting a connection to lynching photographs that often showed a smiling audience. In Smith's lyrics, the pitchforks that were stuck in the dreamer find their exact image in Traylor's art. (See *Two Figures with Pitchfork*, plate 20.) The subject in the song is running from this hell but cannot get away. The small figures often running to the right in the bottom half of Traylor's paintings suggest this theme was central in Traylor's works as well.[25]

In many blues lyrics, the subject talks to a second, inner self. These blues are both outside and inside and with him/or her, whether awake or asleep. Big Bill Broonzy sings such a "Conversation with the Blues," which opens as though it is going to be a song of lost love, but at the end of his song Broonzy reveals that his fear of lynching is at the root of his blues, singing: "Now why don't you try to help me to live, instead of tryin' to break my neck?" It was Broonzy who told of the lynching of his uncle to the circle that included Alan Lomax, noting that his murderers feared that his standing up for his pay "might *ruin* the other Negroes."[26]

Ralph Ellison, Trudier Harris, Jacquelyn Hall, Orlando Patterson, and Donald G. Mathews all recognized that the ritualized lynching of blacks, about 38 percent of those recorded, "had all the trappings of a sacred ritual" and in fact were "often presided over by a clergyman." They emphasize that such lynching events were sacrifices and the fire that tortured the victim also

consecrated his or her flesh. A myth created the sin—black men ravishing pure white women—and Christianity provided the means of purging it by crucifixion. Although most southern whites apparently believed that lynching had a positive controlling effect on other black men, they "could not see, as black Christians did, that in a sacrifice celebrated in such dramatic and public fashion, *the Christ had become black.*"[27]

Bill Traylor did see lynched black men as Christ figures. The two black figures he painted on the cross, which Charles Shannon titled *Crucifixion* (plate 21) and *Black Jesus* (plate 22), were, I would argue, both God's son and his own son Will, gunned down by white policemen. Whites who saw these paintings apparently chose not to confront what they might mean. When asked if Traylor had ever talked about religion, Shannon said "no," but noted, "He did draw two crucifixions, one in tempera and one in compressed charcoal." The materials used seemed to be more important than the subject matter, but perhaps Shannon, who had earlier painted a Klan mob on the way to a lynching, and was likely to have known of the black crucifixion scenes displayed in the North, knew consciously or subconsciously that it would not be wise to raise the issue of what these Traylor drawings suggest.[28]

The earlier of these two crucified figures, the one drawn in charcoal sometime before February 1940 (when it hung in the Montgomery gallery show), seems meek and feeble, facing left, with weak legs bent, hanging, and without support. The second crucifixion, painted later in tempera, shows a stronger black Christ, facing right, with his legs straight and his feet in shoes on the ground. The conjure tradition taught that all good things, like most of the single figures in Traylor's pictures, face right, and "Evah'thin' evil goes tuh de left." Hyatt's informants showed him how harmful acts called for using the intended victim's left sock or left shoe and should be carried out with the left hand. The two Traylor crucifixion pictures may represent two sides of Will Traylor that his father remembered at different times, and suggest a change in Bill Traylor's understanding of what his son's death meant. The first suggests he saw him as going wrong, a weak failure, while the second was, as R. C. Baker commented, a "body torqued with anguish," but a strong body facing right. This second figure has a penis that is visible beneath his clothes, suggesting his power even in death, while the first does not.[29]

Bill Traylor memorialized Will Traylor's life in two other pictures that both hide his meaning and reveal his emotion. Shannon labeled one of these

drawings *Possum Chase* (plate 23), but I believe that it depicts the killing of Will. If Traylor was asked, he may have given Shannon this title, or he may simply not have objected to Shannon's statement that the subject looked like a possum chase. A possum is treed in this picture and another similar to it, and people who have seen these pictures have assumed that because they depict men with rifles and animals in trees they must be hunting scenes. If, however, we view this work as an actual hunting scene, we can see the man with a gun is pointing it at a man in the tree and not at an animal.[30]

With Bill Traylor's help, the man holding the gun can be recognized as a white man, and the man in the tree, as a black. Traylor, as noted previously, gave Shannon a key to the figures in his drawings when he placed his small homemade ruler on a profile and said, "Now you see there, when the stick touches the nose and the chin but it doesn't touch the lips, it's a white man." When the faces of the men standing below the tree in the *Possum Chase* picture are put to this test, they prove to be white. Traylor's white men also stand straighter, seem generally stiffer, and have thin necks. In this and other pictures, their skin color is no different from that of the man being shot in the tree, but Traylor was unlikely to paint a picture blatantly representing a white man killing a black man. Those who understood, understood very well. The man being shot in the picture throws out his hands in terror and seems about to fly out of the tree. But the dogs leap at him, and the men below have him in their sights, one pointing a finger, the other a gun. This gun is pointed directly at the black man's genitals, clearly the target of retribution in a case of a Peeping Tom. The terrified round white eyes of this man in the tree tell us he is already a spirit figure.[31]

A second man in the tree is being pursued by a small figure raising a cudgel, apparently ready to knock this second figure in the head. The figure being attacked may well be Traylor, and the small attacker a "little me" spirit, perhaps a part of Traylor attacking himself. The attacked figure is pointing down below, suggesting he is aware of the evil that is being done to the black man in the tree but is unable to aid him. He is being pursued by his own inner demon, his own "little me," and is heading the wrong way.

Lynching was a dangerous issue for a black person to raise publicly. When, in early 1939, Billie Holiday first sang Abel Meeropol's powerful antilynching song, "Strange Fruit," at the Café Society in New York City, she suffered much verbal abuse, and Columbia Records refused to record it. Nevertheless,

"Strange Fruit" became Holiday's special signature song, so closely associated with her that most people who know of the song believe she wrote it; certainly her interpretation made it the powerful icon it has become. Other black artists conflated lynching and Christ's crucifixion as well. While W. E. B. Du Bois was the editor of the *Crisis* (1910–34), he generally used crucifixion images to illustrate lynching reports; Countee Cullen wrote *The Black Christ and Other Poems* in 1929; and Langston Hughes echoed this image in his poem "Christ in Alabama" in 1931. In Aaron Douglas's 1927 painting *Crucifixion*, a powerful black man, surrounded by black people, carries a massive cross; while William H. Johnson depicted a black Christ on Calvary, with his black mother, Mary, and two other black men crucified at his side (1939–40). Gwendolyn Brooks, building on this tradition, later wrote that Jesus was the "loveliest lynchee." All these texts and pictures, however, were published or exhibited in the North. Traylor's paintings of a black Christ and lynched figures are the only such works I know of painted by a black person in the South and exhibited there in the era of lynching. Traylor took an enormous risk in showing them to whites, but he had enough experience to believe that they would not see what he placed before them for what it was, and that they would not ask questions. Moreover, his second Christ on the cross, the one facing right, shows, as noted, what appears to be an erect penis under the fabric of the pants. (See *Black Jesus,* plate 22.) This may allude to the sexual charges against Will Traylor and many others who were lynched; it also shows pride in the manliness of the lynched black man and of black men in general. It was particularly risky to make such a sexual allusion in a crucifixion picture, but Traylor took that risk, too.[32]

While whites could easily overlook the actual subject and meaning of the picture once titled *Possum Chase,* and not question a picture called *Black Jesus,* Bill Traylor risked an even more explicit image expecting that white people would not see it for what it was any more than they saw him for what he was. Apparently no white person recognized the complex meanings of his pictures or suspected that they overstepped the limits of what blacks were permitted to express. No white person seems to have suspected that Traylor could paint symbolically or in code, or that his drawings shouted what blacks were forbidden to whisper. Bill Traylor screamed his protest against a hush-hush outrage, but it was as if he were silent. His drawings were seen, but the white community apparently missed their import.

Traylor's most dangerous picture was given the title *Figures and Trees* (plate 24). Indeed, there are five trees in this picture, and two figures. The figure at the right, who is tied to one of the trees by a rope around his neck, is a black man facing "right," who is dying or dead; while the figure on the left, facing left, is posturing, with his right arm akimbo, and his left raised to heaven. According to Robert Farris Thompson, "In Kongo, placing the left hand on the hip is believed to press down all evil, while the extended right hand acts to 'vibrate' the future in a positive manner." Here, and in several other key pictures, a figure has his right hand on his hip and raises the left hand, perhaps signifying that all is out of kilter, nothing is as it should be, but still suggesting that evil is to be pressed down, and that the future should be more positive. When this picture was exhibited at the Hirschl & Adler Modern Gallery in 1996, Phil Patton wrote a powerful essay for the catalogue in which he noted that while "Traylor's 'social consciousness' must remain a matter of speculation," this picture "appears to allude to lynching"; and he went on to briefly discuss several other images that might also have expressed social criticism. Patton is the only critic to have raised any issue of protest in Traylor's works; however, when this essay was reprinted in a later book on Traylor, this paragraph was deleted.[33]

Knowing of Will Traylor's violent death and the "peeping" charge reported to Bill Traylor, *Figures and Trees* can be seen to express both Traylor's personal pain at what he was certain was a lynching, and his determination to act to change the future. Both figures in the painting appear to have lost their balance, but while the lynched figure is tied to his fate and cannot go beyond it in life, the second figure seems ready to jump into the void to bring down those responsible for the lynching. The unusual shape of the cardboard that Traylor chose to use for this picture is like two halves of a globe or a crystal ball, which was widely used by hoodoo conjurers in the 1930s. It is also reminiscent of the circle used to fix an enemy. "You put your right foot on the seal, and turn to face the West" to "seal" a fix for a death in conjure lore. "When yo' fightin' a person, puttin' down, yo' take it always on de west, yo' see." The figure on the left, turned to the west, was thus signaling that he was ready to fight to put down his enemy. He was sealing his vow to do this, and sealing the enemy's fate. The lynched figure on the right was placed facing east to go on to better things "'cause de sun rise an' dat liftses yo' up." He was indeed a lynch victim, but Traylor is painting his future redemption. There are also

four palm trees in the picture, and the ghost of a fifth one. All five trees are shown as having roots going down into the bottom third of the painting, passing through a box somewhat like a coffin, which rests on five thin shoots. Bill and Laura Traylor had five sons—Clement, Will, Mack, John Henry, and Walter. The four dark trees may well be the living sons of his second wife, while the fifth erased tree is the spirit of Will. Wyatt MacGaffey notes that "in Kongo thought[,] trees were analogous to people." Traylor clearly used this analogy here.[34]

Some symbols in this picture are also similar to those used by the Abakuá men's secret society in Cuba, which reports suggest had a Baron Samedi tradition. Abakuá pictograms, *anaforuana*, feature angled arrows topped by feathers. The symbol for counselors has an arrow with two feathers on either side of the shaft; the one for the individual "in charge of meting out punishment" has an arrow with three feathers on either side of the shaft. If we read the tree poles by this symbolism, the two figures in Traylor's painting are connected to poles for "meting out punishment" with three feathers on each side, while two other poles, each with two feathers, suggest verbal counselors. The top of the ghost pole is not visible, and one of the poles seems to have a varmint at its apex, possibly suggesting that another one of these five sons is at risk of being lynched.[35]

In his "Preachin' Blues (Up Jumped the Devil)," the great blues singer Robert Johnson sang out a blues recipe for dealing with troubles, "studyin' rain": "I been studyin' rain and I'm 'on drive my blues away." Studying rain can, Greil Marcus suggests, take us "back to Shakespeare, [where] it means to contemplate dread, to absorb fear into the soul." For the enslaved African Americans, it also takes us to what Shane White and Graham White have called the "sounds of slavery," especially the moans. They believe that this was "probably a type of congregational moaning, a very deep form of worship, in which it was felt that words were no longer needed" or adequate. In the Jim Crow era, the dread and fear in the souls of African Americans was centered on lynching as the symbol and reality of the white attack on black humanity; the blues absorbed much of this. Moans are a formal part of Robert Johnson's "Preachin' Blues" and many other blues lyrics. They provided "a way to articulate frustration" and pain, as Trudier Harris recognized, but the wider blues culture went far beyond articulating grief. Blues culture achieved a reintegrated mesh of central attitudes and values or what can be termed a

coherent sacred cosmos with which many black people began to see a way to overcome. Moaning remained central, but its role changed.[36]

· Vera Hall, born about 1902, provides evidence that moaning, so important in slavery, continued to play a central role in emotional and spiritual release for many African Americans in the Jim Crow era. Hall related that when she was a young woman, she had a sound-filled visionary experience, and that afterward she developed "a habit of moaning to God" when she needed God's help. Her visionary experience followed the deeply wrenching mass lynching of her neighbors, the Donaldson family, around 1918. A teenager from the Donaldson family was hit over the head with a hammer by "Mr. Billy Sands," who was the local white storekeeper's son. In response, Donaldson forcibly took the hammer from Sands, killed him with a blow, and then ran for his life. News of the murder spread rapidly, and masses of white people stormed the neighborhood, killing eight of Donaldson's brothers, their wives, and their close neighbors. Thirty years later, Vera Hall's fear seemed to radiate out of her words: "We tried to leave the country. But we didn't have the money. We couldn't say anything or do anything. Better not to." Memories of that event remained with her all her life and may have led to her moaning, but the moaning brought her catharsis.[37]

Adam Gussow places the time that significant change occurred in the dominant southern black worldview and in black moans as between 1900 and 1920, and holds that changing reactions to lynch episodes were the key to both. He tells the story of William Malone, a young black man, who slept next to W. C. Handy in his train travels with Mahara's Minstrels in 1900, and moaned dreadfully many times during the night, waking Handy. Malone believed that his moaning came from the time when he was still in his mother's womb and she became agitated, expecting the arrival of a lynch mob seeking to attack his father, a black Mississippi politician who was hiding in a cave dug out under the floor of the shack they were in. Gussow evaluates the "strange, tortured sound" that escaped from Malone's throat in 1900, as an "isolating, imprisoning" moan. By 1920, when Ma Rainey moaned in her public performances, "the audience would moan with her," leading Gussow to view these as healing moans. "What distinguishes Rainey's 'cathartic' moan of 1920 from Malone's isolating one of 1900 . . . is the emergence and development . . . of a fully articulate blues culture within which a meaningful blues moan could be uttered."[38]

In incorporating the moan, the blues took on the cathartic role of the ecstatic black church services. Thomas Dorsey, the "father of gospel blues," consciously sought to carry the blues moan into his gospel songs. Long before Gussow commented on the moan, Dorsey recognized that this cathartic process was crucial: "This moan gets into a person where there is some secret down there that they didn't bring out. See this stuff to come out is in you. When you cry out, that is something down there that should have come out a long time ago."[39]

It was Bill Traylor's painful moans that had led David Ross to inquire what caused Traylor to cry out in his sleep, and prompted his friend Jesse Jackson to speak of Traylor having murdered someone. But his friend from Benton apparently did not know of the lynching of Bill's son—it had happened long after Bill Traylor left Benton—or would not talk of it. The lynching of Will Traylor was "something down there that should have come out a long time ago." Bill Traylor's own achievement of full expression through blues art gave him a way to express a cathartic blues moan tied to lynching that could be shared. He was talking back to the blues, as many lyrics instructed him to do.[40]

Lynching, most often organized and carried out by Klan members, was the apex of the brutality blacks were subjected to and the lodestone of the new black identity that was being forged. Lynching played a role among blacks comparable to that of the Shoah among Jews: Those who came through most often wanted to forget the past in order to embrace life, but could not embrace life until they dealt with their past. Traylor was a survivor, and he had the combination of an almost manic commitment to give witness to what he had seen and knew, and yet the need to keep quiet about it. He found a way to do both.

Traylor was "fighting" his enemies: As he painted out his pain, he came to repeat the call in the bitter blues for violence against whites in retaliation for the lynching of blacks. In one of the bitter blues collected by Gellert, the "Ku Kluck Klan" is openly attacked:

> It say in de Bible How Lawd he make man,
> But who in de Hell make Ku Kluck Klan?
>
> Shaped like a tadpole, Smell like skunk,
> Hide in midnight sheet Like chintz [bedbugs] in a bunk.
>
> Ku Kluck Klan, Ku Kluck Klan,
> Lowest down creeper in de lan.

The verses that follow clearly state that only by feeding the Klan members "lead poison" will the problems they bring end, and that all the Klan members—the "whole crew"—should be wiped out by this means. The last refrain in this song states it was written by Joe Jackson from Tryon, South Carolina, the town where Lawrence Gellert lived. This singular claim of authorship in Gellert's song collection for a song that calls for murdering all Klan members was a very brave act.[41]

In some of Traylor's pictures that depict a black man wielding a cudgel or hatchet, the intended victim and some of the fleeing figures may well be white. The picture labeled *Possum Hunt* (plate 25) is again a hunting scene, but this image has only one man below aiming at the man in the tree. Traylor is apparently retelling another murder narrative in this picture, but—using Traylor's rule of measuring the extension of the lips—this one appears to show a black man killing a white man. A parallel can be found in a song Gellert collected in Alabama, which opens with the "names given to three types of firearms" and adjures: use firearms or wield a broken bottle to "Be a man."

> Owl Head, Lueger, Magmazine
> Can't git no gun Grab anything
> Worl' a bottle In yo han'
> Bus' it open Be a man

In the Traylor paintings that call for retribution, which often picture a figure with a club in hand, and in those showing the male figures' penis, Traylor was signifying exactly what is called for in these bitter lyrics: "Spill dere blood too, show 'em yo's is a man's." Those are the final words from "Sistren an' Brethren," a powerful antilynching song collected in Alabama by Lawrence Gellert in the 1930s:

> Sistren an' brethren, Stop foolin' wid pray, (2x)
> When black face is lifted, Lord turnin' way.
>
> Heart filled wit' sadness, Head bowed wit' woe, (2x)
> In his hour of trouble Where's the black man to go?
>
> We's burying a brudder Kill fo' de crime (2x)
> Tryin' to keep what was his all de time.
>
> When we's tucked 'em on under, What you gonta to do? (2x)
> Wait til' it come Dey's arousin' fo you?

Yo' head tain' no apple Fo' danglin' f'om a tree, (2x)
Yo' body no cahcass Fo' bahbecuein' on no spree.

Stan' on yo' feet, Club gripped 'tween yo' han', (2x)
Spill dere blood too, Show 'em yo's is a man's.[42]

By the late 1930s, Traylor had come through the bitter rain. He had found a way to show "his was a man's." His paintings cried: "They are committing outrages, and we must stop them. Use any force you can. Spill their blood, too. Commit yourself to this program, as I have." He was using his moans, and a lifetime of experience, to create complex symbolic images that demanded action.

4

"BREAKING THROUGH A WALL OF SILENCE"

(1930–1949)

The art I've discussed . . . [is] bound together by one man's singular vision, an artist with a radical and courageous imagination who had a profound emotional stake in the ruin, destruction, and bloodshed he had witnessed in his country, as well as an artist with extraordinary access to his own inner life—to the monsters and ghosts of dreams and hallucinations.

—SIRI HUSTVEDT, 2005

Writing of Francisco Goya, Siri Hustvedt noted: "The horrors [he painted] exist both outside the artist in the world and inside his own head." Bill Traylor's art similarly reflects his courageous imagination and his access to his inner turmoil, as well as his personal stake in the violence of his lifeworld. Unlike Goya, during most of his life Traylor did not have any cultural, social, or economic support to become an artist, but when it became critical for him after Will Traylor was killed, he made his own way to such a role. Bill Traylor's suffering after his son's death stands behind his life-altering decision to devote all his time to painting. Margaret Traylor Staffney, his granddaughter, remembered that "white people took pictures from him at the shanty on Bell Street" long before he was painting on Monroe Street. In 1930, when the census taker came to this shack, which he rented for six dollars a month, he reported that he was a widower, living alone and supporting himself as a shoemaker. When he lost this job he could not pay the rent and began living on the rough,

as so many of those who found themselves in dreadful circumstances during the Depression were forced to do.[1]

When David Ross Sr. offered Bill Traylor a place to spread his pallet in the showroom of the funeral home he owned, Traylor may have seen a casket showroom as a fitting sleeping place for a man who served the Spirit of Death. Caskets figure in many of Traylor's pictures, and in the wry comment he made about David Ross when he painted his portrait in January 1940: "When he comes in, he always looks around seein' if dem boxes is empty." Traylor slept in this showroom for an extended period during which he applied for support from the Old Age Assistance Program in Montgomery County, and gave the address of the funeral home as his home. His request for aid on February 6, 1936, was approved, and he began to receive some fifteen dollars per month, which helped him considerably, given that a main-dish dinner plate cost ten cents at the local Red Bell Café that he frequented.[2]

At this point in his life, it was difficult for Traylor to walk, he was too old and too ill to work, and there was little work even for those much younger and stronger. His move to the Monroe Street sidewalk put him in the center of a busy world where he could sit still and paint, yet where many people could both see his work and speak with him. On Monroe Street, blacks were "buying and selling goods, eating and drinking, and gaming." Along this street, they could find a "shoe shine stand, the gunsmith, the fish market, the seed merchant, the tavern, the second-hand clothing man, the vendor of patent medicines, and the pawn shop keeper," shops where the owners welcomed the trade of black people. On Saturdays, their shops were crowded with people from the city and the surrounding countryside. Since Traylor had chosen to live in this part of the city on his arrival in 1928, he knew it well, and he selected a good spot to work in, one in which he could see an amazingly full life, and yet would be protected by supportive people around him. Lynda Roscoe Hartigan has suggested that Traylor's move to the city may well have been "a transformative event that inspired astonishing creativity." It clearly was crucial for him, but Traylor himself played an important role in making critical choices given his limited means.[3]

In the spring of 1939, Charles Shannon saw Bill Traylor sitting on a box on the Monroe Street sidewalk and drawing, and mistakenly believed he was watching him make his first marks on paper. This was a significant meeting

for both men. Within a short time, Shannon began to play a role in Traylor's work by providing him with art materials and, over time, storing and seeking a market for his art. He brought Traylor poster paints and brushes, which Traylor used, as well as clean boards, which he rejected. Traylor preferred well-seasoned used cardboard, sometimes torn and often with numbers or other marks on it.[4]

Shannon's positive response to his artwork was, no doubt, important to Traylor. Shannon was probably the first white person to see a large body of Traylor's paintings and to show a sustained interest in his art over a long period. His reaction was an affirmation of their worth, and, given that Shannon did not react negatively to their content, it also assured Traylor that he could continue painting his bitter reactions to Jim Crow and lynch law. For Shannon, the meeting led to a passion for Traylor's art that deeply affected his life. Particularly taken by Traylor's calm and joy in life, as well as the ease with which he painted, Shannon noted: "he enhanced my life so much. I couldn't wait to see what he would do next."[5]

Over the years, many have shared Shannon's immediate recognition of the joy and artistry in Traylor's paintings. In 2005, Jeanne Curran, a sociologist on the faculty of California State University, Dominguez Hills, and a founding member of the open Web site "Dear Habermas," read Roberta Smith's review of a Traylor exhibit in the *New York Times* and saw reprints of several Traylor paintings for the first time. Her response, appearing in a detailed analysis of *Female Drinker* (plate 26) on her Web site, tied Traylor's joyful work to other artists and cultures, but also to social criticism:

> *Female Drinker* so clearly represents drinking by the flask, without even a glance to the title. It represents joyous movement, and it clearly represents a female body by the shape. . . . The flatness reminds me of the flatness we have seen in the Japanese neopop movement of childlike figures that represent the darker side of Japan's social development. . . . The antic suggestion of movement reminds me of the joy that I see in the historical celebration of dance and movement in Africa and in the Far East. Remember the Whirling Dervishes? . . . Notice the freedom that subordinates traditional representive [sic] forms to the feeling the artist seeks to transmit. Can you imagine a Picasso like this?

Traylor's work has elicited joyful responses from a wide range of people. It is a classic blues irony that a man without a home, or a job, whose body gave him

pain, and whose legs would not take him very far, made people then and now more aware of freedom and joy in life.[6]

In the summer of 1939, Traylor changed both his sleeping quarters and the location of his outdoor workplace. He chose to sleep on the floor of a nearby small shoe-repair shop, perhaps because there were fewer people sleeping there, or possibly because his friend Jesse Jackson had revealed too much about him to David Ross Sr.; and he chose to sit and paint next to Isaac Varon's fruit store in a building on North Lawrence Street near the corner of Monroe. The spot he selected was well protected: It was in a niche formed by a box refrigerator for cold drinks and a locked door to the "Colord Pool Room" that was entered from the Monroe Street side. Overhead there was a roof, extending out from the fruit stand, which was lit at night, making it possible for him to work into the night: "On summer evenings he would be sitting there at nine or ten o'clock smoking his pipe and drawing." The spot was also a good choice because of the proximity of the Varons, whom both Shannon and Traylor's children remembered as having been helpful to Bill Traylor. Around the corner on Monroe Street was Solomon Varon's Red Bell Café, which catered to colored people, while the place where he spread his pallet at night was about ten feet away. Much of Traylor's time was spent within this small radius, but a rich street life surrounded him.[7]

Nance Varon, Solomon Varon's son, confirms that the Varons' regularly gave Bill Traylor food and drink, as he was the person who brought this to him almost every day. He fondly remembers Traylor and notes that he was friendly and talked at length. In turn, Bill Traylor, who told Nance that he wanted to adopt him, clearly found him a particularly likeable young man. When Varon went into the navy in 1944, Traylor drew a picture of him in uniform as a going-away gift. Varon, knowing little of art then, didn't save it, but many years later he became a collector of folk art.[8]

Unlike David Ross Sr., who knew that Bill Traylor had family both in the North and in Montgomery, the Varons did not think Bill had any family at all, and were extending help to a man they believed was alone in the world. Traylor may have talked to them, but he did not tell them of Sarah Traylor Howard, his daughter, whose home was not far from where he was sitting, but with whom he did not want to live, nor did he talk of his large family in distant locations. Nance Varon did watch Bill Traylor painting, but while Bill talked to him at length, he didn't tell him much about his life or his work.

Fig. 4.1. Bill Traylor Painting on Monroe Street, Montgomery, Alabama, ca. 1939.
Photograph by Jean and George Lewis. Courtesy of Robert Cargo Folk Art Gallery.

Varon remembered that Traylor drew on candy and cigar boxes, that he displayed his pictures, and that he painted all day long, six days a week. Almost sixty-five years later, he still recalled that Traylor was never there on Sundays, and he wondered where he went every single week without telling him.

There is no certainty about where and how Bill Traylor spent his Sundays between 1939 and 1944. Given his later actions, Traylor may have gone to

spend Sunday in the compound of the St. Jude Catholic Church, but a different possibility also exists. It may be more than coincidental that Sunday was the day in the week that conjure doctors most often saw their patients. Jim Haskins, who grew up in a small Alabama town in the 1940s, reports that: "The black community in my small town had several [hoodoo doctors or root workers], all of whom were known to the blacks as well as to many of the whites in the area. They didn't look any different from the other old black people, but they did seem to have an inordinate number of visitors. Particularly on Sundays, when even most blacks didn't work, there was considerable coming and going at these old folks' houses." Bill Traylor, who advertised himself as a man with spirit power, may have arranged to use some space on Sundays to see clients. Certainly many black people knew of him. Shannon reported that, on Saturdays, crowds of blacks left their goods with him while they shopped in the market. They saw his pictures displayed behind him, many of which announced his powers to those who understood.[9]

Traylor arrived at the point where he began to voice his true feelings in public only after the lynching of his son had brought him down lower than he had ever been before. At the bottom, he found a way to pull himself up, and it involved drawing the truth, as he knew it, and hanging it out, literally, as in *Figure in Front of Street Light* (plate 27), for those who could understand it to see. In this drawing, done in 1939, a single figure is sitting on the ground in a position that African seers customarily used. He is under a lamplight that seems to be balanced on his head, possibly signifying the light he can shine on spiritual troubles, and the calm balance that is his. Lamps, however, also play a central role in conjuring. Recipes for crossing or uncrossing individuals often instruct that certain items be placed in a lamp, and that the lamp be kept lit at all times. This lamp was signaling these things to those who knew the lore, while the several Vs in the drawing of the figure's legs also would indicate to those who knew the tradition that he was at the height of his powers. That his penis is exposed in this picture may be a signal of his service to the Spirit of Death, who was believed to have power over sexuality. Someone apparently tried to erase the exposed penis: This may have been Traylor, but I think it is possible that Shannon or a later owner did this. Shannon did note that he cleaned the pictures in preparation for exhibiting them in the late 1970s.[10]

Except for two periods when he traveled north, the first brief and the second protracted, and a late period of serious illness, Traylor painted at his

chosen spot in downtown Montgomery from the spring of 1939 until February of 1946. We can have a good sense of Traylor's extraordinary productivity, as about one hundred of his drawings, chosen from his work of the preceding nine months, were exhibited at the New South Gallery and School in February 1940. This was the final activity of a gallery run by a group of young writers and artists whose aim had been to "broaden the cultural life of Southerners of all classes." Charles Shannon, Blanche Balzer [Shannon Angell], Jean and George Lewis, Jay Leavell, and John Lapsly, all among the founding members of the New South group, had taken an interest in Traylor and provided him with painting materials as well as food when he was ill. The group effort, begun in March 1939, had included art exhibitions, art, music, and literature classes, a writers' group, a production of an antiwar play (*Bury the Dead*, by Irwin Shaw), and a discussion group that considered political and economic issues. The exhibition of Traylor's art fit the concerns of the group on both ideological and aesthetic counts: He was black and very poor, and his art was extraordinary.[11]

Shannon's contribution to this gallery show was a wall mural portraying Traylor as larger than life, on which he emphasized that Traylor was a producer of complex symbolic paintings by copying five at the bottom of the mural. Several members of the group brought Traylor to the gallery to see the exhibition of his works as well as this mural. Shannon later reported that Traylor expressed no emotion when he looked at his pictures on display, and that he made only one comment: "Lookit dat man 'bout to hit dat chicken." After one turn around the gallery, looking at each picture, Traylor was ready to return to his work and never talked about the exhibition afterward. The mural remained on the wall when the New South Gallery closed, and was destroyed when the building was later demolished. (See fig. 4.2.)[12]

Shannon, and others who knew of Traylor's reaction to the exhibition, believed it showed Traylor's distance from his work—that he was reacting as though he himself had not done it. That may well be, but Traylor's behavior also indicates that he was being as cool as he could possibly be. His only comment was about a scene that seemed to suggest a white stereotype: a black man chasing a chicken, perhaps stealing it. His silence about every other picture spoke loudly, but there was no one there who understood it. We can be certain that he observed that his drawing of the crucifixion of a black lynch victim was hung with no one taking note of it, nor did anyone note his other

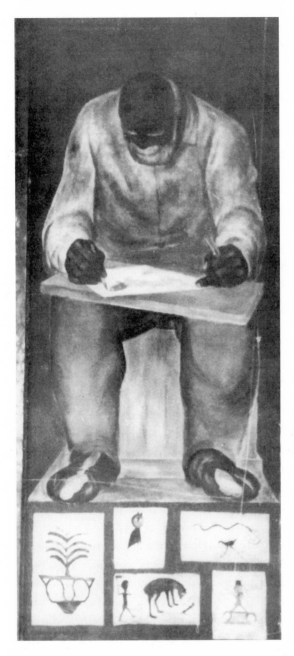

Fig. 4.2. Charles Shannon, *Mural of Bill Traylor,* 1939. Destroyed.
Courtesy of Robert Cargo Folk Art Gallery.

depictions of murder and rage. No one recognized he drew himself calling down wrath, or catching spirits in basketlike nets or bottles. All of these messages hung on the walls of the New South Gallery, and the people who had hung them there apparently had no idea what Traylor meant by them. The catalogue did note that Traylor's "roots lie deeply within the great African tradition," but the exhibition was hung according to simple surface categories: baskets, figures, fantastic designs, storytelling compositions, and houses, animals, symbols, and wild African people and animals.[13]

We might say of Traylor's pictures something similar to what K. K. Bunseki Fu-Kiau says of Kongo life: "Everything is related to symbolism." What of seemingly simple animals? Traylor drew them in great number, but they are unlikely to have been simple at all. Traylor's pictures are filled with spirit cats with human faces and snakes that are often part of constructions. The occasionally paired snakes recall a Haitian Ve-Ve, a symbolic drawing to call down the Dahomean god Damballa. Birds are everywhere, birds that seem to be women, birds that may be spirits bringing wisdom, and birds that appear to signal death. Thompson points to the Yoruba use of a bird to symbolize the god of herbal medicine and "the bird which . . . God places in the head of a man or woman at birth as the emblem of the mind," and finds that similar birds appear atop libation vessels in Nigeria, Dahomey, and Cuba. A similar bird sits atop of what looks much like a libation vessel drawn by Traylor, and myriad birds appear atop Traylor's houses, baskets, and people's heads. Folklore from Alabama and the wider South indicates that these animals played varied symbolic roles. Traylor spoke with and through them in hidden ways. His cats, with human-seeming faces, often seem to be spirits, but generally are far less menacing than the dogs, which are almost always to be feared. A red dog, Fu-Kiau tell us, common in Kongo legends, is seen variously as a symbol of war or power, and is ready to fight malicious enemies, but can also be the symbol of a spiritual medium, as is a red snake. Traylor's red dogs and snakes speak of power, sex, and danger.[14] (See Man with Basket on Head, plate 28, and Mean Dog, plate 29.)

Traylor painted a number of massive male dogs, their extraordinary size indicated by the size of the men holding their leashes, who are only half the height of the dogs. A traditional Kongo power object or container of sacred medicine was often constructed in the shape of a black, male dog, "which signifies aggressive intent by its bared teeth" and was "used by Kongo mystics

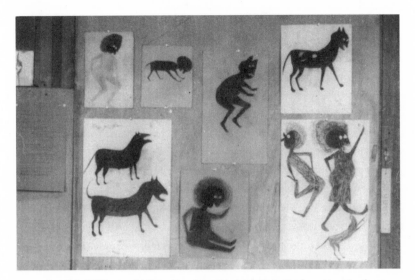

Fig. 4.3. Bill Traylor, "African People and Animals," display from New South
Gallery exhibition, Montgomery, Alabama, 1940.
Photograph by Jean and George Lewis. Courtesy of Robert Cargo Folk Art Gallery.

to see beyond our world." Traylor's giant dogs may well have had a role to play
in this world: They suggest a leashed threat against whites, with blacks hold-
ing the leashes.[15] (See *Untitled: Man and Large Dog*, plate 30.)

When Zora Neale Hurston attended a midnight hoodoo ceremony to get
a black cat's bone, she stood inside a demarcated circle in the woods and later
reported: "Strange and terrible monsters seemed to thunder up to that ring
while this was going on." Traylor's strange animals and people suggest he, too,
may have had such visions, but leave open the question of the nature of the
threat presented by these monsters.[16]

In analyzing Traylor's paintings, Phil Patton emphasized the centrality of
the color blue: "What red was to Titian, yellow to Van Gogh, a high singing
blue was to Bill Traylor. The blue of his drinking figures, of his houses, of his
abstract constructions is 'showcard blue,' 'cobalt blue,' the same blue those
who grew up in the American South remember from the hand painted signs
in the window of the local Piggly Wiggly grocery advertising specials—'yams
15 cents/pound.'" This blue of Traylor's figures was, however, also the African
American conjure blue, and this was its most significant referent for Traylor.
Conjure workers used bluestone in making "mojo hands," particularly those

for protecting people from evil. Bluestone, a sulphate "that is electric blue in color, [and] highly toxic," is also a fungicide used by farmers in the South so it was readily available, as was nontoxic bluing used widely for whitening laundry. Many hoodoo doctors and clients reported: "you have to *dress* your home with *bluestone water* to keep down all danger, you see. You sprinkles with that every morning." It "kills evil and *conjuration*." Clients were advised to wear it in their shoes, or in a bag round the neck, or bathe with it for protection. The spiritual significance of this color can clearly be traced back to Africa, as can the cobalt blue bottles hung on trees to capture evil spirits. Among the Yoruba, "blue represents life fully lived," and blue clothing worn by a conjurer, as in the self-portraits of Traylor, would signify that he was "symbolically journeying 'to and from the spirit world.'" In Traylor's pictures, this electric blue is the color of dogs, cows, houses, constructions, shoes, bags, and clothing as well as the skin of many figures. It is, in many unspoken ways, the symbolic blue that is in blues music as well.[17]

Phil Patton, writing in 1996, raised the issue of social criticism in Traylor's works, and, as noted, is the only critic to have given any serious consideration to this question. Patton wrote that the mules in several of Traylor's paintings might signify black men patiently waiting to strike back at white people. He suggested: "There is a social overtone in this position, a resistance to the system evident in song as well as story in the black culture of the time." He was, however, cautious about reaching the conclusion that Traylor shared this position of resistance, noting: "Traylor's 'social consciousness' must remain a matter of speculation but views of recalcitrant mules, his implicit caricatures of plantation owners and other white authority figures are suggestive of a man who understood and resented the social order. Some of his upright triangle constructions recall slave or prison whipping posts or overseer's watch towers while at least one image—*Figures and Trees*—appears to allude to lynching." Patton's important inferences were not followed up; in fact, when his essay was later reprinted, this paragraph was, as noted, edited out.[18]

Traylor's social consciousness was not an anomaly. It is increasingly recognized that the "transformation of the segregationist South" from the 1930s through the 1970s was due to "a vast array of forces, combining hundreds of local struggles and the work of countless organizers," as well as countless hidden supporters. In the 1930s, poor black people actively resisted Jim Crow

through dangerous joint actions in the Alabama Sharecroppers Union and the Communist Party. Robin Kelley has shown that the poor black working people who became party members in that period "enveloped the Alabama Communist party with a prophetic religious ideology and collectivist values that had grown out of black communities." An important signifier was that they opened party meetings with prayers for Brothers Lenin and Stalin. In the mid-1930s, these values brought some of the poorest rural farmworkers in both Lowndes and Tallapoosa counties to participate in actions and strikes that led to bloodshed and death. In the late 1940s, Alabama black war veterans created clubs determined to get back voting rights, and while the protest activities of women were less formally organized, "accounts suggest that rural black women . . . were the foot soldiers of informal, unorganized resistance" all through the long period of conflict from the end of the Civil War through the civil rights struggle. In Montgomery, it was poor black women who mobbed the police station that was holding the indicted leaders of the bus boycott and frightened the police: "Black women with bandannas on, wearing men's hats with their dresses rolled up. From the alleys they came. That is what frightened white people. Not the collar tie group. . . . One of the police hollered, 'All right, you women get back.' These great big old women with their dresses rolled up told him, . . . 'Us ain't going nowhere. You done arrested us preachers and we ain't moving. . . . If you hit one of us, you'll not leave here alive.'"[19]

An evaluation of the values of those who lived in the Jim Crow era must consider this resistance to the violent racist system of the world in which they lived. As Richard Wright and Robin Kelley remind us, the surreal in the real life of black Americans was at the basis of black artists' "dreams of the marvelous," dreams shared by vernacular artists. Both the "vernacular surrealism" and the secretly organized activities of black people in the South were acts of resistance to the system of white supremacy and black degradation.[20]

When he was interviewed and in his own writings, Charles Shannon consistently avoided the question of social criticism in Traylor's works. In the 1930s and early 1940s, Shannon regarded himself as a progressive, a person who was committed to working for social change that would improve the economic situation of the downtrodden and lead to the recognition of their civil rights. In 1939 and 1940, Shannon's early paintings expressed his deep empathy with blacks facing Jim Crow and lynching, but, when he came to write and

talk about Traylor, the political and economic situation of black people in Alabama was never mentioned. In Shannon's first written introduction to Traylor's art, the catalogue of the 1940 exhibit held in Montgomery, Shannon wrote: "Bill Traylor's works are completely uninfluenced by our Western culture. Strictly in the folk idiom—they are as unselfconscious and spontaneous as Negro spirituals. He has recorded the life he has known with a boundless imagination that is steeped in a real joy in living." All of Shannon's later comments echoed this first evaluation: He consistently held that Traylor's art expressed joy in life, and tried to close the doors to any other possibility.[21]

By now it is clear that there is a good deal more to see in Traylor's paintings. African symbolism, while established by Betty Kuyk's analysis as a central motif in Traylor's art, was part of a complex evolving tradition among Black Belt people, who faced new realities and arrived at new beliefs and values both under the slave system and in the period of so-called freedom. In the June 1940 photograph of Bill Traylor that is this volume's frontispiece, Traylor is holding his pipe in one hand and what appears to be a tobacco can in the other. While this may simply hold his tobacco, such a container often served to hold a protective conjure packet, and knowing that photographs could be used in conjure rituals, Traylor may well have been protecting himself. His belief in such a mojo or conjure bag would go back to his childhood, but Traylor's long life brought him into a modern culture that would have been foreign to his own father. His own mature worldview became a mix of African conjure, black Baptist, and black Freemasonry values and beliefs, plus a hidden ideology of resistance exemplified in the blues, all held together in a modern fashion. Much like the wall posters for Coca-Cola and Dr. Pepper soft drinks that surrounded him on the street in Montgomery, Traylor's drawings were of stark modern shapes that appeared as if from nowhere, but they combined a wealth of cultural referents in a new fashion. "His life as an African American is the basis of everything he painted," as Romare Beardon and Harry Henderson said of Horace Pippin, but Traylor, an extraordinarily gifted man, was more open to the modern art that he saw in advertisements, both in newspapers and magazines, and on the streets around him, than Pippin and others far younger than he was. (See figs. 4.1 and 4.4.)[22]

The following refrain, now known fairly widely, was sung by a chain gang member in the 1930s and recorded by Lawrence Gellert, who noted it should be sung "with irony":

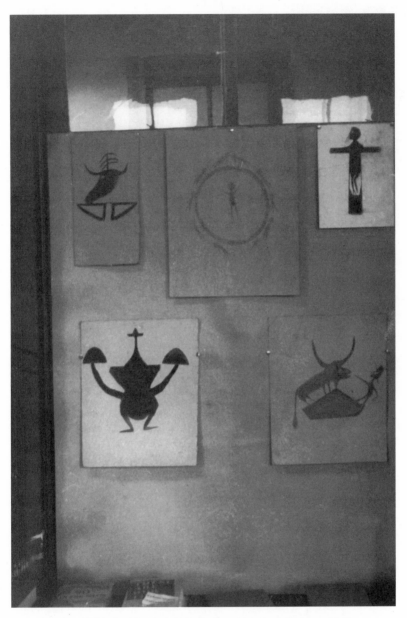

Fig. 4.4. Bill Traylor, "Symbols," display from New South Gallery exhibition, Montgomery, Alabama, 1940. Photograph by Jean and George Lewis. Courtesy of Robert Cargo Folk Art Gallery.

Got one mind for white folks to see,
'Nother for what I know is me;
He don't know, He don't know my mind.

Secrecy was seen as a protective device in the face of the ever-present danger of white intrusion and violence; however, when Fu-Kiau looked at Traylor pictures of truncated bodies with just legs, such as those in *Untitled: Abstract Form* (plate 31), he understood Traylor to be saying that what is in the mind is hidden from everyone, not just white people. In *Untitled: Abstract Form*, it would appear that the legs of a female are on top of male legs, suggesting that male and female know each other sexually but don't know each other's thoughts or feelings. Legs on a base also form triangles, possibly conveying complex symbolic suggestions of leopards and perfection connected to secrecy.[23]

For Traylor, as for most black people in Africa and the Diaspora, secrecy and ambiguity had a positive valence: It was widely believed that knowledge was intended only for the initiated. Art, while clearly visible, was meant to mask much of what it was created to communicate. Masked communication was and is accomplished by means of abstraction, coding, and symbolism. A fine example of Traylor's coding, symbolism, and hidden protest can be seen in the picture titled *The Leopard and the Black Bird,* which was painted on the back of a cardboard with an advertisement for "'Hollywood Oddities': Freaks and Strange People, made famous by Robt. L. Ripley." This advertisement for a "freak show" at the American Legion Hall in Montgomery, less than two blocks from Traylor's street-corner workplace, was an image of a black man with enlarged lips, rings in his ears, a bare chest, and a "freakish" immense conical head. In what can be seen as a response to this image, Traylor painted two figures: a large leopard with his mouth open and teeth bared, and beneath the leopard a black crow with a curved line of dots half-circling its head. The dots can be glossed to mark the left third of a circle cut off by the edge of the cardboard. This picture can then be understood to signify that the angry leopard will bring death to Jim Crow. The crow's death is foretold by the placement of the bird's neck at the western point of the implied circle, the point of death in the hoodoo "four corners of the earth" as well as in the Kongo cosmogram. The circle is a noose around the crow's neck. (See Muriel Burg's sketch of *The Leopard and the Black Bird,* fig. 4.5.)[24]

Ajume H. Wingo, a Banso from Cameroon, maintains that African artworks "are intended by the artist to be silent social teachers." When he saw a

Fig. 4.5. Muriel Burg's sketch of *The Leopard and the Black Bird*. Haifa, Israel, 2006.

secret mask from his own society on public display in a California museum, he was very upset, but in America he himself revealed a secret that has application to Traylor's images. He wrote that an elder told him that a masquerader who was "throwing the arm sideways into the air"—as so many figures do in Traylor's art—was pointing to all the four cardinal points, which "means . . . [he] has looked at all the angles and seen nothing for us humans to fear. It is a message of courage communicated in mimes."[25]

Traylor's artworks can be viewed as "silent social teachers," and many send messages "of courage communicated in mimes." The Traylor painting that Shannon called *Mexican Man in Checkered Shirt* (plate 32) encodes a triumphant spirit figure with its hands up, seemingly surrendering, but apparently holding a gun in one hand. This figure was painted on a cardboard imprinted with the numbers 228 in red, and Traylor arranged his drawing so that the numbers are prominent on the left cheek of the figure, much like a tattoo. *Aunt Sally's . . . Dream Book* gives the number 2 a bivalent interpretation, with predictions of both joy/punishment, good fortune/death or where winning means loss. The number 8 is similarly bivalent, as in the prediction: "You will become great, but beware of falling." Is this the message the figure is impart-

ing? The figure is wearing a checkerboard-patterned shirt colored red, black, and white, a common and important color arrangement in West African material that has stripes, spots or patterns. These three colors are associated with the rainbow snake god Damballa, with abundance, and with a person's three souls. In Kongo culture, human beings are believed to have a black exterior soul, a white interior soul, and a third red shadow soul; all three are believed to leave the body and travel. This is also the color combination reserved for special *minkisi* charms, "those for revenge, those which prepare a man for killing, and those . . . used in order to find out a guilty party." Robert Farris Thompson notes that, in Nigeria, the "'checkerboard' motif is an ancient Ejagham symbol of the leopard." Thompson provides two illustrations of checkerboard leopard costumes—one from Nigeria and one from Cuba, where Abakuá, a leopard society, was organized by the enslaved—and notes that this cloth sends a message: "Take heart. . . . The truth, God's sound, backs our action. We move in silence. He speaks through cloth. He is walking in your midst."[26]

Checkerboard material sent a message in the Black Belt as well as in Cuba and Africa. It was known that conjurers, such as Dr. Jim Jordan (1871–1962), a successful North Carolina conjure doctor, wore checkerboard shirts to protect themselves from witches and perhaps to signify their own powers. A leopard motif appears not only in *Mexican Man* but may have been in a Traylor drawing in the pattern on a skirt; in his painting of triangles, an African symbol representing a leopard skin; in a wondrous painting called *Spotted Leopard*; and in the picture just noted, where a leopard threatens a [Jim] crow. If there was a secret black society in the South that shared leopard lore, no knowledge of it has surfaced, but knowledge of the leopard's symbolic power was diffused in the community. In *Mexican Man,* the symbolically significant leopard cloth shirt is only part of the message. The uncolored face, the large eyes, and the special masklike head-covering all indicate a triumphant armed leopard spirit. Traylor's use of leopard symbols in this and other pictures, and the pictograms representing counselors and a punisher in *Figures and Trees* (plate 24), signify his incorporation of both leopard society symbols and values. Thompson emphasizes that in Nigeria and Cuba the leopard societies found "the master metaphor of masculine accomplishment [in] the leopard, who moves with perfect elegance and strength." Traylor used this master metaphor in Alabama as well.[27]

Bill Traylor's life was spent in a small area of Alabama. The key places he lived were Benton (1853–1904), a farm outside Montgomery (1909–28), and then in downtown Montgomery itself (1928–49). Sometime in 1940, Traylor did take a long bus trip to Detroit, to visit his children there. He was, however, anxious to return to Montgomery and to sit painting at the side of the Varons' fruit store once again, and he was back within a few weeks, complaining aloud to whites as well as blacks about the lack of restrooms provided for black people traveling by bus. This is Traylor's only verbal critique of Jim Crow on record. The North, and his large family, did not offer what he no doubt had hoped to find: a place in which he would feel more comfortable and free. After this trip he returned to his life in Montgomery, perhaps hoping it had more to offer him, but what he found on his return was not what he wanted either, although he continued painting marvelous pictures at his previous pace for some two years.[28]

Animated Scene (figure 4.6) is an image of the two major catastrophes in Traylor's life incorporating murder, lynching, rage, a dead spirit bird, and a live terrified woman in one scene. It is one of the most important of all the lynch pictures Traylor painted. In an unusually literal presentation, this "animated scene" seems to represent the circle of the life and death of his family. The figure upside down at the upper right is, I believe, Bill Traylor. In the conjure tradition, to set anything upside down is "to confuse, upset, or alter existing conditions," as in the lyric: "And the blues fell [on] mama's child, tore me all upside down." If viewed with his feet on the ground, Traylor would be facing right, the good way, but he is upside down, and has his sledgehammer held high in his right hand, aimed at the figure at the lower left. This second figure is the spirit of a dead man, as is indicated by his white skull, but even though he is dead he holds a pole poking the bird above him, a spirit owl. She is tied through her lower body to Traylor as well—she is in the middle between the two men. Here again is the Ur-narrative of Traylor's life: Traylor himself, his first wife, and the man who had sexual relations with her, tied together in an enduring triangle.[29]

But there is more than this triangle in this picture. Below Traylor is another dead white-skulled man, hanging by a rope around his neck. I see him as Will Traylor, the lynched son of Bill and Laura, and believe Laura is the figure in the middle of the bottom group of three figures. Her mouth is open wide in a scream of terror that can be found in a number of Traylor's lynch paintings.

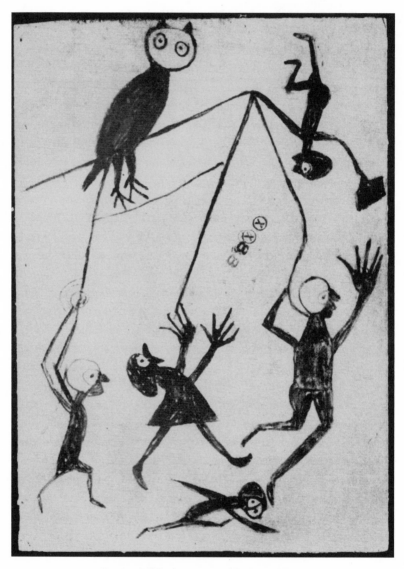

Fig. 4.6. Bill Traylor, *Animated Scene*, 1939–42.
Courtesy of Gerald Fineberg. Photo courtesy of Luise Ross.

Her fingers are spread wide and her arms lifted, but not to heaven as in religious ecstasy: Her large hands are stretched out in front of her signaling her fear and pain, another sign found in many paintings. One of her hands is tied to Bill's hand; Bill is thus tied to the bird, representing his first wife, Larisa, to his second wife, Laura, and to his son Will, while Will is suspended from the lynch rope in the hands of his mother and father. Below them all is a small large-eyed spirit figure, bent over and yet running to the right. A similar figure appears in many of Traylor's pictures. This is, perhaps, Traylor's inner soul or "little me"—separated from his body and pointing to the right way to go.[30]

At the center of this picture, at a point that might mark completion, there are marks that were made on the cardboard before Traylor chose to paint this scene on it. They are two figure eights, and two Xs, each X within a circle—marks that clearly had significance. The number eight figures widely in African American lore. In the game of pool, it is the number painted on the black ball. In the years before he produced most of his paintings, Bill Traylor had spent time in the pool hall for "Colored" people on Monroe Street, and would have been well acquainted with a version of pool that became popular around the turn of the century based on the idea that a player could not sink the eight ball until the variously colored balls numbered one through seven were pocketed. If a ball in play was blocked by the eight ball, the player was in a bad position. One of the phrases used widely in the African American community, then and until this day, is to be "behind the eight ball," which means to be "in imminent danger of losing." The phrase may have preceded the game, but in any event the game makes the meaning of the phrase clear: To be behind an eight ball is to face big trouble, trouble that one stands little chance of overcoming. On this cardboard, the two X marks can be understood as conjure signs: They were the seal on the harsh fate indicated by being behind the eight balls. The letter X in each circle may have marked the four corners of the earth, but it also indicated that two figures had been crossed or fixed: Two men had been conjured to die. Bill was tied to both of them, and his life path had been tied to both of their fates.[31]

Bill Traylor's owl wife, Larisa, is the largest and most grounded of the six figures in this painting. She has a solid line beneath her feet, and her large head and large eyes set in a white spirit background seem at peace. But she has no mouth and no sound can come from her. What can be seen and heard

is the scream clearly coming from Traylor's second wife, Laura. This picture too signifies contemplating "dread, to absorb fear into the soul."[32]

Bill Traylor painted his late-life position in this picture. He saw himself as still tied to both his wives (although one was dead and a silent figure of spirit wisdom), as well as to the man he killed, and to the lynching of his son Will. It is likely he felt that he had failed to protect Will adequately. Furthermore, he tied his own high level of rage, signaled by the hatchet still in his raised hand, to his son's lynching. His rage had apparently led him to kill his first wife's lover, and his rage was conceivably the cause for the breakup of his second family in 1928, with his son Will leaving for Birmingham, where he was killed, and Bill for Montgomery, where news of Will's death reached him. Bill Traylor paints this sense of his own guilt clearly in this picture: Will's lynch rope is in his own hand! He was being punished for his own evil acts, but he did not confound his guilt with the actual act that caused Will's death. His other drawings of the lynching of Will Traylor placed the blame directly on the white men who brought it about. Bill Traylor was "studyin' rain," understanding his life, and driving his blues away.

Sometime during the period that Charles Shannon stayed in weekly contact with Bill Traylor, Shannon suggested that he would drive Traylor for a visit to Benton, and was surprised to find that Traylor was not at all eager to go there. Knowing nothing of the traumatic events that apparently propelled Traylor to run from Benton long ago, Shannon persisted, and Traylor finally agreed to the forty-mile ride down the Selma Road, perhaps his first return trip in almost four decades. When they arrived, Traylor directed Shannon to the village north of the road, rather than to the plantation to the south. In the village he asked Shannon to stop the car near an old black woman, working outside in her garden. Shannon movingly described what followed: "He leaned out the window to embrace her lightly and they murmured gentle greetings to each other. I moved to my side to give them their privacy and they talked along in soft, low tones. I had no idea what they were saying or who the lady was. In a few minutes they grew silent. Bill turned to me and said, 'Let's go on back now.' I said, 'Okay.'"[33]

Notwithstanding the silence about critical matters that apparently characterized the relationship between Shannon and Traylor, Shannon's induction into the army in the summer of 1942 marked the end of perhaps the most satisfying and productive period in Traylor's life. Traylor left Montgomery

soon after as well, and went north again, traveling between the homes of his children in Detroit, upstate New York, Philadelphia, and Washington, D.C., but he could not find a place where he wanted to stay for an extended period of time. The exact length of his trip is not clear, but he was probably away from Montgomery for over a year. Soon after he returned, Traylor's left leg became gangrenous, and the doctors treating him decided to amputate it. Traylor reported: "I begged them not to cut it off. I told them I wanted to go out like I come in." Africans widely believe that damage to the body damages the soul as well, and it may well be that Traylor held this view. Traylor's plea to the doctors suggests he understood that this was the beginning of his end.[34]

In this same period, Traylor chose to make another significant change in his life. On January 5, 1944, Bill Traylor was baptized by the Rev. Joseph Jacobe at St. Jude Church, a Catholic church with a black congregation established by the white priest Father Harold Purcell. When Traylor began to consider conversion to Catholicism is not known. A grandchild, Will's son Clement, was in the first graduating class at St. Jude in 1942, and had been a student there for a good few years before that. Baptized sometime during his schooling, Clement was the first in his family to become Catholic. While Bill Traylor no doubt appreciated the school, the health services, and the broad social outreach provided by whites serving a black congregation, these policies and people are unlikely to have brought about his own conversion without deep needs and firm belief, but these needs and beliefs may have been far from the common ones marking converts. The act of conversion to Catholicism does fit with the core values that Bill Traylor held. By converting, Traylor chose to do exactly what the white Protestants in control in the South would *not* have him do, but it was also a choice that might have been attractive on other grounds. Traylor would have known that Catholicism was a home for the veneration of saints, and had proven compatible with voodoo practice in Louisiana, as blacks throughout the South looked to New Orleans as the source of both conjure supplies and conjure practitioners. Zora Neale Hurston noted that almost all of the mentors who initiated her into the service of spirits were Catholic conjure doctors, and if Traylor had a mentor who taught him about the Spirit of Death or if he underwent an initiation into the service of this spirit, it is likely that his instructor would have been a New Orleans Catholic, too. While the Catholicism of the priests at St. Jude, established by Father Purcell, was not in the Louisiana Catholic hoodoo-accepting tradition,

nevertheless their Catholicism did appeal to Traylor, and it is important to try to understand why.[35]

Father Harold Purcell was an unusual Catholic priest, an ascetic who became a radical. Purcell was born in rural Pennsylvania to working-class Irish Catholic immigrants. His mother took the family to Philadelphia after his father's death in a coal mine accident, a move that provided the opportunity for Purcell to be the first in his family to study beyond grade school. Sister Mary Ruth Coffman, Purcell's biographer, cites his report of an unknown happening at his Catholic high school in Philadelphia as the catalyst of his future: "Father Purcell testified that some event when he was thirteen years old awakened in him a profound compassion for the sufferings of Black people and a determination to do something about the injustices visited on them." Nevertheless, a decade later Purcell chose to join the austere, otherworldly Passionist Order, which focuses on the passion of Christ and techniques of prayer, rather than on the worldly needs of human beings. In March 1934, forty years after he made his childhood commitment to work for the good of blacks, and thirty years after he joined the Passionist Order, he "asked his superior for permission to go to Alabama to build a city 'for the religious, charitable, educational and industrial advancement of the Negro people.'" His superior regarded his plans as outside the concerns of the order, and it was made clear to him that he would have to leave the order to pursue his vision. Purcell must have known this would be the reaction, but he had come to believe his plan was God given, and that he had to pursue it. At the age of fifty-three, he went to Alabama as a parish priest.[36]

Within a relatively short time, Purcell began to realize what had seemed to most people who heard his plans an unrealizable fantasy. He obtained major contributions, purchased land, and began building his "city" for black people in Montgomery, including a school, a clinic, a church, a social welfare agency, and a community center. His goal was to create the potential for a radically improved material life for many African Americans, and at the same time to save souls by converting black people to Catholicism. His earthy personality and engaging openness played a significant role in everything he accomplished, and no doubt played a role in the conversion of Bill Traylor, as did his radicalism and dedication to black people.[37]

Purcell was conscious of the need to use art and symbols in his project. He designed his church in a way that he felt would be particularly attractive

to black people, using "rich, hand-carved wood, [with] . . . warm tones." He had the roof covered with blue tiles and placed statues of "Black saints: St. Monica and St. Augustine, . . . St. Benedict the Moor and Blessed Charles Lwanga" inside the church. Purcell wanted to create a setting in which black people would feel welcome, and apparently many did, among them Henrietta Graham [Humphries], who was in the first graduating class of 1942 together with her cousin Clement Traylor, Bill's grandson. The two children had spent years in the church school, and were very much at home there. In 1944, Bill Traylor felt welcome in this Catholic church as well, although it is likely that he converted in response to far deeper personal needs.[38]

Catholic conversion calls for a lengthy confession of sins. It is probable that in his conversion Bill Traylor spoke both of his violent dreams and the violent acts he had committed over his long life. This must have been a traumatic experience, but also a reassuring one. The Catholic catechism clearly states: "When we made our first profession of faith while receiving the holy Baptism that cleansed us, the forgiveness we received then was so full and complete that there remained in us absolutely nothing left to efface, neither original sin nor offenses committed by our own will, nor was there left any penalty to suffer in order to expiate them." This promise of complete forgiveness was accompanied by the call to live a life of commitment to Catholic values. Service to hoodoo spirits, particularly to the Spirit of Death, and the use of conjure power to harm others, were not acceptable acts at St. Jude. This would have serious implications for the rest of Traylor's life.[39]

While the Catholic Church approved of and fostered belief in saints, outside of New Orleans the North American Catholic hierarchies regarded conjure power as from the Devil. Not only would they have totally rejected the ecstatic "riding" of a seer by the Spirit of Death, they would have decried any call for retaliatory violence. Although the priests at St. Jude opposed the practices and values he had lived by, Traylor's joining the Catholic Church can be seen as his last major act of defiance. With this act, he became as fully as he could the person that the white Protestant rulers of southern society would not have him be.

When Traylor's pictures had called for the spilling of blood, was he signifying? John Wideman defines this term as "verbal play, serious play that serves as instruction, entertainment, mental exercise, preparation for interacting with friend and foe in the social arena." Traylor's call to arms was certainly all of the above, and more: Until he became a Catholic, he was conceivably issuing

a serious call to shed whites' blood—to retaliate against those responsible for atrocities against blacks—to show that blacks, too, were men. When he became a Catholic, this no doubt became unacceptable, both in the judgment of his mentors and himself. Traylor had shifted his allegiance to a new outside authority, and changed in compliance with this authority's directives.[40]

There is a long list of great bluesmen who were reborn into the Baptist or Methodist churches, and are known to have given up singing the blues and acting in ways their churches found unacceptable. John W. Work, whose research on Delta music was recently recovered from the archives of Alan Lomax, spoke with churched people who had once been musicians in his study of music in Coahoma County, Mississippi, in 1941. They too had given up an important part of their lives, and some missed it deeply. One painfully noted: "Yes, I used to be a musician going around playing the guitar for lots of folks. I coulda been a rich man too playing reels and all kinds of stuff like that. But since I joined the church, I just done put all that behind. I don't even fool with none of that no more. To tell the truth, I really don't like to talk about it no more, 'cause you see it bring back too many memories." After Traylor turned to religion, he no doubt had to give up conjure as others had to give up the blues. He too symbolically hung his broken banjo on the wall. The major tension in his art was gone.[41]

Nevertheless, after he recovered from the amputation of his leg, Traylor returned to sitting on his box next to the Varons' fruit store, where he tried to work as he had before. Shannon found him there when he returned to Montgomery in January 1946, following his release from military service. Shannon was shocked both by the marked change in Traylor's physical condition and by the quality of his painting. He felt that his new drawings were so poorly done they were not worth saving. Shannon was unaware of Traylor's conversion to Catholicism and could not have factored this in as a cause of the change he observed.

Shannon's negative reaction to his newest paintings, and his loss of interest in seeing Traylor again, no doubt affected Traylor badly, but these were not the only blows he suffered in this period. Sometime in 1946 an official of the Alabama Social Services Department learned that Traylor had a daughter living in Montgomery and as a result withdrew his welfare payments and demanded that he move in with her. Traylor understood that this meant the end of his independence. He had lived in downtown Montgomery over a seventeen-year

period, and he had come to recognize that his creative life and his social life were dependent on his observing and interacting with a vibrant world, full of people. He knew that at his daughter's, where he had recuperated after the amputation of his leg, he would be virtually dead to the world. Indeed, the Varons, and no doubt many of the black people who had visited with him weekly, thought he had died when he stopped coming to work at his spot. They missed him but knew of no one to ask about what had happened to him.[42]

In all the time he had spent with Shannon and the Varons, Traylor had never mentioned he had a daughter living in Montgomery. He was not close to Sarah Traylor Howard, and they clearly did not like each other, which can be traced back to the troubles of about 1904, the time when his marriage to her mother ended, which was the last time they had lived together. It is likely she blamed him for the breakup of that family, perhaps for her mother's death. Now, over forty years later, while she accepted the burden of housing and feeding him, caring for him as a person was another question. Nevertheless, he was forced to move into her Bragg Street home and become fully dependent upon her. Sarah Traylor Howard, and many other family members, did not value the art of Bill Traylor, thinking it childish, or the work of an obsessed man. Apparently his daughter in Detroit, Easter Traylor Graham, was the only one in the family who hung his pictures on her walls, although Lillian Traylor Hart, in Washington, saved some of them. Lillian and Easter's appreciation of his art, and of Bill Traylor himself, stood in stark contrast to the feelings of Sarah Traylor Howard.[43]

Bill Traylor's granddaughters, Margaret and Myrtha Lee, remembered that he cried when they visited him in Sarah's backyard. Traylor told them he cried because he was remembering his son Will, their father, and that he was also upset that his daughter did not want him in her house and left him sitting alone in the backyard all day, leading seventeen-year-old Myrtha Lee to wish she could have taken him away with her. Traylor tried to take his life back into his own hands: He thought that his daughter Easter Traylor Graham would take him back to Detroit if she knew of his situation. He had someone ask Shannon to come visit him, and requested that he write to Easter Traylor Graham telling her he wanted to come live with her. Shannon wrote, but she turned her father down, noting that her second-story apartment would not do for a man with one leg, and that given his previous visits, she knew that he would not want to stay for very long.[44]

Easter Traylor Graham may not have realized how radically life had changed for Traylor, and how strongly he wanted to get away from the Alabama house and yard he found himself confined to, which was indeed like a prison for him. This was perhaps the only time that Bill Traylor let Shannon see his anger, as it was directed against his own family. Shannon remembered: "He felt awfully abused. He'd sit in his daughter's backyard under a fig tree and try to draw. But he wasn't happy. He wanted to be on the street." Traylor believed that on the street he could continue to function as he had so successfully in his last good years.[45]

The columnist Allen Rankin came to interview him in this backyard on March 1, 1946, planning to write a piece on Traylor for *Collier's Magazine*. Rankin had earlier spoken with Charles Shannon, and brought along some of Traylor's paintings from Shannon's collection to use in photographs. He reported to Shannon afterwards that Traylor hadn't responded to his questions, and asked Shannon "to fill him in on his story." As a result, his article contains virtually nothing new about Traylor, but photographs of Traylor taken that day by Horace Perry are quite valuable, as they provide a record of some of Traylor's paintings from this last period of his life. They show Traylor's backyard worktable with an open bottle of brown paint and a number of pictures painted on pages taken from a large pad of white paper, unlike any of his earlier paintings. Some five of these new paintings are all in brown, while one has some yellow as well, apparently the only colors Traylor then had available. The paintings are of animal and human figures, with a man running for his life in one, and an arguing couple both pointing up to the left in another; there is not a single drawing of the Spirit of Death or of a figure with a raised cudgel. After his conversion to Catholicism, it is unlikely that Traylor drew such figures. In the background were ten works on odd-shaped cardboards with a far richer palette and subject matter, most of which are known to have been in Shannon's storeroom. Shannon recorded that he never came to Bragg Street to pick up any of the new, and indeed different, pictures.[46] (See "Bill Traylor in Bragg Street Backyard," plate 33.)

Displayed in the backyard on the same occasion was a collage of Traylor's paintings, mostly the older ones, but one, painted on the white pad and shown in the photo of his worktable as well, was a recent one. While Shannon had sent over the older paintings, it was the positioning of each of the works in this display that was crucial. The photographer or the interviewer

may have set out the pictures, but the arrangement suggests that Traylor was responsible for doing this, much as he had made all the arrangements for his street-side displays. This was the last collage of his works, and the array is highly structured, although its structure was not likely to have been apparent to the viewers (see plate 34). The collage includes references to sex, drinking, threatened violence (both black on black and white on black), isolation in huts and other small spaces, attempts to find balance in life, and achievement of a blue state of completion. It is Traylor's life in one circle, which starts at the right with the picture of the red power-filled and dangerous house, a picture that shows the complexity and confusion of his early adult life and his attempts to find balance. It moves on to the story at the center top, where the apex of life should be, showing him going left in his intention to attack a man because of a "bird" as well as his drinking and the presence of the ubiquitous armed and threatening spirit.

The next painting in the collage is of a man in brown or black standing next to a yellow-robed woman of power, painted on the white pad that marks it as a recent work. The dramatic couple pictured are clearly exchanging strong words with each other: both hold their left arms akimbo, and point their right arms up to the left—the correct arm to appeal to spirits according to Kongo tradition, but the negative direction, signifying death, was clearly not a good way to go. The woman is in yellow—but she is not like the figure in a popular blues song, where a woman in a green dress trimmed with yellow is "soft and mellow." On the contrary, this woman looks like she is in a total rage. Here yellow stands for strong emotion as it did in Traylor's picture of a yellow house, and in the conjurer's painting of a yellow bolt of lightning on Hurston's back. Yellow, as noted, is the color of the southern point in the Kongo cosmogram, and denotes the domain of spirits. The large white eye in this woman's big head also suggests her spirit power. With an economy of lines and colors, Traylor indeed suggests this woman is sexy, powerful, independent, and angry. The man, replying in kind, is dressed all in black/brown, with his skin and clothes all of one tone. He clearly has a strong power of his own: Black is the Death Spirit's color. The woman appears, however, the more centered, the more frightening, and the stronger of the two. This painting may well refer to Traylor's relationship with his second wife. This is the only picture photographed from his postconversion period that refers back to conjure colors and body language, but it does so without invoking a conjure

threat. While anger is still part of the picture, it portrays two calls to a spirit power to right wrongs, and suggests that Traylor had come to recognize that both he and the woman in his life had a right to do this.[47]

In the picture at the bottom of the collage, a white authority figure on a horse is hunting, although he is being shafted at the same time; a black man is running from him with his huge fingers extended—a mark of great fear; while a terrified black woman looks on. Some animals are running by these figures; they serve to mask the fact that this picture portrays the hunt of a black man, and all the signs suggest that the lynching of this man will follow. This painting is on the back of an advertising board that was a cutout of a white man. Traylor has laid this man low, and is exposing a lynching behind his back.

The arrangement ends with the painting of a cool blue spirit house, ringed by a red outline of power and topped by a bird of wisdom facing right. A man sitting at ease in this house is dressed in black and smoking a cigar, again signs of his previous connection to the Spirit of Death. Taken together, the paintings appear to be a memory board of Bill Traylor's life arranged around the "four corners of the earth" he had traversed, his own memorial and the only one he has as he was buried in an unmarked grave.

The brown figures on Traylor's backyard worktable in March 1946 do seem markedly less complex than most of his earlier works. Traylor's postconversion paintings on his worktable indicate the radical change he underwent. Spirit figures no longer dominate; the Death Spirit is not to be seen; and conjure threats cannot be found. Beyond these brown drawings, and a series of larger, simpler drawings Albert Kraus photographed two years later, it is not certain which, if any, of Traylor's known works were painted after June 1942, the point at which Shannon was drafted and stopped collecting Traylor's pictures. Dan Cameron, however, in a sensitive and perceptive review of Traylor's art, made reference to pictures he believes were done in the last years of Traylor's life, stating, "The work from this period shows a marked loss of definition and compositional energy, but there is sometimes an added poignancy. 'Self-portrait with woman' shows him one-legged, floating with shoes adjacent to his companion's knees (Traylor apparently stood close to 6'4") and gesticulating wildly, eyes rolling. She is half-akimbo, clutching an umbrella; her head is pulled back turkey-like from Traylor's, as if he, in mid-sentence, still emanated last night's whiskey." Cameron's description of a picture I have

not been able to locate suggests that although Traylor was no longer wielding threatening weapons, he was still able to communicate through his art and to react to the world as it was changing for him. It does also suggest that he was losing hope.[48]

Traylor was old and sick, and his immobility and lack of contact with the outside world no doubt further hastened his decline. When he was ill in February 1947, he was sent to the Fraternal Hospital, and while there he had a note sent to Shannon asking him to visit. Shannon responded to Traylor's request, but he found Traylor in extremely poor health and barely able to talk; he found the nursing home appalling. The conditions in black nursing homes and hospitals in Montgomery (and in most of the South) were infamous. There were only two small and poorly equipped so-called hospitals that accepted black patients, and the black nursing homes were more like holding pens for the dying. In 1952, Joe Azbell, editor of the *Montgomery Advertiser,* exposed their shameful state, charging: "Aged Negroes are a lost generation without anyone who cares what happens to them, whether they die, or whether they are cast in asylums as a means of getting rid of them." He selected one home in particular as so bad as to be unbelievable, its name— "Happy Kitchen"—suggesting a sick joke. Inside everything was filthy, including the patients and their bedding. Dirty rags and blankets were everywhere, while the kitchen held food-encrusted pots and dishes, but no food. Dr. Eugene H. Dibble, the medical director of the hospital at Tuskegee Institute, was persuaded to inspect "Happy Kitchen" on Oak Street, and was in shock after his visit: "In all my years as a doctor, going into all types of shacks and holes, I have never seen anything as brutally depressing, as shameful, as bad as this place." In 1947, Traylor was put in an institution on Oak Street very like this one, perhaps in the very same building.[49]

Shannon reported that soon after his visit to the nursing home in February 1947, Traylor's daughter Sarah called and told him that Bill Traylor had died and was already buried; and that she wanted to pick up the twenty-five dollars that Shannon had been holding for Traylor, his largest commission ever for a painting. Shannon believed this report of Traylor's death and never saw him again, and through Shannon this date entered the literature, and still appears in many reviews of his life.[50]

Traylor recovered sufficiently to return to his daughter's home, and a year later, on March 30, 1948, Allen Rankin visited him there again, drawn back

even though Traylor had been so unwilling to talk to him two years earlier. Rankin was accompanied by another photographer, Albert Kraus, who made a record of Traylor's most recent paintings of large animals and static male and female figures with uncolored faces. These indicate that the tone of Traylor's painting had changed again, as they seem even less dramatic than the paintings photographed in 1946, although patterns, colors, and used cardboards reappeared. Rankin was not impressed by this evidence of Traylor's activity, and reported in the *Alabama Journal:* "He sits in the sun and dozes. His thoughts grow as long and confused and tangled as his white beard." Traylor may have simply decided not to talk to a white stranger, but Rankin wrote that his life was almost over. Traylor did live for another year and a half after Rankin's second visit, but he may have been ill for a good part of that time. Bill Traylor died on October 23, 1949, at the Oak Street Hospital, which in the memories of Bill's grandchildren was filled with rats, roaches, and filth as dreadful as the infamous "Happy Kitchen" home. The irresponsibility of the caretakers is reflected in their failure to report Traylor's death to the Alabama Health Department. St. Jude Catholic Church kept the only formal record of Bill Traylor's death, which suggests that a priest may well have given him last rites at the Oak Street Hospital.[51]

The priests at St. Jude also held a funeral mass for Bill Traylor, with the Rev. Harold Purcell himself conducting the service. I think Bill Traylor would have liked that, although it deeply upset many members of his "hard-core Baptist" family. He might have liked the thought of that as well. When family members learned of his conversion, they did not take it seriously and reported that he never was religious, and that they don't remember his ever going to any church. Alabama Baptists were reputed to have a particular animosity toward the Catholic Church, and many in the Traylor family shared this view. The Catholic Church does not have a record of where Traylor was buried, and the family doesn't really know either. There is a possibility that after the Catholic mass, he was buried with other members of the family in an old black Baptist cemetery in Lowndes County, where he would have been "buried with his head to the west" so he would not "have to turn round to rise when Gabriel blows the trumpet." The old cemeteries, with their broken pots and personal items, tied the community to their African past, and Bill Traylor might have appreciated that as well. (See fig. 4.7.)[52]

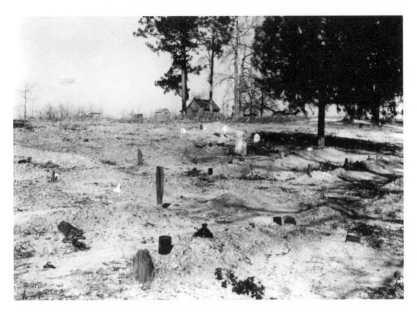

Fig. 4.7. "Negroes' Graveyard, Macon County, Alabama," April 1937.
Photograph by Arthur Rothstein. Library of Congress, LC-USF34-025436-D.

CODA

Openings are made in a life by suffering that are not made in any other way. Serious
questions are raised and primary answers come forth. Insights are reached concerning
aspects of life that were hidden and obscure before the assault.
—HOWARD THURMAN, 1963

Form is the shape of content.
—BEN SHAHN, 1957

Significantly affected by what he believed to be the lynching of his son Will,
Bill Traylor's paintings of the late 1930s and early 1940s held together strains
of great beauty as well as ugliness in a complex pattern found in much of
black visual arts as well as the blues. David Evans has noted that blues music is
"both hot and cool; . . . hard and soft or mellow; rough and smooth; heavy and
light or easy; lowdown and classy; dirty, nasty, or funky and clean or pretty;
and finally, simply bad and good." Evans believes that black artists strive for
this same mix, with "images of fear, chaos, danger, mystery, and awesome
power . . . brought into the realm of human life and society rather than exiled
from it or demonized." Bill Traylor's paintings contain this volatile amalgam,
as did his life, but very little was known of Traylor's life, and very few of
those writing about Traylor's art addressed the hot, rough, and bad in it.[1]

The evidence suggests that while Traylor grew up under the very harsh
conditions of Black Belt slavery, he was part of a longstanding large family
including parents, siblings, and fictive black kin, and was raised in an African
American cultural matrix centered on conjure. The end of the Civil War did

not bring him freedom, but his response to the new situation did reflect his deep sense of responsibility and attachment to his family: At age thirteen, he became the head of his family, and worked to support his mother and siblings for many years. After the war, he continued to work under the control of the man who had been his ostensible master and no doubt felt he was still enslaved, as his grandchildren and great-grandchildren judge him to have been. He established a family, married, fathered some nine or ten children, and may have appeared to have settled for the conditions he found himself in, although there are signs that he was a man with much inner rage who was anxious to escape the limits placed upon him. His apparent murder of his wife's lover, the hidden, violent, and traumatic event that led to his departure from Benton, attests to this rage. His painting of the two deaths that circled his life—the death of his wife's lover at his own hands and the lynching of his son Will by Birmingham policemen—suggests his anger had not abated by the late 1930s; rather, it had grown. (See *Animated Scene*, fig. 4.6.) He was still carrying a cudgel and ready to use it; he was still turned upside down. He was the man with a fire in his belly that he painted a number of times.[2]

It was through painting that Traylor found a better way to express his rage and a way to give his life meaning and purpose. Traylor signified that there was a meaning to his works deeper than narration of past events when he commented: "Sometimes they buys 'em when they don't even need 'em." Traylor clearly believed that he was painting something that black people *needed*. He created his art for a purpose, and a key question is what function he intended it to serve.[3]

Before he painted these pictures, Traylor had lived his life behind a "wall of silence for his spirit," a wall that he was made aware of when he was an enslaved child on a cotton plantation and that he respected in public until the 1930s. It had both imprisoned and protected his spirit until this period of great personal change, marked by an extraordinary burst of creativity. Behind this wall of silence, Traylor maintained values that came out of a collective process, developed over generations, and were best described by Frederick Douglass. Douglass detailed his realization of what should govern his behavior after Hugh Auld, one of his white masters, decreed that he would not allow him to learn to read. From that time on, Douglass was determined to act in negative response to this white man's values: "What he most dreaded, that I most desired. What he most loved, that I most hated. That which to him was

a great evil, to be carefully shunned, was to me a great good to be diligently sought." Traylor followed this oppositional pattern consistently, and it is a key to understanding Traylor's actions as well as his art.[4]

Donald G. Mathews maintains that leading white Protestants in the post-Reconstruction South, who were determined to regain control and demean blacks in the process, elevated the white body "to sacred status—its boundaries secured, its orifices purified, and its distancing perfected." In the process of reorienting their worldview to the new reality, "southern Protestantism [was fused] with prohibition, repressed sexuality, and the canonization of white women." Bill Traylor, by his actions and in his paintings, made it clear that his values stood in strong opposition to every one of these central southern white Protestant values and goals.[5]

If, for white southern Protestants, "the body was elevated to sacred status," in Traylor's works, the body is violated, vulnerable, broken. If, for white southern Protestants, the body's "orifices were purified" and "its boundaries [were] secured," in Traylor's work, its orifices are invaded and often punctured, especially the anus, the penis, and the vagina, with traveling spirits attacking the body's boundaries from within and without. If, for white southern Protestants, the body's "distancing is perfected," for Traylor, it is embraced in all its dreadful states. Traylor countered "normative" southern white Protestantism with a veiled African/conjure/and finally Catholic faith. Traylor countered sacrosanct Prohibition with drinking, drinking, and more drinking. Traylor countered the call for "repressed sexuality" with slyly secreted expressive sexuality. And he countered the canonization of pure white women with his recognition of strong and angry, sexually expressive black women.

Traylor violated another key white value in his celebration of black power by means of conjuring, a power he was not likely to explain to anyone, certainly not to a white man such as the artist Charles Shannon, nor to anyone else who did not understand his allusions. It was a dangerous power to celebrate, but the only one he could use, in part because he was an aged black man, living rough and working on the street, but in greater measure because this was part and parcel of who he was. In fact, it was the innermost part, and Traylor advocated its use to oppose white control.

Many analysts still maintain that the blues were not concerned with social protest, but by now, a good number recognize that the blues' demand for freedom was critical. On the basis of Lawrence Gellert's collection of lyrics

from the 1920s and 1930s, we can go much further. Beyond the underlying assertion of the right of all black people to be truly free, many blues singers, as well as Traylor, expressed not only criticism but also a call to use retaliatory violence. Nevertheless, this call, if made in public, was issued in a semiveiled form, and whites did not recognize it. Sometimes, however, the criticism seems so blatant that it appears that white observers wore metaphorical blinkers. In Traylor's case, they could not believe that an illiterate old black man could be painting symbolically or allegorically or even critically, and therefore they could not see what he had painted.[6]

Wherever he encountered blues, in the fields, in rural home-parties, or in jukes, Traylor became a bluesman. He was not, as far as is known, a musician, but at his height he became a painter of lyrical power, whose compositions reflect the worldview, value structure, and compositional structure found in many of the early folk blues. Improvisations around a central theme in a surround of "free associations," his blues drawings, much as the songs, shock with their "realignment of common place elements," their stark minimalism, the truths they tell, and the needs they meet.[7]

Richard Wright explained the process of improvisation in the blues as comparable to his grandmother's "ability to tie the many floating items of her environment together into one meaningful whole." Robin D. G. Kelley notes that Wright saw both his grandmother's construction of reality and "the blues structure [as] analogous to the surrealists' use of . . . the chance encounter, the juxtaposing of seemingly unrelated things in order to reveal the Marvelous." Traylor's blues paintings do much the same: They obliquely reflect his own origins in slavery, both his "time on the cross" and that of his family, his sense of being imprisoned in a small space, and his experience with violence, destruction, and death, but not in any linear fashion. They deal with social reality, but Traylor's works were far from social realism. They indeed touch on the marvelous and can provide a healing vision, but they also call for the spilling of blood.[8]

Traylor's art played a key role in his own individuation. The changing patterns of individuation have a history that can be charted: Over the course of the colonial period in America, most people continued to develop in ways that had been normative in the preceding period—they thought of themselves as having a collective self, whose boundaries with others were permeable. Beginning in the greater Revolutionary era, many began to develop into

more autonomous individuals. Four practices were critical in this process of change: In myriad instances where individuation occurred, dreams were regarded as life-altering visions; an oppositional alien or enemy other was created, most often of a different race; an outside authority was recognized; and a life narrative was fashioned to reframe the past and record the process of development.[9]

All four of these processes played a special role in Bill Traylor's development. Taken together, they helped him become the "serene" man that Shannon characterized as "calm and right with himself, beautiful to see." It is likely that Traylor took his dreams seriously from childhood on, and that in his last decade he painted them repeatedly. Not only did they keep him in touch with his pain and provide relevant imagery, his interpretation of them was likely to have directed him to actions to pursue and turns to take in life. Traylor also composed a lengthy, complex, life narrative in over 1,200 pictures. He was certainly reframing his past, emphasizing what he saw as turning points, recognizing the real potential he had for finding a strong voice, and, notwithstanding his age and situation, advocating a powerful reaction to Jim Crow. These developments were dependent upon his having come to creatively reassess his enemy other: the white oppressor, thief, and murderer who had enslaved him from his childhood on, stealing his labor, murdering his son, and controlling his right to express himself freely in enraged response. His outside authority for much of his mature life was the collective voice heard in the blues. It told him: Know your enemy, know your self, and when you find your own voice, use it with pleasure.[10]

Traylor appears to have functioned by "falling back" for most of his life, much as Ned Cobb described himself doing. He did not break through the wall of silence that surrounded him, as he knew how dangerous that could prove to be. Traylor finally broke through this barrier by "harlern," or shouting shouts—including loud falsetto calls and yodeling—much like those of the enslaved that he had heard in his childhood. John Traylor had beaten enslaved shouters for this behavior in 1841, but in 1939, Bill Traylor found that the drawings, which shouted out his rage, did not call down whites' wrath, but rather their approval. When he realized that they did not know what he was saying, or that they would turn a blind eye toward his message or even enter into an unspoken alliance supporting it, as perhaps Charles Shannon and the other members of the New South had, he, unlike the blues singers,

could display his most radical work for all to see. His crucifixion paintings and the hunting scenes that depict the chase after men are among his most radical protest images; they conflate the cross and the lynching tree. James Cone has recently analyzed these signs in the African American symbolic universe, commenting that: "Christ is made black through God's loving solidarity with lynched black bodies and divine judgment against the demonic forces of white supremacy." While Traylor would not have used these words, I believe that his view, expressed in these pictures, was much the same.[11]

Shannon, like Traylor, was a man of secrets. After his death in 1996, his widow and daughter revealed that he had been concerned in the 1930s and early 1940s that white racists might learn of his underground participation in organizing the black Sharecroppers Union, an aspect of his life he had not discussed in public. In his private record of his early works, now in the archives of the Georgia Museum of Art, Shannon did state that he had destroyed his powerful 1939 painting of Klansmen on their way to a lynching, marching over a family hiding underground, as he "was afraid of being caught with it." (A sketch for this painting is extant.) In 1940, he had good reason to fear that raising the issue of criticism of Jim Crow and lynching in his own art or in the art of a black man whose works he had put on display would have endangered himself, the New South Gallery and School, and Bill Traylor. His participation in organizing black sharecroppers to join a union, as well as his founding of the New South Gallery and School, and his support for Bill Traylor and his art, all acts of courage and bravery, do fit the Communist Party program for the Black Belt. Even his turn from concern with Traylor to interest in white sharecroppers in Georgia in 1941 matched the Communist Party's changing program in the South. Shannon had reason to worry about being regarded as an opponent of the Ku Klux Klan, a supporter of interracial contacts, and a Communist sympathizer in this period when the KKK was so powerful. The reasons Shannon did not raise any questions related to the content of Traylor's paintings in the 1940s are clear.[12]

After the war, criticism of racial policy was still not an issue to be raised with impunity in the South. So far as is known, Shannon did not participate actively in any progressive movement in this period, but devoted himself to his own career and eventually became the chairman of the Art Department at Auburn University in Montgomery. By the time he chose to renew his efforts to gain interest in Traylor's art, the civil rights movement had brought signifi-

cant change to the South, but Shannon remained committed to his earliest nonpolitical evaluation of Traylor's works. In 1986, he answered the question, posed by Michael Bonesteel, of what made Traylor's work great much as he had in the 1940s: "What made his work great is like trying to answer 'what is grass?' The rhythm, the interesting shapes, the composition, the endless inventiveness—it all reflects such a wonderful joy of living. His whole sense of life comes through. It was just the man. I think he was a great man. It's not so much how he depicted or what he did. It was just the soul of the man."[13]

Members of the Traylor family might have disagreed with this assessment of Bill Traylor's joy, but they were not aware of Shannon's views or of his successful promotion of Traylor's art; some were not even aware that Traylor had been an artist or that Shannon had saved his works. A few learned of the recognition of Traylor's paintings when the Corcoran Gallery's show of 1982 was discussed on the CBS television program *Sixty Minutes* and Traylor's paintings in the exhibit were showcased. Over the next decade, as the prices for Traylor's art soared, family members learned more about their marketing and became convinced that Shannon had taken advantage of Bill Traylor and had robbed the family of their inheritance. In the late 1980s, Shannon reported that he had given Traylor "a few dollars every week," but he also noted, "I took the work home to protect it. . . . I saw myself as a caretaker." By December 1992, when the Traylor family proceeded with a case against Shannon in the State of New York (where Shannon sold Traylor's pictures through the Hirschl & Adler Modern Gallery), Shannon had no compunction about claiming his full rights to ownership. What is certain is that without Shannon's rescue of the paintings, they would have disappeared, a point to which the family did not relate. The press gave prominent coverage to the family's charge that Charles Shannon had stolen the works, and that racial exploitation was involved. Shannon felt this was a totally unfounded attack on the idealism that had moved him in the Depression years, and now marred what he had termed his "second life" as a successful promoter of Traylor's art. Shannon moved to settle the case out of court, and offered the family twelve pictures in return for the withdrawal of their charges and the acknowledgment of his positive role. Shannon did not talk to the press, but in announcing the settlement, his lawyer defended him as a "progressive" whose paintings "dealt starkly with social oppression, depicting the tragedy and human pain of lynchings."[14]

Notwithstanding this public reference to his own painting of lynch threats, Shannon's title for Traylor's painting of a human figure hanging from a tree remained *Figures and Trees:* He never referred to this Traylor picture, or any other, as a lynching scene (see plate 24). In 1940, Bill Traylor had no doubt been relieved that Shannon's exhibition of his pictures did not lead the KKK to attack him or Shannon. It was clear that most whites did not understand his paintings, but they were not the audience he was concerned about. He believed that black people needed them, and he sought to make both his values and his advice clear to this audience. For this purpose, he did not need written titles but rather a symbolic visual language that was stark and uncluttered, in clear contradistinction to the ruling tradition in African American vernacular art.

Traylor chose to oppose this and other values of his own family and community, but above all, he opposed the values of the white Protestant ruling class. His oppositional attitudes in regard to sex, women, and the family were certainly part of the social fabric of rural black life. He inherited them, as it were, but he affirmed them anew in his personal recognition of his opposition to the values of the ruling class. His views of conjure power came from his elders as well, but he personally expanded his range of expertise through what he learned of the tradition of the Spirit of Death. In addition, he developed techniques for hiding his meaning in art and for displaying conjure messages that were highly critical of the racist regime. This took both deep conviction and great courage, but after the death of his son at the hands of the police, he was ready to take this risk. With his choice of Catholicism, he reached the height of his personal oppositional actions: With this act, he violated the communal ethos and broke with the African Baptist traditions of his family as well as most African Americans in the Black Belt. But he was also adding an attribute that the KKK hated: Not only was he black, he was Catholic. He had succeeded in becoming more of what "they" did not want him to be, but he had also found a way to use his pain and his sorrow and to become more of what he himself wanted to be.

Henrietta Graham Humphries and her cousin Clement Traylor, Will's son and Bill's grandson, were the first Catholics in the "hard-core Baptist" Traylor and Graham families. Even though she and Clement had been together at the St. Jude School for four years, Clement never talked to her about how Will Traylor died. She recalls that in her childhood no one ever spoke to her of the

terrible things that happened to family members. These were, in her words, "hush-hush" issues. The Traylor family was not unusual in their response to the trauma of lynching. When, in 2005, the United States Senate apologized publicly for never having passed an antilynching law during the Jim Crow period, they chose to do this at a dinner to which the families of lynch victims were invited. A number of family members revealed that they had never before been told how their forefathers died. For those in families like Traylor's where the facts remain hidden, the wounds are still raw. In June 2004, when I told Henrietta Graham Humphries that I would be writing about Will Traylor's murder by Birmingham policemen in 1929, she said, "If you have to."[15]

I do feel I have to. I am certain that the lynching of Will Traylor had an enormous impact on Bill Traylor and Bill Traylor's art. As with so many early blues artists, lynching was a defining experience for Bill Traylor. It forced him to find a way to break through his wall of silence. He painted out of pain, and pointed to conjure as a way for black people to overcome, a message that white people never understood. Robert Farris Thompson tells us that in Ki-Kongo, "Art that brings spirit and image together is *ki-mooyo*. This is literally the idiom of the soul." That is what Traylor's art was and is: *ki-mooyo*. It moves the soul to sing, to see farther, and to act.[16]

It took well over a decade for me to begin to see the "bitter blues" in Traylor's pictures. I, and many other white people who looked at Traylor's works on display, did not recognize that his subject was often lynching. One might well understand how and why white southerners in the late 1930s might not want to focus on this disturbing material, but I, too, as well as many others outside the South, focused on other things. There is increasing scientific concern with the processing of data from our senses, and increasing evidence that vision, as well as smell, hearing, and touch, is not passive. On the contrary, it is now known that "sensation is a very active process," inasmuch as we selectively attend to certain things. There is a "brain mechanism that functions as a gate for information, enabling our brain to focus on what [our senses are] . . . telling us when we want it to, and more importantly, ignore it when we choose to." I was looking for spirits and representations of the "little me" and did not focus on (or, more accurately, ignored) the strong social commentary that I now see in Bill Traylor's work. I had seen the *Figures and Trees* lynch painting (plate 24) exhibited at the Hirschl & Adler Modern Gallery in New York City in February 1997, and walked right by it. I, too, ignored this image

of a lynch scene painted by a man with a strong sense of how to bring "spirit and image together."[17]

Traylor's art communicated "courage in mimes." He sought to serve the needs met by the cathartic blues as well as the bitter blues. He sought both to allow black people to moan for their dead and dying, and to provide courage for a new life. He sought to suggest hidden ways to attain retribution and freedom. With limited means at his disposal, he accomplished his major goals.

Bill Traylor was a man of vision. I can only wish that he might have foreseen the changes that came about in the years after he died, especially the 1955 Montgomery bus boycott and the 1965 Selma to Montgomery civil rights march. In 1955, many of the people he had met on the streets of Montgomery participated in the yearlong bus boycott, which energized and changed the black community he had known. In 1965, starting from Selma Bridge, marchers led by Martin Luther King Jr. walked for four days following the same route along the Selma-Montgomery road that Bill Traylor, and Wilson's Raiders, had taken many years earlier. When they camped near Benton on their way to Montgomery, black people from the town came out, and some, taking great risk, joined the marchers. Their last overnight campsite on the fourth day of the march was on the outskirts of Montgomery on the grounds of St. Jude Church. This was the very place where Traylor had been baptized in 1944 and where a memorial mass was held to commemorate his death in 1949. On March 24, 1965, an enormous crowd, variously estimated as from ten to twenty-five thousand people, including James Baldwin, Joan Baez, Harry Belafonte, Sammy Davis Jr., and Peter, Paul, and Mary, congregated on the grounds of St. Jude. They had come to celebrate through music the enormous changes they were helping to bring about. Their voices were as well a fitting memorial to those in earlier generations who, notwithstanding the terror and violence, had fought for change in hidden ways. Bill Traylor was among them.[18]

NOTES

INTRODUCTION

1. On Traylor's "radical modernity," see Josef Helfenstein, preface, and "From the Sidewalk to the Marketplace: Traylor, Edmondson, and the Modernist Impulse," in *Bill Traylor, William Edmondson, and the Modernist Impulse,* ed. Helfenstein and Roxanne Stanulis (Champaign, Ill.: Krannert Art Museum and the Menil Collection, 2004), 8, 45–67. Alfred M. Fischer, "Looking at Bill Traylor: Observation on the Reception of His Work," in *Bill Traylor, 1854–1949: Deep Blues,* ed. Josef Helfenstein and Roman Kurzmeyer (New Haven: Yale University Press, 1999), 162–68; Jenifer P. Borum, "Bill Traylor and the Construction of Outsider Subjectivity," in *Sacred and Profane: Voice and Vision in Southern Self-Taught Art,* ed. Carol Crown and Charles Russell, (Jackson: University of Mississippi Press, 2007), 238–60; Roberta Smith, "Altered Views in the House of Modernism," *New York Times,* April 29, 2005.

2. On the reaction of the Museum of Modern Art to Traylor's paintings, see Roman Kurzmeyer, "The Life and Times of Bill Traylor (1854–1949)," in *Bill Traylor, 1854–1949: Deep Blues,* 175. Charles Shannon, "Bill Traylor's Triumph: How the Beautiful and Raucous Drawings of a Former Alabama Slave Came to Be Known to the World," *Art and Antiques* (February 1988): 61–65, 88; Jane Livingston and John Beardsley, *Black Folk Art in America, 1930–1980* (Jackson: University of Mississippi Press for the Corcoran Gallery of Art, 1982); Kinshasha Holman Conwill, "In Search of an 'Authentic' Vision: Decoding the Appeal of the Self-Taught African-American Artist," *American Art* 5, no. 4 (Autumn 1991): 2–9; Joe Wilkinson, "Bill Traylor's Drawings," in *Bill Traylor Drawings from the Collection of Joe and Pat Wilkinson* (New York: Sotheby's, 1997), 13–15. On marketing Traylor's art, see Andrew Dietz, *The Last Folk Hero: A True Story of Race and Art, Power and Profit* (Atlanta: Ellis Lane Press, 2006), 85–94, 130, 146–49.

3. Alfred Schutz and Thomas Luckmann, *The Structures of the Life-World* (Evanston, Ill.: Northwestern University Press, 1973); Frank Maresca and Roger Ricco, "Remembering Bill Traylor: An Interview with Charles Shannon," in *Bill Traylor: His Art—His Life,* ed. Maresca and Ricco (New York: Knopf, 1991), 3, 24.

4. On covert black reactions to Jim Crow in the decades before the civil rights movement, see Samuel C. Adams, "Changing Negro Life in the Delta," in *Lost Delta Found: Rediscovering the Fisk University–Library of Congress Coahoma County Study, 1941–1942*, by John W. Work, Lewis Wade Jones, and Samuel C. Adams, ed. Robert Gordon and Bruce Nemerov (Nashville: Vanderbilt University Press, 2005), 223–90; Steven Hahn, *A Nation under Our Feet: Black Political Struggles in the Rural South from Slavery to the Great Migration* (Cambridge, Mass.: Belknap Press, 2003); Nan Elizabeth Woodruff, *American Congo: The African American Freedom Struggle in the Delta* (Cambridge: Harvard University Press, 2003); Adam Fairclough, *Race and Democracy: The Civil Rights Struggle in Louisiana, 1915–1972* (Athens: University of Georgia Press, 1995), xii–xiii; Robin D. G. Kelley, "We Are Not What We Seem: Black Working-Class Opposition in the Jim Crow South," *Journal of American History* 80 (1993): 75–112; Herbert Shapiro, *White Violence and Black Response: From Reconstruction to Montgomery* (Amherst: University of Massachusetts Press, 1988).

5. For a range of positive views, see Phil Patton, "High Singing Blue," in *Bill Traylor: High Singing Blue* (New York: Hirschl & Adler Modern, 1997), 33; Lowery Stokes Sims, "Bill Traylor: Inside the Outsider," in *Bill Traylor, 1954–1949*, ed. Helfenstein and Kurzmeyer, 92–95; Fischer, "Looking at Bill Traylor"; Shannon, "Bill Traylor's Triumph," 62; N. F. Karlins, "Folk Art Notebook," *Artnet Magazine* (June 14, 2005): 1–2, www.artnet.com/Magazine/Frontpage.asp?N=1. Mary E. Lyons's *Deep Blues: Bill Traylor, Self-Taught Artist* (New York: Scribner's, 1994), a book for young readers, places Traylor in a rich historical context. For the view that "he drew simply about plantation and street life," see Lynn Marmitt, "The Folks of Folk Art," in *Yale–New Haven Teachers Institute* 4 (1993): www.yale.edu/ynhti/curriculum/units/1993/4/93.04.10.x.html. For the view of Traylor as a complex trickster painting masterful narratives, see Borum, "Bill Traylor and the Construction of Outsider Subjectivity." For Traylor's art as enigmatic, see Dan Cameron, "History and Bill Traylor," *Arts Magazine* 60, no. 2 (October 1985): 45–47; Patton, *Bill Traylor*, 9–33; and Stacey C. Hollander, "Temporal Aesthetics in American Folk Art," in *American Anthem: Masterworks from the American Folk Art Museum*, ed. Hollander and Brook Davis Anderson, 15–18 (New York: American Folk Art Museum, 2002). "Visual haiku," in Pamela Wye, *Visionary Artists: Bill Traylor & Minnie Evans* (Wichita, Kans.: Wichita Art Museum, 1992), 2. Betty Kuyk, *African Voices in the African American Heritage* (Bloomington: Indiana University Press, 2003), 133–201. On the relationship of form to content in art, see Ben Shahn, *The Shape of Content* (1957; Cambridge: Harvard University Press, 1963), 72.

6. [Charles Shannon], *Bill Traylor—People's Artist* (Montgomery, Ala.: New South Gallery, 1940); Shannon, in Helfenstein, "Bill Traylor and Charles Shannon," 97; Shannon, in Michael Bonesteel, "Bill Traylor, Creativity and the Natural Artist," in *Bill Traylor Drawings* (Chicago: Chicago Office of Fine Arts, 1988), 21, 24. For Shannon's outline of Traylor's life, see "Chronology," in Maresca and Ricco, *Bill Traylor*, 179.

7. Victor Turner, *The Forest of Symbols: Aspects of Ndembu Ritual* (Ithaca: Cornell University Press, 1967), 36; "wall of silence," in Chaim Aron Kaplan, *The Scroll of Agony: The Warsaw Diary of Chaim A. Kaplan*, trans. and ed. Abraham I. Katsch (New York: Macmillan, 1965), 299–300. On the cross and the lynching tree, see James Cone, "Strange Fruit: The Cross and the Lynching Tree," Ingersoll Lecture at the Harvard University Divinity School, October 19, 2006, reprinted in *Harvard Divinity Bulletin* 35, no. 1 (winter 2007).

1. PAINTING A HIDDEN LIFE (1853–1904)

1. Kitty Baldwin, February 28, 1998, in Kurzmeyer, "The Life and Times of Bill Traylor," 174; Margaret Traylor Staffney, interviews by Mechal Sobel, June 15, 1993, and February 29, 1995, Montgomery, Ala.; Shannon, "Bill Traylor's Triumph," 61–65, 88; Shannon, in Bonesteel, "Bill Traylor, Creativity and the Natural Artist," 2.

2. The 1860 Slave Schedule for Thomas G. Traylor, Old Town Bt., Dallas County, Alabama, slave number 13, male, age 7; William Trailor, age 17, U.S. Census, 1870, Alabama, Lowndes County, Benton. Traylor had an 1855 birth date recorded on *Man with Hat and Cane*, reprinted in Helfenstein and Stanulis, *Bill Traylor, William Edmondson, and the Modernist Impulse*, fig. 67. The 1920 census taker in Traylor's area of Montgomery County recorded all blacks and their parents as having been born in Alabama, suggesting he filled in the census questionnaire without consulting the individuals involved. Certainly, most of the 1920 data in regard to Traylor are inaccurate.

3. Traylor, John G., Diary, Jan. 1, 1834–April 16, 1847, copied by Gladys M. Jones, typescript in Alabama Department of Archives and History, Montgomery; Traylor, John G., Will, Dallas County, Will Book B, pp. 1–2, Alabama Department of Archives and History, Montgomery.

4. Fictive kin "are unrelated by blood or marriage but regard one another in kinship terms" (Linda M. Chatters, Robert Joseph Taylor, and Rukmalie Jayakody, "Fictive Kinship Relations in Black Extended Families," *Journal of Comparative Family Studies* 25 [1994]: 297–312; Herbert G. Gutman, *The Black Family in Slavery and Freedom, 1750–1925* [New York: Pantheon Books, 1976], 216–27). George Traylor noted on *Man with Hat and Cane*, reprinted in Helfenstein and Stanulis, *Bill Traylor, William Edmondson*, fig. 67. Traylor's comment on his "white folks" is in Maresca and Ricco, "Remembering Bill Traylor," 8.

5. John Traylor began overseeing for Green Rives (or Reeves), who owned some seventy-five enslaved people in Collirene, Alabama, on January 1, 1834. In November 1840, Traylor began working for Judge Reuben Saffold, overseeing some fifty African Americans in Dallas County until June 1842 (see June M. Albaugh and Rosa Lyon Traylor, *Collirene: The Queen Hill* [Montgomery: Paragon Press, 1977], 19–21). On the treatment of the enslaved on Gosse's plantation in 1838, see Philip Henry Gosse, *Letters from Alabama: Chiefly Relating to Natural History* (1859; Tuscaloosa: University of Alabama Press, 1993), 253.

6. Bill [Calloway] is identified by the family name of the man who owned him prior to his purchase by John Traylor in order to distinguish him from his son Bill Traylor, the painter; as is George [Calloway], to distinguish him from George Traylor, brother of John Traylor. Bill Traylor (listed as William Traylor) provided information about his parents' birthplaces to census takers in 1880. For Benjamin Calloway, see U.S. Census, 1830, Alabama, Southern District, Lowndes County; and U.S. Census, 1840, Alabama, Southern District, Lowndes County, Macon. Benjamin Calloway was born 1788 in Henry, Virginia, and died intestate in Macon, Alabama, in August 1841. See also Traylor Family, *Traylor-Calloway-Durant Family Reunion* (booklet), 1991, Detroit; Traylor Family, *Traylor-Calloway-Durant Family Reunion* (booklet), 1992, Atlanta; Traylor, Diary, May 17, 1834, July 5, 1834, Dec. 29, 1834, Nov. 21, 1835, Dec. 26, 1835, Jan. 7, 1837, June 2, 1838, July 15, 1841, Aug. 15, 1841 ("sail"), Feb. 23, 1847, Feb. 27, 1847, March 2, 1847, March 12, 1847,

March 18, 1847; Mary Calloway Traylor's death recorded Feb. 15, 1847; Traylor, Will, pp. 1–2; Green Reeves: U.S. Census, 1840, Alabama, Lowndes County; Reuben Saffold: U.S. Census, 1830, Alabama, Dallas County. John Traylor and Mary Calloway were married on November 17, 1836 (Marriage Book I, surname L–Z, Lowndes, Alabama, 1830–48, 154).

7. On "infars," see Traylor, Diary, June 7, 1834; on travels to the Creek nation, see ibid., June 21, 1836; on Traylor's self-encouragement, see ibid., Jan.1, 1836. I am indebted to Miriam Fowler for providing me with a copy of this diary.

8. Traylor recorded the output for each year from 1834 to 1839 in his Diary, Dec. 31, 1839.

9. On whipping for hollering, see Traylor, Diary, July 15, 1841. On African American hollers, see Shane White and Graham White, *The Sounds of Slavery: Discovering African American History through Songs, Sermons, and Speech* (Boston: Beacon Press, 2005), 20–25, and the accompanying CD, *The Sounds of Slavery*, three hollers (tracks 1–3) from the John A. and Ruby T. Lomax collection at the Library of Congress. Traylor, Diary, Aug. 30, 1834, June 2, 1838, Dec. 25, 1840.

10. On holidays at the Traylor plantation, see Traylor, Diary: April 6, 1844, June 8, 1844, Aug. 13–14, 1844, July 4, 1845, April 3, 1847.

11. Traylor, Diary: Feb. 23, 1844, March 14, 1844; on Sally, see: Feb. 5, 1837, Feb. 27, 1847, March 2, 1847; on Bill Calloway, see: March 4, 1847, March 10, 1847, March 12, 1847, March 15, 1847, and March 18, 1847.

12. Traylor, Diary, tests on May 6, 1836 (two months), July 17, 1841 (3 weeks), July 1846 (two weeks), August 8, 1846 (six weeks), October 1846 (two weeks).

13. The years of birth and the ages for Bill [Calloway] and Sally and their children have been extrapolated from the Slave Schedule of Thomas G. Traylor (son of John Traylor), U.S. Census, 1860, Alabama, Dallas County, Old Town, as well as later census records for Bill's siblings. See also Traylor, Diary, Feb. 23, 1844; Traylor, Will, 2.

14. Ned Cobb was given the fictitious name of Nate Shaw in Theodore Rosengarten, *All God's Dangers: The Life of Nate Shaw* (1974; New York: Vintage Books, 1989), 8.

15. Thomas Traylor's military service, noted in *Confederate Veteran* 32 (1924): 475, is summarized on the Web at www.gencircles.com/users/pthomp/1/data/11030. Marie Jenkins Schwartz, *Born in Bondage: Growing Up Enslaved in the Antebellum South* (Cambridge: Harvard University Press, 2000), 144; *Hunter on Horseback*, in Maresca and Ricco, *Bill Traylor*, 139.

16. James Pickett Jones, *Yankee Blitzkrieg: Wilson's Raid through Alabama and Georgia* (Athens: University of Georgia Press, 1976), 103, 106; Walter Calloway, "Ole Joe Had Real 'Ligion," in *The American Slave: A Composite Autobiography*, ed. George P. Rawick (Westport, Conn.: Greenwood Press, 1972), 6: 53.

17. Billy: Alabama State Census, 1866, Lowndes County, Colored, p. 7; William, Emet, and Sally Trailor: U.S. Census, 1870, Alabama, Lowndes County, Benton. On postwar responsibilities assumed for fictive kin, see Gutman, *The Black Family*, 225.

18. Sallie Traylor, William Traylor, Emit Traylor, and Susan Walker (described as a "servant" in Sallie Traylor's home): U.S. Census, 1880, Alabama, Lowndes County, Benton. Bill Traylor's brothers were not far away in Lowndes County: Frank Traylor, Henry Traylor, James Traylor. Drusilla's children can also be identified in this 1880 census: Harrison Traylor, Richard Traylor, and George Traylor.

19. On Thomas Traylor being called "Master" long after the Civil War, see an obituary in *Confederate Veteran* 32 (1924): 475, and a Web summary at www.gencircles.com/users/pthomp/1/data/11030. The white plantation owner, George Traylor, died on March 23, 1881, at age eighty; an obituary is reprinted in Traylor Family, *Traylor-Calloway-Durant Family Reunion* (booklet), 1992. Bill Traylor, quoted in Maresca and Ricco, "Remembering Bill Traylor," 8; "Field Notes" of Alpha Champion, county surveyor for Lowndes County, Alabama, noting Bill Traylor's job, on the verso cover of Phyllis Stigliano, *Bill Traylor: Exhibition History, Public Collections, Selected Bibliography* (New York: Luise Ross Gallery, 1990).

20. After the Civil War, the term "Black Belt" was used to refer to some two hundred plantation counties, from Virginia to Texas, where a majority of the population was African American. See William Traylor, age 26, in the U.S. Census, 1880, Alabama, Lowndes County, Benton. Larisa Dunklin Traylor was recorded as Laurine on her marriage license in 1891, and as Larisa in the census of 1900. See Colored Marriage Record Book, 1889–1897, p. 202, Lowndes County Courthouse, Hayneville, Alabama; Larisa Traylor, U.S. Census, 1900, Alabama, Lowndes County, Benton. On family formation in the Black Belt, see Charles S. Johnson, *Shadow of the Plantation* (1934; New Brunswick, N.J.: Transaction, 1996), 63, 71–80.

21. Ralph Ellison, "An American Dilemma: A Review" (1944), reprinted in Ellison, *Shadow and Act* (1953; New York: Random House, 1964), 314; Albert Murray and John F. Callahan, eds., *Trading Twelves: The Selected Letters of Ralph Ellison and Albert Murray* (New York: Modern Library, 2000); Albert Murray, *From the Briarpatch File: On Context, Procedure, and American Identity* (New York: Pantheon, 2001), 11.

22. Charles Johnson, *Shadow of the Plantation*, 53; Colored Marriage Record Book, 1889–1897, p. 202, Lowndes County Courthouse, Hayneville, Ala.; Bill Traylor, U.S. Census, 1900, Alabama, Lowndes County, Benton.

23. Michael W. Fitzgerald, *The Union League Movement in the Deep South: Politics and Agricultural Change during Reconstruction* (1989; Baton Rouge: Louisiana State University Press, 2000), 7, 43; Hahn, *A Nation under Our Feet*, 177–89; Edward N. Palmer, "Negro Secret Societies," *Social Forces* 23 (December 1944): 207–12; W. E. B. Du Bois, *Economic Co-Operation among Negro Americans* (Atlanta: Atlanta University Press, 1907), 92–127; Katrina Hazzard-Gordon, *Jookin': The Rise of Social Dance Formations in African-American Culture* (Philadelphia: Temple University Press, 1990), 69 nn. 9–10, 193–94; Jacqui Malone, *Steppin' on the Blues: The Visible Rhymes of African American Dance* (Urbana: University of Illinois Press, 1969), 171–75; Charles W. Ferguson, *Fifty Million Brothers: A Panorama of American Lodges and Clubs* (New York: Farrar and Rinehart, 1937), chap. 13, a white racist commentary; William Wells Brown, *My Southern Home; or, The South and Its People* (Boston: A. G. Brown, 1880), 194, a negative evaluation by an African American.

24. Z. R. Pettet and Charles E. Hall, *Negroes in the United States* (1935; New York: Greenwood Press, 1969), 75–76; Jonathan Grossman, "Black Studies in the Department of Labor, 1897–1907," *Monthly Labor Review* (June 1974), available on the Web at www.dol.gov/oasam/programs/history/blackstudiestext.htm; W. E. B. Du Bois Papers, reel 3, Correspondence with U.S. Bureau of Labor, frames 383ff., Nov. 2, 1906, Aug. 30, 1907, May 13, 1908, Du Bois Library, University of Massachusetts, Amherst; David Levering Lewis, *W. E. B. Du Bois, Biography of a Race, 1868–1919* (New York: Holt, 1993), 354; Richard R. Wright, *87 Years behind the Black Curtain:*

An Autobiography (Philadelphia: Rare Book Co., 1965), 158; W. E. B. Du Bois, *The Autobiography of W. E. B. Du Bois: A Soliloquy on Viewing My Life from the Last Decade of Its First Century* (New York: International Publishers, 1968), 226–27. Bill Traylor had probably left Lowndes before these interviews were carried out, but many of his relatives were still there.

25. W. E. B. Du Bois, "The Economic Future of the Negro," *Publications of the American Economic Association,* 3rd ser., 7, no. 1 (February 1906): 234; R. H. Ellis, "The Calhoun School, Miss Charlotte Thorn's 'Lighthouse on the Hill' in Lowndes County, Alabama," *Alabama Review* 37, no. 3 (1984): 183–201. Almost all landowners were men, who were deeded forty- or sixty-acre plots, while a few ten-acre plots were deeded to black women. Within a few more years, more than four thousand acres had been deeded to eighty-five black people.

26. W. E. B. Du Bois, "A Litany at Atlanta," in *The Seventh Son: The Thought and Writings of W. E. B. Du Bois,* ed. Julius Lester (New York: Random House, 1971), 425; Tom Dent, *Southern Journey: A Return to the Civil Rights Movement* (Athens: University of Georgia Press, 2001), 287.

27. "Jim Crow Laws: Alabama," in www.jimcrowhistory.org/insidesouth.cgi?state=Alabama; August Meier and Elliot Rudwick, "The Boycott Movement against Jim Crow Streetcars in the South, 1900–1906," *Journal of American History* 55 (1969): 756, 758, 761, 763, 764.

28. U.S. Census data for 1900 in: http://fisher.lib.virginia.edu/collections/stats/histcensus/php/state.php; Cobb, in Rosengarten, *All God's Dangers,* 8, 35; Leon I. Litwack, *Trouble in Mind: Black Southerners in the Age of Jim Crow* (New York: Knopf, 1998), 364.

29. Guion Griffis Johnson, *Ante-Bellum North Carolina: A Social History* (Chapel Hill: University of North Carolina Press, 1937), 522.

30. Lawrence W. Levine, *Black Culture and Black Consciousness: Afro-American Folk Thought from Slavery to Freedom* (New York: Oxford University Press, 1977); G. White and White, *Stylin'.*

31. Zora Neale Hurston, "Characteristics of Negro Expression," in *Negro: An Anthology,* ed. Nancy Cunard (1934; New York: Ungar, 1969), 45. See John Michael Vlach, *The Afro-American Tradition in Decorative Arts* (1978; Athens: University of Georgia Press, 1990), 44–75.

32. *Quilts of Gee's Bend,* dir. Matt Arnett and Vanessa Vadim, videorecording (Atlanta, Ga.: Tinwood Media, 2002).

33. These ritual practices are generally termed "vodun" in studies of the Guinea Coast, the Slave Coast, and the Bight of Benin in Africa; "vodou" in regard to Haiti; and "voodoo" in New Orleans. By the 1920s, African American conjuration practices disassociated from an organized cult were increasingly referred to as "hoodoo." Africanists have long used the spelling "Kongo" to distinguish the culture shared beyond political borders from the political states called the Congo. Newbell Niles Puckett, *Folk Beliefs of the Southern Negro* (1926; New York: Negro Universities Press, 1968), 165; Donald J. Waters, ed., *Strange Ways and Sweet Dreams: Afro-American Folklore from the Hampton Institute* (Boston: Hall, 1983), 70; F. Roy Johnson, *The Fabled Doctor Jim Jordan: A Story of Conjure* (Murfreesboro N.C.: Johnson Publishing, 1963), 29; Robert Farris Thompson, "Bighearted Power: Kongo Presence in the Landscape and Art of Black America," in *Keep Your Head to the Sky: Interpreting African American Home Ground,* ed. Grey Gundaker (Charlottesville: University of Virginia Press, 1998), 37–64; Kuyk, *African Voices,* xxii, 13, 43, 53–54, 74–77, 80–83, 133–34, 139–41. On the term "Kongo," see Robert Farris Thompson, *Flash of the Spirit: African and Afro-American Art and Philosophy* (New York: Random House, 1983), 103.

34. Georgia Writers' Project (Savannah Unit), Works Projects Administration, *Drums and Shadows: Survival Studies among the Georgia Coastal Negroes* (1940; Athens: University of Georgia Press, 1986), new introduction by Charles Joyner, ix–xxiv, xl, 3, 5, 19, 28, 36, 42, 43, 84, 90, 93, 102, 114, 125, 135, 148, 195–249.

35. Sharla M. Fett, *Working Cures: Healing Health, and Power on Southern Slave Plantations* (Chapel Hill: University of North Carolina Press, 2002), 84–108.

36. Wyatt MacGaffey, *Art and Healing of the BaKongo Commented by Themselves* (Stockholm: Folkens Museum-Etnografiska, 1991), 4, 10–11; Grey Gundaker, correspondence with Mechal Sobel, April 10, 2005; Suzanne Preston Blier, *African Vodun: Art, Psychology, and Power* (Chicago: University of Chicago Press, 1995), 4, 16, 40; Melville J. Herskovits, *Dahomey: An Ancient West African Kingdom* (Evanston: Northwestern University Press, 1967), 2: 305–8; Mark Leone and Gladys-Marie Fry, "Conjuring in the Big House Kitchen: An Interpretation of African American Belief Systems, Based on the Use of Archaeology and Folklore Sources," *Journal of American Folklore* 112, no. 445 (1999): 372–403; Harry Middleton Hyatt, *Hoodoo–Conjuration–Witchcraft–Rootwork: Beliefs Accepted by Many Negroes and White Persons, These Being Orally Recorded among Blacks and Whites*, 5 vols., paginated consecutively (Hannibal, Mo.: Western Publishing, 1970–78), 4157.

37. Several of Hyatt's informants state that Buzzard was a white man who died in the 1920s: Hyatt, *Hoodoo*, 933, 995, 1466, 1469, 1599, 1609, 2260, 4688, 4689. Others referred to white doctors: Hyatt, *Hoodoo*, 906, 908, 920, 1599–1600. Cornelia Walker Bailey and Christena Bledsoe, *God, Dr, Buzzard, and the Bolito Man: A Saltwater Geechee Talks about Life on Sapelo Island* (New York: Doubleday, 2000), 190, suggest Buzzard was an African who "got off the boat" near St. Helena, South Carolina, and began practicing conjure. In *A Revolutionary Soldier* (Clinton, La.: Feliciana Democrat, 1859), James Peter Collins, a white man, documents his consultations with black conjure doctors in the first and second decades of the nineteenth century, and his cure by one of them (15, 16, 127, 141–47, 160–61, 168).

38. Mechal Sobel, *Trabelin' On: The Slave Journey to an Afro-Baptist Faith* (Westport, Conn.: Greenwood Press, 1979), 40, 73, 245. On coherency in hoodoo, see Michael Edward Bell, "Pattern, Structure, and Logic in Afro-American Hoodoo Performance," Ph.D. diss., Indiana University, 1980; David H. Brown, "Conjure/Doctors: An Explanation of a Black Discourse in America, Antebellum to 1940," *Folklore Forum* 23 (1990): 3–46; and Hyatt, *Hoodoo*, 1–19.

39. On small black bottles, see Hyatt, *Hoodoo*, 159, 1391, 1604, 1605, 1256, 1708, 1793; on purse or grip, see 1391, 1459, 1604. The index to Hyatt's five volumes on hoodoo, incomplete at his death, was not published, but the Ph.D. dissertation by Bell, "Pattern, Structure, and Logic in Afro-American Hoodoo Performance," a study of Hyatt's work on hoodoo, provides an analytic index through the extensive footnotes organized by key words.

40. David Ross, January 1987, in Kuyk, *African Voices*, 167, 190. On the Yoruba staff, see Henry John Drewal, "Art and Divination among the Yoruba: Design and Myth," *Africana Journal* 14 (1987): 139–56. For a Nigerian diviner's bag, see Alisa LaGamma, *Art and Oracle: African Art and Rituals of Divination* (New York: Metropolitan Museum of Art, 2000), 53. On American conjurer's' bags, see Hyatt, *Hoodoo*, 1391, 1459, 1536, 1604; Leonora Herron and Alice M. Bacon, "Conjuring and Conjure-Doctors in the Southern United States," *Southern Workman and*

Hampton School Record 24 (1895), 361; Puckett, *Folk Beliefs*, 202; and Kuyk, *African Voices*, 11–15, 147–48, 151–54, 198.

41. Grey Gundaker, *Signs of Diaspora/Diaspora of Signs: Literacies, Creolization, and Vernacular Practice in African America* (New York: Oxford University Press, 1998), 22–26. A Doctor Caffrey referred to himself as "a two-headed man" in Hyatt, *Hoodoo*, 1459, 4241. Puckett, *Folk Beliefs*, 201.

42. See Fett, *Working Cures*, 37–40, 84–108; MacGaffey, *Religion and Society in Central Africa: The BaKongo of Lower Zaire* (Chicago: University of Chicago Press, 1986), 218.

43. Hyatt, *Hoodoo*, 1172–78; MacGaffey, *Art and Healing*, 6; Thompson, *Flash of the Spirit*, 107, 117–31l; Anita Jacobson-Widding, "The Encounter in the Water Mirror," in *Body and Space: Symbolic Models of Unity and Division in African Cosmology and Experience*, ed. Jacobson-Widding (Stockholm: Almquist and Wiksell International, 1991), 203.

44. Hyatt, *Hoodoo*, 1386–401. In 1910, there was just one black man over sixty named Charles Jackson in the Alabama census: Charles Jackson in Marion, in Perry County, who was seventy-four years old. In 1920, his age was recorded as eighty. By 1930, he was not in the census, and was probably dead.

45. Puckett, *Folk Beliefs*, 255–56. On mojos or hands, see Hyatt, *Hoodoo*, 519–669, 1035, 1056, 1256, 1297, 1312, 1723; Loudell F. Snow, *Walkin' Over Medicine* (Detroit: Wayne State University Press, 1998), 108; MacGaffey, *Art and Healing*, 5; D. Brown, "Conjure/Doctors," 26–35.

46. On the creation and function of a worldview, see Thomas Luckmann, *The Invisible Religion: The Problem of Religion in Modern Society* (New York: Macmillan 1967), 53; Sobel, *Trabelin' On*, 3–5; Hyatt, *Hoodoo*, 40, 1173, 1174, 1220, 1265, 1266, 1460, 2619, 2817, 2831, 2966, 3051, 3197, 3193; Zora Neale Hurston, *Mules and Men* (1935; Bloomington: Indiana University Press, 1978), 211; Grey Gundaker and Judith McWillie, *No Space Hidden: The Spirit of African American Yard Work* (Knoxville: University of Tennessee Press, 2005), 195; Washington, quoted in the Georgia Writers' Project (Savannah Unit), *Drums and Shadows*, 135.

47. A seventeenth-century Bakongo brass crucifix depicts Christ wearing an apron with a large *X* on it (Vlach, *The Afro-American Tradition in Decorative Arts*, 45, fig. 18). On the cross within a circle, see: Robert Farris Thompson and Joseph Cornet, *The Four Moments of the Sun: Kongo Art in Two Worlds* (Washington, D.C.: National Gallery of Art, 1981), 28; Kuyk, *African Voices*, 74–77, 178, 188, 192; K. K. Bunseki Fu-Kiau, *African Cosmology of the Bântu-Kôngo: Tying the Spiritual Knot, Principles of Life and Living*, 2nd ed. (Brooklyn, N.Y.: Anthelia Henrietta Press, 2001), 158–59. Fu-Kiau notes that in Kongo culture, the cosmogram circle represents both the "paths of the sun and the human soul," and that everything in the daily life of Kongo society can be understood as related to this cosmology (Fu-Kiau, *Tying the Spiritual Knot*, 25–29, 38–39, 158–59; K. K. Bunseki Fu-Kiau, "Ntangu-Tandu-Kolo: The Bantu-Kongo Concept of Time," in *Time in the Black Experience*, ed. Joseph K. Adjaye [Westport, Conn.: Greenwood Press, 1994], 24–25). Robert Farris Thompson, "Siras Bowens of Sunbury, Georgia: A Tidewater Artist in the Afro-American Visual Tradition," in *Chant of Saints: A Gathering of Afro-American Literature, Art, and Scholarship*, ed. Michael S. Harper and Robert B. Steptoe (Urbana: University of Illinois Press, 1979), 230–40; Thompson and Cornet, *The Four Moments*, 152; Gundaker, *Signs*, 44–45, 71–75, 93–94. For cosmograms found at slave sites, see Kenneth L. Brown, "Material Culture

and Community Structure: The Slave and Tenant Community at Levi Jordan's Plantation, 1848–
1892," in *Working toward Freedom: Slave Society and Domestic Economy in the American South*, ed.
Larry E. Hudson Jr. (Rochester, N.Y.: University of Rochester Press 1994), 95–118; J. W. Joseph,
Theresa M. Hamby, and Catherine S. Long, *Historical Archaeology in Georgia*, Georgia Archaeo-
logical Research Design Papers 14 (Athens: University of Georgia Press, 2004), 85–86; Mathew
David Cochran, "Hoodoo's Fire: Interpreting Nineteenth-Century African-American Material
Culture at the Brice House, Annapolis, Maryland," *Maryland Archaeology* 35, no. 1 (1999): 25–33;
Leone and Fry, "Conjuring in the Big House Kitchen." On color significance, see Judith McWillie,
correspondence with Mechal Sobel, May 24, 2006. Kara Ann Morrow, "Bakongo Afterlife and
Cosmological Direction: Translation of African Culture into North Florida Cemeteries," *Athanor*
20 (2002): 105–15.

48. Hyatt, *Hoodoo*, 1708, 3223, 162–63; Puckett, *Folk Beliefs*, 157, 242–44.

49. Antoinette Beeks, interview by Mechal Sobel, April 27, 2004, Atlanta, Ga.

50. Khiru Nzegwu, curator, "Abakua: Nsibidi Motifs In Cuba," *Ijele: Art eJournal of the African
World*, no. 4 (2002), www.africaresource.com/ijele/issue4/toc4.htm/; Muneera Umedaly Spence,
"Nsibidi and Vai: A Survey of Two Indigenous West African Scripts," master's thesis, Yale Univer-
sity, 1979, 13; Thompson, *Flash of the Spirit*, 245; *Man/Bars*, in Maresca and Ricco, *Bill Traylor*, 41;
Thompson, *Flash of the Spirit*, 257; Gundaker, *Signs*, 11–13, 42–44, 53–54, 71–73; Kuyk, *African
Voices*, 130–98.

51. Shane White set me straight on the early history of playing the numbers. See Ann Fabian,
Card Sharps, Dream Books, and Bucket Shops: Gambling in Nineteenth-Century America (Ithaca:
Cornell University Press, 1990), 8–9, 136–50; Puckett, *Folk Beliefs*, 190; Gundaker, *Signs*, 152–53;
John Drzazga, "Gambling and the Law. Policy," *Journal of Criminal Law, Criminology, and Police
Science* 44, no. 5. (1954): 665–70; Bailey and Bledsoe, *God, Dr. Buzzard, and the Bolito Man*, 145–
56; Mary A. Owen, "Among the Voodoos," *Papers and Transactions*, ed. Joseh Jacobs and Alfred
Nutt. International Folk-lore Congress, 1891 (London, 1892), 231; Cobb, in Rosengarten, *All God's
Dangers*, 7; *Aunt Sally's Policy Players' Dream Book and Wheel of Fortune* (1899; Los Angeles: Indio
Products, 1997), 5–35; catherine yronwode, "Hoodoo in Theory and Practice: An Introduction
to African-American Rootwork," 1995–2003, "Aunt Sally's Policy Players Dream Book," www
.luckymojo.com/hoodoo.html.

52. Gosse, *Letters from Alabama*, 253; *Aunt Sally's*, 28; Mechal Sobel, *Teach Me Dreams: The
Search for Self in the Revolutionary Era* (Princeton: Princeton University Press, 2000), 193–94,
236, 294 n. 76, 295 n. 78, 306 n. 88.

53. Thompson and Cornet, *The Four Moments*, 165–77; Robert Farris Thompson, "Kongo
Influences on African-American Artistic Culture," *Africanisms in American Culture*, ed. Joseph
Holloway (Bloomington: University of Illinois Press, 1990), 148–84; William Pollitzer, *The Gul-
lah People and Their African Heritage* (Athens: University of Georgia Press, 1999), 162–64; Gun-
daker, *Signs*, 44–45, 67, 71–73; Clémentine M. Faïk-Nzuji, *Tracing Memory: A Glossary of Graphic
Signs and Symbols in African Art and Culture* (Quebec: Canadian Museum of Civilization, 1996),
32, 144, 148, 161, 167; New Orleans Mistic, "White, Red, Green, Black and Purple Spells," www
.neworleansmistic.com/freespells.htm.

54. Shannon, in Maresca and Ricco, "Remembering Bill Traylor," 14.

55. Henry Green's son, "Autobiography II: A Preacher from a God-fearing Plantation," in Clifton H. Johnson, ed., *God Struck Me Dead: Religious Conversion Experiences and Autobiographies of Ex-Slaves* (1945; Philadelphia: Pilgrim Press, 1969), 90; Darline Clark Hine, "Rape and the Inner Lives of Black Women in the Middle West: Preliminary Thoughts on the Culture of Dissemblance," *Signs* 14 (1989): 912–20; Michele Mitchell, "Silences Broken, Silences Kept: Gender and Sexuality in African-American History," *Gender and History* 11, no. 3 (1999): 433–44; Deborah Gray White, *Ar'n't I a Woman? Female Slaves in the Plantation South*, 2nd rev. ed. (New York: Norton, 1999), 3–29.

56. Rev. Israel Massie, in Charles L. Perdue Jr., Thomas E. Barden, and Robert K. Phillips, eds., *Weevils in the Wheat: Interviews with Virginia Ex-Slaves* (Charlottesville: University of Virginia Press, 1976), 206–8.

57. Lisa Cardyn, "Sexualized Racism/Gendered Violence: Outraging the Body Politic in the Reconstruction South," *Michigan Law Review* 100 (2002): 716–35. A black couple adopted Mimia Traylor's baby, and she did not learn of her birthmother and other kin until she was seventeen. See Myrtha Lee Traylor Delks, in Traylor Family, *Traylor-Calloway-Durant Family Reunion* (booklet), 1992.

58. K. K. Bunseki Fu-Kiau, interview by Mechal Sobel, May 23, 2001, Haifa, Israel.

59. Sterling Stuckey, *Slave Culture: Nationalist Theory and the Foundations of Black America* (New York: Oxford University Press, 1987); Traylor, Diary, Feb. 5, 1837, Aug. 13–14, 1844. Williadean Crear, then a student at a Black Baptist Seminary, was my research assistant in April 2003. She commented that Benton Black Baptist Church seemed "more like a foreign country" when she joined me at a service there. A young man giving testimony to his recent spiritual experiences at this service was dressed in a cobalt blue suit, shirt, and socks, the color that Traylor painted with and hoodooists widely used in rituals, an outward sign of the older practices still followed.

60. Thomas Wentworth Higginson, *Army Life in a Black Regiment* (1900; New York: Collier Press, 1962), 41.

61. John Dove (1792–1876), *The Virginia Text-book: Containing a history of masonic grand lodges, and the constitution of masonry, or ahiman rezon, together with a digest of the laws, rules, and regulations of the Grand Lodge of Virginia, also, a complete compilation of the illustrations of masonic work. . . .* (1846; Richmond, 1866), 157–58. A copy of Dove's text is available on the Web at http://quod.lib.umich.edu/cgi/t/text/text-idx?c=moa;idno=AHK6880. For the history of the Prince Hall adoption of Dove's text, see Allen Roberts, "Who Are These Prince Hall Masons?" (2005), www.indianafreemasons.com/imomiddle/prince.html. David G. Hackett, "The Prince Hall Masons and the African American Church: The Labors of Grand Master and Bishop James Walker Hood, 1831–1918," *Church History* 69, no. 4 (2000): 777, 780, 782; Joanna Brooks, "The Early American Public Sphere and the Emergence of a Black Print Counterpublic," *William and Mary Quarterly* 62 (2005): 78–85.

62. Daniel Béresniak, *Symbols of Freemasonry* (1997; New York, 2000), 8.

63. Joanna Brooks, "Prince Hall, Freemasonry, and Genealogy, " *African American Review* 34 (2000): 199; Maurice Wallace, "'Are We Men?': Prince Hall, Martin Delany, and the Masculine Ideal in Black Freemasonry, 1775–1865," *American Literary History* 9 (Autumn 1997): 396–424;

Martin Delany, *The Origin and Objects of Ancient Freemasonry: Its Introduction into the United States and Legitimacy among Colored Men* (1853; Xenia, Ohio, 1904), www.libraries.wvu.edu/delany/masint.htm; Corey D. B. Walker, "The Freemasonry of the Race: The Cultural Politics of Ritual, Race, and Place in Postemancipation Virginia," Ph.D. diss., College of William and Mary, November 2001.

64. Prince Hall, "A Charge Delivered to the Brethren of the African Lodge at the Hall of Brother William Smith in Charleston" (Boston: 1792), reprinted in David L. Gray, *Inside Prince Hall* (Lancaster, Va.: Anchor Communications LLC, 2003), 52.

65. Hall, "A Charge Delivered," 52; Béresniak, *Symbols of Freemasonry,* 50, 52; George H. Steinmetz, *Freemasonry: Its Hidden Meaning* (Richmond, Va.: Macoy Pub. and Masonic Supply Co., 1948), 202.

66. William A. Muraskin, *Middle-Class Blacks in a White Society: Prince Hall Freemasonry in America* (Berkeley and Los Angeles: University of California Press, 1975); Loretta J. Williams, *Black Freemasonry and Middle-Class Realities* (Columbia: University of Missouri Press, 1980). Moses Bondy, secretary of the Most Worshipful Prince Hall Grand Lodge of Alabama (MWPHGL), Birmingham, Ala., provided information on the Benton Lodge via telephone, April 20, 2003. The Old Oakwood Cemetery, in Montgomery Alabama, has a number of pre–Civil War black graves with Masonic symbols on the gravestones. Statistics from William H. Grimshaw, *Official History of Freemasonry among the Colored People in North America* (1903; New York: Negro Universities Press, 1969), 67–83, 288–90; Hackett, "The Prince Hall Masons," 785 n. 46.

67. Du Bois , *Economic Co-Operation,* 109–27; Howard W. Odum, *Social and Mental Traits of the Negro: Research into the Conditions of the Negro in Southern Towns, a Study in Race Traits, Tendencies and Prospects* (New York: Columbia University, 1910), 267; Levine, *Black Culture and Black Consciousness,* 268.

68. Betty M. Kuyk, "The African Derivation of Black Fraternal Orders in the United States," *Comparative Studies in Society and History* 25, no. 4 (1983): 559–92; Tera W. Hunter, *To 'Joy My Freedom': Southern Black Women's Lives and Labors after the Civil War* (Cambridge: Harvard University Press, 1997), 70–73; John F. Szwed, *Space Is the Place: The Lives and Times of Sun Ra* (New York: Da Capo Press, 1998), 14; Nancy R. Ping, "Black Musical Activities in Antebellum Wilmington, North Carolina," *Black Perspective in Music* 8, no. 2 (Fall 1980): 139; Gray, *Inside Prince Hall,* 104; Woodruff, *American Congo,* 83–84, 107–13, 134, 166. *Social Science History* 28, no. 3 (2004) is devoted to fraternal organizations, with contributions including: Joe W. Trotter, "African American Fraternal Organizations in American History: An Introduction," 355–66; Bayliss J. Camp and Orit Kent, "'What a Mighty Power We Can Be': Individual and Collective Identity in African American and White Fraternal Initiation Rituals," 439–83; Theda Skocpol and Jennifer Lynn Oser, "Organization Despite Adversity: The Origins and Development of African American Fraternal Associations," 367–437.

69. Grey, *Inside Prince Hall,* 136.

70. Thompson, *Flash of the Spirit,* 245; Kuyk, *African Voices,* 149; Grimshaw, *Official History of Freemasonry,* 335. Traylor's painting with fourteen rungs on a ladder titled *Figure/Construction, Man Stealing Liquor* is in Maresca and Ricco, *Bill Traylor,* 70. Joe Minter, interview by Mechal Sobel, April 10, 2003.

71. Geoffrey Parrinder, *West African Psychology: A Comparative Study of Psychological and Religious Thought* (London: Lutterworth Press, 1951), 17, 18; Blier, *African Vodun*, 198; Jacobson-Widding, "The Encounter in the Water Mirror," 195; Clifton H. Johnson, *God Struck Me Dead*, 63, 151; Sobel, *Trabelin' On*, 108–11; Harold Bloom, *The American Religion: The Emergence of the Post-Christian Nation* (New York: Simon and Schuster, 1992), 238–43; Ruth Bass, "The Little Man," *Scribner's Magazine* 97 (February 1935) : 120–23, reprinted in *Mother Wit from the Laughing Barrel: Readings in the Interpretation of Afro-American Folklore*, ed. Alan Dundes (New York: Garland, 1981), 388–96.

72. William Ferris, "Vision in Afro-American Folk Art: The Sculpture of James Thomas," *Journal of American Folklore* 88: 348 (April–June 1975): 115–16 n. 5; Ferris, "If You Ain't Got It in Your Head, You Can't Do It in Your Hand: James Thomas, Mississippi Delta Folk Sculptor," *Studies in the Literary Imagination* 3 (1970): 89–107; Sobel, *Teach Me Dreams*, 42–48; Puckett, *Folk Beliefs*, 109–10, 188, 220, 328, 469; Georgia Writers' Project (Savannah Unit), *Drums and Shadows*, 5, 72, 78, 92; Staffney, interviews by Sobel.

73. Kuyk, *African Voices*, 145, 195–98; Sallie Traylor: U.S. Census, 1900, Alabama, Lowndes County, Benton; Sarah B. Howard: U.S. Census, 1930 Census, Alabama, Montgomery.

2. "SEEM LIKE MURDER HERE" (1904–1928)

1. Ned Cobb, called Nate Shaw in Rosengarten, *All God's Dangers*, 545; Bill Traylor, quoted in Maresca and Ricco, "Remembering Bill Traylor," 8.

2. Kuyk, *African Voices*, 167, 170; Jesse Jackson, born ca. 1886: U.S. Census, 1920, Alabama, Lowndes County, Benton.

3. Kuyk, *African Voices*, 170; Hyatt, *Hoodoo*, 283, 4311, 1729, 1772; Shannon in Maresca and Ricco, "Remembering Bill Traylor," 12.

4. Kuyk, *African Voices*, 170.

5. Hyatt, *Hoodoo*, 1686.

6. Myrtha Delks and Margaret Staffney, interview by Miriam Fowler and Marcia Webber, second Traylor family reunion, 1992, Atlanta, Ga. (tape on file at the Alabama State Council of the Arts, Montgomery).

7. *Mother with Child*, in Maresca and Ricco, *Bill Traylor: His Art, His Life*, 111; words on verso.

8. On family violence, see: Rosengarten, *All God's Dangers*, 6, 9, 10, 14, 17, 18–20, 22, 23, 56–57, 88, 270–71; Penny Young, *Survival: The Will and the Way* (San Francisco: Vantage Press, 2003), 33, 70, 80–81; Hosea Hudson, *The Narrative of Hosea Hudson: His Life as a Negro Communist in the South*, ed. Nell Irvin Painter (Cambridge: Harvard University Press, 1979), 59; Charles S. Johnson, *Shadow of the Plantation*, 57–70, 187, 189–92; Charles Denby [Matthew Ward], *Indignant Heart: A Black Worker's Journal* (1952; Boston: South End Press, 1978), 1–12, 85–86; Ralph Luker, "Documenting Vernon Johns," posted Cliopatria blog, April 19, 2004, http://hnn.us/blogs/entries/4722.html; Luker, "Murder and Biblical Memory: The Legend of Vernon Johns," *Virginia Magazine of History and Biography* 112, no. 4 (2005): 372–418; Cardyn, "Sexualized Racism," 834–58; Sheldon Hackney, "Southern Violence," *American Historical Review* 74 (1969): 906–25.

9. David Honeyboy Edwards, in Adam Gussow, *Seems Like Murder Here: Southern Violence and the Blues Tradition* (Chicago: University of Chicago Press, 2002), 6; Zora Neale Hurston, *The Sanctified Church* (Berkeley: Turtle Island, 1983), 21; Hyatt, *Hoodoo*, "How Murderer Can Escape," 3241–58; ibid., "How Murderer Can Be Caught," 3258–93.

10. In the 1980s, Shannon contacted Rosa Traylor, the widow of one of the sons of Marion Traylor and the family historian, and found that she then knew very little about Bill Traylor, and was glad to have the information that Shannon thought was correct; she repeated it in her contacts with the press and Bill Traylor's relatives. None of the white Traylors who could have contradicted these data was alive. In numerous interviews and articles, Shannon continued to report that Traylor had stayed in Benton from his birth to the late 1930s, and that he had died in 1947. These incorrect dates are still widely reprinted by critics and in museum catalogues.

11. Bill Traylor's move to Montgomery County by 1910 was first uncovered by Miriam Fowler and Marcia Weber. (The Bill Traylor family was recorded both as Taylor and Trailor in the 1910 census, leading investigators to assume Bill Traylor was not in that record.) Miriam Fowler, "A Glimpse at William "Bill" Traylor," in O'Kane Gallery, *Bill Traylor* (Houston: University of Houston, O'Kane Gallery, 2001), n. 11. The new household included Rueben, Easter, Alice, and Lillian, children of Bill Traylor's first wife, and Larcey (Laura) Williams's daughter Nellie Williams, as well as four sons born to Laura and Bill Traylor: Clement (born in 1895), Will (1901), Mack (1903), and John (1908). Traylor family (Taylor and Trailor): U.S. Census, 1910, Alabama, Montgomery County, Kendall.

12. Lynda Roscoe Hartigan, "Going Urban: American Folk Art and the Great Migration," *American Art* 14, no. 2 (Summer 2000): 48; Malone, *Steppin' on the Blues*, 63; Eleanor J. Baker, "Silas Green Show," and Charles Reagan Wilson, "Traveling Shows," in *Encyclopedia of Southern Culture*, ed. Wilson and William Ferris (Chapel Hill: University of North Carolina Press, 1989), 223–24, 1247–49. On the music in Birmingham, see Szwed, *Space Is the Place*, 11–17. On mobility and changing musical taste, see Work, Jones, and Adams, *Lost Delta Found*, 84, 266–72.

13. Hurston, "Characteristics of Negro Expression," 44; Birney Imes, *Juke Joint: Photographs* (Jackson: University Press of Mississippi, 2002), 4–5; Sobel, *Trabelin' On*, 139–218.

14. Charles Peabody, "Notes on Negro Music," *Journal of American Folklore* 16, no. 62 (July 1903): 148–52; Michael Taft, *Talkin' to Myself: Blues Lyrics, 1920–1942* (1983; New York: Routledge, 2005), xii; *Oxford English Dictionary*, 2nd ed. (1989); Albert Murray, *Stomping the Blues* (1976, New York: Da Capo Press, 1987), 69; Christopher Small, *Music of the Common Tongue: Survival and Celebration in African American Music* (1987; Hanover, N.H.: University Press of New England, 1998), 50, 197–215. On hearing and making early blues, see: Jeff Todd Titon, *Early Downhome Blues: A Musical and Cultural Analysis* (1977; Chapel Hill: University of North Carolina Press, 1994), 3–29; Giles Oakley, *The Devil's Music: A History of the Blues* (New York: Harcourt Brace Jovanovich, 1976), 1–53; Abbe Niles in W. C. Handy, ed., *A Treasury of the Blues: Complete Words and Music of 67 Great Songs from Memphis Blues to the Present Day*, with text by Abbe Niles (1926; New York: Charles Boni, 1949), 11, 52–54, 240; David Evans, *Big Road Blues: Tradition and Creativity in the Folk Blues* (Berkeley and Los Angeles: University of California Press, 1982), 32–38; Peter R. Aschoff, "The Poetry of the Blues: Understanding the Blues in Its Cultural Context," in *The Triumph of the Soul: Cultural and Psychological Aspects of African American Music,*

ed. Ferdinand Jones and Arthur C. Jones (Westport, Conn.: Praeger, 2001), 35–68; Michael Taft, *Blues Lyric Poetry: A Concordance,* 3 vols. (New York: Garland, 1984), vol. 1, introduction, www .dylan61.se/Preface_Concor/4.3%20PREFACEConcordance.htm. For biblical proverbs in blues, see Anand Prahlad, *African American Proverbs in Context* (Jackson: University Press of Mississippi, 1996), 77–118.

15. Howard W. Odum, "Folk-Song and Folk-Poetry: As Found in the Secular Songs of the Southern Negroes," *Journal of American Folklore* 24 (1911): 267, 272–73, 351–96; Howard W. Odum and Guy Benton Johnson, *The Negro and His Songs: A Study of Typical Negro Songs in the South* (Chapel Hill: University of North Carolina Press, 1925); Lynn Moss Sanders, *Howard W. Odum's Folklore Odyssey: Transformation to Tolerance through African American Folk Studies* (Athens: University of Georgia Press, 2003), 30.

16. Odum, "Folk-Song and Folk-Poetry," 259; Paul Oliver, *Songsters and Saints: Vocal Traditions on Race Records* (Cambridge: Cambridge University Press, 1984), 20.

17. Evans, *Big Road Blues,* 18, 32, 53–4; Paul Oliver, *The Story of the Blues* (London: Barrie and Rockliff, Cresset Press, 1969), 6; Samuel Charters, *Poetry of the Blues* (New York: Oak, 1963), 17–18, 58; James H. Cone, *The Spirituals and the Blues: An Interpretation* (1972; Maryknoll, N.Y.: Orbis Books, 2008), 103; Murray, *Stomping the Blues,* 250–51.

18. David Evans, "The Development of the Blues," in *The Cambridge Companion to Blues and Gospel Music,* ed. Allan Moore (Cambridge: Cambridge University Press, 2002), 20–43.

19. William Ferris, *Blues from the Delta* (Garden City, N.Y.: Anchor Press/Doubleday, 1979), 101–3; Ellen King speaking with Mary A. Poole in *Alabama and Indiana Narratives,* vol. 6 of *The American Slave: A Composite Autobiography,* ed. George P. Rawick, 19 vols. (1941; Westport, Conn.: Greenwood Press, 1972), 249.

20. Hall, called Nora in Alan Lomax, *The Rainbow Sign: A Southern Documentary* (New York: Duell, Sloan and Pearce, 1959), 61–63. Lomax's full 1948 interview with Hall, ed. Gabriel Greenberg, is in the Library of Congress Lomax Collection on the Web at www.lomaxarchive.com/ index.html. Greenberg also wrote "'Like a Spirit on the Water': The Life and Music of Vera Hall," which was on the Web in 2003.

21. Vera Hall, interview by Alan Lomax, reel 9, p. 6, Lomax Collection, Association for Cultural Equity, Hunter College, New York City; Nora [Hall], in Lomax, *The Rainbow Sign,* 62–69, 107.

22. Nora [Hall], in Lomax, *The Rainbow Sign,* 109–12.

23. Ibid., 64.

24. E. C. Perrow, "Songs and Rhymes from the South," *Journal of American Folklore* 25 (1912): 155; Burgin Mathews, "'Looking for Railroad Bill': On the Trail of an Alabama Badman," *Southern Cultures* 9, no. 3 (2003): 66–88.

25. The position of Samuel Charters, that "there is little social protest in the blues," has been widely cited. Charters, *The Poetry of the Blues,* 152; Gussow, *Seems Like Murder Here,* 161–62, 171–83, 191–93; Leadbelly (Huddie Ledbetter), in Guido Van Rijn, *Roosevelt's Blues: African-American Blues and Gospel Songs on FDR* (Jackson: University Press of Mississippi, 1997), 135; Lawrence Gellert, *Negro Songs of Protest,* scores by Elie Siegmeister (New York: American Music League, 1936); Gellert, *"Me and My Captain" (Chain Gangs): Negro Songs of Protest,* scores by Lan Adomian (New York: Hours Press, 1939).

26. Bruce Michael Harrah-Conforth, "Laughing Just to Keep from Crying: Afro-American Folksong and the Field Recordings of Lawrence Gellert" (master's thesis, Indiana University, 1984), 21–59; "Songs of Protest," *Time Magazine*, June 15, 1936, www.time.com/time/magazine/article/0,9171,756315,00.html.

27. Bruce Michael Harrah-Conforth, liner notes for *Nobody Knows My Name: Blues from South Carolina and Georgia*, Heritage Records 304, 1984, reprinted on www.wirz.de/music/gellefrm.htm; Conforth, "The Field Recordings of Lawrence Gellert," *Resound: A Quarterly of the Archives of Traditional Music* 2, no. 4 (October 1983): 1–2; Harrah-Conforth, "Laughing Just to Keep from Crying," 38, 47, 50.

28. Lawrence Gellert, "Negro Songs of Protest: North and South Carolina and Georgia," in *Negro: An Anthology*, collected and ed. Nancy Cunard; ed. and abridged Hugh Ford (New York: Ungar, 1970), 227, 229.

29. "Work All De Summer," "Cause I'm a Nigger," in Gellert, *Negro Songs of Protest*, 19, 42–44.

30. Gellert, *"Me and My Captain" (Chain Gangs)*, 30.

31. "Sistren an' Brethren," in Gellert, *Negro Songs of Protest*, 10–11; Gellert, "Negro Songs of Protest: North and South Carolina and Georgia"; Sterling Brown, *Negro Poetry and Drama* (1937; New York: Arno Press, 1969), 27–29; Sterling Brown, "The Blues," *Phylon* 13 (1952): 286–92; Gellert, "Negro Songs of Protest," *Music Vanguard* 1, no. 1 (1935): 13; Steven Garabedian, "Reds, Whites, and the Blues: Lawrence Gellert, 'Negro Songs of Protest,' and the Left-Wing Folk Song Revival of the 1930s and 1940s," *American Quarterly* 57, no. 1 (2005): 182; Richard A. Reuss and JoAnne C. Reuss, *American Folk Music and Left-Wing Politics, 1927–1957* (Lanham, Md.: 2000), 136. See chap. 2 of Zachary Kilpatrick, "'I Ain't Gonna Be Your Old Work Ox No More': Black Work Songs, Folk Collectors, Protest, and Their Influence on the Black Rights Movement in the 20th Century" (honors' thesis, Rice University, 2005), www.math.utah.edu/~kilpatri/opening.pdf. "Tamiris, Helen," in Britannica Online, www.britannica.com/eb/article-9071116/Helen-Tamaris; Howard Rye, liner notes for *Field Recordings*, vol. 9, *Georgia, South Carolina, North Carolina, Virginia, Kentucky, 1924–1939*, Document Record 5599 (1998); David Margolick, *Strange Fruit: Billy Holiday, Cafe Society, and an Early Cry for Civil Rights* (Philadelphia: Running Press, 2000), 21.

32. Steven Garabedian, "Red, Whites, and the Blues: Blues Music, White Scholarship, and American Cultural Politics" (Ph.D. diss., University of Minnesota, 2004); Lawrence Gellert interviews by Richard A. Reuss, August 31, 1966, March 28, 1968, May 7, 1968, June 25, 1969, and September 11, 1969, Archives of Traditional Music, Indiana University, Bloomington; Conforth, "The Field Recordings of Lawrence Gellert"; Harrah-Conforth, "Laughing Just to Keep from Crying."

33. *E. D. Nixon: The Forgotten Hero*, dir. Tom C. Leonard, videorecording (Montgomery: Office of Information Technology–Media Production Group, Auburn University and Alabama State University, 1982), www.montgomeryboycott.com/bio_ednixon.htm; Edgar Daniel Nixon, interview by Steven M. Millner, January 17, 1979, in Millner, "The Montgomery Bus Boycott: A Case Study in the Emergence and Career of a Social Movement," in *The Walking City: The Montgomery Bus Boycott, 1955–1956*, ed. David J. Garrow (Brooklyn, N.Y.: Carlson, 1989), 418, xviii; David J. Garrow, "The Origins of the Montgomery Bus Boycott," in *The Walking City*, ed. Garrow, 609.

There are 133 songs from Gellert's collection reprinted in Harrah-Conforth, "Laughing Just to Keep from Crying," 168–338. Between 1967 and 1976, William R. Ferris Jr. recorded many songs in the Mississippi Delta that were still not performed in a public venue if whites might be in the audience. Ferris, "Racial Repertoires among Blues Performers," *Ethnomusicology* 14 (September 1970): 441; Ferris, *Blues from the Delta,* xi, 12, 14, 91–97.

34. Lawrence Gellert, "Two Songs about Nat Turner," *Worker Magazine,* June 12, 1949, 8, emphasis added. On the wheel as a symbol of the world "moverin' around," see Gundaker and McWillie, *No Space Hidden,* 31, 195.

35. "Work Ox," in Gellert, *"Me and My Captain" (Chain Gangs),* 7.

36. catherine yronwode, whose extensive collections of data and commentary on hoodoo are on the Web, chooses to write her name without any capital letters (yronwode, "Blues Lyrics and Hoodoo," www.luckymojo.com/blues.html#topics%22).

37. Carl Carmer, *Stars Fell on Alabama* (1934; Tuscaloosa: University of Alabama Press, 2000), 195–232; Barry Lee Pearson, "Appalachian Blues," *Black Music Research Journal* 23, no. 1–2 (Spring–Fall 2003): 26, 28, 29, 32, 34, 38. 39, 47; Oliver, *The Story of the Blues,* 41, 51.

38. Maude Southwell Wahlman, "The Art of Bill Traylor," in *Bill Traylor (1854–1947)* (Little Rock: Arkansas Arts Center, 1982), n.p.; Wahlman, "Bill Traylor: Mysteries," in *Souls Grown Deep: African American Vernacular Art of the South,* vol. 1, *The Tree Gave the Dove a Leaf,* ed. Paul Arnett and William Arnett (Atlanta: Tinwood Books, 2000), 276–78; Kuyk, *African Voices,* 11–14, 117, 147–48, 151, 153–54, 162, 168, 177, 198. A photo of the Baron Samedi statue is in C. Kirk Dewhurst, Betty MacDowell and Marcia MacDowell, *Religious Folk Art in America: Reflections of Faith* (New York: Dutton, 1983), 77, catalogue no. 106. See also catherine yronwode, www .luckymojo.com/blues.html; F. Johnson, *The Fabled Doctor Jim Jordan,* 2; Waters, *Strange Ways and Sweet Dreams,* 227; and Puckett, *Folk Beliefs,* 19–20.

39. Howard Dodson and Sylviane A. Diouf, eds., *In Motion: The African-American Migration Experience* (New York: Schomburg Center for Research in Black Culture, 2005); Paul Lachance, "Repercussions of the Haitian Revolution in Louisiana," in *Impact of the Haitain Revolution in the Atlantic World,* ed. David P. Geggus (Columbia: University of South Carolina Press, 2001), 209–30; Hyatt, *Hoodoo,* 1: xxx.

40. Haitian portrayals of Baron Samedi are in Laennec Hurbon, *Voodoo: Search for the Spirit* (1993; New York: Abrams, 1995), 72–75; Alfred Metraux, *Voodoo in Haiti* (1959; New York: Schocken Books, 1972), plate 5, which clearly shows burial tools similar to those in Traylor's *WPA Poster* in Maresca and Ricco, *Bill Traylor,* 67; Zora Neale Hurston, *Voodoo Gods: An Inquiry into Native Myths and Magic in Jamaica and Haiti* (London: Dent, 1939), 210–17. Kuyk, *African Voices,* 14, 204 n. 32, cites fragmentary evidence of knowledge of the Spirit of Death in Alabama.

41. Zora Neale Hurston, "Hoodoo in America," *Journal of American Folklore* 44 (1931): 326–89; Hurston, *Mules and Men,* 193, 195, 200; Robert E. Hemenway, *Zora Neale Hurston: A Literary Biography* (1977; Urbana: University of Illinois Press, 1980), 123.

42. I have chosen to use the names given in the 1935 version of *Mules and Men* (1935; Bloomington: Indiana University Press, 1978), 209–15, rather than those in Hurston's article "Hoodoo in America," *Journal of American Folklore* 44 (1931): 317–417. On this choice, see Valerie Boyd, *Wrapped in Rainbows: The Life of Zora Neale Hurston* (New York: Scribner, 2003), 460 n. 179;

Hurston to Langston Hughes, April 3, 1929, in Carla Kaplan, ed., *Zora Neale Hurston: A Life in Letters* (New York: Doubleday, Macmillan, 2002), 137.

43. Anatol Pierre in Hurston, *Mules and Men*, 217.

44. Carolyn Morrow Long, "Perceptions of New Orleans Voodoo: Sin, Fraud, Entertainment, and Religion," *Nova Religio* 6, no. 1 (October 2002), 86–101; Carolyn Morrow Long, *Spiritual Merchants: Religion, Magic and Commerce* (Knoxville: University of Tennessee Press, 2001), 53–66. Traylor paintings of busts: *Truncated Blue Man with Pipe* and *Blue Man atop Construction*, in *Bill Traylor: Observing Life* (New York: Ricco/Maresca Gallery, 1997), 27, 64. The New Orleans statue has articulated, folding arms and legs, and could have been seated on a throne. Hurston, *Mules and Men* (Kitty Brown), 147–48.

45. Zora Neale Hurston to Langston Hughes, October 15, 1928, in Carla Kaplan, *Zora Neale Hurston*, 127; Hurston, *Voodoo Gods*, 213–14.

46. Suzanne Preston Blier, "Vodun: West African Roots of Vodou," in *Sacred Arts of Haitian Vodou*, ed. Donald J. Cosentino (Los Angeles: UCLA Fowler Museum of Cultural History, 1995), 83, n. 89, 419; Karen McCarthy Brown, "Systematic Remembering, Systematic Forgetting: Ogou in Haiti," in *African-American Religion: Interpretive Essays in History and Culture*, ed. Timothy E. Fulop and Albert J. Raboteau (New York: Routledge, 1997), 455–56; Leslie Desmangles, *The Faces of the Gods: Vodou and Roman Catholicism in Haiti* (Chapel Hill: University of North Carolina Press, 1992), 114–24; Kuyk, *African Voices*, 166. See also Traylor's pictures: *Hunter on Horseback*; the penile shafts in Bill Traylor's paintings *Black and Red Dogfight*, *Brown House with Figures and Birds*, *Figure/Construction with Inverted H*, in Maresca and Ricco, *Bill Traylor*, 57, 76, 78, 138.

47. Alvira Wardlaw, ed., *Black Art/Ancestral Legacy: The African Impulse in African-American Art* (Dallas: Dallas Museum of Art, 1989), 250–51; Maude Southwell Wahlman, *Signs and Symbols: African Images in African American Quilts* (1993; New York: Museum of American Folk Art, 2001), 97. See Traylor, *Basket, Man and Owl*, in Maresca and Ricco, *Bill Traylor*, 105.

48. In West Africa, a woman's genitals are linked with witchcraft (Blier, *African Vodun*, 147; Bell, *Pattern, Structure, and Logic*, 117–21; Hyatt, *Hoodoo*, 1209, 1240, 1245, 1256–57, 1297, 1421, 2545–55, 2557–58, 2571–72, 2575, 2582–84, 2587–89, 2626, 2618–36, 2690, 2818, 3017, 3218, 4378; Puckett, *Folk Beliefs*, 255ff.; Snow, *Walkin' Over Medicine*, 81–82, 87–92).

49. Robert Farris Thompson, "African Influence on the Art of the United States," in *Black Studies in the University*, ed. Armstead L. Robinson, Craig C. Foster, and Donald H. Oglivie (New Haven: Yale University Press, 1969), 156–57.

50. On sexual behavior in the Black Belt, see Charles Johnson, *Shadow of the Plantation*, 49.

51. Jeffrey E. Anderson, *Conjure in African American Society* (Baton Rouge: Louisiana State University Press, 2005), 72–74; yronwode, "Hoodoo: African American Magic," www.luckymojo .com/hoodoohistory.html; Hyatt, *Hoodoo*, 1672.

52. yronwode, "The Crossroads in Hoodoo Magic and the Ritual of Selling Yourself to the Devil," www.luckymojo.com/crossroads.html; William Jones, cited by Hurston, "Hoodoo in America," 396; Zora Neale Hurston, *Folklore, Memoirs, and Other Writings* (New York: Library of America 1995), 700; Hyatt, *Hoodoo*, 173, 1116, 1195; Kuyk, *African Voices*, 136–38; Thomas F. Marvin, "Children of Legba: Musicians at the Crossroads in Ralph Ellison's *Invisible Man*," *American Literature* 68 (1996): 587–606.

53. Hyatt, *Hoodoo*, 1540, 24, emphasis added; Anderson, *Conjure*, 14, 217. Gwendolyn Midlo Hall maintains that Laveau "had no Haitian ancestors. She was Louisiana Creole" (Hall, interview by Ned Sublette, *Afropop Worldwide*, July 1, 2005, New Orleans, www.afropop.org/multi/interview/ID/76/Gwendolyn+Midlo+Hall-2005#top). Carolyn Morrow Long believes that she was born in New Orleans about 1801 (Long, *Spiritual Merchants*, 45–46, 272–73 nn. 26–28). See also Ina Johanna Fandrich, *The Mysterious Voodoo Queen, Marie Laveaux: A Study of Powerful Leadership in Nineteenth-Century New Orleans* (New York: Routledge, 2005), 152, 227, 248. A present-day hoodoo doctor, Ernest Braton, in Alexandria, Virginia, is known as "Dr. Buzzard." He claims that politicians in Washington, D.C., use his services for political purposes; www.doktorsnake.com/2008/05/07/healing-hoodoo. Hurston, *Mules and Men*, 200; Sobel, *Trabelin' On*, 49–57.

54. Bell "Pattern, Structure, and Logic," 32; Anderson, *Conjure*, 72–74.

55. Paul Garon, *Blues and the Poetic Spirit* (1975; San Francisco: City Lights Books, 1996), 54. On blues culture, see Houston A. Baker Jr., *Blues, Ideology, and Afro-American Literature: A Vernacular Theory* (Chicago: University of Chicago Press, 1984); William Barlow, *Looking Up at Down: The Emergence of Blues Culture* (Philadelphia: Temple University Press, 1984), 5, 37; Trudier Harris, "No Outlet for the Blues: Silla Boyce's Plight in Brown Girl, Brownstones," *Callaloo* 18 (Spring–Summer 1983): 57–67; Adam Gussow, "'Make My Getaway'": The Blues Lives of Black Minstrels in W. C. Handy's *Father of the Blues*," *African American Review* 35, no. 1 (2001): 5–28; Paul Oliver, *Blues Fell This Morning: Meaning in the Blues* (1960; Cambridge: Cambridge University Press, 1990), 265–89; Ellison, *Shadow and Act*, 78–79. Susan M. Crawley reviews the literature on blues music and Traylor's art in "Words and Music: Seeing Traylor in Context," in *Sacred and Profane: Voice and Vision in Southern Self-Taught Art*, ed. Carol Crown and Charles Russell (Jackson: University Press of Mississippi, 2007), 214–37.

56. Small, *Music of the Common Tongue*, 198–99.

57. The term "quincunx," although not used by Hyatt's informants—who did, however, describe the arrangement of materials in four corners and in the center of houses, rooms, and beds, in many of their reports—was used by Benjamin Banneker, the black surveyor and almanac writer, in a 1791 dream report noted in Sobel, *Teach Me Dreams*, 206, 296 n. 1. For drawings of signs and symbols, see Hyatt, *Hoodoo*, 1184, 2010, 2920, 3447, 3853, 3961, 4112, 4113, 4132, 4133, and 4265. Ruby Andrews Moore prints a picture of the figure drawn in the sand to alleviate pain in Moore, "Superstitions in Georgia," *Journal of American Folklore* 5 (1892): 230–31. An image of the Ife antiwitch guard is in Spence, "Nsibidi and Vai," 2. An illustration of a "Voodoo Dance" around a quincunx by Edward Windsor Kimble (1881) published in "Creole Slave Songs," by George W. Cable in *Century Magazine* 31 (1886), is reproduced in Sobel, *Trabelin' On*, 51.

58. Lawrence Gellert, "All the Wrong White Folks," in Harrah-Conforth, *Laughing Just to Keep from Crying*, 217. See also Gellert, "Negro Songs of Protest," *Music Vanguard* 1, no. 1 (1935): 11.

59. Will Traylor: U.S. Census, 1920, Alabama, Montgomery County, Selma Road, Will Sellers Plantation, records the occupation of separate homes and land by two of Traylor's sons, and their care for two younger Traylor "brothers" who may have been Bill Traylor's sons "outside" his marriage. For a review of the economy of cotton production, and its effect on African Americans' lives, see Doug McAdam, *Political Process and the Development of Black Insurgency, 1930–1970*

(Chicago: University of Chicago Press, 1982), 65–116. Landlords were charging an average of 37 percent interest on their loans for food and clothes, and some 40 percent of Alabama share-croppers owed their landlords for previous years' loans, making them virtual peons. See Harry Haywood, *Negro Liberation* (New York: International Publishers, 1948), 38, 43. Quotation from Blier, *Vodun*, 139. Traylor's red-bellied man, titled *Man with Black Umbrella*, is the property of Judy A. Saslow Gallery.

3. "MY HEART STRUCK SORROW" (1928–1930)

1. On unemployment in Birmingham, see Robin D. G. Kelley, *Hammer and Hoe: Alabama Communists during the Great Depression* (Chapel Hill: University of North Carolina Press, 1990), 9. Laura Williams, U.S. Census, 1930, Alabama, Montgomery. This Laura Williams reported she was ten years younger than Bill Traylor's wife, but altering ages for the census taker was very common. Bill Traylor's daughter Sarah Traylor Howard reported she was ten years younger than she was after she married.

2. "Traylor Wm (c) [colored] lab [laborer] r [rear] 9 Coosa," in *Montgomery City Directory* (Montgomery: R. L. Polk and Co., 1928), 874.

3. "Negro Burglar Is Slain at Home in West End," *Birmingham Post*, August 26, 1929; "Body of Burglar Identified by Father," *Birmingham Post*, August 29, 1929. I am indebted to Yvonne Crumpler, department head at the Tutwiler Collection of Southern History and Literature, Birmingham Public Library, for locating these articles. The official death certificate for Will Traylor, issued by the State of Alabama, confirms that his father, Bill Traylor, was living in Montgomery, and that his mother was Laura Traylor. She is not listed as deceased (Alabama Bureau of Vital Statistics, Will Traylor Certificate of Death, August 26, 1929; copy in possession of Mechal Sobel). The 1929 Birmingham City Directory lists a "Wm Traylor colored renter, rear 1321 6th Alley South." The same address is also listed for "Mack Traylor colored, laborer, married to Alberta." This was Will's brother, another of Bill and Laura Traylor's sons, born ca. 1903. By 1930, he was in Detroit. See Mack Traylor: U.S. Census reports for 1910 and 1920 for Alabama, and 1930 for Michigan.

4. See the Traylor Family reunion booklets of 1991 and 1992, and Hunton and Williams, attorneys, "Statement by the Parties Announcing Settlement of the Lawsuits Concerning the Art of Bill Traylor" (New York City, October 5, 1993), 4. In this statement, the family also preserves the misinformation that Bill Traylor left "the plantation in Benton to bury his son." No mention is made of his having moved to Montgomery County some time prior to the 1910 census, nor of his living in Montgomery in 1929, as is stated on Will Traylor's death certificate.

5. On charges of sexual transgression and lynching, see Cardyn, "Sexualized Racism," 763–70. Beeks, interview by Sobel.

6. In 1939, both Tuskegee and the NAACP included in their lynching lists a case in which only two white men abducted and killed a black taxi driver who had accidentally run over their brother. Tuskegee also held that a lynch victim "must have met death illegally," but in nine other cases (one in Alabama), "murders, committed 'with authority of law' (1931–1941), are classified as lynchings." The NAACP included "Peeping Tom" as a reason given for lynching. See Jessie

Daniel Ames, *The Changing Character of Lynching: Review of Lynching, 1931–1941* (1942; New York: AMS Press, 1973), 26–27, 30; Robert E. Martin, "Lynching," *Encyclopedia Americana* (Danbury, Conn.: Groelier, 1981), 17: 884–85. For the "fascist regime" quotation, see Jacquelyn Dowd Hall, "Mobilizing Memory: Broadening Our View of the Civil-Rights Movement," *Chronicle of Higher Education*, 46 (July 27, 2001): B7. Project Hal, the Historical American Lynching Data Collection Project, which records new lynch data, is run by Elizabeth Hines and Eliza Steelwater at: http://people.uncw.edu/hinese/HAL/HAL%20Web%20Page.htm. Blain A. Brownell, "Birmingham, Alabama: New South City in the 1920s," *Journal of Southern History* 38, no. 1 (February, 1972): 40; William Robert Snell, "Masked Men in the Magic City: Activities of the Revised Klan in Birmingham, 1916–1940," *Alabama Historical Quarterly* 34 (1927): 206–27. On "lynch law," see Ida B. Wells, *Southern Horrors: Lynch Law in All Its Phases* (1892), reprinted in *Southern Horrors and Other Writings: The Anti-Lynching Campaign of Ida B. Wells, 1892–1900*, ed. Jacqueline Jones Royster (Boston: Bedford Books, 1997), 49–72.

7. Robert W. Bagnall, "The Present South," *Crisis* 36, no. 9 (September 1929): 303.

8. Denby, *Indignant Heart*, 40–43; Dent, *Southern Journey*, 287.

9. Glenn Feldman, "Soft Opposition: Elite Acquiescence and Klan-Sponsored Terrorism in Alabama, 1946–1950," *Historical Journal* 40 (1997): 753–77; Alan Lomax, *The Land Where the Blues Began* (New York: Pantheon, 1993), 461, 467, 469. For Lomax's failure to acknowledge black participation in this study and contribution to what he published, as well as findings that contradicted some of his positions, see Work, Jones, and Adams, *Lost Delta Found*, xv–xvi, 1–26.

10. Alan Lomax, "I Got the Blues," *Common Ground* 8 (Summer 1948), 38–42; reprinted in *Mother Wit from the Laughing Barrel*, ed. Dundes, 469–86; *Blues in the Mississippi Night*, United Artists LP, 1959.

11. Hurston, *Mules and Men*, 4–5.

12. The picture of Rhodes, titled *Chicken Charlie* by Shannon, is inscribed: "November the 9/55 Years old/Charlie Rhodes/1886," and on the verso side of the cardboard is the sentence: "Writing by Charlie Rhodes who taught Bill Traylor to write his name." This picture is reprinted in Wilkinson, *Bill Traylor Drawings*, 32. See Charles Rhodes, U.S. Census, 1930, Alabama, Montgomery City, where he reported that he knew how to read and write.

13. Ned Cobb, who was given the pseudonym Nate Shaw in Rosengarten, *All God's Dangers*, 545.

14. Cobb [Shaw], ibid., 317–43, 545.

15. Bagnall, "The Present South," 303. There are four major listings of lynch statistics: the *Chicago Tribune* list, begun in 1882; that of Tuskegee Institute from 1892; the one kept by the NAACP from 1912; and the fourth, project HAL, at the University of North Carolina at Wilmington. Of these, project HAL is the most inclusive, but even there no lynching is recorded for Alabama in 1929. Data from "Project HAL: Historical American Lynching Data," http://users.bestweb.net/~rg/Lynchings.htm, "Lynchings: By Year and Race," Archives of the Tuskegee Institute, document a total of ten lynching incidents in 1929, in which seven of the murdered people were black, but none is in Alabama: www.law.umkc.edu/faculty/projects/ftrials/shipp/lynchingyear.html.

16. See Patricia Sullivan, *Days of Hope: Race and Democracy in the New Deal Era* (Chapel Hill: University of North Carolina Press, 1996), 87–89; Dan T. Carter, *Scottsboro: A Tragedy of the American South* (Baton Rouge: Louisiana State University Press, 1969); data from "Project HAL: Historical American Lynching Data"; Gellert, *Negro Songs of Protest,* 44–45.

17. Kelley, *Hammer and Hoe,* 81, 91; John Beecher, "The Share Croppers' Union in Alabama," *Social Forces* 13 (October 1934): 124–32; Dorothy Autrey, "'Can These Bones Live?': The National Association for the Advancement of Colored People in Alabama, 1918–1930," *Journal of Negro History* 82 (1997): 1–12.

18. Gellert, interview by Reuss, August 31, 1966, OT 6546, tracks 6, 9. On the cotton choppers' strike in May 1935, the Communist Party in Alabama, and the use of music at meetings, see Kelley, *Hammer and Hoe,* 144–51, 161–63; Robin D. G. Kelley, "Share Croppers Union," in *Major Problems in American History, 1920–45, Documents and Essays,* ed. Colin Gordon (New York: Houghton Mifflin, 1999), 253–62; Gellert, in John Greenway, *American Folksongs of Protest* (1953; New York: Octagon Press, 1970), 86.

19. Eric Foner, *Reconstruction: America's Unfinished Revolution* (New York: Harper and Row, 1988), 119, 436; Ida B. Wells, *The Red Record: Statistics and Alleged Causes of Lynching in the U.S.* (1895), reprinted in *Southern Horrors and Other Writings: The Anti-Lynching Campaign of Ida B. Wells, 1892–1900,* ed. Jacqueline Jones Royster (Boston: Bedford Books, 1997), 75; "Project HAL," http://users.bestweb.net/~rg/Lynchings.htm.

20. The other urban sites of racial violence were in Atlanta, Georgia (1898); Springfield, Illinois (1908); East St. Louis, Illinois; Chicago, Illinois; Elaine, Arkansas; Charleston, South Carolina; Knoxville, Tennessee; Longview, Texas; Omaha, Nebraska; and Washington, D.C. (all in 1919); and Tulsa, Oklahoma (1921). Gunnar Myrdal, *An American Dilemma* (New York: Harper and Brothers, 1944), 560–66; Woodruff, *American Congo,* 102–3; Joseph Boskin, *Urban Racial Violence in the Twentieth Century* (1969; Beverly Hills, Calif.: Glencoe Press, 1976).

21. Gussow, *Seems Like Murder Here,* 17–65; Shelby "Papa Jazz" Brown, in Ferris, *Blues from the Delta,* 19. On memories of lynching, see Wright, *87 Years behind the Black Curtain,* 69–70; Denby, *Indignant Heart,* 40–41.

22. Big Joe Duskin, in Steven C. Tracy, *Going to Cincinnati: A History of the Blues in the Queen City* (Urbana: University of Illinois Press, 1993), 101–2.

23. Duskin, ibid., 103–4.

24. Howard Odum, quoted by Oliver, *Songsters and Saints*; Gussow, *Seems Like Murder Here,* 22.

25. Angela Y. Davis, *Blues Legacies and Black Feminism: Gertrude "Ma" Rainey, Bessie Smith, and Billie Holiday* (New York: Pantheon, 1998), 266–67. See Bessie Smith, "Blue Spirit Blues," with lyrics by Spencer Williams, New York, Oct. 11, 1929, in Taft, *Talkin' to Myself,* 530.

26. Big Bill Broonzy's "Conversation with the Blues," recorded July 17, 1941, on the LP *Big Bill Broonzy 1935–41*; Broonzy, in Lomax, *The Land Where the Blues Began,* 469.

27. Orlando Patterson, *Rituals of Blood: Consequences of Slavery in Two American Centuries* (Washington, D.C.: Civitas/CounterPoint, 1998), 198. The quotation "They could not see . . . that Christ had become black" is from the closing words of Donald G. Mathews, "The Southern Rite of Human Sacrifice: Lynching and Religion in the South," *Journal of Southern Religion* 3 (2000), http://jsr.fsu.edu/matthews.htm (emphasis added). The findings of W. Fitzhugh Brund-

age indicate that some 35 to 40 percent of all southern lynching was done by mass mobs and followed a "highly ritualized choreography" (Brundage, *Lynching in the New South: Georgia and Virginia, 1880–1930* [Urbana: University of Illinois Press, 1993], 36; Trudier Harris, *Exorcising Blackness: Historical and Literary Lynching and Burning Rituals* [Bloomington: Indiana University Press, 1984], 103, 126; Ellison, *Shadow and Act*, 24–44).

28. Maresca and Ricco, "Remembering Bill Traylor," 15. Shannon's study for "Ku Klux Klan" (1939) is reproduced in William U. Eiland, "Picturing the Unvictorious: The Southern Scene in Alabama, 1930–1946," in *The American Scene and the South: Paintings and Works on Paper, 1930–1946,* ed. Patricia Phagon (Athens: Georgia Museum of Art: 1996), 55.

29. Hyatt, *Hoodoo,* 1724; Grey Gundaker, correspondence with Mechal Sobel, April 10, 2005; Thompson, *Flash of the Spirit,* 255; quotation from R. C. Baker, "Two Artists Who Didn't Need to Be Told Anything: Bill Traylor and William Edmondson," *Village Voice,* June 21, 2005, www .villagevoice.com/art/0526,baker,65374,13.html-2005-06-21.

30. Kurzmeyer, "The Life and Times of Bill Traylor," 174.

31. Charles Shannon quoting Bill Traylor, in Maresca and Ricco, "Remembering Bill Traylor," 14.

32. A. Davis, *Blues Legacies and Black Feminism,* 181–97; Margolick, *Strange Fruit,* 69–74; Amy Helene Kirschke, *Art in Crisis: W. E. B. Du Bois and the Struggle for African American Identity and Meaning* (Bloomington: Indiana University Press, 2007), 64–65, 75–77, 88, 109, 226–27; Qiana Whitted, "In My Flesh Shall I See God: Ritual Violence and Racial Redemption in 'The Black Christ,'" *African American Review* 38, no. 3 (Fall 2004): 379–94; Harris, *Exorcising Blackness;* Patricia Schechter, "Unsettled Business: Ida B. Wells against Lynching, or How Antilynching Got Its Gender," in *Under Sentence of Death: Lynching in the South,* ed. W. Fitzhugh Brundage (Chapel Hill: University of North Carolina Press, 1997), 297 n. 14; D. Mathews, "The Southern Rite of Human Sacrifice"; Aaron Douglas, *Crucifixion* (1927), is discussed in Richard J. Powell, "Art History and Black Memory: Toward a "Blues Aesthetic," in *History and Memory in African-American Culture,* ed. Geneviève Fabre and Robert O'Meally (New York: Oxford University Press, 1994), 237. Douglas used the Baron Samedi colors of black and purple to portray his Christ figure. Jacob Lawrence, *Harriet Tubman Series No. 2,* 1939–40, Hampton University Museum, Hampton Virginia; William H. Johnston, *Mount Calvary,* ca. 1944, National Museum of American Art, Smithsonian Institution, Washington, D.C. On Johnson, see Richard J. Powell, *Homecoming: The Art and Life of William H. Johnson* (New York: Rizzoli, 1991), and Richard J. Powell, "'In My Family of Primitiveness and Tradition': William H. Johnson's *Jesus and the Three Marys,*" *American Art* 5, no. 4 (Autumn 1991): 20–33. Gwendolyn Brooks, "The Chicago Defender Sends a Man to Little Rock," in Brooks, *Selected Poems* (New York: Harper and Row, 1963), 89. The white artist Prentiss Taylor drew black crucifixion scenes in 1932 (*Christ in Alabama*), as did the African American artist Allen R. Crite in 1935; however, both Crite and Taylor were born in the North, and painted outside the South. Cheryl Rivers notes that Clementine Hunter began drawing black crucifixion scenes in Louisiana in the mid-1940s, and that Catholic "holy cards" illustrated with images of black martyrs were marketed in the South in this period (Rivers, "Clementine Hunter: Chronicler of African-American Catholicism," in *Sacred and Profane: Voice and Vision in Southern Self-Taught Art,* ed. Carol Crown and Charles Russell [Jackson: University Press of Mississippi, 2007], 163–64). Donna M. Cassidy, "Competing Notions of American and Artistic

Identity in Visual and Written Autobiographies in the 1930s and Early 1940s," in *Writing Lives: American Biography and Autobiography*, ed. Hans Bok and Hans Krabbendam (Amsterdam: VU University Press, 1998), 63–73. Hale Woodruff, an African American artist born in Tennessee and working at Atlanta University, sent several lynching paintings to be displayed in New York City in 1935. See Marlene Park, "Lynching and Antilynching: Art and Politics in the 1930s," *Prospects: An Annual of American Cultural Studies* 18 (1993): 311–65 (a shorter version is Marlene Park, "Lynching and Antilynching: Art and Politics in the 1930s," in *The Social and the Real: Political Art of the 1930s*, ed. Alejandro Anreus, Diana L. Linden, Jonathan Weinberg, 155–77 [University Park: Pennsylvania State University Press, 2006]); Helen Langa, "Two Antilynching Art Exhibitions: Politicized Viewpoints, Racial Perspectives, Gendered Constraints," *American Art* 13 (1999): 10–39; and Helen Langa, *Radical Art: Printmaking and the Left in 1930s New York* (Berkeley and Los Angeles: University of California Press, 2004), 138, 145–46, 149–67. On Woodruff and other southern-born black painters of lynching exhibiting in the North, see Dora Apel, *Imagery of Lynching: Black Men, White Women, and the Mob* (New Brunswick, N.J.: Rutgers University Press, 2004), 104–10. Caroline Goeser, "'On the Cross of the South': The Scottsboro Boys as Vernacular Christs in Harlem Renaissance Illustration," *International Review of African American Art* 19 (2003): 23; Kirschke, *Art in Crisis*; Kymberly N. Pinder, "'Our Father, God; our Brother, Christ; or Are We Bastard Kin': Images of Christ in African American Painting," *African American Review* 31, no. 2 (1997): 223–33. For other figures drawn by Traylor that have visible penises, see *Man Wearing Maroon and Blue with Bottle* (plate 3), and *Figure in Front of Street Light* with penis exposed but partially erased, perhaps by Shannon (plate 27).

33. Patton, "High Singing Blue," in *Bill Traylor*, 24. The edited version without the lynching reference can be found in Patton, "High Singing Blue," in *Bill Traylor, 1854–1949: Deep Blues*, ed. Helfenstein and Kurzmeyer, 109–14, and at www.philpatton.com/traylor.html. Thompson, "Kongo Influences," 161.

34. Hyatt describes a "Crystal ball used by Doctor" in *Hoodoo*, 172, and 3199–200. The Alabama-born Charles Denby described a court case in which a black man was convicted on the report of Mabel Jefferson, a conjurer who used a crystal ball (Denby, *Indignant Heart*, 69–74). The North Carolina conjure doctor Jim Jordan (1871–1962) used a crystal ball as well (see F. Johnson, *The Fabled Doctor Jim Jordan*, 59). A narrative by his patient Ella Jackson, as told to Rudolph Lewis, confirms his use of a crystal ball (see "Conjuring and Doctoring," *New Laurel Review* 21 (1999), reprinted on the Web at www.nathanielturner.com/conjuring.htm). MacGaffey, *Religion and Society*, 189; Hyatt, *Hoodoo*, 1187.

35. Nzegwu, "Abakua"; Lydia Cabrera, *Anaforuana: Ritual y simbolos de la iniciacion en la sociedad secreta Abakuá* (Madrid: Los de hoy, Liberia Orbe, 1975. On African and Cuban leopard societies and *nsibidi*, see Robert Farris Thompson, *African Art in Motion: Icon and Act* (Berkeley and Los Angeles: University of California Press, 1974), 180–87; and Thompson, *Flash of the Spirit*, 225–68. On the Cuban leopard society, Abakua, also known as Naniguismo, and Baron Samedi, see Julio Finn, *The Bluesman: The Musical Heritage of Black Men and Women in the Americas* (1986; New York: Interlink, 1992), 66–67; Spence, "Nsibidi and Vai."

36. Robert Johnson, "Preachin' Blues (Up Jumped the Devil)," recorded November 27, 1936, San Antonio, Texas; lyrics in Scott Ainslee, *Robert Johnson at the Crossroads* (Milwaukee: Leon-

ard, 1992), 64; Greil Marcus, *Mystery Train: Images of Rock 'n' Roll Music* (1975; New York: Plume, 1997), 189; S. White and White, *The Sounds of Slavery,* 101–2; Harris, "No Outlet for the Blues," 58; Harris, *Exorcising Blackness.*

37. Vera Hall [Nora], in Lomax, *The Rainbow Sign,* 71–74; Vera Hall, in the Alan Lomax Database, Report on Session 42, "On First Becoming a Christian," reference T810.0 track 7, Vera Hall 1948, www.lomaxarchive.com/index.html.

38. Gussow, "Make My Getaway," 18.

39. Thomas Dorsey, January 1977, in Michael W. Harris, *The Rise of Gospel Blues: The Music of Thomas Andrew Dorsey in the Urban Church* (New York: Oxford University Press, 1992), 99.

40. "Good Morning Blues," on *Roots of the Blues,* LP, vol. 2, *Leadbelly* [Ledbetter], (June 5, 1940), Direct Source Special Products, 2001; Charley Patton's "Mean Black Moan," December 1929; Taft, *Blues Lyric Poetry.*

41. Garon, *Blues and the Poetic Spirit,* 198, 200; Lawrence Gellert, "Ku Kluck Klan," in Olin Downes and Elie Siegmeister, *A Treasury of American Songs* (1940; Consolidated Music Publishers: New York, 1943), 398.

42. Gellert, "Negro Songs of Protest," *Music Vanguard* 1, no. 1 (1935): 11, 12. Reprinted in Gellert, "Sistren an' Brethren," in *Negro Songs of Protest,* 10–11, with a slight variation in wording and punctuation.

4. "BREAKING THROUGH A WALL OF SILENCE" (1930–1949)

1. Siri Hustvedt, *Mysteries of the Rectangle: Essays on Painting* (New York: Princeton Architectural Press, 2005), 118; *Montgomery City Directory* (1929), 787; U.S. Census, 1930, Alabama, Montgomery County, Montgomery, Bill Traylor, 214 Bell Street. There is no death certificate for Laura Williams Traylor in the Alabama records for the 1920s, nor does Will Traylor's death certificate indicate his mother was deceased. This is not proof that she was alive in 1930, but there was, as noted in chapter 3, a Laura Williams, "mother in law," living with Julius Jackson and his wife, Eliza Williams Jackson, in Montgomery in 1930. Eliza could have been one of Laura's daughters born before her marriage to Bill Traylor (Laura Williams, 1930 U.S. Census, 1930, Alabama, Montgomery). Margaret Traylor Staffney, recorded by Miriam Fowler and Marcia Weber, second Traylor family reunion, 1992, Alabama State Council on the Arts.

2. Miriam Rogers Fowler, comp., "Bill Traylor," in *Outsider Artists in Alabama* (Montgomery: Alabama State Council on the Arts, November 1991), 52, 53 n. 2. The reference to the painting *Ross the Undertaker,* and the verso note (dated January 1940) are in Bonesteel, "Bill Traylor, Creativity and the Natural Artist," 29 n. 23. Maresca and Ricco, "Remembering Bill Traylor," 4. For food costs, see "Food Time Line . . . historic food prices," www.foodtimeline.org/foodfaq5.html.

3. Lynda Roscoe Hartigan and Judge John B. Scott, "Monroe Street," March 13, 1958, in Hartigan, "Going Urban," 31, 48.

4. Shannon, in Maresca and Ricco, "Remembering Bill Traylor," 3.

5. Ibid., 4, 20, 31; Bonesteel, "Bill Traylor, Creativity and the Natural Artist," 24; Helfenstein, "Bill Traylor and Charles Shannon," 104.

6. Jeanne Curran, "Bill Traylor's *Female Drinker,*" *Dear Habermas* 23, no. 15, May 1, 2005, www.scudh.edu/dearhabermas/jcls2315.htm.

7. Shannon's photo of the "Colord Pool Room" door is in Helfenstein and Kurzmeyer, *Bill Traylor, 1854–1949,* 122. Maresca and Ricco, "Remembering Bill Traylor," 4.

8. Nance Varon, telephone interview by Mechal Sobel, June 29, 2004, Montgomery, Ala.

9. Jim Haskins, *Voodoo and Hoodoo: Their Tradition and Craft as Revealed by Actual Practitioners* (1978; Lanham, Md.: Scarborough House, 1990), 13.

10. On lamps, candles, and spirit contact, see Hyatt, *Hoodoo,* 283, 1182, 1729, 1772, 4311. *Brown Lamp with Figures,* in Maresca and Ricco, *Bill Traylor,* 77. On cleaning the pictures, see Shannon, in Maresca and Ricco, "Remembering Bill Traylor," 25–26.

11. Eiland, "Picturing the Unvictorious," 57–69; Miriam Rogers Fowler, "New South School and Gallery," in *New South, New Deal and Beyond: An Exhibition of New Deal Era Art, 1933–1943,* ed. Fowler (Montgomery: Alabama Council on the Arts, 1989), 7, 9–10.

12. Maresca and Ricco, "Remembering Bill Traylor," 19.

13. "It was obvious that he hardly considered the pictures his own. He was merely the medium through which they had happened" (in Allen Rankin, "He Lost 10,000 Years," *Collier's Magazine,* June 22, 1946, 67); Charles Shannon, "The Folk Art of Bill Traylor," *Southern Works on Paper, 1900–1950* (Atlanta: Southern Arts Federation, 1981), 16. The categories are listed in the catalogue for the New South Gallery's exhibition of Bill Traylor's works, [Charles Shannon], *Bill Traylor—People's Artist,* February 1940.

14. Milo Rigaud, *Ve-Ve: Diagrammes rituels du voudou* (New York: French and European Publications, 1974), 85, 168. The Traylor painting of two snakes, *Snake at the Crossroads,* collection of David and Bobbye Goldburg, is on the Web at www.humanities-interactive.org/cultures/blackart/ex012_05b.htm. Thompson, *Flash of the Spirit,* 11, 110, fig. 46. Traylor's *Red Bird on Construction* is in Maresca and Ricco, *Bill Traylor,* 177. On large dogs, cats, and other animals as spirits of dead people or ghosts, see Puckett, *Folk Beliefs,* 129–30, 138, 149–51.

15. Wyatt MacGaffey, "Complexity, Astonishment and Power: The Visual Vocabulary of Kongo Minkisi," *Journal of Southern African Studies* 14 (1988): 193, 199; MacGaffey, *Religions and Society,* 132; Thompson, *Flash of the Spirit,* 121; Hyatt, *Hoodoo,* 1556, 4693.

16. Zora Neale Hurston, *Dust Tracks on a Road* (1942), reprinted in Hurston, *Folklore, Memoirs, and Other Writings* (New York: 1995), 700. See also Puckett, *Folk Beliefs,* 182.

17. Patton, "High Singing Blue," in *Bill Traylor,* 13; catherine yronwode, "Bluestone and Blueing," www.luckymojo.com/bluestone.html; Hyatt, *Hoodoo,* 419; Lisa Aronson, review of *Cloth That Does Not Die,* by Elisha P. Renne, "H-AfrArts, H-Net Reviews," July 1997, www.h-net.org/reviews/showrev.cgi?path=24094872714889. Blue is also a significant color in Freemasonry, and it is the only color used in decorating the halls that are termed "Blue Lodges."

18. Patton, *Bill Traylor,* 24. The edited version, without the lynching reference, can be found in: Patton, "High Singing Blue," 109–14; it also appears, with the same title, on the Web at www .philpatton.com/traylor.html.

19. Patricia Sullivan, quoting from interviews with Clarence Mitchell and Palmer Weber, veteran southern activists, in "Southern Reformers, the New Deal and the Movement's Founda-

tion," in *New Directions in Civil Rights Studies*, ed. Armstead L. Robinson and Sullivan (Charlottesville: University Press of Virginia, 1991), 81; Kelley, "We Are Not What We Seem," 83; Kelley, *Hammer and Hoe*, 9, 33, 46–47 55, 99–101, 153, 161–62, 165–68, 230–31; Robin D. G. Kelley, "A New War in Dixie: Communists and the Unemployed in Birmingham, Alabama, 1930–1933," *Labor History* 30, no. 3 (1989): 376–84; W. Fitzhugh Brundage, "The Roar on the Other Side of Violence: Black Resistance and White Violence in the American South, 1880–1940," in *Under Sentence of Death: Lynching in the South*, ed. Brundage (Chapel Hill: University of North Carolina Press, 1997), 279; Millner, "The Montgomery Bus Boycott," 403–5; black women in Montgomery, February 26, 1955, Rev. B. J. Simms, in Millner, "The Montgomery Bus Boycott," 580–81.

20. On earlier organized protests by southern black women, see Hunter, *To 'Joy My Freedom*, 74–98. On southern black responses to Jim Crow and lynch law, see: Hahn, *A Nation under Our Feet*, 464ff.; J. Hall, "Mobilizing Memory," B7; Woodruff, *American Congo*, 110–51, 226–27; Fairclough, *Race and Democracy*, xii–xvii, and chaps. 3–5; Greta de Jong, *A Different Day: African American Struggles for Justice in Rural Louisiana, 1900–1970* (Chapel Hill: University of North Carolina Press, 2002), 1–115; Michael Honey, "Racism, Organized Labor, and the Black Freedom Struggle," *Contours: A Journal of the African Diaspora* 1, no. 1 (Spring 2003): 57–81; John Egerton, *Speak Now Against the Day: The Generation before the Civil Rights Movement in the South* (Chapel Hill: University of North Carolina Press, 1995); Harvard Sitkoff, *The Struggle for Black Equality, 1945–1980* (New York: Hill and Wang, 1981); Brundage, "The Roar on the Other Side of Violence," 271–91; Shapiro, *White Violence and Black Response*. Many of Hyatt's informants make mention of their purchases of esoteric books; catherine yronwode has a collection of the literature, and has documented some of the borrowings. See her notes added to informants list at www.luckymojo.com/hyattinformants.html and www.luckymojo.com/luckybrown.html. Richard Wright, "Memories of My Grandmother," Richard Wright Papers, Yale Collection of American Literature, Beinecke Rare Book and Manuscript Library, Yale University Library, New Haven, Conn.; Kelley, *Freedom Dreams*, 157–94; Paul Garon, ed., "Surrealism and Blues," special supplement of *Living Blues* 25 (Chicago: Living Blues, 1976), reprinted in Ron Sakolsky, ed., *Surrealist Subversions: Rants, Writings and Images by the Surrealist Movement in the United States* (Brooklyn, N.Y.: Autonomedia, 2002), 611–46.

21. [Shannon], *Bill Traylor—People's Artist*, unpaginated.

22. See Helfenstein and Stanulis, *Bill Traylor, William Edmondson and the Modernist Impulse*; Romare Beardon and Harry Henderson, *A History of African American Artists: From 1792 to the Present* (New York: Pantheon, 1993), 374.

23. Gellert, *"Me and My Captain" (Chain Gangs)*, 5; Fu-Kiau, interview by Sobel.

24. Ajume H. Wingo, "African Art and the Aesthetics of Hiding and Revealing," *British Journal of Aesthetics* 38 (1998): 251–64; Mary H. Nooter, "The Visual Language of Secrecy," in *Secrecy, African Art That Conceals and Reveals*, ed. Nooter, 49–52 (New York: Museum for African Art, 1993). Traylor's painting *The Leopard and the Black Bird* can be seen in Bonesteel, "Bill Traylor, Creativity and the Natural Artist," *Bill Traylor Drawings*, 25; it was in the collection of Joe and Pat Wilkinson (with the pencil inscription verso "Circus Animal, Coon, Mar. '40") and put at auction by Sotheby's on January 23, 2005. It is in their catalogue *Important Americana*, January 15, 2005.

25. Wingo, "African Art," 258–59.

26. Blier, *African Vodun*, 198, 269; Anita Jacobson-Widding, *Red-White-Black as a Mode of Thought: A Study of Triadic Classification by Colours in the Ritual Symbolism and Cognitive Thought of the Peoples of the Lower Congo* (Stockholm: Almquist and Wiksell International, 1979), 143, 303; Jacobson-Widding, "The Encounter in the Water Mirror," 195; Thompson, *Flash of the Spirit*, 248, plate 158: 261, plate 159: 262; Thompson, "Communiqué from Afro-Atlantis," *African Arts* 32, no. 4 (winter 1999): 7; David H. Brown, *The Light Inside: Abakuá Society Arts and Cuban Cultural History* (Washington, D.C.: Smithsonian Institution Press, 2003), plate 4.

27. F. Johnson, *The Fabled Doctor Jim Jordan*, 29, 33–36, 127; Wahlman, "The Art of Bill Traylor"; Wahlman, "Bill Traylor: Mysteries"; Kuyk, "The African Derivation." Betty Kuyk cites a recording by Louis Armstrong on which he describes a New Orleans jazz funeral procession, saying: "the Leopards can form a line to swing back to the hall playing 'Didn't He Ramble,'" which suggests that a Leopard Society existed in New Orleans (Kuyk, *African Voices*, xxviii, 10–11). The word Kuyk cites as "leopards," however, is not clear in the online recording, where it sounds like "members" rather than "leopards." David Evans kindly listened to his copy of this record, and wrote that "Armstrong definitely says 'members.'" He also expressed his view, based on broad knowledge of the black community in this period, that there was no society, nor any group of musicians, known as the leopards (David H. Evans, e-mail to Mechal Sobel, December 3, 2007). I have written to a number of jazz and blues museums and archives and found no listing of any group known as the leopards. Louis Armstrong, *New Orleans Function*, which includes "Oh, Didn't He Ramble," can be heard on the "Smithsonian Jazz Class" at www.smithsonianjazz.org/class/armstrong/kit/kit.asp. For Traylor's use of Haitian *anaforuana*, see *Figures and Trees* (plate 24). On *The Leopard and the Black Bird*, see note 24 above. *Spotted Leopard* (1939) is in Diane Finore, "Art of Bill Traylor," *Clarion* (Spring–Summer 1985): 42; Thompson, *Flash of the Spirit*, 228, 245.

28. Maresca and Ricco, *Bill Traylor*, 8.

29. Bell, "Pattern, Structure, and Logic," 417.

30. For information about Laura Williams Traylor and the possibility that she was alive and living in Montgomery, see above, chap. 4, n. 2.

31. E. D. Hirsch, Joseph F. Kett, and James Trefil, *New Dictionary of Cultural Literacy*, 3rd ed. (Boston: Houghton Mifflin: 2003), www.bartleby.com/59/. For a contemporary reference to being "behind the eight ball" in the African American community, see Tony Amsterdam on "the general behind-the-eight-ball-ism that have-nots face in this society," in Michael A. Fletcher, "The Fight Goes On: Elaine Jones's Latter-Day Battle," *Washington Post*, June 23, 2003. Traylor made reference to the time he spent in the pool room when interviewed by a reporter for the *Acme Press*, June 6, 1940.

32. Marcus, *Mystery Train*, 189; Robert Johnson, "Preachin' Blues (Up Jumped the Devil)," recorded November 27, 1936, San Antonio, Texas; from *The Complete Recordings*, CBS 467246 2, and Columbia/Legacy C2K–46222 and Columbia 4622 and Sony 64916) copyright, emphasis added.

33. Although he often visited Montgomery and sent friends to collect Traylor's pictures when he was not there, Shannon was artist-in-residence at West Georgia College from 1940 to 1942, and was inducted in the army after that (Angela Culpepper and Alan Vannoy, "Biographies and

Major Sources," in Patricia Phagan, ed., *The American Scene and the South: Paintings and Works on Paper, 1930–1946* [Athens: Georgia Museum of Art, 1996]; Maresca and Ricco, "Remembering Bill Traylor," 20).

34. Roman Kurzmeyer reports that Traylor's gangrenous left leg was amputated while he was living with his daughter Lillian Traylor Hart in Washington, D.C., but his granddaughter Margaret Elizabeth Traylor Staffney, who lived in Montgomery, reported: "I remember when they took his leg off, we cried everyday. When his leg was well, he went back to his drawing board," which indicates that the operation was done in Montgomery (Kurzmeyer, "The Life and Times of Bill Traylor"; Staffney, in Traylor Family, *Traylor-Calloway-Durant Family Reunion* [booklet], 1992; Shannon, in Maresca and Ricco, "Remembering Bill Traylor," 20).

35. St. Jude's "Baptismal Record Book," vol. 1, p. 35, entry 12, January 5, 1944; Long, "Perceptions of New Orleans Voodoo," 87.

36. Sister Mary Ruth Coffman, *Build Me a City: The Life of Father Harold Purcell* (Montgomery: Pioneer Press, 1984), 37, 65.

37. Ibid., 104, 131–213. Purcell built a hospital as well, which opened in 1951, two years after Traylor died.

38. Ibid., *Build Me a City*, 130, 170–71. In June 2004, when I talked with her, Humphries was still attending this church and doing volunteer work in its social services department.

39. The Catholic Profession of Faith, Article 10, Section I. See Kuyk, *African Voices*, 112, 198.

40. See the lyrics of "Sistren an' Brethren" in chapter 3 of this volume. John Wideman, review of *The Signifying Monkey: A Theory of African-American Literary Criticism*, by Henry Louis Gates, in the *New York Times Book Review*, August 14, 1988, 3.

41. Georgia Tom (Thomas A. Dorsey) and Gatemouth Moore (Rev. Dwight Moore) were among those who gave up blues for the pulpit. See John F. Szwed, "Musical Adaptation among Afro-Americans," *Journal of American Folklore* 82 (1969): 114–16; Charles Keil, "From 'Role and Response,'" in *Write Me a Few of Your Lines: A Blues Reader*, ed. Steven C. Tracy (Amherst: University of Massachusetts Press, 1999), 219–20; Judith McWillie, "Traditions and Transformations: Vernacular Art from the Afro-Atlantic South," in *Dixie Debates: Perspectives on Southern Cultures*, ed. Richard H. King and Helen Taylor (New York: New York University Press, 1996), 197; Work, Jones, and Adams, *Lost Delta Found*, 80. As a result of Gordon and Nemerov's book, Alan Lomax's interpretation of the music and his ethics have come under serious criticism (Ted Drozowski, "Lomax Uncovered: Challenging the Delta Historian," *Boston Phoenix*, October 28–November 2, 2005, www.mrqe.com/lookup).

42. The African view of amputation of limbs was provided by K. K. Bunseki Fu-Kiau on seeing one of Traylor's paintings of a one-legged man (Fu-Kiau, interview by Sobel). Shannon, "Bill Traylor's Triumph," 64.

43. Sarah Traylor Howard lived on Bragg Street from 1925 to 1950. Traylor is listed as a resident in her home from 1945 to 1949. See *Montgomery City Directory* (1925–1950). Sarah B. Howard and Albert Howard can be found in the U.S. Census, 1930, Montgomery County, Montgomery City. Albert Howard, a tailor, had a shop, while Sarah Traylor Howard, a hairdresser, was working at home. Born in 1887, she gave her age as thirty-two.

44. Comments of Margaret Traylor Staffney and Myrtha Lee Traylor Delks, taped at the second Traylor family reunion, by Miriam Fowler and Marcia Weber, Alabama State Council on the Arts, Montgomery; Delks, in Traylor Family, *Traylor-Calloway-Durant Family Reunion* (booklet), 1992; Shannon, in Maresca and Ricco, "Remembering Bill Traylor," 21–22. Easter Traylor Graham ran a rooming house in Detroit and provided a home for many family members, as noted in the *Traylor-Calloway-Durant Family Reunion* booklets (1991, 1992).

45. Shannon, cited in Maridith Walker, "Bill Traylor: Freed Slave and Folk Artist," *Alabama Heritage* 14 (Fall 1989): 31.

46. Shannon in Maresca and Ricco, "Remembering Bill Traylor," 24; Shannon, "The Folk Art of Bill Traylor," 16; Shannon, "Bill Traylor's Triumph," 60–65, 88; Rankin, "He Lost 10,000 Years," 67.

47. Rosevelt Sykes, "The Honeydripper," "Soft and Mellow" (February 1936), on *Roots of the Blues*, vol. 2, Plattsburgh, N.Y., Direct Source, 2001. In Africa, yellow is widely associated with heat and with passionate personalities, who express love and hate strongly. On the Yoruban understanding of "pupa" colors, including dark yellow, see Aronson, review of *Cloth That Does Not Die*, by Renne; Roxanne Farrar, "The Aesthetics of Color: Yoruba Color Aesthetics," www.faculty.de.gcsu.edu/~dvess/ids/fap/yoruba.htm.

48. Dan Cameron, "History and Bill Traylor," 47.

49. Coffman, *Build Me a City*, 133; David T. Beito, "Black Fraternal Hospitals in the Mississippi Delta, 1942–1967," *Journal of Southern History* 65 (1999): 108–40; Joe Azbell, "They Call It Happy Kitchen," *Montgomery Advertiser*, April 1, 8, 11, 13, 18, 1952; May 6, 8, 13, 1952; and December 5, 1952; *Montgomery Examiner*, April 17, May 1, August 14, November 27, December 4, 1952; *Baptist Leader*, April 17, 1952; *Norfolk Journal and Guide*, April 26, 1952. I am indebted to Dr. Ralph E. Luker, who sought out this large range of articles on black hospitals and nursing homes in Montgomery, Alabama, and sent copies to me.

50. Maresca and Ricco, "Remembering Bill Traylor," 22.

51. Allen Rankin, "He'll Paint for You—Big 'Uns 20 Cents; Lil 'Uns, a Nickel," Rankin File, *Alabama Journal*, March 31, 1948, which includes the photograph by Albert Kraus. This photo shows a series of larger paintings that Traylor made in this period that were apparently discarded after his daughter Sarah's death. Photo reprinted in Phyllis Stigliano, *Bill Traylor: Exhibition History, Public Collections, Selected Bibliography* (New York: Luise Ross Gallery, 1990), 4. The two nursing homes that Traylor had been in, as well as the Happy Kitchen, were on Oak Street. Rev. Mathew A. Sindek, of St. Jude Church, confirmed the church's records of Bill Traylor's birth, baptism, death, and funeral mass, in a letter to Marcia Weber on April 11, 1996, stating that he died on October 23, 1949. The letter is on file in Marcia Weber, Alabama Folk Artists Collection, 1949–93, Archives and Special Collections, Auburn University, Montgomery, Ala.

52. Antoinette Beeks, interview by Mechal Sobel, April, 27, 2004, Atlanta. In my telephone conversation with Henrietta Graham Humphries, Clement Traylor's cousin, on June 29, 2004, she recounted that she and Clement, while attending school at St. Jude's, were the first family members to become Catholic, and that the Traylors were by and large "hard-core Baptists" who were deeply upset by the conversion of Clement, Henrietta, and later Bill Traylor to Catholicism.

On the Baptist opposition to Catholics, see Glen N. Sisk, "Churches in the Alabama Black Belt, 1875–1917," *Church History* 23, no. 2 (1954): 155. On African and African American gravesites, see Thompson, *Flash of the Spirit*, 134; Morrow, "Bakongo Afterlife," 105–15; Association for Gravestone Studies data on Southern African American gravesites at www.state.sc.us/scdah/cemsymbolism.htm. At the 1992 Traylor family reunion, Margaret Staffney suggested Bill Traylor was buried in "West Point" without a marker, in a common grave that held others as well. Myrtha Delks and Margaret Staffney, interview by Miriam Fowler and Marcia Webber, at the second Traylor family reunion, 1992, Alabama State Council of the Arts, Montgomery. Other family members suggest he might have been buried in the Mount Moriah Cemetery, where his daughter Sarah Howard was later buried. Hunton and Williams, "Statement by the Parties," 5.

CODA

1. David Evans, "Form, Imagery and Style in Blues and African-American Folk Art," *River City* 15, no. 2 (1995): 108–9. On the ugly in African American vernacular art, see William Ferris, ed., *Afro-American Folk Art and Crafts* (Boston: Hall, 1983), 112–13. [Charles Shannon], "Bill Traylor—People's Artist." As noted above, Miriam Fowler, Marcia Webber, and Betty Kuyk have sought out critical data relating to Traylor's life.

2. See *Untitled (Man with Red Stomach)* in O'Kane Gallery, *Bill Traylor* (Houston: University of Houston, 2001), unpaginated.

3. Traylor, quoted by Shannon, in Maresca and Ricco, "Remembering Bill Traylor," 8.

4. On creativity, see Hartigan, "Going Urban," 48. On the "wall of silence," see Chaim Aron Kaplan, *The Scroll of Agony*, 299–300. On Douglass's oppositional values, see Frederick Douglass, *Narrative of the Life of Frederick Douglass, an American Slave, Written by Himself,* edited by Benjamin Quarles (1845; Boston: Belknap Press, 1960), 59. On oppositional personal development, see Sobel, *Teach Me Dreams,* 5, 6, 14, 27, 48, 56, 61, 126, 144, 182, 187, 227, 242.

5. D. Mathews, "The Southern Rite of Human Sacrifice."

6. See, for example, the change in view of Jeff Todd Titon, who in 1977 thought that the blues "were about love and sex and floods and bootlegging and farming, not about social or racial protest"; by 1994, however, he had become convinced that they were centrally about social and racial protest (Titon, *Early Downhome Blues,* 266). The literature on this subject is assessed by Stephen T. Asma, "The Blues Artist as Cultural Rebel," *Humanist* 57, no. 4 (July–August 1997): 8–16.

7. On early folk blues, see Pearson, "Appalachian Blues," 6, 28, 29, 32, 34, 38, 39, 47; S. Brown, "The Blues," 288, 292; S. Brown, *Negro Poetry and Drama,* 26–29; S. Brown, "The Blues as Folk Poetry," 372; Harry Oster, *Living Country Blues* (Detroit: Folklore Associates, 1969), 11–25; Aschoff, "The Poetry of the Blues," 57; Peter J. Welding, liner notes on *Big Joe Williams and Sonny Boy Williamson,* Blues Classics: BC 21 (Berkeley: Arhoolie, 1969); Taft, *Blues Lyric Poetry: A Concordance,* vol. 1, introduction, on the Web at www.dylan61.se/Preface_Concor/4.3%20PREFACEConcordance.htm.

8. Wright, "Memories of My Grandmother." See Qiana J. Whitted, "'Using My Grandmother's Life as a Model': Richard Wright and the Gendered Politics of Religious Representation,"

Southern Literary Journal 36, no. 2 (2004): 13–30. Robin D. G. Kelley's analysis of Wright's understanding of surrealism is in Kelley, *Freedom Dreams,* 182. On vernacular surrealism in the blues, see Garon, *Blues and the Poetic Spirit,* 207–16; Sakolsky, *Surrealist Subversions,* 611–46. It is Traylor's surrealism that sets his paintings apart from the social commentary of most other socially conscious painters in his period. See Bram Dijkstra, *American Expressionism: Art and Social Change 1920–1950* (New York: Abrams, 2003); and Stacey I. Morgan, *Rethinking Social Realism: African American Art and Literature, 1930–1953* (Athens: University of Georgia Press, 2004).

9. Sobel, *Teach Me Dreams,* 3–16.

10. Shannon cited in Bonesteel, "Bill Traylor, Creativity and the Natural Artist," 24; Shannon, "Bill Traylor's Triumph," 62.

11. Rosengarten, *All God's Dangers,* 545; Cone, "Strange Fruit."

12. On Shannon as an avowed progressive, see Hunton and Williams, "Statement by the Parties." For the report of Shannon's widow and daughter on his political activities in Alabama, see Helfenstein, "Bill Traylor and Charles Shannon," 97, 104. Shannon's fear of being "caught" is cited by Phagan in *The American Scene and the South,* 30 n. 17. A discussion of the New South and Communist Party membership, as well as a reprint of Shannon's study for the KKK painting, is in Eiland, "Picturing the Unvictorious," 55, 61. Kelley, in *Hammer and Hoe,* analyzes Communist Party work overall, but does not mention the New South group.

13. Bonesteel, "Bill Traylor, Creativity and the Natural Artist," 21, 24.

14. Shannon cited in Bonesteel, "Bill Traylor, Creativity and the Natural Artist," 21; Richard Perez-Pena, "Link to an Illustrious Past, and a Possible Fortune," *New York Times* Wednesday, December 9, 1992; Hal Davis, "Art Dealer Sued over Prints and the Pauper," *New York Post,* November 27, 1992; Jonathan M. Moses, "Heirs of Ex-Slave and Folk Artist Sue Collector for Rights to Work," *Wall Street Journal,* November 30, 1992; Richard Perez-Pena, "Settlement over Artwork by an Ex-Slave," *New York Times,* October 7, 1993; Hunton and Williams, "Statement by the Parties," 4. The settlement involved the establishment of a "Bill Traylor Family Trust collection" with the Hirschl and Adler Gallery to manage any sales. Dietz, *The Last Folk Hero,* 146–49. For Shannon's "second life," see Shannon, "Bill Traylor's Triumph," 88.

15. Sheryl Gay Stolberg, "Senate Issues Apology for Failure on Lynch Law," *International Herald Tribune,* June 15, 2005; Humphries, telephone interview by Sobel.

16. Robert Farris Thompson, "Communiqué from Afro-Atlantis," 8.

17. C. Zelano, M. Benisafi, J. Porter, J. Mainland, B. Johnson, E. Bremner, C. Telles, R. Khan, N. Sobel, "Attentional Modulation in Human Primary Olfactory Cortex," *Nature Neuroscience* 8 (2005): 114–20.

18. Wilson's Raiders, one of the Union forces barreling across Alabama, passed through Benton and camped one mile away en route from Selma to Montgomery on April 11, 1865. One hundred years later (March 7, 1965), the Alabama state troopers met the civil rights marchers taking the same route, at the Edmund Pettus Bridge in Selma with a bloody attack. The televised trooper attack brought about the massive King-led march on March 9–12, 1965, which started with some 3,200 and grew to some 25,000 on the final morning. John Jackson, now mayor of the village of White Hall, an all-black town adjacent to Benton, Alabama, joined the march and later founded the Lowndes County Freedom Organization, which in the 1960s successfully

worked to bring black people to register and vote. Lowndes County, however, remained one of the poorest counties in the United States: In 1960, the median income for blacks was $935 per year. See Jones, *Yankee Blitzkrieg*, 103, 106; Dent, *Southern Journey*, 287; Townsend Davis, *Weary Feet, Rested Souls: A Guided History of the Civil Rights Movement* (New York: Bantam Books, 1998), 50–51. A map of the march to Montgomery, and the overnight stopping points, can be found in Joy Hakim, *A History of US: All the People, 1945–1999* (New York: Oxford University Press, 1999), 10: 126; John Jackson, interview by Mechal Sobel, February 21, 2001, White Hall, Ala.

BIBLIOGRAPHY

Adams, Samuel C. "Changing Negro Life in the Delta." In *Lost Delta Found: Rediscovering the Fisk University–Library of Congress Coahoma County Study, 1941–1942*, by John W. Work, Lewis Wade Jones, and Samuel C. Adams; edited by Robert Gordon and Bruce Nemerov, 223–90. Nashville: Vanderbilt University Press, 2005.

Ainslee, Scott. *Robert Johnson at the Crossroads*. Milwaukee: Leonard, 1992.

Alabama Bureau of Vital Statistics. Will Traylor Certificate of Death. Montgomery, August 26, 1929.

Alabama Census, Lowndes County, Colored, 1866. Handwritten original on file at the Alabama Department of Archives and History, Montgomery.

Albaugh, June M., and Rosa Lyon Traylor. *Collirene: The Queen Hill*. Montgomery: Paragon Press, 1977.

Ames, Jessie Daniel. *The Changing Character of Lynching: Review of Lynching, 1931–1941*. 1942. New York: AMS Press, 1973.

Anderson, Jeffrey E. *Conjure in African American Society*. Baton Rouge: Louisiana State University Press, 2005.

Apel, Dora. *Imagery of Lynching: Black Men, White Women, and the Mob*. New Brunswick, N.J.: Rutgers University Press, 2004.

Arnett, Paul, and William Arnett, eds. *Souls Grown Deep: African American Vernacular Art of the South*. Atlanta: Tinwood Books, 1999–2001.

Aronson, Lisa. Review of *Cloth That Does Not Die: The Meaning of Cloth in Bùnú Social Life*, by Elisha P. Renne. H-AfrArts, H-Net Reviews (July 1997). www.h-net.org/reviews/showrev.cgi?path=24094872714889.

Aschoff, Peter R. "The Poetry of the Blues: Understanding the Blues in Its Cultural Context." In *The Triumph of the Soul: Cultural and Psychological Aspects of African American Music*, edited by Ferdinand Jones and Arthur C. Jones, 35–68. Westport, Conn.: Praeger, 2001.

Asma, Stephen T. "The Blues Artist as Cultural Rebel." *Humanist* 57, no. 4 (July–August 1997): 8–16.

Atkinson, Samuel T. "Masonic Ritual in Virginia." *Transactions of A. Douglass Smith, Jr., Lodge of Research #1949, AF&AM* 1 (1982–87): 1–17.

Aunt Sally's Policy Players' Dream Book and Wheel of Fortune. 1899. Los Angeles: Indio Products, 1997.

Autrey, Dorothy. "'Can These Bones Live?': The National Association for the Advancement of Colored People in Alabama, 1918–1930." *Journal of Negro History* 82 (1997): 1–12.

Azbell, Joe. "They Call It Happy Kitchen." *Montgomery Advertiser,* April 1, 1952.

Bagnall, Robert W. "The Present South." *Crisis* 36, no. 9 (September 1929): 303.

Bailey, Cornelia Walker, and Christena Bledsoe. *God, Dr. Buzzard, and the Bolito Man: A Saltwater Geechee Talks about Life on Sapelo Island.* New York: Doubleday, 2000.

Baker, Eleanor J. "Silas Green Show." In *Encyclopedia of Southern Culture,* edited by Charles Reagan Wilson and William Ferris, 223–24. Chapel Hill: University of North Carolina Press, 1989.

Baker, Houston A., Jr. *Blues, Ideology, and Afro-American Literature: A Vernacular Theory.* Chicago: University of Chicago Press, 1984.

Baker, R. C. "Two Artists Who Didn't Need to Be Told Anything: Bill Traylor and William Edmondson." *Village Voice,* June 29, 2005, www.villagevoice.com/.

Barlow, William. *Looking Up at Down: The Emergence of Blues Culture.* Philadelphia: Temple University Press, 1984.

Bass, Ruth. "The Little Man." *Scribner's Magazine* 97 (February 1935): 120–23. Reprinted in *Mother Wit from the Laughing Barrel: Readings in the Interpretation of Afro-American Folklore,* edited by Alan Dundes, 388–96. New York: Garland, 1981.

Beardon, Romare, and Harry Henderson. *A History of African American Artists: From 1792 to the Present.* New York: Pantheon, 1993.

Beecher, John. "The Share Croppers' Union in Alabama." *Social Forces* 13 (October 1934): 124–32.

Beeks, Antoinette. Interview by Mechal Sobel. April 27, 2004. Atlanta, Ga. Notes, Mechal Sobel, personal collection.

Beito, David T. "Black Fraternal Hospitals in the Mississippi Delta, 1942–1967." *Journal of Southern History* 65 (1999): 108–40.

Bell, Michael Edward. "Pattern, Structure, and Logic in Afro-American Hoodoo Performance." Ph.D. diss., Indiana University, 1980.

Béresniak, Daniel. *Symbols of Freemasonry.* 1997. New York: Assouline, 2000.

Blier, Suzanne Preston. *African Vodun: Art, Psychology, and Power.* Chicago: University of Chicago Press, 1995.

———. "Vodun: West African Roots of Vodou." In *Sacred Arts of Haitian Vodou*, edited by Donald J. Cosentino, 61–87. Los Angeles: UCLA Fowler Museum of Cultural History, 1995.

Bloom, Harold. *The American Religion: The Emergence of the Post-Christian Nation*. New York: Simon and Schuster, 1992.

Bonesteel, Michael. "Bill Traylor, Creativity and the Natural Artist." In *Bill Traylor Drawings*, 9–24. Chicago: Chicago Office of Fine Arts, 1988.

Borum, Jenifer P. "Bill Traylor and the Construction of Outsider Subjectivity." In *Sacred and Profane: Voice and Vision in Southern Self-Taught Art*, edited by Carol Crown and Charles Russell, 238–60. Jackson: University Press of Mississippi, 2007.

Boskin, Joseph. *Urban Racial Violence in the Twentieth Century*. 1969. Beverly Hills, Calif.: Glencoe Press, 1976.

Boyd, Valerie. *Wrapped in Rainbows: The Life of Zora Neale Hurston* (New York: Scribner, 2003).

Brooks, Gwendolyn. *Selected Poems*. New York: Harper and Row, 1963.

Brooks, Joanna. "The Early American Public Sphere and the Emergence of a Black Print Counterpublic." *William and Mary Quarterly* 62 (2005): 67–92.

———. "Prince Hall, Freemasonry, and Genealogy." *African American Review* 34 (2000): 197–217.

Brown, David H. "Conjure/Doctors: An Explanation of a Black Discourse in America, Antebellum to 1940." *Folklore Forum* 23 (1990): 3–46.

———. *The Light Inside: Abakuá Society Arts and Cuban Cultural History*. Washington, D.C.: Smithsonian Institution Press, 2003.

Brown, Karen McCarthy. "Systematic Remembering, Systematic Forgetting: Ogou in Haiti." In *African-American Religion: Interpretive Essays in History and Culture*, edited by Timothy E. Fulop and Albert J. Raboteau, 433–62. New York: Routledge, 1997.

Brown, Kenneth L. "Material Culture and Community Structure: The Slave and Tenant Community at Levi Jordan's Plantation, 1848–1892." In *Working toward Freedom: Slave Society and Domestic Economy in the American South*, edited by Larry E. Hudson Jr., 95–118. Rochester, N.Y.: University of Rochester Press, 1994.

Brown, Ray. "Some Notes on the Southern 'Holler.'" *Journal of American Folklore* 67 (1954): 73–77.

Brown, Sterling A. "The Blues." *Phylon* 13 (1952): 286–92.

———. "The Blues as Folk Poetry." *Folk-Say* 1, edited by Benjamin A. Botkin, 324–39. Norman: Oklahoma Folk-lore Society and University of Oklahoma Press, 1930. Reprinted in *The Book of Negro Folklore*, edited by Langston Hughes and Arna Bontemps, 371–86. New York: Dodd, Mead, 1958.

———. *Negro Poetry and Drama*. 1937. New York: Arno Press, 1969.

Brown, William Wells. *My Southern Home; or, The South and Its People.* Boston: A. G. Brown, 1880.

Brownell, Blain A. "Birmingham Alabama: New South City in the 1920s." *Journal of Southern History* 38 (1972): 21–48.

Brundage, W. Fitzhugh. *Lynching in the New South: Georgia and Virginia, 1880–1930.* Urbana: University of Illinois Press, 1993.

———. "The Roar on the Other Side of Violence: Black Resistance and White Violence in the American South, 1880–1940." In *Under Sentence of Death: Lynching in the South,* edited by Brundage, 271–91. Chapel Hill: University of North Carolina Press, 1997.

Cabrera, Lydia. *Anaforuana: Ritual y simbolos de la iniciacion en la sociedad secreta Abakuá.* Madrid: Los de hoy, Liberia Orbe, 1975.

Cameron, Dan. "History and Bill Traylor." *Arts Magazine* 60, no. 2 (October 1985): 45–47.

Camp, Bayliss J., and Orit Kent. "'What a Mighty Power We Can Be': Individual and Collective Identity in African American and White Fraternal Initiation Rituals." *Social Science History* 28 (2004): 439–83.

Cardyn, Lisa. "Sexualized Racism/Gendered Violence: Outraging the Body Politic in the Reconstruction South." *Michigan Law Review* 100 (2002): 675–867.

Carmer, Carl. *Stars Fell on Alabama.* 1934. Tuscaloosa: University of Alabama Press, 2000.

Carter, Dan T. *Scottsboro: A Tragedy of the American South.* Baton Rouge: Louisiana State University Press, 1969.

Cassidy, Donna M. "Competing Notions of American and Artistic Identity in Visual and Written Autobiographies in the 1930s and Early 1940s." In *Writing Lives: American Biography and Autobiography,* edited by Hans Bok and Hans Krabbendam, 63–73. Amsterdam: VU University Press, 1998.

Charters, Samuel. *The Poetry of the Blues.* New York: Oak, 1963.

Chatters, Linda M., Robert Joseph Taylor, and Rukmalie Jayakody. "Fictive Kinship Relations in Black Extended Families." *Journal of Comparative Family Studies* 25 (1994): 297–312.

Cochran, Matthew David. "Hoodoo's Fire: Interpreting Nineteenth-Century African-American Material Culture at the Brice House, Annapolis, Maryland." *Maryland Archaeology* 35, no. 1 (1999): 25–33.

Coffman, Sister Mary Ruth. *Build Me a City: The Life of Father Harold Purcell.* Montgomery: Pioneer Press, 1984.

Cone, James H. *The Spirituals and the Blues: An Interpretation.* 1972. Maryknoll, N.Y.: Orbis, 2008.

———. "Strange Fruit: The Cross and the Lynching Tree." Ingersoll Lecture at Harvard University Divinity School. October 19, 2006. Reprinted in *Harvard Divinity Bulletin* 35, no. 1 (winter 2007).

Conforth, Bruce. "The Field Recordings of Lawrence Gellert." *Resound: A Quarterly of the Archives of Traditional Music* 2, no. 4 (October 1983): 1–2.

Conwill, Kinshasha Holman. "In Search of an 'Authentic' Vision: Decoding the Appeal of the Self-Taught African-American Artist." *American Art* 5, no. 4 (Autumn 1991): 2–9.

Cosentino, Donald. "Imagine Heaven." In *Sacred Arts of Haitian Vodou*, edited by Donald Cosentino, 25–60. Los Angeles: UCLA Fowler Museum of Cultural History, 1995.

Crawley Susan M. "Words and Music: Seeing Traylor in Context." In *Sacred and Profane: Voice and Vision in Southern Self-Taught Art*, edited by Carol Crown and Charles Russell, 214–37. Jackson: University Press of Mississippi, 2007.

Culpepper, Angela, and Alan Vannoy. "Biographies and Major Sources." In *The American Scene and the South: Paintings and Works on Paper, 1930–1946*, edited by Patricia Phagan, 243–63. Athens: Georgia Museum of Art, 1996.

Davis, Angela Y. *Blues Legacies and Black Feminism: Gertrude "Ma" Rainey, Bessie Smith, and Billie Holiday.* New York: Pantheon, 1998.

Davis, Townsend. *Weary Feet, Rested Souls: A Guided History of the Civil Rights Movement.* New York: Norton, 1998.

de Jong, Greta. *A Different Day: African American Struggles for Justice in Rural Louisiana, 1900–1970.* Chapel Hill: University of North Carolina Press, 2002.

Delany, Martin. *The Origin and Objects of Ancient Freemasonry: Its Introduction into the United States and Legitimacy among Colored Men.* 1853. Xenia, Ohio: A. D. Delany, 1904.

Delks, Myrtha, and Margaret Staffney. Interview by Miriam Fowler and Marcia Webber. 1992. Second Traylor family reunion, Atlanta, Ga. Alabama State Council of the Arts, Montgomery.

Denby, Charles [Matthew Ward]. *Indignant Heart: A Black Worker's Journal.* 1952. 2nd rev. ed. Boston: South End Press, 1978.

Dent, Tom. *Southern Journey: A Return to the Civil Rights Movement.* 1997. Athens: University of Georgia Press, 2001.

Desmangles, Leslie. *The Faces of the Gods: Vodou and Roman Catholicism in Haiti.* Chapel Hill: University of North Carolina Press, 1992.

Dewhurst, C. Kurt, Betty MacDowell, and Marcia MacDowell. *Religious Folk Art in America: Reflections of Faith.* New York: Dutton, 1983.

Dietz, Andrew. *The Last Folk Hero: A True Story of Race and Art, Power and Profit.* Atlanta: Ellis Lane Press, 2006.

Dijkstra, Bram. *American Expressionism: Art and Social Change 1920–1950*. New York: Abrams, 2003.

Dodson, Howard, and Sylviane A. Diouf, eds. *In Motion: The African-American Migration Experience*. New York: Schomburg Center for Research in Black Culture, 2005.

Douglass, Frederick. *Narrative of the Life of Frederick Douglass, an American Slave, Written by Himself.* 1845. Edited by Benjamin Quarles. Cambridge, Mass.: Belknap Press, 1960.

Dove, John. *The Virginia Text-book: Containing a history of masonic grand lodges, and the constitution of masonry, or ahiman rezon, together with a digest of the laws, rules, and regulations of the Grand Lodge of Virginia, also, a complete compilation of the illustrations of masonic work. . . .* 1846. 3rd ed. Richmond: J. E. Goode, 1866.

Downes, Olin, and Elie Siegmeister. *A Treasury of American Songs.* 1940. Consolidated Music Publishers: New York, 1943.

Drewal, Henry John. "Art and Divination among the Yoruba: Design and Myth." *Africana Journal* 14 (1987): 139–56.

Drzazga, John. "Gambling and the Law: Policy." *Journal of Criminal Law, Criminology, and Police Science* 44, no. 5 (1954): 665–70.

Du Bois, W. E. B. *The Autobiography of W. E. B. Du Bois: A Soliloquy on Viewing My Life from the Last Decade of Its First Century.* New York: International Publishers, 1968.

———. *Economic Co-Operation among Negro Americans.* Atlanta: Atlanta University Press, 1907.

———. "The Economic Future of the Negro." *Publications of the American Economic Association*, 3rd ser., 7, no. 1 (February 1906): 219–42.

———. "A Litany at Atlanta." In *The Seventh Son: The Thought and Writings of W. E. B. Du Bois*, edited by Julius Lester, 422–26. New York: Random House, 1971.

———. *The Negro Church: Report of a Social Study Made under the Direction of Atlanta University.* Atlanta: Atlanta University Press, 1903.

———. Papers. Du Bois Library, University of Massachusetts, Amherst.

Dundes, Alan, ed. *Mother Wit from the Laughing Barrel: Readings in the Interpretation of Afro-American Folklore.* New York: Garland, 1981.

E. D. Nixon: The Forgotten Hero. Directed by Tom C. Leonard. Videorecording. Montgomery: Office of Information Technology–Media Production Group: Auburn University and Alabama State University, 1982. www.montgomeryboycott.com/bio_ednixon.htm.

Egerton, John. *Speak Now Against the Day: The Generation before the Civil Rights Movement in the South.* Chapel Hill: University of North Carolina Press, 1995.

Eiland, William U. "Picturing the Unvictorious: The Southern Scene in Alabama: 1930–1946." In *The American Scene and the South: Paintings and Works on Paper, 1930–1946*, edited by Patricia Phagan, 33–74. Athens: Georgia Museum of Art, 1996.

Ellis, R. H. "The Calhoun School, Miss Charlotte Thorn's 'Lighthouse on the Hill' in Lowndes County, Alabama." *Alabama Review* 37, no. 3 (1984): 183–201.

Ellison, Ralph. *Shadow and Act.* 1953. New York: Random House, 1964.

Evans, David. *Big Road Blues: Tradition and Creativity in the Folk Blues.* Berkeley and Los Angeles: University of California Press, 1982.

———. "The Development of the Blues." In *The Cambridge Companion to Blues and Gospel Music*, edited by Allan Moore, 20–43. Cambridge: Cambridge University Press, 2002.

———. "Form, Imagery and Style in Blues and African-American Folk Art." *River City* 15, no. 2 (1995): 100–110.

Fabian, Ann. *Card Sharps, Dream Books, and Bucket Shops: Gambling in Nineteenth-Century America.* Ithaca: Cornell University Press, 1990.

Faïk-Nzuji, Clémentine M. *Tracing Memory: A Glossary of Graphic Signs and Symbols in African Art and Culture.* Quebec: Canadian Museum of Civilization, 1996.

Fairclough, Adam. *Race and Democracy: The Civil Rights Struggle in Louisiana, 1915–1972.* Athens: University of Georgia Press, 1995.

Fandrich, Ina Johanna. *The Mysterious Voodoo Queen, Marie Laveaux: A Study of Powerful Female Leadership in Nineteenth-Century New Orleans.* New York: Routledge, 2004.

Feldman, Glenn. "Soft Opposition: Elite Acquiescence and Klan-Sponsored Terrorism in Alabama, 1946–1950." *Historical Journal* 40 (1997): 753–77.

Ferguson, Charles W. *Fifty Million Brothers: A Panorama of American Lodges and Clubs.* New York: Farrar and Rinehart, 1937.

Ferris, William, ed. *Afro-American Folk Art and Crafts.* Boston: Hall, 1983.

———. *Blues from the Delta.* Garden City N.Y.: Anchor Press/Doubleday, 1978.

———. "If You Ain't Got It in Your Head, You Can't Do It in Your Hand: James Thomas, Mississippi Delta Folk Sculptor." *Studies in the Literary Imagination* 3 (1970): 89–107.

———. "Racial Repertoires among Blues Performers." *Ethnomusicology* 14 (September 1970): 439–49.

———. "Vision in Afro-American Folk Art: The Sculpture of James Thomas." *Journal of American Folklore* 88 (April–June 1975): 115–31.

Fett, Sharla M. *Working Cures: Healing, Health, and Power on Southern Slave Plantations.* Chapel Hill: University of North Carolina Press, 2002.

Fine, Gary Alan. *Everyday Genius: Self-Taught Art and the Culture of Authenticity.* Chicago: University of Chicago Press, 2004.

Finn, Julio. *The Bluesman: The Musical Heritage of Black Men and Women in the Americas.* 1986. New York: Interlink Books, 1992.

Finore, Diane. "Art by Bill Traylor." *Clarion* (Spring–Summer 1985): 42–48.

Fischer, Alfred M. "Looking at Bill Traylor: Observation on the Reception of His Work." In *Bill Traylor, 1854–1949: Deep Blues,* edited by Josef Helfenstein, and Roman Kurzmeyer, 162–68. New Haven: Yale University Press, 1999.

Fitzgerald, Michael W. *The Union League Movement in the Deep South: Politics and Agricultural Change during Reconstruction.* 1989. Baton Rouge: Louisiana State University Press, 2000.

Foner, Eric. *Reconstruction: America's Unfinished Revolution.* Harper and Row: New York, 1988.

Fowler, Miriam Rogers. "Bill Traylor." In *Outsider Artists in Alabama,* compiled by Fowler, 52–53. Montgomery: Alabama State Council on the Arts, November 1991.

———. "A Glimpse at William 'Bill' Traylor." In *Bill Traylor.* Houston: University of Houston, O'Kane Gallery, 2001.

———. "New South School and Gallery." In *New South, New Deal and Beyond: An Exhibition of New Deal Era Art, 1933–1943,* edited by Fowler, 6–10. Montgomery: Alabama Council on the Arts, 1989.

Fu-Kiau, K. K. Bunseki. *African Cosmology of the Bântu-Kôngo: Tying the Spiritual Knot, Principles of Life and Living.* 2nd ed. Brooklyn, N.Y.: Anthelia Henrietta Press, 2001.

———. Interview by Mechal Sobel. May 23, 2001. Haifa, Israel. Notes, Mechal Sobel, personal collection.

———. "Ntangu-Tandu-Kolo: The Bantu-Kongo Concept of Time." In *Time in the Black Experience,* edited by Joseph K. Adjaye, 17–34. Westport, Conn.: Greenwood Press, 1994.

Garabedian, Steven. "Reds, Whites, and the Blues: Blues Music, White Scholarship, and American Cultural Politics." Ph.D. diss., University of Minnesota, 2004.

———. "Reds, Whites, and the Blues: Lawrence Gellert, 'Negro Songs of Protest,' and the Left-Wing Folk Song Revival of the 1930s and 1940s." *American Quarterly* 57, no. 1 (2005): 179–206.

Garon, Paul. *Blues and the Poetic Spirit.* 1975. San Francisco: City Lights Books, 1996.

Garrow, David J. "The Origins of the Montgomery Bus Boycott." In *The Walking City: The Montgomery Bus Boycott, 1955–1956,* edited by David J. Garrow, 607–20. Brooklyn, N.Y.: Carlson Press, 1989.

Gates, Henry Louis, Jr. *The Signifying Monkey: A Theory of African American Literary Criticism.* New York: Oxford University Press, 1987.

Gellert, Lawrence. Interviews by Richard A. Reuss. August 31, 1966, March 28, 1968, May 7, 1968, June 25, 1969; and September 11, 1969. Archives of Traditional Music, Indiana University, Bloomington.

———. "Me and My Captain" (Chain Gangs): Negro Songs of Protest. Scores by Lan Adomian. New York: Hours Press, 1939.

———. "Negro Songs of Protest." Music Vanguard 1, no. 1 (1935): 11.

———. Negro Songs of Protest. Scores by Elie Siegmeister. New York: American Music League, 1936.

———. "Negro Songs of Protest: North and South Carolina and Georgia." In Negro: An Anthology, collected and edited by Nancy Cunard; edited and abridged by Hugh Ford, 226–37. New York: Ungar, 1970.

———. Papers, 1927–1978. Lilly Library, Indiana University.

———. "Sound Recordings, Afro-Americans, 1920–1940." Archives of Traditional Music, Indiana University, Bloomington.

———. "Two Songs about Nat Turner." Worker Magazine, June 12, 1949, 8.

Georgia Writers' Project (Savannah Unit), Works Projects Administration. Drums and Shadows: Survival Studies among the Georgia Coastal Negroes. 1940. Athens: University of Georgia Press, 1986.

Goeser, Caroline. "'On the Cross of the South': The Scottsboro Boys as Vernacular Christs in Harlem Renaissance Illustration." International Review of African American Art 19 (2003): 19–27.

Gosse, Philip Henry. Letters from Alabama: Chiefly Relating to Natural History. 1859. Tuscaloosa: University of Alabama Press, 1993.

Gray, David L. Inside Prince Hall. Lancaster, Va.: Anchor Communications LLC, 2004.

Green, Henry. "Autobiography II: A Preacher from a God-fearing Plantation." In God Struck Me Dead: Religious Conversion Experiences and Autobiographies of Negro Ex-Slaves, edited by Clifton H. Johnson, 68–90. 1945. Philadelphia: Pilgrim Press, 1969.

Greenberg, Gabriel. "'Like a Spirit on the Water': The Life and Music of Vera Hall." Accessed in 2004 at www.verahallproject.com, 2003; no longer on the Web.

Greenway, John. American Folk Songs of Protest. 1953. New York: Octagon, 1970.

Grimshaw, William H. Official History of Freemasonry among the Colored People in North America. 1903. New York: Negro Universities Press, 1969.

Grossman, Jonathan. "Black Studies in the Department of Labor, 1897–1907." Monthly Labor Review (June 1974).

Gundaker, Grey. Signs of Diaspora/Diaspora of Signs: Literacies, Creolization, and Vernacular Practice in African America. New York: Oxford University Press, 1998.

Gundaker, Grey, and Judith McWillie. No Space Hidden: The Spirit of African American Yard Work. Knoxville: University of Tennessee Press, 2005.

Gussow, Adam. "'Make My Getaway': The Blues Lives of Black Minstrels in W. C. Handy's *Father of the Blues*." *African American Review* 35, no. 1 (2001): 5–28.

———. *Seems Like Murder Here: Southern Violence and the Blues Tradition*. Chicago: University of Chicago Press, 2002.

Gutman, Herbert G. *The Black Family in Slavery and Freedom, 1750–1925*. New York: Pantheon, 1976.

Hackett, David G. "The Prince Hall Masons and the African American Church: The Labors of Grand Master and Bishop James Walker Hood, 1831–1918." *Church History* 69, no. 4 (2000): 770–803.

Hackney, Sheldon. "Southern Violence." *American Historical Review* 74 (1969): 906–25.

Hahn, Steven. *A Nation under Our Feet: Black Political Struggles in the Rural South from Slavery to the Great Migration*. Cambridge, Mass.: Belknap Press, 2003.

Hakim, Joy. *A History of US: All the People, 1945–1999*. Vol. 10. New York: Oxford University Press, 1999.

Hall, Jacquelyn Dowd. "Mobilizing Memory: Broadening Our View of the Civil-Rights Movement." *Chronicle of Higher Education* 46 (July 27, 2001): B7.

Hall, Prince. "A Charge Delivered to the Brethren of the African Lodge at the Hall of Brother William Smith in Charleston." Boston, 1792. Reprinted in David L. Gray, *Inside Prince Hall*, 48–53. Lancaster, Va.: Anchor Communications, 2003.

Hall, Vera. Interview by Alan Lomax. 1948. Lomax Collection, Association for Cultural Equity, Hunter College, New York City.

Handy, W. C., ed., with text by Abbe Niles. *A Treasury of the Blues: Complete Words and Music of 67 Great Songs from Memphis Blues to the Present Day*. 1926. New York: Charles Boni, distributed by Simon and Schuster, 1949.

Harrah-Conforth, Bruce Michael. "Laughing Just to Keep from Crying: Afro-American Folksong and the Field Recordings of Lawrence Gellert." Master's thesis, Indiana University, 1984.

Harris, Michael W. *The Rise of Gospel Blues: The Music of Thomas Andrew Dorsey in the Urban Church*. New York: Oxford University Press, 1992.

Harris, Trudier. *Exorcising Blackness: Historical and Literary Lynching and Burning Rituals*. Bloomington: Indiana University Press, 1984.

———. "No Outlet for the Blues: Silla Boyce's Plight in Brown Girl, Brownstones." *Callaloo* 18 (Spring–Summer 1983): 57–67.

Hartigan, Lynda Roscoe. "Going Urban: American Folk Art and the Great Migration." *American Art* 14, no. 2 (Summer 2000): 26–51.

Haskins, Jim. *Voodoo and Hoodoo: Their Tradition and Craft as Revealed by Actual Practitioners*. 1978. Lanham, Md.: Scarborough House, 1990.

Haywood, Harry. *Negro Liberation*. New York: International Publishers, 1948.

Hazzard-Gordon, Katrina. *Jookin': The Rise of Social Dance Formations in African-American Culture.* Philadelphia: Temple University Press, 1990.

Helfenstein, Josef. "Bill Traylor and Charles Shannon: A Historic Encounter in Montgomery." In *Bill Traylor, 1854–1949: Deep Blues,* edited by Helfenstein and Roman Kurzmeyer, 96–108. New Haven: Yale University Press, 1999.

———. "From the Sidewalk to the Marketplace: Traylor, Edmondson, and the Modernist Impulse." In *Bill Traylor, William Edmondson, and the Modernist Impulse,* edited by Helfenstein and Roxanne Stanulis, 45–67. Champaign, Ill.: Krannert Art Museum and the Menil Collection, 2004.

Helfenstein, Josef, and Roman Kurzmeyer, eds. *Bill Traylor, 1854–1949: Deep Blues.* New Haven: Yale University Press, 1999.

Helfenstein, Josef, and Roxanne Stanulis, eds. *Bill Traylor, William Edmondson, and the Modernist Impulse.* Champaign, Ill.: Krannert Art Museum and the Menil Collection, 2004.

Hemenway, Robert E. *Zora Neale Hurston: A Literary Biography.* 1977. Urbana: University of Illinois Press, 1980.

Herron, Leonora, and Alice M. Bacon. "Conjuring and Conjure-Doctors in the Southern United States." *Southern Workman and Hampton School Record* 24 (1895): 117–18, 193–94, 209–11. Reprinted in *Mother Wit from the Laughing Barrel: Readings in the Interpretation of Afro-American Folklore,* edited by Alan Dundes, 359–68. New York: Garland, 1981.

Herskovits, Melville J. *Dahomey: An Ancient West African Kingdom.* 2 vols. Evanston, Ill.: Northwestern University Press, 1967.

Higginson, Thomas Wentworth. *Army Life in a Black Regiment.* 1900. New York: Collier, 1962.

Hine, Darline Clark. "Rape and the Inner Lives of Black Women in the Middle West: Preliminary Thoughts on the Culture of Dissemblance." *Signs* 14 (1989): 912–20.

Hines, Elizabeth, and Eliza Steelwater. "Project HAL: Historical American Lynching Data." http://users.bestweb.net/~rg/Lynchings.htm.

Hollander, Stacey C. "Temporal Aesthetics in American Folk Art." In *American Anthem: Masterworks from the American Folk Art Museum,* edited by Stacey C. Hollander and Brook Davis Anderson, 15–18. New York: American Folk Art Museum, 2002.

Holley, Lonnie. "The Unspeakable Taboo." In *Souls Grown Deep: African American Vernacular Art of the South,* edited by William Arnett and Paul Arnett, vol. 2, *Once That River Starts to Flow,* 28–31. Atlanta: Tinwood Books, 2001.

Honey, Michael. "Racism, Organized Labor, and the Black Freedom Struggle." *Contours: A Journal of the African Diaspora* 1, no. 1 (Spring 2003): 57–81.

Hudson, Hosea. *The Narrative of Hosea Hudson: His Life as a Negro Communist in the South.* Edited by Nell Irvin Painter. Cambridge: Harvard University Press, 1979.

Humphries, Henrietta Graham. Telephone interview by Mechal Sobel. June 29, 2004. Montgomery, Ala. Notes, Mechal Sobel, personal collection.

Hunter, Tera W. *To 'Joy My Freedom: Southern Black Women's Lives and Labors after the Civil War.* Cambridge: Harvard University Press, 1997.

Hunton and Williams, attorneys. "Statement by the Parties Announcing Settlement of the Lawsuits Concerning the Art of Bill Traylor." October 5, 1993. New York City. Bill Traylor Papers, Alabama State Council on the Arts, Montgomery.

Hurbon, Laennec. *Voodoo: Search for the Spirit.* 1993. New York: Abrams, 1995.

Hurston, Zora Neale. "Characteristics of Negro Expression." 1934. In *Negro Anthology,* edited by Nancy Cunard, 44–46. New York: Ungar, 1969.

———. *Dust Tracks on a Road: An Autobiography.* New York: Lippincott, 1942. Reprinted in Hurston, *Folklore, Memoirs, and Other Writings.* New York: Library of America, 1995.

———. "Hoodoo in America." *Journal of American Folklore* 44 (1931): 317–417.

———. *Mules and Men.* 1935. Bloomington: Indiana University Press, 1978.

———. Review of *Voodoo in New Orleans,* by Robert Tallant. *Journal of American Folklore* 60 (1947): 436–38.

———. *The Sanctified Church.* Berkeley: Turtle Island, 1983.

———. "Seeing the World as It Is." In the restored text of *Dust Tracks on a Road* (1942) in Hurston, *Folklore, Memoirs, and Other Writings,* 782–95. New York: Library of America, 1995.

———. *Voodoo Gods: An Inquiry into Native Myths and Magic in Jamaica and Haiti.* London: Dent, 1939.

Hustvedt, Siri. *Mysteries of the Rectangle: Essays on Painting.* New York: Princeton Architectural Press, 2005.

Hyatt, Harry Middleton. *Hoodoo–Conjuration–Witchcraft–Rootwork: Beliefs Accepted by Many Negroes and White Persons, These Being Orally Recorded among Blacks and Whites.* Five vols. paginated consecutively. Hannibal, Mo.: Western Publishing, 1970–78.

Imes, Birney. *Juke Joint: Photographs.* Jackson: University Press of Mississippi, 2002.

Jackson, Harvey H. "Philip Henry Gosse: An Englishman in the Alabama Black Belt." *Alabama Heritage* 28 (1993): 37–45.

Jackson, John. Interview by Mechal Sobel. February 21, 2001. White Hall, Ala. Notes, Mechal Sobel, personal collection.

Jacobson-Widding, Anita. "The Encounter in the Water Mirror." In *Body and Space: Symbolic Models of Unity and Division in African Cosmology and Experience,* edited by Jacobson-Widding, 177–216. Stockholm: Almquist and Wiksell International, 1991.

———. *Red-White-Black as a Mode of Thought: A Study of Triadic Classification by Colours in the Ritual Symbolism and Cognitive Thought of the Peoples of the Lower Congo.* Stockholm: Almquist and Wiksell International, 1979.

James, A. Everett. "Images of African Americans in Southern Painting, 1840–1940." *Southern Cultures,* 9, no. 2 (Summer 2003): 67–81.

Johnson, Charles S. *Shadow of the Plantation.* 1934. New Brunswick, N.J.: Transaction, 1996.

Johnson, Clifton H., ed. *God Struck Me Dead: Religious Conversion Experiences and Autobiographies of Ex-Slaves.* 1945. Philadelphia: Pilgrim Press, 1969.

Johnson, F. Roy. *The Fabled Doctor Jim Jordan: A Story of Conjure.* Murfreesboro, N.C.: Johnson Publishing, 1963.

Johnson, Guion Griffis. *Ante-Bellum North Carolina: A Social History.* Chapel Hill: University of North Carolina Press, 1937.

Jones, James Pickett. *Yankee Blitzkrieg: Wilson's Raid through Alabama and Georgia.* Athens: University of Georgia Press, 1976.

Joseph, J. W., Theresa M. Hamby, and Catherine S. Long. *Historical Archaeology in Georgia.* Georgia Archaeological Research Design Papers 14. Athens: University of Georgia Press, 2004.

Kaplan, Carla, ed. *Zora Neale Hurston: A Life in Letters.* New York: Doubleday, Macmillan, 2002.

Kaplan, Chaim Aron. *The Scroll of Agony: The Warsaw Diary of Chaim A. Kaplan.* Translated and edited by Abraham I. Katsch. New York: Macmillan, 1965.

Keil, Charles. "From 'Role and Response.'" In *Write Me a Few of Your Lines: A Blues Reader,* edited by Steven C. Tracy, 216–18. Amherst: University of Massachusetts Press, 1999.

———. *Urban Blues.* Chicago: University of Chicago Press, 1966.

Kelley, Robin D. G. "'Comrades, Praise Gawd for Lenin and Them!': Ideology and Culture among Black Communists in Alabama, 1930–1935." *Science and Society* 52, no. 1 (Spring 1988): 59–82.

———. *Freedom Dreams: The Black Radical Imagination.* Boston: Beacon Press, 2002.

———. *Hammer and Hoe: Alabama Communists during the Great Depression.* Chapel Hill: University of North Carolina Press, 1990.

———. "A New War in Dixie: Communists and the Unemployed in Birmingham, Alabama, 1930–1933." *Labor History* 30, no. 3 (1989): 367–84.

———. "Share Croppers Union." In *Major Problems in American History, 1920–45, Documents and Essays,* edited by Colin Gordon, 253–62. New York: Houghton Mifflin, 1999.

———. "'We Are Not What We Seem': Rethinking Black Working-Class Opposition in the Jim Crow South." *Journal of American History* 80 (1993): 75–112.

Kirschke, Amy Helene. *Art in Crisis: W. E. B. Du Bois and the Struggle for African American Identity and Memory.* Bloomington: Indiana University Press, 2007.

Kurzmeyer, Roman. "The Life and Times of Bill Traylor (1854–1949)." In *Bill Traylor, 1854–1949: Deep Blues,* edited by Josef Helfenstein, and Kurzmeyer, 169–77. New Haven: Yale University Press, 1999.

———. "Plow and Pencil." In *Bill Traylor, 1854–1949: Deep Blues,* edited by Josef Helfenstein and Kurzmeyer, 10–30. New Haven: Yale University Press, 1999.

Kuyk, Betty M. "The African Derivation of Black Fraternal Orders in the United States." *Comparative Studies in Society and History* 25, no. 4 (1983): 559–92.

———. *African Voices in the African American Heritage.* Bloomington: Indiana University Press, 2003.

Lachance, Paul. "Repercussions of the Haitian Revolution in Louisiana." In *Impact of the Haitian Revolution in the Atlantic World,* edited by David P. Geggus, 209–30. Columbia: University of South Carolina Press, 2001.

LaGamma, Alisa. *Art and Oracle: African Art and Rituals of Divination.* New York: Metropolitan Museum of Art, 2000.

Langa, Helen. *Radical Art: Printmaking and the Left in 1930s New York.* Berkeley and Los Angeles: University of California Press, 2004.

———. "Two Antilynching Art Exhibitions: Politicized Viewpoints, Racial Perspectives, Gendered Constraints." *American Art* 13 (1999): 10–39.

Leone, Mark, and Gladys-Marie Fry. "Conjuring in the Big House Kitchen: An Interpretation of African American Belief Systems, Based on the Use of Archaeology and Folklore Sources." *Journal of American Folklore* 112, no. 445 (1999): 372–403.

Levine, Lawrence W. *Black Culture and Black Consciousness: Afro-American Folk Thought from Slavery to Freedom.* New York: Oxford University Press, 1977.

Lewis, David Levering. *W. E. B. Du Bois: Biography of a Race, 1868–1919.* New York: Holt, 1993.

Lewis, Ella Jackson, as told to Rudolph Lewis. "Conjuring and Doctoring: A True Story about the Fabled Doctor Jim Jordan." *New Laurel Review* 21 (1999).

Litwack, Leon I. *Trouble in Mind: Black Southerners in the Age of Jim Crow.* New York: Knopf, 1998.

Livingston. Jane, and John Beardsley, eds. *Black Folk Art in America, 1930–1980.* Jackson: University Press of Mississippi for the Corcoran Gallery of Art, 1982.

Lomax, Alan. *The Land Where the Blues Began.* New York: Pantheon, 1993.

———. *The Rainbow Sign: A Southern Documentary.* New York: Duell, Sloan and Pearce, 1959.

Long, Carolyn Morrow. "Perceptions of New Orleans Voodoo: Sin, Fraud, Entertainment, and Religion." *Nova Religio* 6, no. 1 (Oct. 2002): 86–101.

————. *Spiritual Merchants: Religion, Magic and Commerce.* Knoxville: University of Tennessee Press, 2001.

Lowndes County, Alabama. Marriage Book I, surnames L–Z, 1830–1848.

Luckmann, Thomas. *The Invisible Religion: The Problem of Religion in Modern Society.* New York: Macmillan, 1967.

Luker, Ralph E. "Murder and Biblical Memory: The Legend of Vernon Johns." *Virginia Magazine of History and Biography* 112, no. 4 (2005): 372–418.

Lyons, Mary E. *Deep Blues: Bill Traylor, Self-Taught Artist.* New York: Scribner's, 1994.

MacGaffey, Wyatt. *Art and Healing of the BaKongo Commented by Themselves: Minkisi from the Laman Collection.* Stockholm: Folkens Museum-Etnografiska, 1991.

————. "Complexity, Astonishment and Power: The Visual Vocabulary of Kongo Minkisi." *Journal of Southern African Studies* 14 (1988): 188–203.

————. *Religion and Society in Central Africa: The BaKongo of Lower Zaire.* Chicago: University of Chicago Press, 1986.

Malone, Jacqui. *Steppin' on the Blues: The Visible Rhymes of African American Dance.* Urbana: University of Illinois Press, 1969.

Marcus, Greil. *Mystery Train: Images of America in Rock 'n' Roll Music.* 1975. 4th rev. ed. New York: Plume, 1997.

Maresca, Frank, and Roger Ricco, eds. *Bill Traylor: His Art—His Life.* New York: Knopf, 1991.

————. "Remembering Bill Traylor: An Interview with Charles Shannon." In *Bill Traylor: His Art—His Life,* edited by Maresca and Ricco, 3–31. New York: Knopf, 1991.

Margolick, David. *Strange Fruit: Billy Holiday, Cafe Society, and an Early Cry for Civil Rights.* Philadelphia: Running Press, 2000.

Martin, Robert E. "Lynching." In *Encyclopedia Americana,* 17: 884–85. Danbury, Conn.: Grolier, 1981.

Marvin, Thomas F. "Children of Legba: Musicians at the Crossroads in Ralph Ellison's *Invisible Man.*" *American Literature* 68 (1996): 587–606.

Mathews, Burgin. "'Looking for Railroad Bill': On the Trail of an Alabama Badman." *Southern Cultures* 9, no. 3 (2003): 66–88.

Mathews, Donald G. "The Southern Rite of Human Sacrifice: Lynching and Religion in the South, 1875–1940." *Journal of Southern Religion* 3 (2000). http://jsr.fsu.edu/mathews.htm.

Matibag, Eugenio. *Afro-Cuban Religious Experience: Cultural Reflections in Narrative.* Gainesville: University Press of Florida, 1996.

McAdam, Doug. *Political Process and the Development of Black Insurgency, 1930–1970.* Chicago: University of Chicago Press, 1982.

McGinty, Doris Evans. "Black Scholars on Black Music: The Past, the Present, and the Future." *Black Music Research Journal* 13 (1993): 1–13.

McWillie, Judith. "Traditions and Transformations: Vernacular Art from the Afro-Atlantic South." In *Dixie Debates: Perspectives on Southern Cultures,* edited by Richard H. King and Helen Taylor, 193–217. New York: New York University Press, 1996.

Meier, August, and Elliot Rudwick. "The Boycott Movement against Jim Crow Streetcars in the South, 1900–1906." *Journal of American History* 55 (1969): 756–75.

Metraux, Alfred. *Voodoo in Haiti.* 1959. New York: Schocken, 1972.

Millner, Steven M. "The Montgomery Bus Boycott: A Case Study in the Emergence and Career of a Social Movement." In *The Walking City: The Montgomery Bus Boycott, 1955–1956,* edited by David J. Garrow, 381–606. Brooklyn, N.Y.: Carlson, 1989.

Minter, Joe. Interview by Mechal Sobel. April 20, 2003. Birmingham, Ala. Tapes, Mechal Sobel, personal collection.

Mitchell, Michele. "Silences Broken, Silences Kept: Gender and Sexuality in African-American History." *Gender and History* 11 (1999): 433–44.

Montgomery City Directory. Richmond: R. L. Polk and Co., 1925–50.

Moore, Ruby Andrews. "Superstitions in Georgia." *Journal of American Folklore* 5 (1892): 230–31.

Morgan, Stacey I. *Rethinking Social Realism: African American Art and Literature, 1930–1953.* Athens: University of Georgia Press, 2004.

Morrow, Kara Ann. "Bakongo Afterlife and Cosmological Direction: Translation of African Culture into North Florida Cemeteries." *Athanor* 20 (2002): 105–15.

Mumford, Lewis. "The Art Galleries: Autobiographies in Paint." *New Yorker,* January 18, 1936, 48–49.

Muraskin, William A. *Middle-Class Blacks in a White Society: Prince Hall Freemasonry in America.* Berkeley and Los Angeles: University of California Press, 1975.

Murray, Albert. *From the Briarpatch File: On Context, Procedure, and American Identity.* New York: Pantheon, 2001.

———. *Stomping the Blues.* 1976. New York: Da Capo Press, 1987.

Murray, Albert, and John F. Callahan, eds. *Trading Twelves: The Selected Letters of Ralph Ellison and Albert Murray.* New York: Modern Library, 2000.

Myrdal, Gunnar. *An American Dilemma.* New York: Harper and Brothers, 1944.

Nooter, Mary H. "The Visual Language of Secrecy." In *Secrecy, African Art That Conceals and Reveals,* edited by Nooter, 49–52. New York: Museum for African Art, 1993.

Nzegwu, Khiru, curator. "Abakua: Nsibidi Motifs in Cuba." *Ijele: Art eJournal of the African World,* no. 4 (2002). www. africaresource.com/ijele/issue4/toc4.htm.

Oakley, Giles. *The Devil's Music: A History of the Blues.* New York: Harcourt Brace Jovanovich, 1976.

Odum, Howard W. "Folk-Song and Folk-Poetry: As Found in the Secular Songs of the Southern Negroes." *Journal of American Folklore* 24 (1911): 255–94, 351–96.

———. *Social and Mental Traits of the Negro: Research into the Conditions of the Negro in Southern Towns, a Study in Race Traits, Tendencies and Prospects.* New York: Columbia University, 1910.

Odum, Howard W., and Guy Benton Johnson. *The Negro and His Songs: A Study of Typical Negro Songs in the South.* Chapel Hill: University of North Carolina Press, 1925.

O'Kane Gallery. *Bill Traylor.* Houston: University of Houston, O'Kane Gallery, 2001.

Oliver, Paul. *Blues Fell This Morning: Meaning in the Blues.* 1960. Cambridge: Cambridge University Press, 1990.

———. *Songsters and Saints: Vocal Traditions on Race Records.* Cambridge: Cambridge University Press, 1984.

———. *The Story of the Blues.* London: Barrie and Rockliff, Cresset Press, 1969.

Oster, Harry. *Living Country Blues.* Detroit: Folklore Associates, 1969.

Owen, Mary A. "Among the Voodoos." In *Papers and Transactions,* edited by Joseph Jacobs and Alfred Nutt. International Folk-lore Congress, 1891. London, 1892.

Palmer, Edward N. "Negro Secret Societies." *Social Forces* 23 (December 1944): 207–12.

Park, Marlene. "Lynching and Antilynching: Art and Politics in the 1930s." *Prospects: An Annual of American Cultural Studies* 18 (1993): 311–65.

———. "Lynching and Antilynching: Art and Politics in the 1930s." In *The Social and the Real: Political Art of the 1930s in the Western Hemisphere,* edited by Alejandro Anreus, Diana L. Linden, and Jonathan Weinberg, 155–77. State College: Pennsylvania State University Press, 2006.

Parrinder, Geoffrey. *West African Psychology: A Comparative Study of Psychological and Religious Thought.* London: Lutterworth Press, 1951.

Patterson, Orlando. *Rituals of Blood: Consequences of Slavery in Two American Centuries.* Washington, D.C.: Civitas/CounterPoint, 1998.

Patton, Phil. "High Singing Blue." In *Bill Traylor: High Singing Blue.* New York: Hirschl and Adler Modern, 1999.

———. "High Singing Blue." In *Bill Traylor, 1854–1949: Deep Blues,* edited by Josef Helfenstein and Roman Kurzmeyer, 109–14. New Haven: Yale University Press, 1999.

Peabody, Charles. "Notes on Negro Music." *Journal of American Folklore* 16, no. 62 (July 1903): 148–52.

Pearson, Barry Lee. "Appalachian Blues." *Black Music Research Journal* 3, no. 1–2 (Spring–Fall 2003): 23–52.

Perdue, Charles L., Jr., Thomas E. Barden, and Robert K. Phillips, eds. *Weevils in the Wheat: Interviews with Virginia Ex-Slaves.* Charlottesville: University Press of Virginia, 1976.

Perrow, E. C. "Songs and Rhymes from the South." *Journal of American Folklore* 25 (1912): 137–55.

Pettet, Z. R., and Charles E. Hall. *Negroes in the United States, 1920–32.* 1935. New York: Greenwood Press, 1969.

Phagan, Patricia, ed. *The American Scene and the South: Paintings and Works on Paper, 1930–1946.* Athens: Georgia Museum of Art, 1996.

Pinder, Kymberly N. "'Our Father, God; our Brother, Christ; or Are We Bastard Kin': Images of Christ in African American Painting." *African American Review* 31, no. 2 (1997): 223–33.

Ping, Nancy R. "Black Musical Activities in Antebellum Wilmington, North Carolina." In *Black Perspective in Music* 8, no. 2 (Fall 1980): 139–60.

Pollitzer, William S. *The Gullah People and Their African Heritage.* Athens: University of Georgia Press, 1999.

Powell, Richard J. "Art History and Black Memory: Toward a "Blues Aesthetic." In *History and Memory in African-American Culture,* edited by Geneviève Fabre and Robert O'Meally, 228–43. New York: Oxford University Press, 1994.

———. *Homecoming: The Art and Life of William H. Johnson.* New York: Rizzoli, 1991.

———. "'In My Family of Primitiveness and Tradition': William H. Johnson's *Jesus and the Three Marys.*" *American Art* 5, no. 4 (Autumn 1991): 20–33.

Prahlad, Anand. *African American Proverbs in Context.* Jackson: University Press of Mississippi, 1996.

Puckett, Newbell Niles. *Folk Beliefs of the Southern Negro.* 1926. New York: Negro Universities Press, 1968.

Quilts of Gee's Bend. Directed by Matt Arnett and Vanessa Vadim. Videorecording. Atlanta, Ga.: Tinwood Media, 2002.

Rankin, Allen. "He Lost 10,000 Years." *Collier's Magazine,* June 22, 1946, 67.

———. "He'll Paint for You—Big 'Uns 20 Cents; Lil 'Uns, a Nickel." Rankin File, *Alabama Journal,* March 31, 1948.

Rawick, George P., ed. *The American Slave: A Composite Autobiography.* 19 vols. Westport, Conn.: Greenwood Press, 1941–72.

———. *The American Slave: A Composite Autobiography.* Supplement, ser. 2, 10 vols. Westport, Conn.: Greenwood Press, 1979.

Renne, Elisha P. *Cloth That Does Not Die: The Meaning of Cloth in Bunu Social Life.* Seattle: University of Washington Press, 1995.

Reuss, Richard A., with JoAnne C. Reuss. *American Folk Music and Left-Wing Politics, 1927–1957.* Lanham, Md.: Scarecrow Press, 2000.

Ricco/Maresca Gallery. *Bill Traylor: Observing Life.* New York: Ricco/Maresca Gallery, 1997.

———. *Bill Traylor: Postcard Book.* New York: Artpost, 2000.

Rigaud, Milo. *Ve-Ve: Diagrammes rituels du voudou.* New York: French and European Publications, 1974.

Rivers, Cheryl. "Clementine Hunter: Chronicler of African-American Catholicism." In *Sacred and Profane: Voice and Vision in Southern Self-Taught Art,* edited by Carol Crown and Charles Russell, 146–71. Jackson: University Press of Mississippi, 2007.

Rosengarten, Theodore. *All God's Dangers: The Life of Nate Shaw.* 1974. New York: Vintage, 1989.

Ross, David, Jr. Telephone interview by Mechal Sobel. June 21, 2004. Montgomery, Ala. Notes, Mechal Sobel, personal collection.

Royster, Jacqueline Jones, ed. *Southern Horrors and Other Writings: The Anti-Lynching Campaign of Ida B. Wells, 1892–1900.* Boston: Bedford Books, 1997.

Rustin, Nichole T. "Forever Free: Modern Black Subjectivity and the Art of Bill Traylor and William Edmondson." In *Bill Traylor, William Edmondson, and the Modernist Impulse,* edited by Josef Helfenstein and Roxanne Stanulis, 159–86. Champaign, Ill.: Krannert Art Museum and the Menil Collection, 2004.

Sakolsky, Ron, ed. *Surrealist Subversions: Rants, Writings and Images from Arsenal and Other Publications of the Surrealist Movement in the United States.* Brooklyn, N.Y.: Autonomedia, 2002.

Sanders, Lynn Moss. *Howard W. Odum's Folklore Odyssey: Transformation to Tolerance through African American Folk Studies.* Athens: University of Georgia Press, 2003.

Schechter, Patricia. "Unsettled Business: Ida B. Wells against Lynching, or How Anti-lynching Got its Gender." In *Under Sentence of Death: Lynching in the South,* edited by W. Fitzhugh Brundage, 292–317. Chapel Hill: University of North Carolina Press, 1997.

Schutz, Alfred, and Thomas Luckmann. *The Structures of the Life-World.* Evanston, Ill.: Northwestern University Press, 1973.

Schwartz, Marie Jenkins. *Born in Bondage: Growing Up Enslaved in the Antebellum South.* Cambridge: Harvard University Press, 2000.

Shahn, Ben. *The Shape of Content.* 1957. Cambridge: Harvard University Press, 1963.

Shannon, Charles. "Bill Traylor's Triumph: How the Beautiful and Raucous Drawings of a Former Alabama Slave Came to Be Known to the World." *Art and Antiques,* February 1988: 61–65, 88.

[———.] *Bill Traylor—People's Artist.* Montgomery, Ala.: New South Gallery, 1940. Copy in Marcia Weber, Alabama Folk Artists Collection, ca. 1949–93. Archives and Special Collections, Auburn University, Montgomery.

———. "The Folk Art of Bill Traylor." In *Southern Works on Paper, 1900–1950,* edited by Richard Cox, 16. Atlanta: Southern Arts Federation, 1981.

Shapiro, Herbert. *White Violence and Black Response: From Reconstruction to Montgomery.* Amherst: University of Massachusetts Press, 1988.

Sims, Lowery Stokes. "Bill Traylor: Inside the Outsider." In *Bill Traylor, 1854–1949: Deep Blues,* edited by Josef Helfenstein, and Roman Kurzmeyer, 92–95. New Haven: Yale University Press, 1999.

Sisk, Glen N. "Churches in the Alabama Black Belt, 1875–1917." *Church History* 23, no. 2 (1954): 153–74.

Sitkoff, Harvard. *The Struggle for Black Equality, 1945–1980.* New York: Hill and Wang, 1981.

Skocpol, Theda, and Jennifer Lynn Oser. "Organization Despite Adversity: The Origins and Development of African American Fraternal Associations." *Social Science History* 28, no. 3 (2004): 367–437.

Small, Christopher. *Music of the Common Tongue: Survival and Celebration in African American Music.* 1987. Hanover, N.H.: University Press of New England, 1998.

Snell, William Robert. "Masked Men in the Magic City: Activities of the Revised Klan in Birmingham, 1916–1940." *Alabama Historical Quarterly* 34 (1927): 206–27.

Snow, Loudell F. *Walkin' Over Medicine.* Detroit: Wayne State University Press, 1998.

Sobel, Mechal. *Teach Me Dreams: The Search for Self in the Revolutionary Era.* Princeton: Princeton University Press, 2000.

———. *Trabelin' On: The Slave Journey to an Afro-Baptist Faith.* Westport, Conn.: Greenwood Press, 1979.

———. *The World They Made Together: Black and White Values in the Eighteenth Century.* Princeton: Princeton University Press, 1987.

Spence, Muneera Umedaly. "Nsibidi and Vai: A Survey of Two Indigenous West African Scripts." Master's thesis, Yale University, 1979.

Spriggs, Lynne E., Joanne Cubbs, and Lynda Roscoe Hartigan. *Let It Shine: Self-Taught Art from the T. Marshall Hahn Collection.* Atlanta: High Museum of Art, 2001.

Staffney, Margaret Traylor. Interviews by Mechal Sobel. June 15, 1993, and February 29, 1995. Montgomery, Ala. Notes, Mechal Sobel, personal collection.

Steinmetz, George H. *Freemasonry: Its Hidden Meaning.* Richmond, Va.: Macoy Pub. and Masonic Supply Co., 1948.

Stigliano, Phyllis. *Bill Traylor: Exhibition History, Public Collections, Selected Bibliography.* New York: Luise Ross Gallery, 1990.

Stuckey, Sterling. *Slave Culture: Nationalist Theory and the Foundations of Black America.* New York: Oxford University Press, 1987.

Sullivan, Patricia. *Days of Hope: Race and Democracy in the New Deal Era.* Chapel Hill: University of North Carolina Press, 1996.

———. "Southern Reformers, the New Deal and the Movement's Foundation." In *New Directions in Civil Rights Studies,* edited by Armstead L. Robinson and Patricia Sullivan, 80–104. Charlottesville: University Press of Virginia, 1991.

Szwed, John F. "An American Anthropological Dilemma: The Politics of Afro-American Culture." In *Reinventing Anthropology,* edited by Dell Hymes, 153–81. New York: Pantheon, 1972.

———. "Musical Adaptation among Afro-Americans." *Journal of American Folklore* 82 (1969): 112–21.

———. *Space Is the Place: The Lives and Times of Sun Ra*. New York: Da Capo Press, 1998.

Taft, Michael. *Blues Lyric Poetry: A Concordance*. 3 vols. New York: Garland, 1984.

———. *Talkin' to Myself: Blues Lyrics, 1920–1942*. 1983. New York: Routledge, 2005.

Thompson, Robert Farris. *African Art in Motion: Icon and Act in the Collection of Katherine Coryton White*. Berkeley and Los Angeles: University of California Press, 1974.

———. "African Influence on the Art of the United States." In *Black Studies in the University: A Symposium*, edited by Armstead L. Robinson, Craig C. Foster, and Donald H. Ogilvie, 122–70. New Haven: Yale University Press, 1969.

———. "Bighearted Power: Kongo Presence in the Landscape and Art of Black America." In *Keep Your Head to the Sky: Interpreting African American Home Ground*, edited by Grey Gundaker, 37–64. Charlottesville: University Press of Virginia, 1998.

———. "Communiqué from Afro-Atlantis." *African Arts* 32, no. 4 (winter 1999): 1–8.

———. *Flash of the Spirit: African and Afro-American Art and Philosophy*. New York: Random House, 1983.

———. "Kongo Influences on African-American Artistic Culture." In *Africanisms in American Culture*, edited by Joseph E. Holloway, 148–84. Bloomington: Indiana University Press, 1990.

———. "Siras Bowens of Sunbury, Georgia: A Tidewater Artist in the Afro-American Visual Tradition." In *Chant of Saints: A Gathering of Afro-American Literature, Art, and Scholarship*, edited by Michael S. Harper and Robert B. Steptoe, 230–40. Urbana: University of Illinois Press, 1979.

Thompson, Robert Farris, and Joseph Cornet. *The Four Moments of the Sun: Kongo Art in Two Worlds*. Washington, D.C.: National Gallery of Art, 1981.

Thurman, Howard. *Disciplines of the Spirit*. 1963. Richmond, Ind.: Friends United Press, 1987.

Titon, Jeff Todd. *Early Downhome Blues: A Musical and Cultural Analysis*. 1977. 2nd ed. Chapel Hill: University of North Carolina Press, 1994.

Tracy, Steven C. *Going to Cincinnati: A History of the Blues in the Queen City*. Urbana: University of Illinois Press, 1993.

Traylor, John G., Diary. January 1, 1834–April 16, 1847. Typescript. Copied by Gladys M. Jones. Alabama Department of Archives and History, Montgomery.

———. Will, Dallas County, Will Book B, pp. 1–2. Microfilm copy, LGM 75, reel 22. Alabama Department of Archives and History, Montgomery.

Traylor Family. *Traylor-Calloway-Durant Family Reunion*. Booklet. Unpaginated. August 9–11, 1991. Detroit. Marcia Webber, Alabama Folk Artists Collection, ca. 1949–93. Archives and Special Collections, Auburn University, Montgomery.

———. *Traylor-Calloway-Durant Family Reunion.* Booklet. Unpaginated. August 7–9, 1992. Atlanta. Marcia Webber, Alabama Folk Artists Collection, ca. 1949–93. Archives and Special Collections, Auburn University, Montgomery.

Trotter, Joe W. "African American Fraternal Organizations in American History: An Introduction." *Social Science History* 28, no. 3 (2004): 355–66.

Turner, Victor. *The Forest of Symbols: Aspects of Ndembu Ritual.* Ithaca: Cornell University Press, 1967.

Tuskegee Institute. "Lynchings: By Year and Race." Tuskegee Institute Archives: www .law.umkc.edu/faculty/projects/ftrials/shipp/lynchingyear.html.

United States Bureau of the Census. Populations Schedule. *Second Census of the United States.* Washington, D.C., 1800.

———. Populations Schedule. *Third Census of the United States.* Washington, D.C., 1810.

———. Populations Schedule. *Fourth Census of the United States.* Washington, D.C., 1820.

———. Populations Schedule. *Fifth Census of the United States.* Washington, D.C., 1830.

———. Populations Schedule. *Sixth Census of the United States.* Washington, D.C., 1840.

———. Populations Schedule. *Seventh Census of the United States.* Washington, D.C., 1850.

———. Populations Schedule. *Eighth Census of the United States.* Washington, D.C., 1860.

———. Populations Schedule. *Ninth Census of the United States.* Washington, D.C., 1870.

———. Populations Schedule. *Tenth Census of the United States.* Washington, D.C., 1880.

———. Populations Schedule. *Twelfth Census of the United States.* Washington, D.C., 1900.

———. Populations Schedule. *Thirteenth Census of the United States.* Washington, D.C., 1910.

———. Populations Schedule. *Fourteenth Census of the United States.* Washington, D.C., 1920.

———. Populations Schedule. *Fifteenth Census of the United States.* Washington, D.C., 1930.

Van Rijn, Guido. *Roosevelt's Blues: African-American Blues and Gospel Songs on FDR.* Jackson: University Press of Mississippi, 1997.

Varon, Nance. Telephone interview by Mechal Sobel. June 29, 2004. Montgomery, Ala. Notes, Mechal Sobel, personal collection.

Vlach, John Michael. *The Afro-American Tradition in Decorative Arts*. 1978. Athens: University of Georgia Press, 1990.

Wahlman, Maude Southwell. "The Art of Bill Traylor." In *Bill Traylor (1854–1947)*. Little Rock: Arkansas Arts Center, 1982.

———. "Bill Traylor: Mysteries." In *Souls Grown Deep: African American Vernacular Art of the South*, edited by Paul Arnett and William Arnett, vol. 1, *The Tree Gave the Dove a Leaf*, 276–81. Atlanta: Tinwood Books, 2000.

———. *Signs and Symbols: African Images in African-American Quilts*. 1993. New York: Museum of American Folk Art, 2001.

Walker, Corey D. B. "The Freemasonry of the Race: The Cultural Politics of Ritual, Race, and Place in Postemancipation Virginia." Ph.D. diss., College of William and Mary, November 2001.

Walker, Maridith. "Bill Traylor: Freed Slave and Folk Artist." *Alabama Heritage* 14 (Fall 1989): 19–31.

Wallace, Maurice. "'Are We Men?': Prince Hall, Martin Delany, and the Masculine Ideal in Black Freemasonry, 1775–1865." *American Literary History* 9 (Autumn 1997): 396–424.

Wardlaw, Alvira, ed. *Black Art/Ancestral Legacy: The African Impulse in African-American Art*. Dallas: Dallas Museum of Art, 1989.

Waters, Donald J., ed. *Strange Ways and Sweet Dreams: Afro-American Folklore from the Hampton Institute*. Boston: Hall, 1983.

Wells, Ida B. *The Red Record: Statistics and Alleged Causes of Lynching in the United States, 1892–1893–1894*. 1895. Reprinted in *Southern Horrors and Other Writings: The Anti-Lynching Campaign of Ida B. Wells, 1892–1900*, edited by Jacqueline Jones Royster, 49–72. Boston: Bedford Books, 1997.

———. *Southern Horrors: Lynch Law in All Its Phases*. 1892. Reprinted in *Southern Horrors and Other Writings: The Anti-Lynching Campaign of Ida B. Wells, 1892–1900*, edited by Jacqueline Jones Royster, 49–72. Boston: Bedford Books, 1997.

White, Deborah Gray. *Ar'n't I a Woman? Female Slaves in the Plantation South*. 1985. 2nd rev. ed. New York: Norton, 1999.

White, Graham J., and Shane White. *Stylin': African American Expressive Culture, from Its Beginnings to the Zoot Suit*. Ithaca: Cornell University Press, 1999.

White, Shane, and Graham J. White. *The Sounds of Slavery: Discovering African American History through Songs, Sermons, and Speech*. Boston: Beacon Press, 2005.

Whitted, Qiana. "In My Flesh I Shall See God: Ritual Violence and Racial Redemption in 'The Black Christ.'" *African American Review* 38, no. 3 (Fall 2004): 379–94.

———. "'Using My Grandmother's Life as a Model': Richard Wright and the Gendered Politics of Religious Representation." *Southern Literary Journal* 36, no. 2 (2004): 13–30.

Wilkinson, Joe. "Bill Traylor Drawings." In *Bill Traylor Drawings from the Collection of Joe and Pat Wilkinson*, 13–15. New York: Sotheby's, 1997.

Williams, Loretta J. *Black Freemasonry and Middle-Class Realities*. Columbia: University of Missouri Press, 1980.

Willis, W. Bruce. *The Adinkra Dictionary: A Visual Primer on the Language of Adinkra*. Washington, D.C.: Pyramid Complex, 1998.

Wilson, Charles Reagan. "Traveling Shows." In *Encyclopedia of Southern Culture*, edited by Charles Reagan Wilson and William Ferris, 1247–49. Chapel Hill: University of North Carolina Press, 1989.

Wingo, Ajume H. "African Art and the Aesthetics of Hiding and Revealing." *British Journal of Aesthetics* 38 (1998): 251–64.

Wolf, John Quincy. "Aunt Caroline Dye: The Gypsy in the 'St. Louis Blues." *Southern Folklore Quarterly* 33 (1969): 330–46.

Woodruff, Nan Elizabeth. *American Congo: The African American Freedom Struggle in the Delta*. Cambridge: Harvard University Press, 2003.

Work, John W., Lewis Wade Jones, and Samuel C. Adams. *Lost Delta Found: Rediscovering the Fisk University–Library of Congress Coahoma County Study, 1941–1942*. Edited by Robert Gordon and Bruce Nemerov. Nashville: Vanderbilt University Press, 2005.

Wright, Richard. "Memories of My Grandmother." N.d. Richard Wright Papers. Yale Collection of American Literature, Beinecke Rare Book and Manuscript Library, Yale University Library, New Haven, Conn..

Wright, Richard R. *87 Years behind the Black Curtain*. Philadelphia: Rare Book Company, 1965.

Writers' Program, Alabama, Works Project Administration. *Alabama: A Guide to the Deep South*. New York: Smith, 1941.

Wye, Pamela. "Visionary Artists: Bill Traylor and Minnie Evans." Wichita, Kans,: Wichita Art Museum, 1992.

Young, Penny. *Survival: The Will and the Way*. New York: Vantage Press, 1999.

yronwode, catherine. "Hoodoo in Theory and Practice: An Introduction to African-American Rootwork." 1995–2003. www.luckymojo.com/hoodoo.html.

Zelano, C., M. Benisafi, J. Porter, J. Mainland, B. Johnson, E. Bremner, C. Telles, R. Khan, and N. Sobel. "Attentional Modulation in Human Primary Olfactory Cortex." *Nature Neuroscience* 8 (2005): 114–20.

INDEX